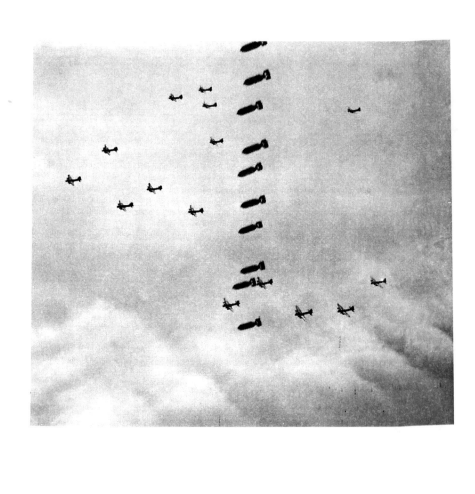

STRATEGIC BOMBING BY THE UNITED STATES IN WORLD WAR II

The Myths and the Facts

Stewart Halsey Ross

McFarland & Company, Inc., Publishers
Jefferson, North Carolina, and London

ALSO BY STEWART HALSEY ROSS

*Propaganda for War: How the United States Was
Conditioned to Fight the Great War of 1914–1918*
(McFarland, 1996)

*The Management of
Business-to-Business Advertising*
(1986)

Frontispiece: Squadrons of B-17 Flying Fortresses "blind bombing" targets
in Europe. The 8th Air Force often bombed the countryside, occasionally
struck the wrong city, and sometimes hit the wrong country (Switzerland).
(Courtesy National Archives)

Library of Congress Cataloguing-in-Publication Data
Ross, Stewart Halsey.
Strategic bombing by the United States in
World War II : the myths and the facts / Stewart Halsey Ross.
p. cm.
Includes bibliographical references and index.

ISBN 0-7864-1412-X (softcover : 50# alkaline paper)

1. World War, 1939–1945—Aerial operations.
2. Bombing, Aerial.
3. Aeronautics, Military—United States—History.
4. United States Strategic Bombing Survey.
I. Title.
D785.U57R67 2003 707'.1'173541—dc21 2002014698

British Library cataloguing data are available

Front cover: U.S. 8th Air Force B-17 Flying Fortress seconds after
release of its bombs on a raid over Germany. ©2002 *Art Today*

Manufactured in the United States of America

*McFarland & Company, Inc., Publishers
Box 611, Jefferson, North Carolina 28640
www.mcfarlandpub.com*

To my beloved wife of half a century
and closest friend, Judith

No historian can describe the past as it actually was and every historian's work — that is, his selection of facts, his emphasis, his omissions, his organization, his method of presentation — bears a relationship to his own personality and the age and circumstances in which he lives.

—Charles Austin Beard,
That Noble Dream, 1935

Contents

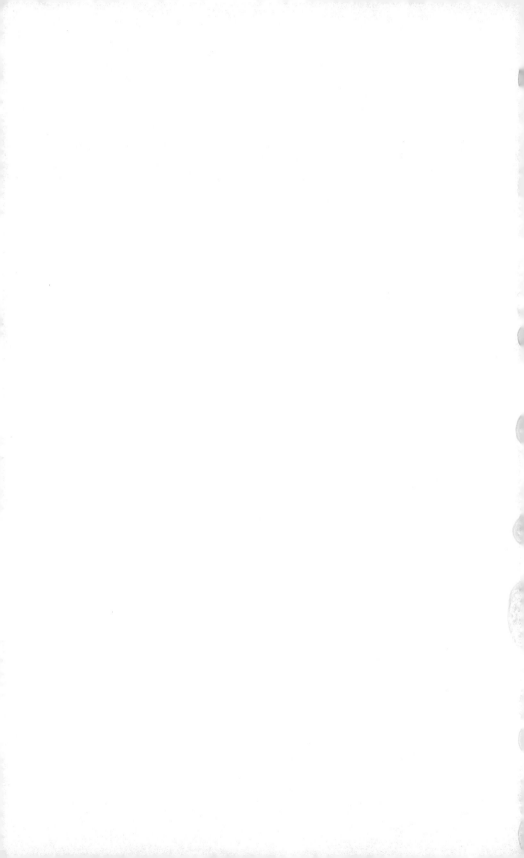

Preface

Every bombing campaign ever launched has had an attack on civil-
ian morale as one of its aims. The aim of such campaigns is to cause a col-
lapse of that morale, and that can only be achieved by terror bombing—the
bomber, when deployed strategically, is fundamentally a terror weapon,
and that fact has to be faced and not fudged.[1]

[The] RAF would use its Bomber Command with a purposeful vin-
dictiveness against German civilians never matched by the USAAFs—
nor, indeed, by the Luftwaffe in 1940.[2]

This book has its origins in an earlier book I wrote, *Propaganda for War:*
How the United States Was Conditioned to Fight the Great War of 1914–1918.
My intent then was to bring to light what I called the great myths and leg-
ends that contributed to America's fateful decision to intervene in that water-
shed conflict, an intervention that had an enormous and enduring impact on
the history of the 20th century. In that book I focused on the many hypocrisies
that bankrupted U.S. foreign policy at a time when clear vision was called
for—but was blurred by powerful jingoistic forces.

My purpose in this book is similar: to expose the deceits and coverups,
purposeful as well as benign, that still cloud the realities of U.S. strategic
bombing attacks against German and Japanese targets during World War II.
Americans today by the millions who trust the attractive documentary-style
"History Channel" as their principal source of historical information seem
unaware that they are being fed a smoothly orchestrated blend of fact and
patriotic fiction. World War II remains the "good war," and the selection of
film clips and sincere-speaking veterans buttress that comfortable view.

American military strategists have always found aerial bombing attractive.
For a country that does not actively seek to expand its territories, but rather

to achieve global hegemony, strategic air power is the nearly perfect weapon. America's geographical position is unique among global powers—bordered by two oceans and two friendly contiguous land masses. This has meant, until the advent of intercontinental ballistic missiles with their nuclear warheads, invulnerability to retaliation.

The simplistic notions of the trio of influential prewar soothsayer-generals—the Frenchman Gulio Douhet, the Englishman Hugh Trenchard, and the American William "Billy" Mitchell—that long-range bombers could penetrate enemy airspace, strike accurately, and return with minimal losses were dispelled almost immediately. The "surgical" air campaigns envisioned were superseded in the war that finally came by unimagined realities: heavy aircrew casualties and minimal results. A war of attrition developed, pitting America's vast reserves of manpower and productive capability against German technological prowess and Japanese tenacity—it was a war the Axis powers could not win. At a fundamental level, the airwar from 1939 to 1945 turned out to be not much different from combat on the ground, if not in total numbers, certainly in intensity. It could be compared to the daily butchery in the trenches in France between 1914 to 1918.

This book's focus is not on propaganda, although the reader will find many instances of blatant lies and purposeful coverups by high-ranking officials. Rather, its intent is to probe the government myth-building deceit that fits comfortably into America's inward-looking and hypocritical view of itself as a nation uniquely humanitarian among all others. We draw our sword reluctantly, we tell ourselves over and over—and only when thoroughly provoked. As a corollary, America does not aim bombs at civilians.

Nor is it my intent to dig deeply into comparative moralities, but from time to time, I must do so. When an English woman in her seventies, which puts her a teenager during the London *Blitz*, responded to the author's statement that the destruction of the German city of Dresden in the waning weeks of the war in Europe by Royal Air Force Bomber Command and the U.S. 8th Air Force could be defined as an atrocity, she responded instantly, almost in programmed fashion, "What about Coventry?" Coventry was a major aircraft manufacturing center, producing Spitfires for the RAF. Reliable postwar estimates are that about 700 civilians were killed by German bombers over Coventry in 1940, while the British and American bombers killed probably 100 times that number in the firestorm of Dresden in 1945. Dresden manufactured practically no war goods according to a later-well-known American prisoner of war who survived the firestorm. Remarkably, the almost-universal revulsion to that Renaissance city's wanton destruction was never matched by reaction to the even more devastating incendiary-bomb raid by American B-29s on Tokyo in March 1945. According to Japanese official reports, more civilian residents were killed in that attack than in the nuclear bombing of Hiroshima. Four years earlier, Japanese naval aircraft had killed

about 2,400 people, nearly all military personnel, when they bombed U.S. navy warships and naval facilities at Pearl Harbor; the Japanese planes, however, did not bomb adjacent Honolulu.

Any analysis of U.S. airpower during World War II must also cover the role played by interservice rivalry—the conflict between the "battleship admirals" and the "bomber generals"—a conflict that runs long and deep and continues unabated into the 21st century. This joust for military-policy dominance—and federal funding—began in earnest in 1921, when Army Air Corps General Mitchell staged the bombing and sinking of a captured German battleship. The contest was ongoing through the 1930s as the flyers strove to move out of the shadow of the Navy, and its powerful supporters in the Congress, and the Navy's entrenched and influential steel and shipbuilding contractors. Not only was military doctrine at stake, but the individual career ambitions of the competitors themselves were on the line. However, the most important issue of all, from the flyers' standpoint, was independence, for only an entirely separate air force would enable untrammeled use of airpower.

It was a tall order for the flyers, as Americans historically had been conditioned to believe that the defense of the nation resided in seapower. President Franklin Delano Roosevelt, a former Assistant Secretary of the Navy and a

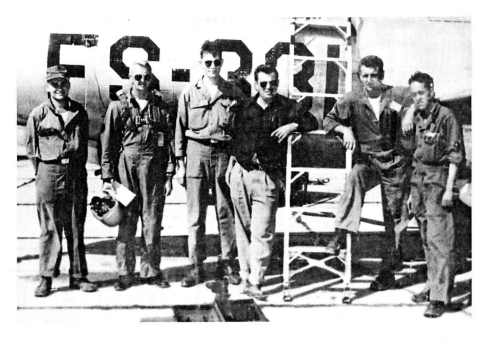

Flight line at Edwards Air Force Base, California, 1955. Far left: Author, PFC, U.S. Army Ordnance Corps and project engineer, Aberdeen Bombing Mission. With him (all unidentified) are an Air Force test pilot, contractors, and Air Force ground crew. Background: Republic F-84E Thunderjet. (Author's collection)

sailor at heart, was of this same mindset. In May 1940, he remarked at a White House press conference: "One additional word about aircraft. Recent wars, including the current war in Europe, have demonstrated beyond doubt that fighting efficiency depends on unity of control. In sea operations the airplane is just as much an integral part of unit of operations as are the submarine, the destroyer, and the battleship, and in land warfare the airplane is just as much a part of military operations as are the tank corps, the engineers, the artillery, or the infantry itself. Therefore, the air forces should be part of the Army and Navy."[3] U.S. flyers had their work cut out for them.

With America in World War II, the fortunes for the U.S. Army Air Forces (USAAF) brightened overnight. Now there would be practically unlimited opportunities to showcase air power. The two principal centerpieces of a thoroughgoing public-relations program would be the photogenic four-engine bombers, the B-17 Flying Fortresses, B-24 Liberators, and B-29 Superfortresses, and the Norden bombsight that supposedly dropped bombs into pickle barrels. These magnificent flying machines and the wondrous Norden were reflections of the nation's technology and productive capability, and Americans would be made proud of these achievements. The planes were crewed by carefully screened volunteers, the nation's best and brightest. Only military and industrial facilities of the enemy would be targeted and the Norden would put bombs precisely on target.

The big bombers were touted as being able to take care of themselves. They would fly high, fast, and in tight defensive formations so that their many guns could be brought to bear on attacking fighter planes. There was no need foreseen for escort fighters to accompany the bombers. As for the Norden, it worked just fine in the environment in which it had been tested: the cloudless skies over the American western deserts where the bombardiers could clearly see and delineate the targets, asphalt circles outlined in the sand, without enemy fighters boring in, their cannons winking; and carpets of deadly, black anti-aircraft bursts rocking the heavy planes.

Reality was slow to seep into the psyches of the commanders. Horrific tolls of unescorted B-17s and B-24s and their 10-man crews in combat over Germany was immutable evidence that the bombers were not self-defending. The Air Force's hallowed doctrine of precision bombing was also proving to be a chimera and the Norden a worthless black box much of the time. If the bombardier could not see his target through his Norden's optical viewfinder, he could not hit his target—and weather over Europe was almost always cloudy. Radar bombsights were even less accurate. Over Japan in early 1945, high-flying B-29s encountered for the first time the jet stream, winds of up to 200 miles per hour; the bombing tables needed for accurate daylight bombing compiled during testing in the United States were useless.

Such are the "fortunes of war"; apologists could explain it away in such a fashion. Not so the shocking American intelligence blunder of astonishing

proportions—and incalculable cost. It had been the firm understanding of Air Force planners that Nazi Germany had been operating on a wartime footing from September 1939 on and that their economy was stretched taut. A sustained bombing campaign would most certainly sever these tenuous lifelines. Not until Germany had surrendered and members of the United States Strategic Bombing Survey (USSBS) had interviewed key economic and military leaders and dug into German wartime records, was it learned otherwise, that Germany's economy had had enormous "slack" well into 1944.

The chief spokesman for communicating the successes of his bombers and obfuscating their failures to America's citizens was the Air Force's avuncular commanding general, Henry Harley "Hap" Arnold. Arnold's genial smile masked his ruthlessness and driving ambition to build "his" Air Force into an independent military arm on a par with the Navy and the Army. In 1911, he had been taught to fly by Orville Wright in ten days in Dayton, Ohio, receiving Military Aviator's License No. 2 the same year. In the mid–1930s, Arnold was the driving force behind establishment of an instrumented bombing and aerial gunnery range for the Army Air Corps at Muroc Dry Lake, California, in the high Mojave Desert about 100 miles east of Los Angeles.[4] He intended to win the war with his airplanes—for the nation, certainly, but also for his Army Air Forces (successor to the Army Air Corps which would become an independent military service as a result of his focused efforts on September 18, 1947.

Arnold kept plenty of heat on his subordinates to produce decisive bombing results. When Lt. General Ira Eaker did not produce the results Arnold demanded, he replaced him with Maj. General James Doolittle in the European Theater. He later shunted aside Brig. General Haywood Hansell in the Pacific in favor of Brig. General Curtis E. LeMay who more readily embraced terror bombings. While he and his field commanders in Europe and the Pacific talked precision bombing to the media, they were indiscriminately bombing cities. In public, Arnold referred to area bombing as "abhorrent to our humanity, our sense of decency." Privately to his staff he said that "the way to stop the killing of civilians is to cause so much damage and destruction and death that the civilians will demand that their governments cease fighting."[5] To satisfy his voracious appetite for "ink," Arnold sent a list of 50 points as public-relations guidelines to be followed in the writing of news releases to all his commanders.

With fires still raging from the previous night's firebombing by the Royal Air Force, the U.S. 8th Air Force on the morning of February 14, 1945, bombed the burning rubble of Dresden and its Mustang fighters swept low over the prostrate city and purposefully machine-gunned civilians in the streets. At the end of the month, in the war's most massive display of air power, in one day about 9,000 Allied warplanes strafed and bombed hundreds of small towns and villages throughout Germany, to bring home to

every German that their country had been conquered. Arnold's principal lieu-tenant in Europe at the time, General Carl Spaatz, opposed air strikes that were openly terroristic, but was willing to commit American bombers to pul-verizing German cities if "some credible window-dressing could be erected around their purpose," as a British historian cynically phrased it.[6]

The nighttime firebomb raids by B-29s over Japan starting with the March 9/10, 1945, firestorm in Tokyo, which incinerated an estimated 100,000 civilians, and the methodical razing of 67 of Japan's largest cities and the torching of their populations—culminating in the nuclear destruction of Hiroshima and Nagasaki in August—ended World War II.

Introduction

One Air Force study concluded that it required two complete combat wings of B-17's, 108 aircraft in total, carrying over 1,000 aircrew, escorted by several hundred fighter planes, supported by thousands of maintenance and other ground personnel, dropping 648 bombs to guarantee a 96 percent chance of getting just two hits on a single Nazi power-generating plant measuring 400 by 500 feet.[1]

On August 17, 1942, 18 B-17 bombers trundled from their new hardstands at Grafton Underwood Air Base northwest of London, taxied on the muddy perimeter track to the end of the runway, and one by one lumbered into an uncharacteristically clear sky. The planes noisily formed up over the field and then in loose formation climbed slowly heading west. The mission—the first strategic bombing raid for the United States 8th Air Force—called for 12 of the planes to attack railroad marshaling yards at Rouen in occupied France, with the remaining six to run a diversionary sweep along the French coast. The attack altitude would be 22,500 feet with four Royal Air Force Spitfire squadrons flying close escort for the main attack group on the approach to the target and five squadrons covering the withdrawal. General Ira Eaker, who later became 8th Air Force commander, flew the lead plane, with Major Paul Tibbets as copilot on his right. Three years later Tibbets would pilot *Enola Gay*, the B-29 that dropped Little Boy on Hiroshima.

All of the planes returned safely after the 3½ hour mission. No enemy fighters rose in defense and anti-aircraft fire was called "light." The only casualties occurred on the return leg when one plane struck a pigeon on its landing approach, which shattered the Plexiglas nose and slightly injured the navigator and bombardier. Piece of cake! Of the 111 airmen on the mission, 31 would eventually be killed or listed as missing in action. Their survival rate

would be somewhat better on average than for the approximately 200,000 U.S. combat aircrew to follow, who would make the 8th the largest air force in aviation history.

Uncritical interpretations of reconnaissance photographs of the rail yards taken the next day showed "exceptionally good" placement of the bombs, and General Spaatz, 8th Air Force commander, exuberantly wired Washington that the attack "far exceeded in accuracy any previous high-altitude bombing in the European theater by German or Allied aircraft" and that he was pleased with "the speed, armament, armor, and bomb load of the B-17" and considered it "suitable for the task at hand." Spaatz was carried away with his enthusiasm. Throughout the war—over Germany in B-17s and B-24s and later over Japan in B-29s—these aircraft only rarely achieved "good" and practically never "exceptionally good" bombing accuracy, however loosely these subjective terms were defined. The 8th Air Force daylight bombers sometimes hit the wrong cities, even the wrong countries; often bombed the countryside; and typically missed their intended targets by hundreds and thousands of yards.

There were ample reasons for this lack of precision. Hitting a target smaller than a football field from five miles up with a plain "iron bomb" was then—as it has remained over 50 years later—a daunting challenge. America's secret wonder weapon, the vaunted and well-publicized Norden bombsight, was nearly useless over cloud-covered targets, whatever their size. The radar bombsights that came later, to overcome the problem of hitting targets through the overcast, achieved even less precision. Furthermore, American bombardiers arrived in England inadequately trained, as were the rest of the hurriedly trained bomber aircrews. And as the Luftwaffe fighter planes and radar-directed antiaircraft batteries took an increasing toll on American bombers, the planes were flown higher to reduce losses, further degrading bombing accuracy.

Spaatz was equally sanguine about the ability of his B-17s to defend themselves against Luftwaffe fighters. Contributing to this sense of the relative invulnerability of his heavy bombers was an overly optimistic November report from his subordinate Eaker, informing him that on the basis of the first 1,100 sorties, aircraft losses had totaled a readily acceptable 1.6 percent. What Eaker had not bothered to mention was that nearly all the short-range missions had been well protected by fighter escorts. Those attacks that had flown to the fringes or beyond of U.S. fighter-plane range, on the other hand, had suffered far heavier losses. No missions had yet flown over targets in the German homeland where it would be learned immediately that enemy defenses, fighter planes and antiaircraft fire, would be devastatingly stronger.

By the end of 1943 when it finally became clear to U.S. mission planners in Washington and England that American heavy bombers were incapable of hitting so-called "precision" targets, there was a purposeful shift to

area bombing of German cities as practiced by the Royal Air Force. In the Pacific war in early 1945, commanders of the 20th Air Force flying B-29s out of bases in the Mariana Islands to hit targets in Japan, quickly came to the same conclusion. Nighttime firebomb raids, continuing for a week in August even after Little Boy and Fat Man had destroyed Hiroshima and Nagasaki, methodically set fire to Japan's readily flammable cities, large and small.

As for the "speed, armament, armor, and bomb load" of the optimistically named Flying Fortress itself, Spaatz was wrong on every count. The B-17, faster than contemporary "pursuit" planes when it first flew in 1936, in 1942 and throughout the war was outclassed by Germany's fighters. While it bristled with up to 13 .50-caliber machine guns, the Fortress was unable to defend itself against the aggressive and skilled German Luftwaffe. German fighter-plane pilots, close-up observers, referred to the B-17s and their sister B-24s as "flying coffins."[2] Regarding the Fortress' "suitable-for-the-task" bomb-carrying capability, RAF air commanders would have snorted to hear of Spaatz's impertinence. *Their* four-engine Stirlings, Wellingtons, and Lancasters delivered twice the load of bombs to the same targets and furthermore had long bomb bays to carry big bombs.

Yet young Americans, all of whom who had eagerly volunteered for the USAAF, bravely flew into combat, typically several grueling missions a week weather permitting, knowing their slim chances of survival. And the most dangerous missions were as aircrew in the big bombers. The statistics were ghastly: in 1943, when the Luftwaffe was at the height of its strength, a U.S. flyer in a B-17 or B-24 had only one chance in four of completing 25 missions before becoming a casualty.[3] Nearly 100,000 airmen in the 8th and 15th Air Forces in Europe were casualties: killed in action, declared missing in action, made prisoners of war, or severely wounded. These figures include fighter-plane pilots who flew escort for the bombers and aircrew of smaller bombers, such as B-25s and B-26s. But most of the losses were in the 10-man crews of the B-17s and B-24s. Overall, Air Force totals represented some 20 percent of the 405,000 Americans who lost their lives in World War II.[4]

On balance, what did these enormous AAF casualties contribute to the winning of the war? Over Germany, the strategic bombing offensive (in combination with Royal Air Force Bomber Command's nighttime missions) must be given mixed reviews. Germany's war production was scarcely interrupted. The purposeful bombings of city centers killed and seriously wounded hundreds of thousands of civilians but did not adversely affect morale. By late 1944, it was finally the destruction of Germany's oil refineries and the nation's transportation networks, both results of the bombing campaigns, that critically reduced the effectiveness of German military forces. One reason why Germany's Ardennes offensive in late December 1944 sputtered to a halt was because of lack of oil. At war's end, the hundreds of brand-new German fighter-aircraft, including jet-powered Messerschmitt 262s, that lined the

fields alongside the *Autobahns* were paradoxes—testament to the inability of strategic bombing to disrupt their production, on the one hand, and to the bombers' successes in cutting off the fuel the Luftwaffe needed to train new pilots and fly defensive missions. But the war in Europe was not won by Anglo-American bombers, or even by Anglo-American ground forces alone. It was the Red Army that contributed most decisively to the ultimate defeat of the German army in the view of many objective historians. These observers are convinced that the Anglo-American landings in Normandy in June 1944 could never have succeeded if Russian forces had not already decimated the Wehrmacht and depleted the Luftwaffe on the eastern front.

The impact of the strategic bombing campaign over Japan remains less controversial. By 1945, the U.S. Navy's submarines had applied a tightening sea blockade of the Japanese home islands, supported by wide-ranging carrier-based bombers, effectively choking Japan's economy and threatening starvation. But it was the B-29s' night-after-night firebombing of the country's principal cities, however, that finally convinced recalcitrant Japanese military and political leaders that Japan had lost the war. Prince Fumimaro Konoye told USAAF interrogators after the war: "Fundamentally the thing that brought about the determination to make peace was the prolonged bombing by the B-29s."[5] Konoye should have added that the twin shocks of the U.S. nuclear bombing of Hiroshima and Nagasaki coupled with the Soviet Union's declaration of war were the catalysts that brought Japan's surrender on the decks of the battleship *Missouri* on September 2, 1945.

1

The Beginnings

*Then came a great crash and uproar, the breaking down of the
Brooklyn Bridge ... and the bursting of bombs in Wall Street and the
City Hall. New York as a whole could do nothing.... The city surren-
dered.... But the truce could not last. And the airships could not occupy
their conquered territory. They could only bomb.*[1]

In 1783, six years before the storming of the Bastille that marked the start
of the French Revolution, two brothers, papermakers Jacques Étienne and Joseph
Michel Montgolfier, demonstrated an unmanned hot-air balloon near Paris in
front of King Louis XVI and Marie Antoinette among hundreds of astonished
onlookers. Two years later, an American, John Jeffries, joined another French
aviation pioneer, Jean Pierre Blanchard, to fly a balloon across the English Chan-
nel when the wind was blowing in the right direction. As surely as the coming
revolution would shake the political foundations of western civilization—and the
guillotine take the heads of France's last hereditary ruler and his consort—these
epochal 18th-century balloon flights, among many others to follow in the 19th,
would be the first hesitant steps in man's long-dreamed-of conquest of the air.

Almost immediately, these primitive flying machines with their wicker gon-
dolas were put to military use. During the French Revolution, French army
observers in captive balloons directed ground artillery fire against Austrian forces.
In the American Civil War and the Franco-Prussian War, tethered balloons were
in common use as observation platforms. The U.S. Army used a balloon in Cuba
during the Spanish-American War to spot artillery fire at the Battle of San Juan.

But tethered balloons had limited utility and free-flyers were at the mercy
of the wind. What was sought was a powered airship whose direction would
be under the control of its pilot. As early as 1852, a French inventor had flown
a cigar-shaped gas bag nearly 150 feet long, filled with hydrogen, powered by

11

a steam engine driving a screw propeller. Other contemporary designs used battery-powered electric motors to drive their propellers. But steam engines were too heavy and storage batteries were impractical. It was not until the 1880s when lightweight and powerful gasoline engines were perfected that airships were able to carry useful loads over long distances.

Ferdinand Graf von Zeppelin, a retired German army general officer, was the first to successfully match such an engine to a lighter-than-air craft. Zeppelin's design used a streamlined rigid frame of aluminum alloy covered by fabric, enclosing and supporting hydrogen-filled gas bags for buoyancy. In 1886, Zeppelin wrote to the chief of staff of the German army that his new dirigibles would be able to perform not only reconnaissance and supply missions but would be able to "bombard enemy fortifications and troop formations with projectiles."[2] Three years later, Ivan Stanislavovich Bloch, a Polish lawyer, published a remarkable book dealing with the technical, economic, and political aspects of future warfare. Among his projections, he correctly foresaw the rapid conquest of the air as being of ominous portent to civilization. Airships would be able to drop bombs, he wrote, thus adding a new dimension to warfare: "It seems that we are very close to facing a danger to which our world cannot remain indifferent."[3] In 1900, Zeppelin dramatically demonstrated the commercial potential of his flying machine—if not its military capabilities—by taking aloft five passengers in a 420 foot long, 38 foot diameter dirigible, powered by two 15-horsepower gasoline engines. It reached an altitude of 1,300 feet and flew nearly four miles in 18 minutes.[4]

Soon zeppelins were demonstrating their long-range reliability and load-carrying capabilities by safely and smoothly ferrying paying passengers from city to city in Germany. Between 1912 and 1914, for example, the *Viktoria Luise,* named after the Kaiserin, flew nearly 3,000 passengers on 489 flights covering almost 34,000 miles in 981 flying hours.[5] The German Navy also tested so-called pressure airships, non-rigid designs whose successors are today's familiar blimps that are flying billboards promoting a variety of products. Interestingly, one of the early German non-rigids was also a flying sign carrier, promoting Stollwerck Chocolate confections in the skies over Berlin just before the war. While the German Navy offhandedly dismissed the non-rigids as militarily useless, the U.S. Navy in World War II found them well suited for offshore patrolling and anti-submarine warfare. At the start of the Great War, ten zeppelins were in commercial service in Germany and others were rapidly built for both Navy and Army use; by war's end, 67 zeppelins had been built, 16 of which survived the war.[6]

The lighter-than-air craft had earlier been favorite subjects of pioneer science-fiction writers. In 1873, for example, Jules Verne introduced his readers to the concept of global air power in *Clipper of the Clouds.* In this fantasy, the hero swoops around the world in a balloon bristling with guns. Ten years later, Albert Robida, in a scenario set in the year 1975, titled *War in the Twentieth Century,* projected a far-fetched conflict between Australia and

Mozambique. Australia opened the hostilities with a surprise air attack, bombarding enemy cities with a fleet of 600 war balloons firing "torpedo rockets" with two-gram charges of "superdynamite."

Across the Atlantic, Wilbur and Orville Wright, bicycle builders from Dayton, Ohio, were working on a different approach to powered flight. On December 7, 1903, they made the first "sustained, powered, controlled flight" of a heavier-than-air machine, in their first *Flyer*.[7] The fourth and final flight that day lasted 59 seconds and covered 852 feet, skimming just feet above the sand dunes at Kitty Hawk, North Carolina. Two years later the Wrights demonstrated an advanced *Flyer* which could bank, turn, circle, make figure-eights, and remain aloft for as long as the fuel supply held out. Far-seeing generals and admirals looked beyond the flimsy wood, wire, and fabric construction and recognized the primitive airplane for what it ultimately would become: a multi-capable weapon that would change the face of war for the remainder of the 20th century. They saw it correctly as a quantum leap beyond von Zeppelin's cumbersome, slow, and vulnerable airships.

It would be Herbert George Wells, even more presciently than military officers, who creatively combined the two new technologies, airships and airplanes, becoming at the same time the first true seer of air power. In 1908, Wells, whose "fantastic and imaginative romances" had already established him as his generation's most respected science-fiction writer and political prophet, published *War in the Air*. In this panoramic tale of a modern war, he began his chronicle with a devastating strike on New York City by a German air fleet of giant dirigibles that had towed small one-man *Drachenflieger* [dragon flyer] airplanes across the Atlantic and cast them off to attack enemy airships and to bomb targets in America. Wells, as was his hallmark, did his homework thoroughly: "These German airships were held together by rib-like skeletons of steel and 'aluminum' and a stout inelastic canvas outer skin, within which was an impervious rubber gas-bag, cut up by transverse dissepiments into from fifty to a hundred compartments. These were all absolutely gas tight and filled with hydrogen.... These monsters were capable of ninety miles per hour in a calm, so that they could face and make headway against nearly everything except the fiercest tornado."[8]

Wells referred to a global arms race among the United States, Germany and "the great alliance of Eastern Asia, a close-knit coalescence of China and Japan ... the three most spirited and aggressive powers in the world. Far more pacific was the British Empire." And with remarkable political prescience, for the Bolshevik Revolution was still nine years away, he predicted: "As for Russia, that nation was divided within itself, torn between revolutionaries who were equally capable of social re-construction, and so sinking towards a tragic disorder of political vendetta."[9]

Ever the patriotic Englishman, Wells was not averse to adding a pinch of anti–German vitriol, for it was Germany "that attacked New York in her

last gigantic effort for world supremacy." Why New York City? "In the year of the German attack it was the largest, richest, in many respects the most splendid ... city the world had ever seen. As the dirigibles cruised slowly and threateningly over Manhattan at low altitude, there was panic and then traffic stopped.... In this manner the massacre of New York began.... Given the circumstances the thing had to be done." Almost casually, Wells anticipated the end of the reign of battleships, bombed and sunk by "cheap things of gas and basket-work ... smiting them from out of the sky!"[10] Once the Great War was under way, Wells devoted his considerable writing talents to supporting his nation's war effort. He wrote four successful propaganda books aimed at both British and American readers: *The War That Will End War*, 1914; *What Is Coming?—A European Forecast*, 1916; *Italy, France, and Britain at War*, 1917; and a popular novel, *Mr. Britling Sees It Through*, 1917.

The Wrights' pioneering flights triggered a rush of competing airplane developments by the large European powers which were involved in an arms race that would contribute to the eruption of the Great War in August 1914. Their governments, to a far greater degree than the United States, enthusiastically embraced the exciting new technology, supporting aviation by sponsoring air meets and air races, subsidizing private development, purchasing airships and airplanes, and establishing military flying corps. The 20-mile cross-Channel flight of Frenchman Louis Blériot in his stuttering low-wing monoplane in 1909, designed and built in Italy, perhaps more than any other single event of the pre–World War II years, convinced skeptical military officers throughout Europe that the airplane was about to become a serious war machine. The flight also was a startling wake-up call to the British; the English Channel—the "blessed ditch" that for nearly 900 years had withstood the forces of invaders from the continent—was no longer a difficult-to-ford moat.

As Germany built one zeppelin after another and began ordering airplanes from its plane makers, France countered with its own orders and in 1910 purchased 100 airplanes. The French further demonstrated the fast pace of aircraft technology by raising the speed record from 48 miles per hour in 1909 to 83 miles per hour in 1911. They also set new distance records, from 146 miles to 449 miles, and a new altitude record of 12,828 feet. That same year, fighting broke out between Italy and Turkey and the Italian War Ministry managed to mobilize a ragtag squadron of nine airplanes, from four different foreign manufacturers, for the fighting in Libya—the first time airplanes would be used as military weapons. For the first time, too, bombs were dropped from airplanes, pineapple-size spheres weighing a few pounds. This conflict also marked the inaugural use of wireless (radio) communication between an airplane and a ground station; Guglielmo Marconi, its inventor, was in Libya in person to monitor the successful experiments. The British, Italians, Russians, and Austro-Hungarians, not to be left in the blocks, also were ordering new airplanes with improved performance for their growing

military air forces. These six major European powers, divided into two military alliances, would shortly have the opportunity to test the mettle of their new flying machines against one another.

In the United States, by contrast, aviation languished. In 1909, the Army Signal Corps had only a single plane and one active pilot and its annual budget was a piddling $150. It was not until 1911 that a military flight school was established and a year later that the Congress appropriated $125,000 for the following fiscal year. By the end of 1912, the Army Signal Corps boasted 12 planes and 51 men attached to them. When America entered the war in 1917 it was ill prepared for the new war in the air. Just as every cannon fired in France by American doughboys was foreign-made, every airplane flown by American pilots was of either French or British manufacture.

Earlier, in an effort to forestall the armament race among the great powers of Europe that some diplomats feared would lead to a general war, two international disarmament conferences were held at The Hague in the Netherlands. The first was in 1899, the second in 1907, both at the invitation of Tsar Nicholas II of Russia. They were promoted as a means to help achieve "a real and lasting peace and, above all, to limit the progressive development of existing armaments." Behind the pacific intent of the Tsar's solicitations, however, was his country's imperative need to slow the other more adept runners in an armaments race in which industrially backward Russia could not compete. The United States was one of 26 nations represented in 1899, and one of 44 nations which attended in 1907.

The conferences failed to achieve any meaningful arms limitations agreements. Three declarations, however, were adopted at the first conference: asphyxiating gases were forbidden; expanding bullets were outlawed; and the "discharge of projectiles and explosives" from balloons was prohibited. At the 1907 meetings, this last declaration was rejected by most of the great powers. A seemingly contradictory article was adopted, however, that prohibited military attack on undefended cities and residential areas. At that time, at the very birth of the airplane, only armies and navies were envisioned by the conferees. The way was open to aerial bombing by international agreement, not only from balloons, but, by extension, from dirigibles and airplanes. Furthermore, poison gases would be used by both sides in the Great War to devastating effect and individual infantrymen would cut slots in the soft lead bullets of their cartridges to create handmade dum-dums that would open gaping wounds in their enemies.

The coming war nurtured real-world seers, rather than fiction-writer prophets, whose wartime experiences would shape the growth and importance of military air power. Three high-ranking Allied flying officers emerged from the conflict—Douhet, the Frenchman. Trenchard, the Englishman, and Mitchell, the American—with firm doctrines on how bombers should be employed in future wars beyond the limited tactical role in which they had been used. Collectively they put indelible stamps on war in the air for decades to come.

2

The Great War

...a far more glamorous role tempted the officers of both services [German Army and Navy airship services]: strategic bombing of enemy cities in the rear areas, and particularly of the enemy capitals, with the aim of exerting pressure on the opposing political leaders and forcing them to sue for peace.[1]

I desire no sort of participation by the Air Service of the United States in a plan ... which has as its object promiscuous bombing upon industry, commerce, or populations in enemy countries disassociated from obvious military needs to be served by such actions.

—Woodrow Wilson[2]

Air warfare during the Great War was portrayed romantically in popular postwar films and nickel-and-dime "pulps" in the United States as chivalrous dogfights between swashbuckling, goggled flyers in their Fokker, Spad, and Nieuport pursuit planes, white scarves streaming behind their open cockpits, seemingly more intent on performing daring aerial maneuvers than machine-gunning their foes. Indeed, when it became apparent that one of the combatants had run out of ammunition or his machine guns had jammed, the other warrior would fly alongside, throw a gauntleted salute at his gallant foe, then smoothly barrel-roll and dive steeply for his home airdrome.

The realities were quite otherwise, reflecting the brutal war in the trenches below. While the public was enamored of the glamorous fighter-plane aces, whose feats were front-page news—Manfred von Richthofen of Germany and Eddie Rickenbacker of the U.S., whose names and deeds are still celebrated by aviation enthusiasts almost 100 years later—there were more mundane and important functions to be performed by the new machines: as

observers, scouts, and artillery spotters. Aerial observers, for example, were able to discern with the naked eye individual soldiers from altitudes of three or four thousand feet and larger groups on the move at perhaps twice that altitude. Cameras with telephoto lenses were also introduced, providing close-up details of enemy trenches and locations of artillery batteries and munitions dumps.

But it was the new dimension of aerial bombardment that most intrigued military leaders in 1914. At the start of the Great War, Germany immediately pressed into military service its three big commercial zeppelins, their great range, high ceiling, and enormous load-carrying capacity seemingly making them ideal bombing platforms. Wicker furniture was removed from the passenger cabins to clear the center walkway for bombs and the installation of primitive bombsights. Soon both sides introduced multi-engine airplanes to carry heavy bombs on underwing racks. "By-eye" bomb aiming gave way to optical-mechanical devices that promised improved accuracy, but rarely delivered.

The Germans with their zeppelins were the first to introduce the concept of long range strategic bombing, attacking targets, military and civilian, well beyond the tangle of rusting barbed wire that marked no-man's land. These dirigibles, although marvels of engineering, proved to be vulnerable to aircraft attack as well as ground fire. They were massive targets, ponderous in their maneuverability—over 500 feet long and 60 feet in diameter. When flying into a stiff wind they could barely make headway. Significantly, their lifting gas was hydrogen which when mixed with oxygen in the air became highly flammable and explosive.[3]

On August 4, 1914, when Great Britain declared war against Germany, Germans of every stripe raged against "perfidious Albion." Germany had ignored the British ultimatum demanding German withdrawal of its troops from "neutral" Belgium and the two countries had gone to war.[4] The Germans had expected, since the crisis had begun on July 28 with the assassination of the heir apparent to the Austro-Hungarian throne and his consort, that the British would stand aside as Germany dealt with the army of France first and then with the Russians on their eastern borders. Had not the German Kaiser told his advisers that he "had the word of a king" that Great Britain would not involve itself in a war against Germany, based on his son's meeting with his uncle, George V, some weeks earlier? When the English immediately aligned themselves against Germany, the hatred of ordinary Germans for "that nation of shopkeepers" became virulent.

England was across the narrow channel, guarded by the powerful Royal Navy. German military strategists, frustrated by the Royal Navy's immediate imposition of a "distant blockade" at the start of the war—technically a violation of international law—looked for a way to retaliate. The only way the Germans could strike at England was through the air, bombing the British

and their cities with the big zeppelins that had become so familiar to the German people in the past decade.[5] Bombing of cities would be a seductive lure for all the combatants in World War I and the remaining wars of the 20th century. And the enemy's capital city would be a principal target. This harked back over a century to the Napoleonic wars when military leaders understood that when the enemy's capital came under bombardment, the war was over.

An influential early advocate for aerial attacks against England was Konteradmiral Paul Behncke, deputy chief of the German Naval Staff. Two weeks into the war, Behncke proposed bombing London with the Admiralty building in Whitehall as the aiming point. Such attacks he wrote, "may be expected, whether they involve London or the neighborhood of London, to cause panic in the population which may possibly render it doubtful that the war can be continued."[6] Kaiser Wilhelm II has been caricatured by most American historians as a blood-thirsty warlord wearing on his head a comic *Pickelhaube*— a "Hun" to be feared and hated, whose soldiers routinely impaled infants on their bayonets and raped nuns, and whose submariners gleefully machine-gunned merchant-ship crews in their lifeboats. Nevertheless, he was initially able to keep the brakes on. Wilhelm was particularly concerned about the safety of his royal first cousin in Buckingham Palace, as well as historic monuments in London. He was, after all, a grandson of Queen Victoria, her favorite according to many in the court. And behind the Kaiser's garish military uniforms and his upswept, waxed moustaches was a man of remarkable *Kultur* and broad knowledge, by far the intellectual leader of all of Europe's reigning monarchs. In fact, at the silver anniversary of his succession to the throne just one year before, The *New York Times* in a special commemorative section of the newspaper had written effusively:

> ...he is acclaimed everywhere as the greatest factor for peace that our time can show. It was he, we hear, who again and again threw the weight of his dominating personality, backed by the greatest military organization in the world ... into the balance for peace wherever war clouds gathered over Europe.... And, on every hand, this is enthusiastically acknowledged by his contemporaries. In this twenty-fifth year of his rule eminent men here and abroad are intoning a chorus of praise to him as the great peace lord of the world."[7]

By early October, Behncke was preparing plans for the zeppelin bombing missions that would be conducted over the next four years. In a letter to his naval superior, he concluded that "we dare not leave untried any means of forcing England to her knees, and successful air attacks on London, considering well-known nervousness of the public, will be a valuable measure."[8] As far as the strictures of International Law went, Behncke saw no legal obstacles to this new way of fighting a war. At the 1899 Hague

disarmament conference, Germany had signed the declaration forbidding aerial bombardment by the use of balloons or other means, but that declaration had not been renewed by the original signatories in 1904 when it had automatically expired. At the 1907 Hague conference, Germany had not initialed Article 25 of the Land Warfare Convention which prohibited the bombardment of "undefended places." An ambiguous article of the Naval Convention, which Germany had signed, allowed that "military installations" if located in "undefended places" could be bombed. Behncke's rationale was straightforward: London certainly harbored "military installations," such as its factories, docks, and even its anti-aircraft batteries—and thus was a legitimate target.

At the same time that plans were formulated for bombing English targets with Navy zeppelins from their sheds in Germany, the army was anticipating the capture of Calais, only 90 miles from London. With air bases there, the great British capital and much of industrial southeastern England lay within easy range of existing heavier-than-air bombers. But the German army's southward sweep through Belgium to mop up the French channel ports was stopped well north of Calais. Longer-ranged bombers were needed but it would be two years before they would be designed, built, and their crews trained. Meanwhile, the zeppelins were readied for combat.

The first bombing raids by any of the belligerents, however, was by the French, on Mullheim in Baden in late August, followed by attacks on Dusseldorf and Koln, and in November on Friedrichshafen—all supposedly aimed at military objectives in those cities. In September, French General Joffre ordered the beginning of strategic bombing, which he hoped would promptly influence the outcome of the war from the air. In early October, the French began bombing troop concentrations and rail yards. By the end of November, a special bombardment group was established to strike far behind German lines.

When the Germans introduced poison gas on the Western Front in the spring of 1915, the French responded by bombing the factory that produced the gas. In June and July the French bombed industrial plants in two German cities and a 50-bomber raid hit blast furnaces and steel mills at another. These air attacks finally triggered a response from Grossadmiral Alfred von Tirpitz who signed on with his subordinate Behncke: it was time to retaliate. On December 26, he wrote confidently to Admiral Hugo von Pohl, High Sea Fleet commander: "The measure of the success [of the forthcoming zeppelin raids] will lie not only in the injury which will be caused to the enemy, but also in the significant effect it will have in diminishing the enemy's determination to prosecute the war...."[9] Tirpitz also prevailed on the reluctant Kaiser to allow such bombing missions.

The first airship raid on England, target London, was by two German Navy zeppelins, in mid–January 1915. Little damage was done and London was not hit. But the announcement of the raid was greeted enthusiastically

throughout Germany. A newspaper editorial two days later reflected the general sentiments of the populace:

> German warships have already bombarded English seaports, German airmen have dropped bombs on Dover ... and now the first Zeppelin has appeared in England and has extended its fiery greetings to our enemy.... The most modern air weapon, a triumph of German inventiveness ... has shown itself capable of crossing the sea and carrying the war to the soil of old England. An eye for an eye, a tooth for a tooth.... This is the best way to shorten the war, and thereby in the end the most humane.[10]

And soon, school children were singing a popular song:

> *Zeppelin, flieg,*
> *Hilf uns im Krieg,*
> *Flieg nach England,*
> *England wird abgebrannt,*
> *Zeppelin, flieg!*[11]
> [Zeppelin, fly,
> Help us in war,
> Fly to England,
> England shall be destroyed with fire,
> Zeppelin, fly!]

The German Chancellor, Theobald von Bethmann-Hollweg, like the Kaiser, had also had been opposed to the bombing of civilian targets. He was looking for a diplomatic accommodation with England to end the war and was sensitive to the attitudes of a certain powerful neutral. On the day after the first bombing raid hit London, in March, Bethmann-Hollweg sent a harsh message to von Pohl emphasizing that bombing "apparently undefended places makes a very unfavorable impression on foreign neutrals, particularly in America."[12]

As late as the summer of 1915, the "City"—the financial heart of the British Empire with the stock exchange, the Bank of England, and the headquarters of many great international corporations—was still off-limits to the zeppelins. An edict by the Kaiser in May had prohibited bombing London east of the Tower of London, which meant the City. But a French air raid on Karlsruhe in mid–June was the catalyst for a note to the Emperor by Vizeadmiral Gustav Bachmann, chief of the Naval Staff. He had gotten the Chancellor's support for bombing of the City, on the condition that raids would take place only on weekends to minimize civilian casualties. However, bombing only on weekends was militarily unacceptable because of weather factors. The Kaiser finally gave in, permitting unrestricted attacks on London, except for the royal palaces and historic buildings and monuments such as Westminster Abbey, St. Paul's Cathedral, and the Tower of London.

The British knew that the German zeppelins were filled with explosive

hydrogen gas. Early in the war, however, they were convinced that the air-ships ducted engine exhaust gases, rich in carbon-dioxide, into the envelope to serve as inert-gas blankets. Thus, the only way to shoot down a zeppelin, it was thought, was to puncture the hydrogen gas bags inside the envelope and thus destroy buoyancy. Once the Royal Flying Corps, soon to become the Royal Air Force, learned otherwise, explosive bullets and phosphorous-coated incendiary bullets were introduced. Machine-gun belts were loaded with both types of rounds: the explosive bullets would tear large holes in the envelope and the interior gas cells, and the phosphorous rounds would then ignite the escaping hydrogen. The Germans addressed the problem of inflammable hydrogen, as one zeppelin after another was shot down in flames over England, by using a double-wall gas cell in which a layer of inert nitro-gen surrounded the inner bag of hydrogen. The weight penalty led to seri-ously compromised performance, however, and the work was halted.

The zeppelin advocates had one last card to play. If the airships could be lightened, they could fly higher, above the ceiling of pursuit planes and antiaircraft fire. Quickly new zeppelins were introduced: defensive machine guns were removed, structures pared down, control cars made smaller, crew's quarters eliminated, and fuel tankage reduced. In early March 1916, zeppelin L42 reached the astonishing altitude of 19,700 feet in a test. The British labeled the new zeppelins "height climbers" and their distinctive black-painted hulls made them almost invisible on dark nights when most missions were flown. There were serious trade-offs for the zeppelin crews, however. At those extreme altitudes, crews suffered from lack of oxygen and the constant sub-zero temperatures. Performance of engines, too, was degraded from oxygen deprivation; superchargers were still years ahead. Zeppelins that could cruise at 70 miles per hour at sea level, could barely fly at 45 miles an hour at 20,000 feet.

As was expected, navigation at night above high cloud layers was seri-ously compromised and bombing became even more inaccurate: "Over England at night, particularly with impaired visibility, little detail could be distinguished in the blacked-out countryside; headlands, rivers and cities look alike, and wishful thinking played a large part in a commander's guess as to where he was."[13] Royal Air Force night-bomber aircrews a generation later, with their far less crude radio navigation and bombing aids—and even with sophisticated radar systems—often would still depend on "wishful thinking" to put their bombs somewhere close to targets in Germany.

In mid–March 1917, five of the new "height climbers" flew across the Channel to raid England. British night fighters were unable to reach the zep-pelins, but with a solid deck of clouds over London, the crews had little idea of their positions. Two of the zeppelins reported they had bombed London when they returned, but records show no bombs that night fell closer than Canterbury in Kent, some 20 miles east of London. Nevertheless,

the advanced airships could be viewed obliquely as aeronautical engineering triumphs: "only twice before the Armistice were any more zeppelins shot down by aircraft in raids on England and antiaircraft guns had no further successes."[14]

Although airships continued to attack England intermittently until almost the last days of the war, the Germans concluded sensibly that their zeppelins were ineffective war machines. If the high-altitude performance of the latest designs made them less vulnerable to aircraft and antiaircraft attack, zeppelins still were extremely costly to manufacture, difficult to maintain, and increasingly subject to destruction and damage inside their massive and easily identified sheds by enemy bombers. During the war the German Navy operated 78 airships which flew 306 bombing sorties. Losses included 26 to enemy action, 14 to bad weather, and 12 to fire or explosion.

Forty years later, a commander of five of the German airships reminisced on his Great War experiences and acknowledged the lack of tangible results from four years of zeppelin bombing missions over England: "But the morale effect was something else. It was important to remind the English that their island empire was no longer safe from attack—attack from the air."[15]

At the end of 1917, the U.S. sent a technical committee to Europe to study airship developments in England and France. In mid–1918, the committee recommended to the Secretaries of War and Navy that four rigid airships be purchased immediately, two in England and two to be built in the United States. Following the armistice, the four airships of the program were reduced to two, one to be bought overseas and one designed and constructed in America—and an airship base built. This led to the purchase of the British R-38 and the construction of the U.S.S. *Shenandoah*.[16] The Army's Camp Kendrick in New Jersey became the U.S. Naval Air Station, Lakehurst. The U.S. military's War Plan Orange foresaw a likely war in the vast Pacific against Japan in the coming two decades and the great range and endurance capabilities inherent in such craft made them seemingly attractive military weapons.

* * *

From its unsuccessful zeppelins, Germany turned to its newly developed heavy bombers, the Gotha and the Giant, to punish Londoners. The first to see combat over England was the four-engine Gotha G.IV, a twin-engine biplane of conventional design of the period. It carried a crew of three: commander, pilot, and midships gunner. The commander was responsible for navigation and bomb-aiming. A high-performance aircraft for its time, it had a top speed of 87 miles per hour at 12,000 feet, a service ceiling of over 21,000 feet, and a range of 300 miles depending on bomb load. It could carry a half-ton of bombs and mounted two machine guns, one in the nose and one in the midships cockpit. The Gotha's upper-wing span was 78 feet,

greater than that of any German bomber that flew against England in World War II.

The first Gotha mission was a daylight raid on London at the end of May 1917, with 21 planes making landfall on the English coast. These missions would continue intermittently for nine months. None of the raiders on that first day saw London because of cloud cover, hitting instead the small channel town of Folkstone and killing 95 civilians, the highest casualty total of any air raid to that date. In mid–June the Gothas finally struck London, killing 162 people, which would be the largest toll from a single air raid during the war. The last daylight raid over England was at the end of August, when the Germans switched to night attacks.

To counter the bombers, the British based squadrons of pursuit planes west of London and ringed the city with antiaircraft artillery. Balloon barrages, arrays of hydrogen-filled tethered balloons, were floated over London at altitudes up to about 10,000 feet and carried steel wires interconnecting adjacent balloons. These defense webs proved to be moderately effective and cheap defenses (as they would again be in World War II), not so much as a means of damaging or even downing enemy aircraft, but to force the attacking planes to fly at predictable altitudes which simplified antiaircraft fuze settings.

The Giants, by contrast to the Gothas, were radical airplanes, even by the rapidly evolving standards of aircraft design during that period. These *Zeppelin-Staakens* or *Riesenflugzeugen* (giant airplanes) were configured with either four or six engines. Their top speed and range were about the same as those for the Gothas, but they could carry 2½ tons of bombs. For its crews of up to nine, the sophisticated Giant had a gyro-compass and a contemporary "wireless" set that aided navigation, electrically heated flying suits, oxygen, and parachutes for its crew, and up to six machine guns for defense. Aptly named, the awkward looking plane had a wing span of 138 feet, only three feet shorter than the Boeing B-29 Superfortress of a generation later. The German bomber flights over England were long and grueling, often eight hours or more, remarkably little longer than the U.S. B-17 and B-24 missions over Germany 25 years later.

A Giant dropped a 13-foot-long, 2,200-pound bomb on London in 1918. The Germans had also developed a sophisticated magnesium incendiary bomb they called the Elektron, which burned at 3,000 degrees Fahrenheit and was difficult to extinguish. It was never used in combat for fear of retaliation. The French used incendiaries to burn wheat fields in Bulgaria, and both England and France firebombed grain fields in German-occupied sections of France. The Germans attempted, unsuccessfully, to set afire the vast forests of Russia in 1916.

On May 19–20, 1918, 38 Gothas and three Giants overflew London. The squadron was met by "an astonishing barrage of more than 30,000 shells and

numerous patrolling fighters." Three of the raiders were shot down by fighter planes and three by antiaircraft fire. This nearly 15 percent loss rate was unsustainable and represented a major defeat for the German strategic bombing campaign against Great Britain. It would be the last bombing raid over England for 22 years. The results: "In 103 raids on Britain during the war, German bombers—zeppelins and airplanes—dropped 270 tons of bombs, which killed 1,114 persons and injured 3,416 others. In the same period nearly twice as many persons were killed in traffic accidents and ten times as many injured. Fifteen million dollars worth of damage was inflicted ... or about one twentieth of the loss caused by rats in the United Kingdom in a single year."[17]

German aircrews were easy marks for Allied propaganda which pilloried them relentlessly as Huns, the Boche, and worse. As the war drew to a close, the British Royal Air Force, which had come into being on April 1, 1918, partly in response to public clamor for retaliation, was testing its own new bomber, the enormous Handley-Page V-1500. It was about the same size as the Giant and had the range to strike deep into Germany with new demolition bombs up to one ton each. The target would be Berlin, about 650 miles from bases east of London. The Great War ended before RAF bombers would fly such missions.

<p style="text-align:center">* * *</p>

When the United States declared war on Germany on April 6, 1917, America's two separate military aviation programs were woefully unprepared. The Army Air Service had just 65 commissioned officers, only 26 of whom were pilots, and about 1,000 enlisted and civilian personnel. For this handful of pilots, there were only 55 obsolete training aircraft. The Navy's air arm was even smaller: 48 officers and 239 enlisted men. The tiny U.S. aircraft industry was riven with patent disputes that had originated with a federal court decision in January 1917 that the Wright Brothers' patent on wing-warping as a means of controlling an airplane in flight applied broadly to any controls that affected an aircraft's roll. Nevertheless, within weeks of the U.S. entry into the war, Allied military delegations from Europe were arriving in Washington prepared to sign contracts for airplanes and engines with essentially a phantom industry. No less an influential figure than French Premier Alexandre Ribot telegraphed a suggestion that what America needed fast was an air force of 4,500 planes and added that the new "associated power" should gear up to produce 4,000 engines and 2,000 airframes a month. By November 1918, the U.S. had far surpassed Ribot's bogey: the two military services had, astonishingly, about 16,000 aircraft and the nation had an aircraft industry capable of manufacturing over 13,000 planes a year.[18]

The head of the technical section of the U.S. Air Service in France, Lt. Col. Edgar S. Gorrell, developed a plan calling for the bombing of "manufacturing centers, commercial centers, and lines of communications" starting

in early 1918. Such targeting, Gorrell argued optimistically, would not only destroy Germany's ability to wage war but would at the same time demoralize the enemy's civilian population. But Gorrell's ideas were only theoretical: there were no bombers available at that time to the Americans for such strategic missions. In fact, the first American bombing raid did not come until June, five months before the armistice. The last week of the war, American forces managed to assemble 37 bombers to send against a railroad depot in Montmedy. The U.S. squadron managed to drop some four tons of bombs without hitting any railroad tracks nearby.

Earlier that fall, at St. Mihiel, Brig. General Mitchell, head of the First Army Air Service, had commanded the largest group of Allied aircraft squadrons for any operation of the war. The numbers were impressive: 12 pursuit, three day bombardment, ten observation, and one night reconaissance squadron from the U.S.; 46 pursuit and day bombardment, and 12 observation squadrons from the French; plus eight British and two Italian night bombardment squadrons. In total, Mitchell commanded 701 pursuit, 366 observation, 323 day bombardment, and 91 night bombers.[19] Had the war continued into 1919, Mitchell wrote later, he had planned to break the stalemate in the trenches by dramatically parachuting Allied troops behind the German lines, employing as many as 1,200 Handley-Page V-1500 bombers converted into troop transports.

Mitchell had earlier met Trenchard when he was commander of Britain's Royal Flying Corps. By the time Mitchell was air commander at St. Mihiel, Trenchard had become head of the Independent Bombing Force of the new Royal Air Force. This separate command whetted Mitchell's appetite for an autonomous U.S. air command, perhaps one that he would head.

In the United States there was high-level political opposition to the bombing of targets in which civilians were likely to be killed. President Woodrow Wilson, no pacifist by any means but often credited as being one by his hagiographic biographers, came out strongly against any such air raids by U.S. bombers, commenting that he was opposed to any sort of "promiscuous bombing" of enemy targets. Wilson need not have been concerned, for the American Air Service squadrons had dropped a mere total of 138 tons of bombs during its five months of operations in France, losing 33 aircraft from all causes. This figure was so embarrassingly unimpressive that U.S. records later rounded the total to *275,000 pounds*. During the next war, the United States Army Air Forces would not have to hide behind such subterfuge. The USAAF would drop over *2 million tons* of bombs on targets in Germany and Japan during World War II, by far the greatest tonnage on cities.[20]

Wilson's Secretary of War, Newton D. Baker, picked up on the issue of morality in 1919. Baker had been a bonafide pacifist before Wilson had named him to his war cabinet. He declared that bombing civilians had "constituted an abandonment of the time-honored practice among civilized people of

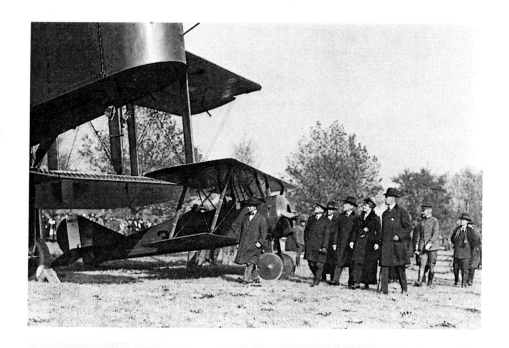

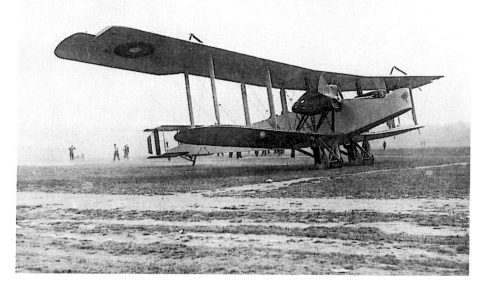

Top: November 14, 1918: Polo Field, Potomac Park MD. The Woodrow Wilson party inspecting the first U.S.-manufactured Handley-Page 0/400 heavy bomber, Langley, foreground. The President is fifth from the right; next to him, the always fashionably attired First Lady, Edith; on his other side, Secretary of War Newton Baker. *Bottom:* Overall view of the ponderous Handley-Page 0/400 twin engine heavy bomber. The biplane had a wing span of 100 feet and was 63 feet long. It could carry 2,000 pounds of bombs at a stately speed of 97 miles per hour. (Courtesy National Archives)

restricting bombardment to fortified places or to places from which the civilian population had an opportunity to be removed." Furthermore, he said that such indiscriminate bombing would be counterproductive, encouraging retaliation in kind. Americans would never condone such terror tactics, he opined, based on the most fundamental ethical grounds. Baker would perhaps have been astonished to learn how easily, two decades later, Americans would embrace the bombing of civilians, including firebombings of cities and the ultimate aerial barbarism, the nuclear destruction of two large cities.

U.S. Army aviators emerged from World War I at the low end of the nation's military—and military procurement—pecking order. From 20,000 commissioned officers on Armistice Day, the Air Service was reduced a hundred-fold, to about 200 in 1919.[21] Twenty-seven years later, it would be a different story. The United States Army Air Force would come out of World War II as the nation's martial darling, poised to become the dominant military service for the balance of the century and into the next.

3

The Seers

It is useless to delude ourselves. All the restrictions, all the international agreements made during peacetime are fated to be swept away like dried leaves on the winds of war. A man fighting a life-and-death fight— as all wars are nowadays—has the right to use any means to keep his life.... The limitations applied to the so-called inhuman and atrocious means of war are nothing but international demagogic hypocrisies.[1]

Aerial bombardment for the purpose of terrorizing the civilian population, of destroying or damaging private property not of a military character, or of injuring non-combatants, is prohibited.
Article 22, "Rules of Aerial Warfare," Washington Naval Conference, 1921–22.[2]

The concept of strategic bombing embraced by the U.S. Army Air Force during World War II had its origins in the stalemated trenches of World War I. Soldiers on both sides had died by the many hundreds of thousands (an average of over 5000 a day for four and a half years!) in the mud of the trenches and on the barbed wire separating no man's land in France. The airplane configured as a bomber was the revolutionary military weapon that promised an end to such slaughter. Nevertheless, the general attitude of the United States during the interwar period toward the threat or the opportunity of the long-range bomber underwent an uncertain evolution. America's geography was unique among the great nations. It was bordered by two oceans and two nations, one English-speaking and a major trading partner and one too weak economically to be a credible military enemy. In 1936, a year after the Flying Fortress was first rolled out, a memorandum to the Army chief of staff piously opposed further procurement at the same time it exaggerated the new bomber's range:

The subject airplane is distinctly an airplane of aggression. It can bomb points in Europe and South America and return without refueling. It has no place in the armament of a nation which has a National Policy of good will and a Military Policy of protection, not aggression.[3]

The concept of the bomber's invincibility—that it "would always get through"—was popularized in the years leading up to World War II. During a debate in the House of Commons in November 1935, on the eve of the Geneva Disarmament Conference, Stanley Baldwin, Britain's prime minister, closed the debate with what the *New York Times* described as an "impassioned plea to abolish military aviation."

Aerial warfare is still in its infancy, and its potentialities are inconceivable. The time wasted at Geneva discussing such matters as the reduction of airplanes, fills me with despair. The prohibition of civil bombardment is quite impracticable as long as bombing exists at all.... What can we do with this new horror now that we have got it? On the solution of this question hangs our civilization.... I think it would be well ... for the man in the street to realize that there is no power on earth that can protect him from bombing, whatever people may tell him.... The bomber will always get through. The only defense is an offense, which means you have got to kill more women and children quicker than the enemy, if you want to save yourselves. I mention that so people may realize what is waiting for them when the next war begins.[4]

It would be the last international effort to control the bomber before World War II. It failed because every nation was seeking its own security—and its own advantage.

Earlier, the U.S. Army Air Corps had found a defensive role for its bombers that would be acceptable to the nation's pacifistic elements. In 1931, the military chiefs agreed that the Army would be assigned all land-based weapons for coastal defense. If the bombers could be given sufficient range, they could detect and engage hostile warships well before they came into cannon range of the coasts. Furthermore, bombers were inherently mobile weapons and could be quickly deployed along both coasts and could fly to defend U.S. interests in the Caribbean and Pacific regions. During this period, the U.S. doctrine of precision bombing began to evolve. Precision bombing meant daylight bombing with a supposedly peerless new instrument, the Norden bombsight, which underwent initial testing in 1931.

The Washington Naval Conference of 1921–22 had also dealt with bombers. Its Aviation Subcommittee concluded that restricting bomber aircraft, either in numbers or performance, would indirectly impose limitations on commercial aircraft and thus would hamper aviation progress. Legal experts from the six participating nations—United States, Great Britain, France, Italy, Japan, and the Netherlands—nevertheless compiled a set of "Rules of Aerial Warfare." Five of the 62 rules related to bombing, one of which, Article 22,

would prove of particular pertinence: "Aerial bombardment for the purpose of terrorizing the civilian population, of destroying or damaging private property not of a military character, or of injuring non-combatants, is prohibited."[5]

In 1923, the International Red Cross oversaw the draft of what were called the "Hague Rules for Aerial Warfare." This document was never brought before an international tribunal, however, or ratified by any nation. The General Disarmament Conference of 1932 specifically addressed the issue, declaring that bombing of civilian populations was contrary to the accepted rules of war. Again, this declaration remained toothless; no nation signed the protocol. And while the big powers were giving lip service to the concept of reducing air fleets, Great Britain was beginning to build the most aggressive fleet of big bombers in Europe. Germany at the same time focused on small, highly maneuverable tactical bombers for its Luftwaffe, particularly the Junkers Ju 87 Stuka dive bomber, that would support the Wehrmacht's fast-moving infantry in battle. And the U.S. Army Air Corps was about to roll out its menacing B-17 long-range bomber.

The Japanese, however, were the first to demonstrate the destructive power of a modern air force. On January 29, 1937, 60 bombers from the aircraft carrier *Kaga* some 100 miles off the coast attacked the Chapei sector of Shanghai, China's largest city. The planes returned intermittently for 12 hours, dropping incendiaries as well as high-explosive bombs and strafing the crowded streets. Edgar Snow, an American correspondent intimately familiar with the Orient, was an eyewitness to the bombing. He wrote:

> The unnecessary brutality of this and subsequent air attacks against a people with whom Japan was not formally at war, the cynical disregard for the lives of non-combatants, the wanton sabotage of the Commercial Press and other great cultural institutions, was never to be satisfactorily explained....[6]

Japanese conduct at Shanghai brought almost universal condemnation from the western powers. Ex–U.S. Secretary of State Henry L. Stimson commented:

> ...the atrocities at Shanghai had occurred in the blazing publicity of a cosmopolitan city. Certainly in America the feeling excited by the bombing and burning of a crowded, unwarned city population was very strong. On that subject Japan had no defenders. None of the explanations put forth by her carried for a minute with our press and our people.[7]

Other major cities bombed included Nanking, the capital, Canton, Chungking, and Hangkow. "From the beginning of hostilities in July 1937 until 31 March 1940, the estimated total number of air raids by the Japanese against civilian populations in China is given as 9,786. More than 142,000

bombs were dropped by 43,000 planes [sorties]. About 51,000 civilians were believed killed by bombings and 65,000 wounded during this period."[8]

Germany was the next country to show the world the devastation the new generation of bombers could wreak. On April 26, 1937, the Luftwaffe's Condor Legion, the so-called volunteer air force in Spain supporting Francisco Franco's rebels in the Spanish Civil War, smashed the ancient Basque town of Guernica, whose population at the time of the attack was between 5,000 and 10,000. A small munitions factory and an army barracks were the only military objectives, and the town had no antiaircraft defenses. Guernica at the time was crowded with civilian refugees and retreating soldiers, almost a microcosm of the German city of Dresden 18 years later. First came the bombers, twin-engine Heinkel 111s and Junkers Ju 87 Stuka dive bombers, dropping about 40 tons of bombs. "After the bombing stopped, fighter aircraft swooped down to machine gun the streets and when the aircraft flew away perhaps a thousand people lay dead in the ruins; 70 percent of the town was totally destroyed, and the rest was badly damaged."[9]

Guernica fell to the rebels two days later but the Franco government paid a dear price for the town, not only in Loyalist Spain but throughout the world. William E. Borah rose in the U.S. Senate on May 6 to castigate the rebels and 76 important Americans cabled a strong protest to Franco. The German embassy in Washington was picketed.[10] Indeed, Guernica was the first milestone on the path that led to the firebombings of Hamburg, Dresden, and Tokyo—and to Hiroshima and Nagasaki.

Pablo Picasso's famous mural memorialized the portentous event. As a citizen of a neutral nation, he had been unaffected by World War I, nor had he shown any interest in politics during the 1920s. But the Spanish Civil War nurtured in Picasso strong partisanship toward the Loyalist cause. He painted the 25-foot-wide mural for the Spanish Republic pavilion at the Paris International Exposition in 1937. The evocative painting is considered to be a prophetic vision of man's self-destructiveness and his ultimate doom.

In June 1938, Britain's Prime Minister Neville Chamberlain declared in the House of Commons that "the fact that there was no international code of law with respect to aerial warfare" was not an issue in Great Britain. As for a nation's deliberate policy to try to win a war "by the demoralization of the civilian populations through the process of bombing from the air ... I do not believe that deliberate attacks upon a civilian population will ever win a war...." Chamberlain, more than a year after the start of the war, nobly proclaimed: "Whatever be the lengths to which others may go, His Majesty's Government will never resort to the deliberate attack on women and children, and other civilians for purposes of mere terrorism."[11] Chamberlain, regardless of the depths of his sincerity, would be out of office by the time RAF Bomber Command purposefully began such terror bombing. His successor, unrequited warrior Winston Spencer Churchill, would have no such qualms, public or private.

For Great Britain, the bomber was an extension of that nation's traditional naval strategy which had been followed in all of her many and successful wars: countering her enemies' generally preponderant land forces by cutting off overseas supplies and striking at their economic resources. Britain had never had the capacity to achieve military victory over a great Continental power. Her fundamental military power had resided in command of the seas. In 1918, the British were the first to create a separate Royal Air Force, with capabilities beyond a supporting tactical role for the Army and Navy. The Royal Navy's longstanding practice of shelling coastal cities to terrorize local populations would henceforth be replaced and supplemented by the RAF's indiscriminate bombing of cities beyond the reach of battleship cannons. Hitler proposed in 1935 and again a year later a universal agreement that aerial bombardment should be restricted to the zone of military operations. However, regardless of Hitler's sincerity, the British did not respond, principally because the Nazi overtures conflicted with the RAF's fast-emerging theories of air warfare.[12]

On September 1, 1939—the day that Germany opened hostilities in World War II—President Franklin D. Roosevelt sent a public message to the belligerents entreating them to declare publicly that their air forces would not engage in the bombing of civilian targets. The next day Adolf Hitler declared that "[the] laws of humaneness [that] demand under all circumstances to desist in connection with military actions from throwing bombs on non-military objects correspond decidedly with my own standpoint and [the bombing] has never been advocated by me." The text of his reply pointed out that his speech to the Reichstag that day had announced that he had already issued such instructions against bombing civilians to his Luftwaffe. He concluded: "A self-evident precondition for letting this command stand is that opposing air forces abide by the same rule."[13]

The British and French governments announced the next day in a carefully crafted joint communiqué that they "solemnly and publicly affirm their attention to conduct hostilities which may be imposed upon them with the firm desire to spare civil populations and to spare in every possible measure monuments of human civilization." In lock-step with Germany's chancellor, the two governments stated that they had already sent instructions to their armed forces that "only strictly military objectives in the narrowest sense would be bombarded by air, by sea or by land artillery." Their communiqué also closed on a note similar to that of the German declaration that "these governments reserve the right to any action which they consider appropriate" in the event of "an adversary" not observing similar restrictions.[14]

* * *

One observer has written that "historians have been hard pressed to identify" the reasons why the United States took the lead in development of the

new concept of strategic air bombardment that precisely targeted an enemy's "key components." Destruction of such targets, it was staunchly believed by its advocates, would cause a chain reaction that would undermine that nation's ability to wage war. Or did the nation's geography play a role?—"inasmuch as years of defending military aviation as a weapon for intercepting ships on trackless oceans placed a high premium on navigational and bombing accuracy."[15]

Nevertheless, there was a confluence of forces during the 1930s that made daylight strategic bombing a seductive notion in the minds of U.S. war planners. First was the Air Corps' obsessive need to justify independence. The flyers wanted to show they could win a big war, not be limited to a subsidiary role of warding off attack as a defender of America's shores. A second consideration was the nation's unique geography. The United States was then relatively immune to retaliatory air attack, unlike Great Britain, for example, whose great city of London lay astride an easily identifiable crook in an easily identifiable river only a few minutes' flight time from the continent. Finally there was America's hypocritical but thoroughly ingrained vision of itself as a nation uniquely humane among all the world's powers. The B-17 bomber was promoted by its advocates as an instrument of surgical precision. The secret Norden bombsight was referred to as America's great defensive weapon and it would be more than a decade before the U.S. War Department was euphemistically renamed the Department of Defense. In 1941, Generals Arnold and Eaker wrote in their book, *Winged Warfare*: "It is generally accepted that bombing attacks on civil populace are uneconomical and unwise.... Human beings are not priority targets except in special situations. Bombers in far larger numbers than are available today will be required for wiping out people in sufficient numbers by aerial bombardment to break the will of a whole nation."[16]

American memories of the Great War were still fresh, although the country had suffered far fewer casualties than the European belligerents. Furthermore, America was disillusioned with the role it had played, exemplified, for example, by the popularity of such antiwar books as *Merchants of Death* and the book-of-the-month selection *Road to War: America 1914–1917*.[17] The nation was staunchly isolationist and President Franklin D. Roosevelt preached deceitfully to this majority over and over again that he would never send their sons to fight in another overseas war. What better substitute for an army was a bomber force that could strike targets across the oceans?

Typical of the previous war's bomber designs, and still flying in 1929, was the Royal Air Force's cumbersome Handley Page Hinaldi, a fabric covered biplane with a forest of struts and wires to add drag, fixed landing gear to slow the plane even more, a maximum speed of barely 115 miles per hour at 5,000 feet, falling to 98 miles per hour at 15,000 feet. It had a combat range of about 100 miles with a bomb load of 1,500 pounds. The Hinaldi's

four-man crew sat in open cockpits, "which enabled them to sense to the full the draughty exhilaration of flying," in the view of one critical observer. In the decade before the outbreak of World War II, however, there was a bonafide revolution in the design of military aircraft, particularly bombers, a "great leap forward," during which time "speeds, altitudes, and range more than doubled."[18]

Most important to the designers was cleaning up the planes' aerodynamic shape, to cut down drag. First came retractable landing gear, then single cantilevered wings; these engineering advances increased airspeed, and range or bomb load, or both. Three additional innovations came soon after: braked wheels, wing flaps and variable-pitch propellers. Brakes were needed as landing speeds increased sharply—a result of the higher wing loadings of single-wing designs. Flaps increased the lift of the smaller-area wings, particularly important at take-off and landing. Fabric coverings gave way to monocoque and semimonocoque all-metal stresssed-skin construction, which was far stiffer, stronger, and smoother. Superchargers were fitted to a new generation of more powerful engines enabling the planes to fly higher and faster, and variable-pitch propellers more efficiently converted the power into thrust over a broad spectrum of airspeeds.

During this period, development of pursuit aircraft—later called fighters—languished in the United States, both because of tightened budgets and because the Air Corps mistakenly, and arrogantly, saw no need for its self-defending B-10s and B-17s to be accompanied by escorts to drive off enemy interceptors. "They can handle themselves" was a flawed mantra that would last through much of World War II. Furthermore, the big bombers could supposedly deal with an enemy before he came within range of important U.S. targets at home and abroad. The Air Corps' top-of-the-line pursuit of the period was the Boeing P-26, a swashbuckling little monoplane with open cockpit and handsome wheel pants for its fixed landing gear—but a woeful performer. It was slower than its stablemate B-17 and had an impractically short range of merely 360 miles. Its successor, the Curtiss P-40, while a major advancement, was inferior in every performance parameter to Germany's Messerschmitt Bf 109 and Japan's Mitsubishi Zero, both put into production at the same time.

Unofficial Air Corps doctrine at the time paralleled the outspoken views of Douhet and Mitchell. Both argued that at the outbreak of war, even before a declaration of war, airpower should strike immediately at the enemy's civilian population centers. This aggressive doctrine was at odds with official War Department directives in the late 1930s that called for defending the continental United States as the principal role of the Air Corps. Nevertheless, the Air Corps Tactical School (ACTS) in Alabama (which became Maxwell Air Force Base) embraced the Douhet-Mitchell principles and the junior-officer instructors there taught it to their students who would rise to positions of

leadership in a few years. The ACTS doctrine, summed up in eight cogent particulars, were the first glimmerings of principles that would guide the USAAF in World War II and would be the driving force that achieved an independent air force in the immediate postwar period:

> 1. The national objective in war is to break the enemy's will to resist and to force the enemy to submit to our will. 2. The accomplishment of the first goal requires an offensive type of warfare. 3. Military missions are best carried through by cooperation between air, ground, and naval forces, although only air can contribute to all missions. 4. The special mission of the air arm is the attack of the whole of the enemy national structure to dislocate its military, political, economic, and social activities. 5. Modern warfare has placed such a premium on material factors that a nation's war effort may be defeated by the interruption of its industrial network, which is vulnerable only to the air arm. The disruption of the enemy's industrial network is the real target, because such a disruption might produce a collapse in morale sufficient to induce surrender. 6. Future wars will begin by air action. Thus we must have an adequate standing air force to ensure our defense and to begin immediate offensive operations. We must place ourselves in a position to begin bombardment of the enemy as soon as possible. 7. The current limited range of our aircraft requires the acquisition of allies to provide forward bases in order to begin action against the enemy. 8. Assuming the existence of allies and forward bases, the air force would have the power to choose between attacking the armed forces or the national structure of the enemy. The latter should be the primary objective.[19]

On June 20, 1941, Secretary of War Stimson authorized a new name for the U.S. Army Air Corps. Henceforth, it would be called the U.S. Army Air Forces (USAAF).

* * *

Of the prominent postwar airpower advocates, Giulio Douhet was the most influential, more so in the United States, Great Britain, and Germany than in his native country. Prior to 1914 he had been an artillery officer in the Italian army and commander of one of his country's first air units. By the time Italy had been wooed away from the Central Powers and enticed to enter the war in May 1915 on the side of the Allies by promises of postwar territory spoils, Douhet had formulated many of his theories. In 1916, he had been tried by a court-martial and imprisoned for a year for his outspoken and abrasive criticisms of his country's inept military policies. It can be assumed that while in prison, like Adolf Hitler a few years later, he had contemplative time to further refine his principles and to organize and draft his first book. In 1920, his wartime court-martial was expunged and a year later he was promoted to general. After Benito Mussolini's popular coup in 1922, Douhet was appointed Commissioner of Aviation.

That same year Douhet packaged his revolutionary ideas in a book appropriately titled *The Command of the Air*. His theme: airpower had fundamentally altered the character of warfare. He postulated that the new weapon—the bomber—was uniquely suited to bringing an enemy nation to its knees quickly. Such a bombing campaign would be directed against the morale of the enemy's civilian population. Douhet not only envisioned high-explosive bombing raids over enemy cities, he projected merciless air attacks—"ravaging his whole country by chemical and bacteriological warfare" and with "incendiaries and poison gases."[20]

He saw future wars as total wars—conflicts among entire peoples—years before the term became commonplace. In his view, there were no distinctions between the combatant and the noncombatant. Practically everyone would take part in the next big war: soldiers in the front lines, women filling shells in the factory, farmers plowing the land, scientists in their laboratories. While the aerial battle fleet envisioned by Douhet would serve tactically to disrupt the enemy's military, its chief target would be the population centers. Civilians were more prone to collapse than military troops, Douhet thought, and hence would be less able to resume normal lives after an air attack. "How could a country go on living and fighting," Douhet asked rhetorically, "oppressed by the nightmare of imminent destruction and death?" And: "Because the offensive may reach anyone, it begins to look now as though the safest place may be in the trenches."[21]

The next war would start as a surprise attack, without formal declaration, he prophesied. Bombers lent themselves admirably to this concept of a first strike. There were ample naval precedents for this sort of undeclared war: the British naval bombardment of Copenhagen in 1801 and the preemptive Japanese naval attack on the Russian fleet in Port Arthur in 1904 that started the Russo-Japanese war. In 1941, Japanese Navy bombers and torpedo planes would strike a devastating blow at the U.S. Pacific Fleet at anchor at Pearl Harbor, Hawaii, before declaring war, drawing America into World War II overnight.

"First would come explosions," Douhet wrote, "then fires, then deadly gases floating on the surface and preventing any approach to the stricken area … without telegraph, telephone, or radio, what, I ask you, would be the effect upon civilians of other cities, not yet stricken but equally subject to bombing attacks? What civil or military authority could keep order, public services functioning, and production going under such a threat…? The time would soon come when, to end horror and suffering, the people themselves, driven by the instinct of self-preservation, would rise up and demand an end to the war—this before the army and navy had time to mobilize at all!"[22] The very character of the airplane, its speed and mobility and the three-dimensional nature of its environment, Douhet argued, meant that the defense would never be able to stop an organized bomber offensive—that the bomber would

always get through. "How can we defend ourselves against them [bombers]?" he asked. "To this I have always answered, 'by attacking.'"[23]

Douhet propounded the idea of air superiority, gained by destroying the enemy's air force. This attainment of command of the air was the principal function of an air force. "To conquer the command of the air," he wrote, "all aerial means of the enemy must be destroyed whether in air combat, at their bases and airports, or in their production centers; in short, wherever they may be found or produced."[24] He summarily dismissed dirigibles as unsuitable weapons of war, echoing what the Germans had learned during their unsuccessful raids over London in 1917 and 1918. Ultimately, to mount the kind of air offensive he envisioned, air forces had to be independent of army and navy control—specifically organized and directed for their decisive strategic role. Douhet saw no place for air forces as auxiliaries to armies and navies. This view of an aggressive and autonomous air force struck particularly respondent chords among high-ranking U.S. Army officers who had cast their lot—and their careers—with offensive airpower.

Douhet published a second book in 1928, *The Probable Aspects of the War of the Future,* shortly after international agreements had been reached to limit naval armaments and to ban the use of poison gas. This book delved deeper into the moral issues of indiscriminate city bombing. The same year, the Kellogg-Briand Pact, sponsored by U.S. Secretary of State Frank B. Kellogg and French Foreign Minister Aristide Briand, was signed by 15 nations in an effort to outlaw war itself. Douhet's response was to thumb his nose at such disarmament conferences and bans on indiscriminate bombing and he indicated that he was aware of the moral implications of the kind of warfare he proposed. But such a total war, he emphasized, would be mercifully short. In turn, it should be looked upon as more civilized because there would be far fewer casualties, military and civilian. This same skewed rationale would be expressed by U.S. air commanders and by top government officials from the president on down during World War II, nearly all of whom heartily endorsed the indiscriminate city bombings in Germany and Japan, including defending the nuclear destruction of Hiroshima and Nagasaki and their civilian populations.

Just before he died in 1930, Douhet wrote a brief futuristic fictional account of how an independent German air force fought giant air battles against French and Belgian air forces, called *The War of _____.* Douhet's imaginative tale, in the genre of H.G. Wells' popular science-fiction books, chronicled the bombing of cities, both during the day and at night, with explosives, incendiaries, and poison gas. His narrative ended with leaflets being dropped by the Germans telling the citizens of Namur, Soissons, Chalons, and Troyes that their cities were about to be wiped out and that Paris and Brussels were also slated for destruction unless the governments sued for peace—which they promptly did.

After his death, Douhet's two books were translated into English, German, French, and Russian, spawning a succession of military disciples who became important air power strategists during the 1930s, and into World War II and beyond. Nevertheless, much of what Douhet had predicted so graphically proved to be wrong. Tactical aviation, for example, played an important role in the Wehrmacht's early successes in Poland and the Soviet Union. It certainly was not true that "the bomber would *always* get through"; the so-called Battle of Britain was arguably a victory for the defense. Over Germany, too, RAF Bomber Command at night and the U.S. 8th Air Force during the day, until mid 1944 on, only "got through" by accepting horrendous losses. And when the bomber did "get through," it typically did not know quite where it was! Nor could Douhet foresee the development of radar as an early-warning device, a ground-based director for both fighter and antiaircraft defense, and an airborne guidance system for interception, all of which would put the bomber at a disadvantage. Nor could he anticipate that heavily armed, incrementally faster fighter aircraft would be able to shoot to pieces even well-defended bombers. Douhet never considered that the bomber might miss its target and he grossly overestimated the destructive power of high-explosive bombs. His obsession with attacking bombers led him to snub the value of defending fighter planes manned by skilled and brave pilots protecting their homelands.

The most significant flaw in Douhet's doctrine—and, by extension, Mitchell's—however, was that bombing of cities would almost certainly demoralize their civilian populations, leading to a prompt "victory through air power." The Luftwaffe's night-after-night blitz over London and other major British cities in 1940 failed to affect significantly British civilian morale. The Anglo-American night/day bombing of Germany's cities was equally a failure. The authoritative United States Strategic Bombing Survey later concluded that German civilian morale, while under heavy stress in 1944 and 1945, was never close to being undermined. The concentrated firebombing of Japan's major cities by U.S. B-29s for five months in 1945 killed about 400,000 civilians and wounded perhaps twice that many, but there were no riots in the streets by the disciplined Japanese calling for surrender.

* * *

On his return to the United States after the armistice and intent on furthering his recently acquired concepts of how air power should be employed, newly promoted Brigadier General Mitchell was appointed Assistant Chief of the Air Service. Mitchell lost no time in becoming a loud and persistent publicist for an independent U.S. Air Force and of unified control of air power. Both of these radical concepts were vigorously opposed by the Army and particularly by the Navy. He publicly challenged the Navy as guardian of the nation's first line of defense and said over and over that his bombers could sink battleships, heresy and worse to Navy brass.

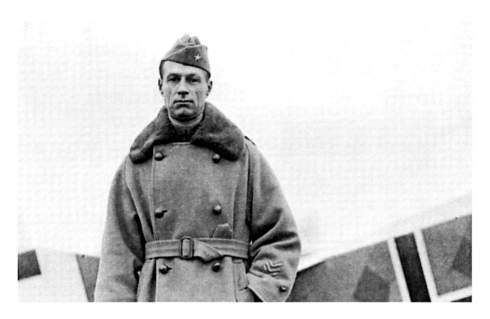

December 30, 1918: Brig. Gen. William "Billy" Mitchell at an airfield in Coblenz, Rhenish Prussia, Germany. (Courtesy National Archives)

To show how effective bombers could be, he managed by dint of his persuasiveness and persistence to set up well publicized bombing attack demonstrations against former German warships moored off the Virginia coast in 1921. First his squadron of Air Service bombers sank a thin-skinned U-boat, then a destroyer, then a cruiser. Then, more ominously for naval big-ship advocates, his bombers sank the "unsinkable" German dreadnought *Ostfriesland* and the obsolete U.S. battleship *Alabama*. In 1923, Mitchell's slow and clumsy bombers conducted successful aerial attacks on two old American battleships, *Virginia* and *New Jersey*. Overnight, Mitchell had made himself into something of a national hero, lionized by newspapers across the country and by the millions who had watched the battleships ponderously roll over and sink on newsreel screens.

As far as Mitchell was concerned, he had proven that existing aircraft could destroy all classes of warships, including the Navy brass' cherished battleships. Navy officials, as might be expected, were far less convinced and considered his tests unrealistic: the ships had been anchored and were effectively sitting ducks; there was, of course, no antiaircraft fire to disturb the bombardiers' low and slow approaches to the target or enemy fighter planes to harass the crews of the lumbering bombers; more importantly the weather was perfectly clear. Mitchell stood fast. His rationale was that if he understood the implications of the tests, certainly foreign powers would also. He was saying that the principal threat to the United States would no longer

come from enemy naval forces but from hostile air forces. By extension, the air threat would particularly imperil American possessions in the far-flung Pacific region.[25]

Mitchell's was the loudest and most abrasive voice in the perennial debate during that period on how to secure the U.S. coastlines against attack from the two oceans that bordered it. The Navy regarded this mission as its exclusive role and had fiercely fought any interlopers in the past and would continue to fight unrelentingly. In Mitchell's radical view, airplanes could blunt attacking foreign navies approaching U.S. shores and thus the bomber represented the correct defense for the future. The sides were drawn up for a fierce and long-lasting interservice squabble, with the outspoken Mitchell squarely on center stage.

In 1923, Mitchell combined a honeymoon with his second wife with a trans–Pacific fact-finding trip, with stops in the three principal U.S. possessions in that region, Hawaii, Guam, and the Philippines, and in Japan, China, India, Java, and Singapore. He later wrote that he found the Japanese military commanders extremely interested in air power and suggested that their air forces, Army and Navy, were underrated. By contrast, Mitchell viewed American Army and Navy commanders as indifferent to air power and seemingly ignorant of their own services' weaknesses. He projected that it was inevitable that Japan would go to war with the United States over economic control of the Pacific rim.[26] With uncanny prescience, he also predicted that Japan would initiate such a war with a surprise attack just after dawn on the U.S. Pacific Fleet in Pearl Harbor by carrier-based aircraft. The only detail Mitchell left out was the day of the week that the attack would take place: on a quiet Sunday morning.[27]

Mitchell returned from his Pacific tour with a new sense of urgency. He fancied himself the messiah to bring the message to Americans that Japanese air power was a fast-growing threat to the United States and her Pacific possessions and that the nation must respond in kind and build a powerful air fleet. But he was stymied by the penny-pinching Calvin Coolidge whose administration's focus was on cutting the federal budget and was unwilling to support innovative programs such as he advocated. Mitchell was dealt a body blow when his report and its recommendations were ignored by the War Department.

Not one to tolerate such cavalier treatment, he became increasingly outspoken in his criticism of the military hierarchy, continually griping publicly about the administration's neglect of aviation. He wrote a series of provocative articles that were published in the popular *Saturday Evening Post* describing how giant fleets of bombers would devastate entire nations and defended such brutal warfare as less costly and more humane than war in the trenches, a refrain that would be echoed by his successors in years to come. He likened the elite warriors who would fight this new air war to the armored knights in

the Middle Ages. Arrogantly he had not cleared the contents of the articles with his boss, Secretary of War John W. Weeks.[28] Mitchell was burning his bridges behind him. To muffle his outpourings, Weeks banished him to Fort Sam Houston in faraway San Antonio, Texas, when his term as Assistant Chief of the Air Service expired in April 1925, and he was reduced to his permanent rank of colonel. There he bided his time and waited for the right opportunity to speak out. He did not have long to wait.

Five months later, Mitchell got his chance. When the Navy dirigible *Shenandoah* broke up in a storm over Ohio, killing 19 of her crew, he picked up his cudgel and flailed out with a vengeance—the administration, the admirals, and the generals be damned! He released a long and detailed statement to the press concluding that the crash was "the direct result of incompetency, criminal negligence and almost treasonable administration by the War and Navy Departments." It was almost as if Mitchell had a death-wish! As for the dirigible, the world's first helium-filled airship: "I do not know exactly what happened to the poor *Shenandoah* ... I believe she was about 50 percent overweight in her structure. She had broken away from her mooring mast—an inefficient way of handling airships, anyway—last spring and her whole structure was badly strained. I believe the number of valves in the gas bags containing the helium had been diminished." The purpose of the fatal flight, its 57th, was simply Navy propaganda, according to Mitchell. "What business has the Navy over the mountains, anyway? Their mission is out in the water—not only in the water but under the water, out of sight, away from the land. That is why we have the Navy."[29]

Mitchell was right on all technical counts, as the Navy's official report later documented. Structurally, the *Shenandoah* had been deficiently designed and it was only a matter of time before she broke up in a storm. Indeed, too, the *Shenandoah*, which made its maiden voyage in September 1923, had proved to be a splendid public-relations tool for the Navy. The 680-foot long, silver airship had made transcontinental demonstration flights and had visited many of the nation's largest cities. But Mitchell had gone too far in his criticisms and had made too many political enemies, including the president of the United States. He was brought before a court-martial accused of insubordination—Coolidge himself preferring the court-martial charges—and was promptly found guilty. He was suspended from active duty for five years, including forfeiture of all pay and allowances. Mitchell flamboyantly resigned. Mitchell had been gingerly defended by ranking Army Air Service officers who were careful not to jeopardize their own careers. Two witnesses called on his behalf at his court-martial were Air Corps majors Arnold and Spaatz. His defense team included a Captain Eaker. These three men would be principal commanders of the Army Air Forces in the coming war.

Since the end of World War II, Mitchell has acquired a coterie of apologists and hagiographic biographers intent on wiping the slate clean of what

they consider a vindictive and unjust court-martial. They focus on the patriotic "Army" Mitchell of 1917–1926, the respected forecaster of the Pacific war with Japan, rather than the bitter "Civilian" Mitchell of 1926–1936, who was more a demagogue than a seer, lecturing casually that just "a few gas bombs" on key cities would be all that would be necessary to win the next big war.

<p align="center">* * *</p>

General Hugh M. Trenchard, commander of Great Britain's Royal Flying Corps until the formation of the Royal Air Force in 1918, was the first chief of the Air Staff in the newly created independent service. He had regarded the Flying Corps as an integral arm of the Army and was opposed to the use of aircraft except in their role as supporter of land forces. Like most military commanders on both sides, Trenchard felt that the war could be won only in ground battles on the Western Front. Trenchard maintained his opposition to strategic bombing throughout the war. Even when his government decreed the formation of a special long-range bomber force to attack targets in Germany in retaliation for German raids on London, he openly disagreed with this decision. When the independent RAF was formed, with the intention of carrying out a systematic aerial bombardment of German cities, it was ironic that Trenchard was appointed to command it.

In June 1917, at the time London was being bombed by German Gothas, Trenchard was ordered back from France to advise the War Cabinet how to best respond. Rather than recommend retaliation, like the good ground-war officer that he was, he urged that the Belgian coast be captured, denying close-in air bases to the German air force. Bombing cities would be counterproductive, he pointed out: "The enemy would almost certainly reply in kind and unless we are determined and prepared to go one better ... it will be infinitely better not to attempt reprisals at all."[30]

But as the war neared its end, Trenchard's views changed dramatically. "Trenchard dreamed of a huge round-the-clock campaign, making use of French and American as well as British squadrons, some of them flying the new 'super Handley Pages' from Norfolk. Already it was clear that enemy morale as well as strictly military objectives were to be targets." When the new air minister wrote to Trenchard that he would "very much like if you could start up a really big fire in one of the German towns," and that "I would not be too exacting as regards accuracy," Trenchard's reply was reassuring: "I do not think you need to be anxious about our degree of accuracy when bombing stations in the middle of towns ... all the pilots drop their eggs well into the middle of the town generally."[31] RAF Bomber Command throughout the next war would almost always aim their eggs to hit "well into the middle of the town."

To staunch Englishman Trenchard—an early-day Colonel Blimp[32]—the civilians of other countries were intrinsically more fragile souls than his stiff-upper-lip compatriots. During the 1920s, when France was again regarded—

as it had been for the previous 400 years—as Great Britain's principal enemy on the continent, Trenchard postulated that the nation that would sustain bombing the longest would win the war, and in a bombing duel, "the Frogs would probably squeal before we did." It was also an axiom in at least some quarters of the RAF that the German people did not have the same "right stuff" as the English and those from the dominions, and would promptly succumb to heavy bombing. Like so many other between-the-wars projections, these would prove to be far off the mark. Tens of thousands of RAF Bomber Command aircrew and hundreds of thousands of German civilians would pay the ultimate price for such chauvinistic nonsense.

<center>* * *</center>

Another popular inter-war seer was British military historian B. H. Liddell Hart. In a postwar book with a baffling title, *Paris, or the Future of War*, Liddell Hart focused on Germany's acceptance of the armistice while her army was still powerful and her borders intact. The reason he cited for this: the nation's will to continue to fight had collapsed. Because a highly industrialized state was only as strong as its weakest link, he postulated, the function of a war-fighting strategy was to locate and then exploit the Achilles'

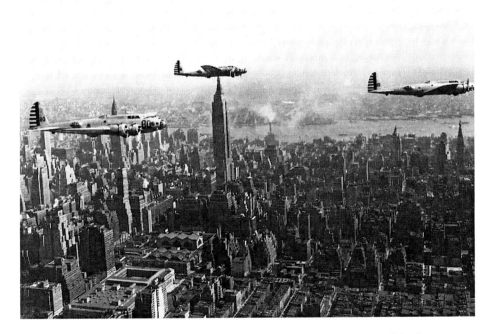

September 21, 1937: Formation of Boeing B-17 Flying Fortresses over Manhattan. Note Empire State Building and Chrysler Building.

heel of the enemy nation—just as Paris, son of Priam, had killed the Greek champion. Liddell Hart saw the airplane clearly as the dominant weapon in future conflicts and projected quick and humane wars. "Imagine for a moment that, of two centralized industrial nations at war," he wrote simplistically, "one possesses a superior air force, the other a superior army. Provided that the blow be sufficiently swift and powerful, there is no reason why within a few hours, or at most days from the commencement of hostilities, the nerve system of the country inferior in air power should not be paralyzed."[33]

* * *

Alexander P. de Seversky was a latecomer to the group of seers who influenced the thinking of American air power strategists during World War II. No armchair influence-peddler, de Seversky was a flyer, an airplane designer, and a skilled demonstrator of his products. Seversky had attended Russia's prestigious Military School of Aeronautics where he was graduated as an aviator in 1915. He saw combat service, losing his right leg while on a bombing mission and returning to active duty with an artificial one. He later held many aircraft speed records and was a holder of the coveted Harmon Trophy for his contributions to aviation. He came to the United States at the end of the war and served as an aide to Mitchell during his bombing demonstrations in 1921. In 1931 he founded the Seversky Aircraft Corporation which later became Republic Aviation Corporation noted for its successful P-47 Thunderbolt fighters and fighter-bombers.

In 1942, he published *Victory Through Air Power,* which was a popular book-of-the-month selection, condensed in *The Reader's Digest,* and brought to the screen by Walt Disney. Both book and movie were blatant wartime propaganda. In the film, Disney creatively blended de Seversky himself, thick Russian accent and all—the Soviet Union was America's heroic ally after all!—with creative animation. Its climax showed big U.S. bombers flying from bases in Alaska to hit Japanese targets. The bombers were transfigured to "an American eagle whose talons, in a prolonged sequence of orgiastic destruction, render and tear at the Japanese octopus whose tentacles surrender their grip on Japan's conquests. Finally, the camera offered a global view of the octopus dissolving into the burned ruins of Japan while the soundtrack poured out 'America the Beautiful'"[34]

In his book, Seversky devoted a chapter to "Air-Power Lessons for America." He listed 11 such lessons, based on the "front-row seat" he claimed he had had since September 1939, to observe the war. Lesson 9 is subtitled "Destruction of enemy morale from the air can be accomplished only by precision bombing, " a lesson Seversky noted "that has taken even air specialists by surprise…. It had been generally assumed that [indiscriminate] aerial bombardment would quickly shatter popular morale, causing deep civilian reactions, possibly even nervous derangements on a disastrous scale. The progress

of this war has tended to indicate that this expectation was unfounded." Seversky went on further to challenge the underpinnings of a fundamental Douhet principle: "...it now seems clear that despite large casualties and impressive physical destruction, civilians can 'take it'.... On the whole, indeed, armed forces have been more quickly demoralized by air power than unarmed city dwellers." Furthermore, he wrote that "Unplanned vandalism from the air must give way, more and more, to planned, predetermined destruction. More than ever, the principal objectives will be critical aggregates of electric power, aviation industries, dock facilities, essential public utilities...." He summed up Lesson 9 by declaring that "the 'panic' that was expected to spread through a city or even a nation as bombs began to fall has turned out to be a myth."[35]

Seversky then put his finger on the nub of what he saw as the new equation:

> Obviously the war of possession is more difficult, more costly in manpower, more hazardous for the nation undertaking it.... Once control of the air over hostile territory is assumed, the further disposition of that area is normally at the will of the conqueror ... he may find the elimination of the country as a world factor more desirable, or more expeditious, than its actual subjugation ... he may find the acquisition of an area intact, for its resources or industry or other economic values, more desirable than its destruction. The deeper the civilization and the national pride of a people, the more likely it is to be subjected to the method of extermination, since such a people cannot be reconciled to living the life of the vanquished.... Because they represent a constant source of danger to the conqueror, through the threat of a "come-back" advanced peoples must, if possible, be reduced to impotence beyond easy recovery, through the annihilation of the industrial foundations of their life.[36]

Elimination, destruction, extermination, annihilation: Seversky was advocating genocide!

But this was what Americans were being conditioned by insistent government propaganda to expect from their military forces. The desolate postwar landscapes of German and Japanese cities attest to calculated Allied bombing campaigns with such goals. One wonders if arch–Germanophobe Henry Morgenthau, Jr., Roosevelt's powerful and vindictive Secretary of the Treasury, had read Seversky.[37] His infamous "Morgenthau Plan" envisioned a pastoral postwar Germany devoid of any industrial capability, administered under the sharp heel of the victors. This program was casually accepted as doctrine for a short time by both Roosevelt and Churchill in 1943, but later was quietly discarded in light of the changing political climate in Europe and the need for a powerful continental power postwar to counter expansionist Soviet Communism.

4

The Planners

The American air war in World War II was the fruit of six staff officers working with adding machines in extreme heat and humidity [Washington, D.C. in the summer] largely without intelligence information, divorced from the exploding bombs, burning fuel, smoke, and torn flesh of war. They based their calculations on practice bombings flown in clear weather and at low altitudes. Practice bombings were one bomb at a time, making multiple passes to achieve higher accuracy.[1]

In July 1941 President Roosevelt requested from his Secretaries of War and the Navy, Henry L. Stimson and Frank Knox, plans that would guide the nation in the likely event of war with the Axis powers, Germany in particular. At that time, and for more than a year previously, FDR had been engaged in a surreptitious naval war in the Atlantic with Germany's U-boats,[2] and despite the strong voices of the isolationists in and out of the Congress there was a growing certainty that America would soon be a belligerent.

For the air war segment of the overall plan, the commander of the Army Air Corps (redesignated the U.S. Army Air Forces, USAAF, by Stimson in June 20, 1941), Major General Henry Harley "Hap" Arnold, selected four young officers to write the plan. The four were Lt. Colonels Kenneth N. Walker and Harold L. George, and Majors Haywood S. Hansell, Jr. and Laurence S. Kuter.[3] Arnold knew them well from their days together at the Army Air Corps Tactical School at Maxwell Field in Montgomery, Alabama. All were single-minded in their beliefs that strategic bombing would be the path to victory in the war they could see coming—and collaterally to an independent and powerful air force in the postwar. They were airplane men deep down and they understood—or thought they understood—the realities of daytime strategic bombing. Walker, who was considered the Air Corps' top guru on high-altitude precision bomb-

ing, had developed the bombing tables for the B-17. Kuter had earlier written a report listing reasons why big bombers were better than small ones. Two of his superficial conclusions, "The big bomber can defend itself...; The big bomber can work alone..." would prove to be well wide of the mark.[4]

Two former Wall Streeters, newly commissioned Air Corps captains Richard Hughes and Malcolm Moss, were added to the team to develop the targets. Presumably these specialists had a grasp of fundamental economics and could extrapolate data from American industry that could be applied to Germany. Arnold empowered the six men to draw together estimates of manpower and equipment needs based on analyses of the strengths and weaknesses of such prospective enemies as Germany, as well as interrelated factors as strategy, targeting, training, support, and basing. In turn, these data would establish goals for the nation's own industrial production. The team was given just ten days to compile the final plan which was called AWPD-1 (Air War Plans Division-1), "Munitions Requirements of the Army Air Forces for the Defeat of Our Potential Enemies."

The document defined three USAAF tasks in order of importance: " 1) to wage a sustained air offensive against Germany; 2) to conduct strategically defensive air operations in the Orient; 3) to provide air actions essential to the defense of the continental United States and the Western Hemisphere." There were four goals outlined for the air offensive against Germany: 1) to reduce Axis naval operations; 2) to restrict Axis air operations; 3) to undermine German combat effectiveness by deprivation of essential supplies, production, and communication facilities; 4) to support a final land invasion of Germany. AWPD-1 called for 2,165,000 men and 63,500 aircraft.[5]

While a remarkable document considering the constraints of time and the handful of people involved, many of its analyses would prove to be seriously flawed. The planners were privy to no intelligence from foreign agents, for example, and apparently knew little about the structure of the German economy. AWPD-1 postulated a German economy that

Gen. Henry Harley ("Hap") Arnold, commander in chief of the United States Army Air Forces during World War II. (Courtesy National Archives)

was inflexible and incapable of repairing bomb damage. The planners did not even consider that the Germans might disperse their production facilities, nor that they could or would built impregnable underground manufacturing facilities. Nor could they know the extent of the efficient integration of western Europe's industry into the Nazi war machine, nor the use of millions of slave laborers. Furthermore, and even more importantly, they had not a clue that Germany, until 1944, was operating on an almost peacetime-economy footing with enormous surplus capacity to be exploited when necessary. AWPD-1 would erroneously characterize Germany's economy as operating under "heavy stress," with the needs of war production adversely impacting the social and industrial fabric of the country.

Where the planners also exhibited a portentous myopia was in their total disregard of advances in enemy fighter aircraft performance and antiaircraft artillery. This, coupled with their ignorance of the potential of radar, were major factors in their assumption of bomber invulnerability—if not invincibility. This assumption is perhaps understandable in light of the fundamental mission of the Air Force to build a strong case for independence. For if squadrons of bombers could be forced to turn back from their targets—a worst-case scenario that never occurred—or if defensive aircraft and antiaircraft fire could inflict unsustainable losses on the bomber formations—a scenario that nearly occurred—the entire concept of strategic bombardment was flawed.

Arnold wrote later that the idea of a long-range fighter had been studied before the war and that he would have preferred to have sent his bombers into Germany with fighter escorts. AWPD-1 did touch briefly on the need for such a plane, but conceived it as a large, heavily armed and thickly armored multi-engine, multi-seater, only marginally faster than the bombers it would escort. These heavy escorts would obviously trade maneuverability and speed for long range, and were intended to fly on the flanks and the rear of the bomber formations and when enemy fighters arrived, to form a screen between the attackers and the bombers. This flawed concept led to the development of the YB-40, a modified B-17 that proved a total failure. They first flew in combat in May 1943 and despite their heavy firepower and armor, they were no match for enemy fighters. Furthermore, once their charges had dropped their bombs, the heavier YB-40s could not keep up on the return to base. What did finally evolve later was a long-range, single-seat fighter that could readily handle the best of the attackers: the P-51B Mustang.

During those heady days of optimistic planning, before the realities of air combat struck home, the planners looked unrealistically to the possibility that strategic air bombardment alone "might break Germany's back, making an invasion unnecessary."[6]

The AWPD-1 planners, like the American public, had been weaned on air force propaganda, that U.S. heavy bombers were precision bombers—and would promptly and surgically reduce the German war machine and the

nation's industrial infrastructure to rubble. Both the venerable B-17 and the newer B-24 were considered eminently suitable for the bombing missions to come. The more advanced B-29 would be a later addition. The planners ignored both the Luftwaffe's and RAF Bomber Command's experiences in 1940; they both had abandoned daylight bombing as too costly of aircraft and aircrews. In 1942 when the 8th Air Force was preparing for its first missions against Germany, the British insisted that the Americans should drop the idea of daylight missions and join the RAF in night bombing. U.S. Air Force commanders, however, contended that the reason the Germans first and then the British had switched to night bombing was because they did not have suitable aircraft for daylight missions and had not sufficiently trained their crews in America's doctrine. That difference in strategy between the RAF and the USAAF would remain a sore point almost until the end of the war.

Despite at least a superficial understanding of the proved effectiveness of Luftwaffe fighters and antiaircraft artillery that had driven the RAF from the daylight skies over Germany, the authors of AWPD-1 stubbornly and arrogantly stated that "by employing large numbers of aircraft with high speed, good defensive fire power, and high altitude, it is feasible to make deep penetrations into Germany by daylight." The document nevertheless conceded that the effectiveness of the planned bombing campaign would be "greatly enhanced by development of an escort fighter."[7]

One of the intermediate objectives, as covered in AWPD-1, was the defeat or at a minimum the "neutralization" of the Luftwaffe. The planners understood, based on the RAF's experiences, that this would be a daunting task. Luftwaffe fighter aircraft were technologically outstanding machines and their aircrews could be expected to be skilled and imaginative, and increasingly aggressive as the 8th Air Force would concentrate on German cities. "We knew that defensive firepower in the air would not suffice to defeat the Luftwaffe," Hansell wrote in his retrospective, "and that we would have to take up the offensive against German bases, aircraft manufacturing and assembly plants, and aircraft engine plants on the ground." In particular, the air bases for the German fighters would prove to be difficult to locate and dangerous targets to attack. The Germans had with sensible foresight devoted considerable effort to providing security for their air squadrons and their operational personnel. "There were approximately 500 air bases in Western Germany and the occupied territories. These were provided with strong flak defenses. The aircraft were generally dispersed about a mile from the landing areas, with each airplane protected by a revetment."[8]

It was also believed at the time that there would be too few air bases in England to accommodate all the B-17s and B-24s required, so plans included two crews for each plane for maximum utilization. The new B-29 Superfortress, far longer-legged than either the B-17 or B-24, was being rushed into production and would solve that problem; it could reach Germany from

bases in the Mediterranean area. The giant Convair B-36 Peacemaker intercontinental bomber, in an earlier stage of development, would have a combat radius of 4,000 miles and hence could be flown from U.S. bases on the East Coast over Europe and return. As it turned out, the British were able to build U.S. bomber bases for all the planes that would be based in England, eliminating the need for double crews. The B-29's production schedule was tightened and the B-36 was pushed onto a back-burner; it would not become operational until 1951. But B-29 production delays coupled with a full pipeline of B-17s and B-24s led to the decision that the Superfortress would not be used over Europe. However, a single B-29 was flown to England in early 1944 and ostentatiously displayed, supposedly to hint to enemy agents of one sort or another of its coming use in that theater. There was another attempted deception: planned security leaks that the B-29 was a failure and would never be used in combat, only as an armed transport.

In line with the Douhet/Mitchell doctrine of destroying the industries of the enemy by strategic bombing, thus making that country incapable of continuing a war, it was necessary for the planners to identify those industries and industrial infrastructures most critical to the war effort. Many of Germany's most modern manufacturing plants had been constructed in the late 1920s and early 1930s with American loans; Wall Street investment firms had their plans in bank vaults in New York City. From them, the AWPD planners got answers, for example, to such detailed questions as: how thick were the roofs and walls and where in each plant was the important equipment located? Using this information and culling information from the thousands of target folders from the RAF, the planners identified exactly 154 principal industrial targets in Germany and were even able to establish aiming points for the bomb drops. Included were airframe and aircraft engine production plants, synthetic oil refineries, aluminum and magnesium refineries, electrical generating stations, and major railroad centers.

With the targets fixed, the planners' next step was to estimate the tonnage of bombs required to destroy each target and then determine the numbers of bombers needed to deliver the bombs on target. The latest bomb accuracy data the planners used established that a single B-17 from 20,000 feet had a 1.2 percent probability of its bombs striking within a 100 foot by 100 foot target representing an ordinary factory building.[9] To raise the probability of hitting such a target to 90 percent, a multiplier of 220 was put into the equation: namely that 220 aircraft would be required. The AWPD planners then added an additional fudge-factor that would reflect the influences on bombing accuracy of enemy antiaircraft fire, fighter attacks, weather, and overall combat conditions. Out of this potpourri of guesstimates and crude multipliers came a final number: 1,100 heavy bombers, or thirty group missions, to ultimately destroy a 10,000 square foot target.

The final step was simpler: how many airplanes and men—pilots,

navigators, bombardiers, radio operators, gunners, instructors, ground crew—
were needed to win the war with Germany? The numbers of aircraft and sup-
porting personnel recommended by AWPD-1 were staggering. Indeed, only
an extremely wealthy and populous nation could even contemplate such huge
numbers. "…11,853 combat aircraft … to be backed by 37,051 trainers, for a
total of 61,799 operational aircraft, including 3, 740 B-36s…. The forces were
to be manned by 179,398 officers and 1,939,237 enlisted men."[10] How long
would it take to bring Germany to its knees? The grandiose plan estimated
it could be accomplished in six months of an all-out air offensive, from April
to September 1944, based on each group of 36 aircraft flying eight missions
per month. The U.S. Army Air Corps would go to war against Germany on
December 11, 1941, with AWPD-1 as its blueprint.

AWPD-1 was based on America's planned wartime policy of "Germany
first," that Germany was a more dangerous prospective foe than Japan, with
far greater military, economic, and scientific capabilities. Even after the Pearl
Harbor attack, the planners still kept their focus on the war in Europe. The
geographically remote and enormous Pacific theater was a daunting prospect
and best put aside temporarily as far as the planners were concerned.

<p style="text-align:center">* * *</p>

In August 1942, FDR requested an up-dated estimate of future Air Force
requirements, a program for "complete air ascendancy over the enemy."
Hansell returned from General Dwight D. Eisenhower's staff in England to
Washington to work on the new plan; Kuter was still in the capital. Both
were brigadier generals by then and both would be major contributors to what
was officially designated AWPD-42 which would supersede AWPD-1.
George and Walker had high-level assignments elsewhere and were unavail-
able to help develop the new plan.

AWPD-42, finalized in early September, kept its focus on Germany but
changed its priorities. It upped the ante for airplanes and aircrews, propos-
ing nearly 20,000 front-line aircraft supported by over 2,000 long-range air
transports and more than 8,000 gliders for the AAF. A total of 2.7 million
officers and enlisted men would be required to man and maintain these air-
craft. Emphases also shifted away from the production of the extremely expen-
sive B-36, to increased numbers of B-17s, B-24s, and B-29s. The plan also
acknowledged that the U.S. strategic bombing campaign in Europe would be
a joint Anglo-American operation. It included provisions for a strategic air
offensive against Japan once Germany surrendered. As might be expected, -
42 was influenced by the rose-colored-glasses assessments of the 8th's first
missions over lightly defended French targets.

AWPD-42 projected that the Germans might still defeat the Soviet
Union, releasing half of the Axis forces fighting in the east. To achieve air
superiority and thus cripple the Luftwaffe, seven target systems comprising

177 individual targets were to be smashed. "In order of priority, this included 11 fighter assembly plants, 15 bomber assembly plants, 17 aircraft engine plants, and 20 submarine yards ... 38 transportation targets, 37 electric power targets, 23 oil production targets, 14 aluminum plants, and two rubber plants."[11] Factored into the projections were grossly overoptimistic estimates: bombing accuracy with an average circular error of 1,000 feet, twice as good as RAF Bomber Command had yet achieved; up to six operations each month; an average aircraft loss rate of 20 percent a month. The planners' optimistic projections were that all of the targets should have been destroyed by May 1944, coinciding with the cross–Channel invasion of occupied France.

The planners were still tuned into their own rhetoric—that the defensive firepower of the bombers and their high-altitude performance would enable them to penetrate German airspace, drop their bombs accurately with the Norden, and return safely. By mid 1942, however, the seven-year-old B-17 was nearing obsolescence and the three-year-old B-24 was close behind. The planners remained smugly confident that these aging bombers nevertheless could defend themselves against the newest and best the Luftwaffe could hurl against them. More ominously, AWPD-42 would again disregard the need for long-range fighter escorts, even the fitting of droppable fuel tanks to extend the range of the P-47s and P-38s. Nevertheless, the planners' estimates for a bomber force of precisely 7,097 "heavies" were remarkably prescient. In March 1945, 7,177 B-17s and B-24s were in combat over Europe.[12]

* * *

Until Japan's stunning victory in the Russo-Japanese war of 1904–1905, American military observers had dismissed the far-off land with its exotic culture as more of a curiosity than a growing threat to U.S. pretensions as a Pacific power. It then became apparent that Japan's Asian-style imperialism was certain to clash with America's interests in East Asia and the so-called Pacific Rim, particularly the "Open Door" policy in China and the newly acquired American colony in the Philippines. The U.S. Navy promptly added another contingent war plan to its roster: War Plan Orange, appropriate to a nation whose flag depicted a rising sun.

The great Tokyo earthquake of 1923 with its raging fires for three days, which killed over 100,000 and destroyed almost one-quarter of the capital's buildings, exposed the city's vulnerability to fire. During the late 1920s and 1930s there had been frank discussion in the media of how American bombers might exploit the crowded and flammable Japanese cities if war came. Mitchell had even gone so far as to publicly propose the most suitable air bases from which to attack Japan, suggesting locations in the Aleutians, the Kuriles, eastern Siberia, and Kamchatka.

The Japanese were a different enemy than the Germans in nearly every

measurable way, culturally, economically and, more ominously, racially. Japan's population was about half and its industrial capacity about 10 percent of the United States'. America was then a transcendentally racist society; 60 years later, minority African-Americans and Hispanic-Americans would insist it remains virulently so. The "Japs" were demonized as little bow-legged men, squinty eyed through their thick glasses, not to be trusted—*Untermenschen* (sub-human people) to adopt a German word. The enforced displacement of Japanese-Americans from the West Coast soon after Pearl Harbor, into bonafide concentration camps, authorized by FDR, revealed a latent and pervasive hatred of Orientals. The "yellow-bellied Jap bastards" had sneakily attacked a peace-loving, unsuspecting America, so the nation's mobilized propaganda mills proclaimed, and Americans were going to pay them back in kind. During the nation's two subsequent wars with Asians, the Korean and Vietnamese enemies were dismissively referred to as gooks and slopes—and the purposefully tiny number of prisoners taken by America's ground troops were rarely treated according to the protocols of international law. As during the bloody Pacific island campaigns, U.S. Marines and Army troops *allowed* few enemy soldiers to surrender.

5

The Crucibles

CINCPAC FILES SECRET (Declassified IAW DOD MEMO OF 3 MAY 1972)
Subject: Captain Steele's "Running Estimate and Summary," covering the period
7 December 1941 to 31 August 1942.
07 2252 OPNAV to CINCPAC, CINCAF & Naval Coastal Frontiers.
EXECUTE UNRESTRICTED AIR AND SUBMARINE WARFARE AGAINST JAPAN.
INFORM ARMY. CINCAF INFORM BRITISH AND DUTCH.

Fiction

We did it in daylight and we did it with precision, aiming our explosives with the care and accuracy of a marksman firing a rifle at a bullseye. We moved in on a city of 50,000 people [Schweinfurt, below] and destroyed that part of it that contributes to the enemy's ability to wage war against us. When that part was a heap of twisted girders, smoking ruin and pulverized machinery, we handed it back, completely useless to the Germans.[1]

Fact

On October 14, 1943, 16 bomb groups flew over 500 miles into Germany [target Schweinfurt, above], without escorting fighters.... The cost was high—60 out of 229 B-17s bombing that day and 138 more damaged, and 599 crewmen dead or missing in action.... Overall, one bomb out of ten hit within 500 feet of the targets and there were 63 direct hits. Three bearing plants lost 10 percent of their machines damaged or destroyed.[2]

On December 8, 1941, Americans were looking for vengeance in kind against the Japanese. It would be four months before U.S. bombers would first attack the Japanese homeland. In the meantime, a hero would have to suffice and a week later the nation found its first champion—or rather the public information staffs for General Douglas MacArthur, commander of the

U.S. Army Far Eastern Forces in the Philippines, and General "Hap" Arnold in Washington collaborated in fabricating one. He was Army Air Forces captain Colin P. Kelly, Jr., who "helped even the score that the Japanese ran up at Pearl Harbor when he planted three bombs on the Japanese battleship *Haruna*" as newspaper headlines jubilantly displayed, and majestically paid for the sinking of the ship with his life. His wife in an interview with the *New York Times* was quoted as saying courageously: "I know he would have wanted to die in action.... I think he must have been flying a Fortress when he was killed."[3] The propaganda mills were shifting into high gear.

Here was a splendid opportunity for Air Force publicists to exploit, all at the same time, heroism, the American precision bombing doctrine, and the B-17 Flying Fortress, the bedrock of U.S. air power. Kelly was Sergeant York and Eddie Rickenbacker rolled into one. "With utter disregard for murderous antiaircraft fire and swarms of enemy fighters—alone and unprotected he and his crew traded their bomber and their lives for the destruction of a powerful, modern and heavily armed Japanese battleship. His feat will live in the history of the Army Air Forces," ran an Air Force communique. More creative hyperbole was on its way. Garishly illustrated tabloid stories told of a mortally wounded Kelly diving his flaming B-17 into the deck of the Japanese battleship *Haruna*, and comic books and penny bubble-gum war cards featured Kelly and his bomber.

Kelly's copilot, Lt. Donald Robins, who survived the mission, told a somewhat different tale of the famous last flight to a UP correspondent on March 6, 1942, on the Bataan Peninsula. His embellished yarn got front-page headlines nationwide and was comforting reading for a nation newly at war.

> "I flew with Kelly. After moving from field to field eluding Jap attacks and even sleeping under the wing of our B-17 overnight, we proceeded to badly bombed Clark Field on the morning of December 10 for a load of bombs and gasoline.... We had time to load only three bombs, but those were big babies.... Colin, who was our deputy squadron leader, told me our mission was to get an aircraft carrier off North Luzon ... there we observed two small Jap transports. But we were after bigger game, so we changed our course and proceeded south. There we saw seven ships—three transports, three destroyers, and one big fat son-of-a-gun.
>
> Three pursuits took after us, so we climbed to 20,000 feet and the pursuits left us, leaving the field open on a perfect bombing day, at a choice altitude. Kelly, myself, and the navigator took turns looking through the glasses and concurred that the fat boy couldn't be anything but a battleship, so we decided to let go. Over the battleship we dropped our three bombs. It was perfect—one hit very near the starboard side, so close it was almost a miss; the second hit amidships near the funnel, and the other explosion occurred near the port side.
>
> It was a bombardier's dream. The gods of luck were with us, and when we left the battleship was already burning fiercely. The bombardier, Corporal

M. Levin, deserves special credit since he was using an untried bombsight of a type slightly different from those he usually operated.

Highly satisfied with our accomplishment, we started back to Clark Field and let down to 10,000 feet ... two or three pursuits came out of a low bank of clouds and attacked us. Their machine gun and cannon fire set our ship afire. When we were hit, we dove for a scud of clouds. Kelly ordered the men to bail out and the rear crew jumped first, with the bombardier and radio operator leaving next from the frontal escape.

A minute later the plane went completely out of control and Kelly and me were pinned against the cabin. I thought, "Well, this is it." All the time Kelly had been hollering to the machine-gunners to do their stuff and beat 'em off. Kelly, a fighter to the last, as usual didn't swear even though he knew we were in a plenty tough spot.

The rest of the story is vague. I tried to make my way to a nearby overhead escape but couldn't seem to move. I believe I was thrown out of the plane by an explosion. Six of the eight members of the crew landed safely. Kelly's body was found near the plane.... He was a real man.[4]

Kelly most certainly was a real man but the yarn of his exploits was unvarnished propaganda. There was no battleship beneath Kelly's plane.

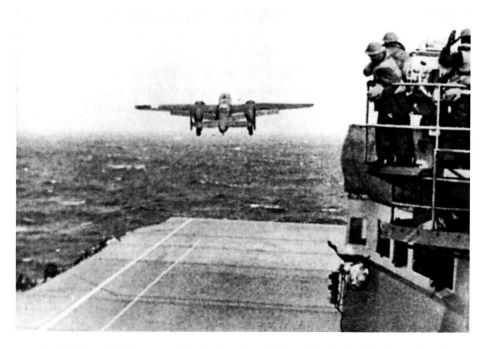

April 18, 1942: The first of 16 North American B-25 Mitchells, Lt. Col. James Doolittle at the controls, off the U.S. aircraft carrier Hornet en route to bomb Tokyo and environs. (Courtesy National Archives)

Official Japanese records clearly establish that there were in Philippine waters at that time one light cruiser, six destroyers, and four transports. There was no battleship. Moreover, no bombs had hit near their light cruiser on December 10.

<p style="text-align:center">* * *</p>

Next came retribution—and the first of the USAAF's avowedly terror bombing raids over Japan masquerading as precision bombing. On April 18, 1942, a squadron of 16 B-25 Mitchell bombers flew off the aircraft carrier *Hornet* in the North Pacific: destination Tokyo and nearby Japanese cities, and on into China. There were powerful political pressures to mount a soon-as-possible riposte to the Pearl Harbor attack and the unorthodox mission was the best Air Force strategists could cobble up on short notice and with the available resources.[5]

In January, Arnold had chosen Lt. Colonel James Doolittle to command the joint Army-Navy mission, Special Project No.1, famously memorialized as the "Doolittle Raid." Doolittle had written extravagantly to Arnold in an undated letter prior to the mission, "the purpose of this special project is to bomb and fire the industrial center of Japan.... This will not only cause confusion and impede production, but will undoubtedly facilitate operations against Japan in other theaters due to their probable withdrawal of troops for the purpose of defending their home country. An action of this kind is most desirable now due to the psychological effect on the American public, our allies, and our enemies ... objectives will be military and industrial targets in the Tokyo-Yokohama, Nagoya, and Osaka-Kobe areas."[6]

Doolittle's checkered background matched his remarkable command. Unlike most USAAF commanders, he was not a West Pointer or a career officer. He had joined the U.S. Army in 1917, transferred to the Aviation Section and served there until 1930 to join Shell Oil and help develop 100-octane aviation fuel. Earlier he had earned a doctorate in aeronautical engineering from the prestigious Massachusetts Institute of Technology. Before the outbreak of the war, Doolittle had built a reputation as a daring airplane racer, setting speed records and gaining international fame.

The plan called for an afternoon takeoff of the first plane, Doolittle's— some 400 miles from the Japanese mainland—so he would arrive over Tokyo at dusk. The remaining 15 planes would take off two or three hours later, at local sunset, "so you can use my fires as homing beacons," he told his aircrews. The B-25s, never intended for carrier operations, were stripped of all unessentials to reduce takeoff weight. The pilots would take advantage of the typically stiff mid-ocean ocean breeze blowing across the deck as the carrier steamed at its top speed of 25 knots directly into the wind to gain sufficient flying speed during their short takeoff rolls and would time their brake releases as the carrier's bow pitched up to gain extra precious altitude. Tests conducted

at Eglin Air Force Base in Florida established that it was feasible for a heavily loaded B-25 to be safely airborne in only 350 feet under those conditions.

The B-25s each carried a one-ton bomb load, three 500 pound general-purpose bombs and a single 500 pound incendiary cluster bomb, plus enough fuel to carry them across their targets and into China where they would pick up homing signals guiding them to airfields under control of the Chinese. These signals were to originate from Flying Tigers' commander Claire Chennault, who operated an early-warning network in eastern China. Doolittle cautioned his aircrews to bomb only military targets. He told them: "I don't want any of you to get any ideas about bombing the Temple of Heaven—the Imperial Palace. And avoid hospitals, schools, and other nonmilitary targets ... drop the demolitions in the shortest space of time, preferably in a straight line, where they will do the most damage ... drop the incendiary cluster as near to the others as possible in an area that looks like it will burn."[7]

The Norden bombsights were removed from the planes: at the low altitudes, 1500 feet and even lower, that the B-25s would sweep across their targets, the Nordens were known to be useless. Instead each bombardier was given a crude, hand-held gadget resembling an oversized high-school protractor with an adjustable sighting bar to compensate for the plane's airspeed and altitude. Called the Mark Twain, it had been designed by one of the armaments officers at Eglin Air Force Base in Florida using "materials that cost only about 20 cents." According to its designer, "actual low altitude bombing tests carried out at 1,500 feet showed a greater degree of accuracy with this simplified sight than was obtained with the Norden by the same bombardiers. This ... obviated the possibility of the highly classified Norden sight from falling into enemy hands." One pilot later wrote that "it was fine for the things we had in mind. It was as simple as pointing a rifle at the object to be bombed and letting the bomb go when you had a bead."[8] Precision bombing in the dark of night with a homemade 20-cent thingamajig?

As events transpired, the 16-ship task force was sighted by a Japanese Navy picket ship at dawn, one of the many small trawlers that screened the sea approaches to Japan. The small ship was promptly sunk by the escorts but it was too late: radio operators on the *Hornet* had picked up what they presumed was a signal from the trawler to the mainland giving the composition, location, speed, and estimated direction of the task force. A hurried conference with task force commander Vice Admiral William "Bull" Halsey, resulted in a radical change in plans. Instead of the original launch position and time, Doolittle's plane took off almost immediately—some 200 miles farther out than planned and about 10 hours ahead of schedule, at 8 A.M. The remaining planes flew off right behind. The last of the B-25s was airborne one hour later. The planes would arrive over their targets in broad daylight with less fuel in their auxiliary tanks than originally planned. Furthermore, no homing signals were ever received as the planes neared the China coast. Halsey

was supposed to have radioed Chennault when the bombers left the carrier that friendly aircraft were inbound into Chinese airspace. Had Halsey followed through under the new circumstances? Perhaps he had chosen not to transmit such a message, clearly giving away his task force's latest position and inviting an attack deep in enemy waters. As far as the Navy was concerned, the B-25s and their aircrews were expendable; the two carriers were not. Or had Chennault's rudimentary navigation beacons simply failed?

All the B-25s managed to reach the Chinese mainland after their haphazard bombing runs over Japan, except for one that made it to Siberia. Most of the crews bailed out safely over Chinese-held territory, the rest crash-landed, with five airmen being killed. Eight of the raiders were captured by the Japanese and brought to Japan. In late August, the prisoners were subjected to a drumhead military trial. Earlier that month, the Japanese government had promulgated a new law called the Enemy Airmen's Act, aimed at flyers who bombed and strafed nonmilitary targets—namely the Doolittle airmen—"or any other violators of international law." The maximum sentence was death. Two pilots and one engineer-gunner were sentenced to death; the remaining five prisoners were given lifetime prison terms. The three U.S. airmen executed were not beheaded, contrary to the creative propaganda photographs later published in American newspapers; they were blindfolded and shot by a firing squad and given formal, respectful military burials. The Japanese army retaliated savagely to the civilians of Sehkiang province where most of the B-25s had crashed-landed, massacring thousands and burning the city of Chuchow toward which the planes had been heading.

On May 19, Roosevelt pinned a Congressional Medal of Honor on Doolittle, a new brigadier general. Earlier, jubilantly announcing the raid, FDR called the attack on Japanese war industries a brilliant success—not the uncoordinated and improvised area assault on cities it had been. When asked by reporters where the planes had been flown from, Roosevelt first shook his head as if to say he could not tell, paused theatrically, and finally said, smiling broadly, they had taken off from Shangri-La, the mythical paradise-on-earth land that had been the focus of a popular early–1930s movie *Lost Horizon*. A year later the War Department finally released its official communiqué of the mission, a transparent propaganda sheet filled with public relations hyperbole and too many adjectives. There were "sheets of flame," "terrific explosions," "flames and columns of smoke leaping several thousand feet into the air. One by one, each objective of each plane was checked off. Now it was a tank factory, now a shipyard with a cruiser in it, now an airplane plant. The explosions and also the flames from incendiary bombs wrecked steel plants, power factories, machinery works, railroad yards and sidings, docks, arsenals, and oil refineries. Direct hits were made on a new cruiser or battleship under construction."

It would be almost three years before the USAAF resumed bombing of

targets on the Japanese home islands. During that time, a plane far more suitable than the twin-engine B-25 for strategic bombing in the Pacific—the Boeing B-29 Superfortress—was readied and bases in the Mariana Islands built. These raids would be on a far greater scale than Doolittle's annoying pin-pricks. Meanwhile there was the strategic air war to be fought in Europe.

* * *

> *The British people are by nature peaceful and kindly. They desire nothing on earth except to retain their liberties, to enjoy their pleasures, and to go about their business in a tranquil frame of mind. They have no ambition for honour and glory, and they regard wars, and even victories, as silly, ugly, wasteful things. They are not either warriors or heroes until they are forced to become so; they are sensible and gentle women and men.*[9]

Based on their experiences during the Great War, it was understandable that the British were particularly concerned about the vulnerability of their cities to air attack from continental powers. During a debate in the House of Commons in November 1935 on the eve of the Geneva Disarmament Conference, former and future Prime Minister Stanley Baldwin closed the discussions with what was described as "an impassioned plea" to abolish military aviation. "Aerial warfare is still in its infancy," he declared presciently, "and its potentialities are inconceivable. The time wasted at Geneva discussing such matters as the reduction of airplanes, fills me with despair. The prohibition of civil bombardment is quite impracticable so long as bombing exists at all.... What can we do with this new horror now that we have got it?" he asked. "On the solution of this question hangs our civilization," Baldwin warned. "I think it would be well ... for the man in the street to realize that there is no power on earth that can protect him from bombing, whatever people may tell him." He then coined a ringing phrase that followed him for the rest of his political career: "The bomber will always get through, and it is very easy to understand if you realize area and space." If Baldwin sounded a little like a pacifist, his concluding remarks were anything but pacifistic: "The only defense is an offense"—taking a page out of Douhet's book—"which means you have got to kill more women and children quicker than the enemy if you want to save yourselves. I mention that so people may realize what is waiting for them when the next war begins."[10] In fact, "The political rationale behind the Royal Air Force's creation seems to have been more the launching of reprisal raids on Germany than the defense of British territory; it was an offensive service arm created to deal with defensive needs."[11]

By September 1939, the British had built up their air defenses and their chain of coastal radar stations and "even more feverishly had built big bombers and were preparing to implement plan W.A. 8," a bonafide strategic aerial offensive "to produce an immediate dislocation of German war industry."[12] The

RAF learned the hazards of daylight bombing during a single mission in December 1940. The British, impelled historically to assign an appropriate name to a particular military engagement, called it the Battle of Heligoland Bight. Twenty-four Vickers Wellington twin-engine bombers, the most advanced in Bomber Command at the time, took off to strike targets on the German offshore island: two ditched en route, Luftwaffe Bf 109s shot down ten, and three heavily damaged bombers crash-landed on return to their base. The mission had scarcely been a battle; rather, it had been a slaughter. Portentously, the lumbering Wellingtons had flown into combat without RAF fighter escorts.

American Air Force generals Spaatz and Eaker, who were in England at the time to observe first-hand the Luftwaffe's blitz with their Heinkel 111 and Junkers 88 twin-engine bombers—and the RAF's countermeasures—appear in hindsight to have learned little that they would apply to the coming American operations to be based in England. The U.S. commanders patiently told their British listeners that the bigger American B-17s with four engines were superior aircraft: they flew higher and faster, could defend themselves better, and could sustain more punishment. Presumably, too, their RAF counterparts were anxious to ingratiate themselves with their high-level visitors who were involved in lend-lease decision making, and listened in hushed respect, feigned or otherwise, when they were given the technical lowdown on the secret Norden bombsight.

A month earlier, on November 8, the RAF had attacked Munich in a night raid, a deliberate provocation to Adolf Hitler, for on the same date in 1923, the Nazis had launched their bid for power in the *Bürgerbräukeller* in that city. The anniversary meeting in the same beer cellar was a big event every year, and the RAF had purposefully disrupted the celebrations, including the *Führer's* traditional speech. The raid would prove to have long-term repercussions. One week later a stream of over 400 Luftwaffe bombers hit the city of Coventry, dropping about 500 tons of high-explosive bombs, nearly 1,000 incendiary cluster bombs, and some 130 big parachute mines. In the words of a patriotic British historiographer three decades later:

> It was a callous and bloody raid. The whole heart of the city, including its fine cathedral, were razed to the ground; 380 civilians were killed and 800 seriously wounded. It was of little account that Lord Haw-Haw explained smoothly that twelve aircraft factories [principally Supermarine facilities manufacturing Spitfires] and nine other industrial plants had been hit. Righteously indignant, the British public demanded a city for a city, and the Government concurred. Within 24 hours the order had gone out to Bomber Command that in the future they would simply aim at the centre of any town they were attacking.[13]

The reasons the RAF's bombing policy evolved into indiscriminate area bombing by night were not simply retribution for Coventry—trumpeted for

decades to come as an example of heinous Nazi atrocities—but from a genuine belief in Douhet's flawed principles that terror bombing would cow civilians who would rise up and demand an end to the war. Britain's post-war bombing Survey Report rationalized the decision:

> At the start of the war ... the prevailing view was that the best use of our bombers would be to apply them in precision attacks against such vital industrial targets as oil installations, power stations, and railway centres.... Experience showed, that except under the best conditions of visibility, crews could not be expected to find their targets or bomb them accurately.... Instead, it was thought in most influential quarters both inside and outside the Air Ministry that spreading attacks—area attacks as they then began to be called— against large centres of population, was the policy of choice, it being understood that the object of the attacks was to demoralize the enemy.[14]

At debriefings, returning RAF aircrews invariably and enthusiastically reported the successes of their missions. Targets had been struck unerringly, giant fires kindled, and the tons of bombs dropped were translated into destroyed factories and reduced enemy war production. Not only was bombing accuracy grossly exaggerated, but the numbers of enemy aircraft shot down by the bombers were typically many multiples of the actual numbers. The aircrews were sincere in their reports, leading the top commanders to put undue credence in them and to subsequently base their decision making on the optimistic reports. U.S. aircrews later would give the same unrealistic and erroneous reports during their post-mission sessions.

In August 1941, after 16 months of nighttime bombing missions over occupied France and Germany, the RAF was suddenly brought up short by a report focusing on Bomber Command's inability to hit its targets. D.M. Butt, a member of the War Cabinet's secretariat, had been charged with looking into the effectiveness of the RAF's bombing missions in light of increasing losses. He studied in detail 600 photographs of 100 raids on 28 cities over a two-month period, using nighttime aerial photographs. His objective findings were startlingly at odds with the roseate aircrew accounts that had been happily embraced by the RAF's commanders since the first raid in April 1940. Butt's depressing report astonished nearly everyone who read it. Among its conclusions: on average, only one of five bombers that supposedly had located their target, dropped its bombs within five miles of the target. Over lightly defended France, three in four managed to meet the average; over targets in Germany's important Ruhr, only one in ten came within five miles.[15]

Bomber Command's top officers initially refused to accept Butt's data and conclusions, even when the results were confirmed by specially flown daytime reconnaissance flights. But the facts spoke for themselves: the RAF then could not navigate to targets at night or drop bombs on targets when it found them—if it found the targets. Severe bomber losses during one RAF mission

later in 1941 punctuated the Butt Report's findings. On the night of November 7, 1941, 400 bombers were sent against targets from the Ruhr in Germany to Norway, including distant and well-defended Berlin. The overall attack was a British disaster, with 37 planes lost. Over Berlin, where only 73 of the 169 dispatched to that target managed to attack, 21 were shot down, for a stunning 28 percent loss rate on that segment of the overall mission. Few bombs struck Berlin proper; there were only 41 casualties on the ground in the general vicinity of Germany's largest city.[16] Air Marshall R.E.C. Peirse blamed the weather and his inexperienced aircrews for the debacle, but few in high places bought into his lame excuses. Three months later he was gone and in came Air Chief Marshall Sir Arthur Travers Harris, the man who, more than anyone else—Brit or Yank—came to personify indiscriminate city bombing during World War II.

Harris was an experienced flyer who had flown against Germany's zeppelins in 1916 and later on bombing missions over the continent. "He was a rough, tough firebrand of a leader who knew what he wanted and why ... and would be one of the most fearless, ferocious and controversial figures on the Allied stage for the rest of the war."[17] At the press conference announcing his appointment, he responded to a question about the role of strategic bombing in winning the war by sternly lecturing that too many of his countrymen were naysayers. "My reply is that it has never been tried yet. We shall see." Harris had no complicated ideas about aerial bombing and the role of his new command. "Let's finish the war by beating the hell out of the Hun," was his simple philosophy. "Maybe one day we'll be able to bomb scientifically every time. But until we reach that stage, let's mainly send over fleets of bombers to flatten Schicklegruber's houses and demoralise his workers."[18]

Harris was supported by the equally amoral Lord Cherwell, the British Cabinet's chief scientific adviser and a man who had Churchill's ear. A month after Harris took over command, Cherwell came up with a simple scheme to win the war. His experts had studied the Luftwaffe's air attacks on Britain's cities and concluded that every ton of bombs dropped had made, on average, about 150 English homeless. It was estimated that the average combat life of an RAF aircrew and its plane was 14 sorties. During these combat missions, the plane could be expected to drop about 40 tons of bombs. The mathematics were straightforward: each bomber would therefore "dehouse" about 6,000 Germans. There were further extrapolations: some 22 million Germans lived in Germany's 58 largest cities (those with populations over 100,000) and all were within range of the new heavy bombers then coming off the assembly lines. If 10,000 of the new bombers were put into combat by the middle of 1943, so the analyses went, one-third of Germany's population would be made homeless. Cherwell, in a memo to Churchill, further stretched his findings: "Investigation seems to show that having one's house demolished is most damaging to morale. People seem to mind it more than having their friends

or even relatives killed.... There seems little doubt that this would break the spirit of the people."[19]

In July 1942 Harris summarized his bombing program unambiguously in a radio broadcast beamed to Germany:

> "We are going to scourge the Third Reich from end to end.... We are bombing Germany, city by city, and ever more terribly, in order to make it impossible for you to go on with the war.... I will speak frankly to you about whether we bomb single military targets or whole cities. Obviously we prefer to hit factories, shipyards and railways. It damages Hitler's war machine most. But those people who work in these plants live close to them. Therefore, we hit your houses and you."[20]

Trenchard came out of retirement to act the role of an *ex-officio* strategic analyst in support of Bomber Command, reporting to Churchill that it was his expert view that the German people were "particularly susceptible to air bombing." He did not say why. Acknowledging that only one percent of bombs dropped hit their targets, he rationalized that the 99 percent that missed "help to kill, damage, frighten, or interfere with Germans." Such a policy Trenchard postulated might well involve heavy losses of RAF airplanes and aircrew. Exhibiting the stiff upper lip of a true son of the British Empire, he concluded that "the counting of our losses has nothing to do with the soundness of the plan once you accept that the nation can stand their casualties. The pilots in the last war stood it, and the pilots of this war are even better, and, I feel, would welcome a policy of this description."[21]

The RAF's ineffectual twin-engine bombers were succeeded by three four-engine heavies. The Short Stirling was the first, followed by growing fleets of Handley-Page Halifaxes and Avro Lancasters, the best performer of the three. It had a top speed of over 280 miles per hour and a service ceiling of 24,500 feet. Its bomb-carrying capacity was the plane's strong point: it carried a normal bomb load of seven tons (compared to a B-17's three tons). On short-range missions, the capacious bomb bay of the Lancaster could carry the largest bomb of the war, the 11-ton Grand Slam. The crews of these bombers defended themselves with short-range .303 caliber machine guns— "pea-shooters" as some in the AAF mocked—and too few of them per plane. Even the vaunted Lancaster had no ventral turret, which Luftwaffe nightfighers exploited in their stealthy radar approaches from "six-o'clock low."

The plodding British bombers when found by the heavily armed Luftwaffe nightfighters were doomed. Only if the bombers were able to detect their hunters immediately, could they "perform their famous 'corkscrew' maneuver by which they sought to evade or at least to present a more difficult target to the fighters; their maneuverability was, nevertheless, far inferior to that of their smaller and speedier opponents ... they were substantially outshot and

completely out-ranged by their cannon-equipped enemies. Their armour plating was progressively removed until little remained. Belching flames from their exhausts as well as radar transmissions ... and in a generally highly flammable and explosive condition, these black monsters presented an ideal target."[22]

RAF doctrine was perhaps best summed up by a Bomber Command pilot with 73 missions:

> We didn't worry too much about not hitting the military targets we were after. Really, so long as we dropped our bombs we were doing some damage somewhere, although the ruling was that if we couldn't see our target we were to bring our bombs back, but nobody did this.... If the target was covered in cloud but you knew [or guessed?] you were over a town somewhere you dropped the bombs, and when you got back at the de-briefing you said there was a hole in the cloud and you bombed through the hole.[23]

As the war wound down in Europe, Hansell observed what he called "a peculiar trend [that] pervaded the air offensive. When command of the air was so completely established that RAF Bomber Command was free to roam the air over Germany in daylight, there was every reason to expect that Bomber Command would take up at long last the selective destruction of industrial targets which it had been forced to abandon early in the war. But this did not transpire. Instead, Bomber Command, after a few sporadic attacks against selected targets, reverted to area urban bombing in an effort to give a last body blow to what was presumed, incorrectly, to be the wavering morale of the German State."[24] A less Anglophilic observer might suggest that this 11th-hour bombing paroxysm was like the purposeful food blockade of German ports by the Royal Navy sustained for nine months after the November 1918 armistice—starving to death between one and two million women and children. That bonafide barbarity, often overlooked by both British and American historians of World War I but considered by others the great atrocity of the Great War, was purposefully intended to retard German postwar recovery and at the same time give an economic jump-start to the victorious British.[25]

* * *

One analyst of U.S. 8th Air Force activities divided its combat operations into three phases: "build-up," the first eight months; "attrition," the second eight months; and "escort," the last 16 months. Less than 1 percent of all bombs dropped and overall sorties flown took place during "build-up." The Luftwaffe sometimes ignored those early and generally ineffective raids, and U.S. losses were light. During the second "attrition" phase until the end of 1943, when U.S. bombers began incursions into Germany, the 8th suffered severe losses, particularly to enemy fighter attacks. The highest monthly loss

rate was in October, close to ten percent, the month of the disastrous second Schweinfurt attack This phase included about six percent of bomb tonnage dropped. In the last "escort" phase, P-51B fighters with external fuel tanks accompanied the bombers to, over, and from their targets deep into Germany.

In January 1943 at the conclusion of their 10-day conference in Casablanca, Roosevelt and Churchill agreed, among other understandings, that the primary objectives of American and British bombing forces would henceforth be two-pronged: the progressive destruction of German military, industrial and economic systems, and the undermining of the morale of the German people to a point where their capacity for armed resistance would be fatally weakened. It was further decided that, instead of the bombers aiming at specific military and industrial targets, they would hit residential areas, expressly without regard to civilian loss of life. There was no recognition, formal or otherwise, that the new policy represented the RAF's old and ongoing *modus operandi*. The target list priority was also updated: 1) submarine construction yards, 2) the aircraft industry, 3) transportation, 4) oil plants, and 5) other plants in the enemy's war industry. The Allied planners also called for the USAAF to have 52,000 aircraft with a total strength of 2.4 million men ready for combat by December 1944 and the RAF to have 10,000 planes available at the same time.

Of more portent was Roosevelt's announcement, seemingly an afterthought to those in attendance, that the Western Allies had agreed to a policy of unconditional surrender. Churchill was inwardly staggered by FDR's off-the-cuff statement that he knew meant extending the war; in his geopolitical view such an extension favored the growing forces of Communism. Presumably he swallowed hard before he endorsed the declaration in the interest of solidarity. But one of his senior advisors, Lord Maurice Hankey, was not so sanguine. He was so troubled that when he returned to England that he dug into the records of 15 of Great Britain's major wars since the Renaissance in the 1500s. "In only one, the Boer War, had the idea of unconditional surrender even been considered, and it had been hastily dropped when the Boers announced they would fight until doomsday. In fact, Hankey could find only one noteworthy example of unconditional surrender in recorded history: the ultimatum that the Romans gave the Carthaginians in the Third Punic War."[26]

Ira Eaker, by then commander of the 8th Air Force and a major general, had gone to Casablanca to prevent the British from stampeding his command into joining the RAF in night bombing over Germany. A student of history himself, Eaker was equally vehement in his opposition to his commander in chief's momentous statement. "Everybody I knew at the time when they heard this said: 'How stupid can you [he] be?' All the soldiers and airmen who were fighting this war wanted the Germans to quit tomorrow. A

child knew once you said this to the Germans, they were going to fight to the last man."[27] When Josef Goebbels, the Nazi propaganda minister, learned of Roosevelt's announcement, he was reported as being "ecstatic."

At the end of the conference, a jaunty FDR announced to reporters that the two Western Allies had reached total agreement on all issues. It was a lie. To the contrary, General George C. Marshall had been ferocious over the British refusal to agree on a cross–Channel invasion in 1943; instead, Churchill had inveigled the president into joint campaigns in the Mediterranean area of no strategic interest to the United States—but vital to the British in their postwar planning somehow to preserve their crumbling empire.

* * *

The sturdy myth of American heavy bombers defending themselves against enemy air attacks without continuous fighter escort was finally demolished on August 17, 1943, although it would be two months and another infamous mission before the most extreme die-hards in the AAF would finally acknowledge reality. Early that morning a force of 146 B-17s took off to bomb the Messerschmitt aircraft plants in Regensburg in central Germany. The planes were fitted with "Tokyo Tanks" in their bomb bays to give them extra range; after they struck the factories and adjacent airfields where completed Bf 109s would be parked, they would fly south to bases in North Africa. Shortly after, a larger group of 230 B-17s was airborne, its destination Schweinfurt, 100 miles from Regensburg, and the home to Germany's principal ballbearing manufacturers.[28] If both targets were destroyed—"choke points" in AAF vernacular—it was grandiloquently believed that the Luftwaffe, certainly, and perhaps the entire Nazi war economy would be paralyzed.

Losses to the 8th Air Force were the heaviest one-day toll to that date: more bombers were shot down than had been lost in all of the 8th's missions between August 1942 and March 1943. "In all, 60 [Regensburg, 24; Schweinfurt, 36] had gone down, 11 had to be scrapped. Seven fighters were lost. The Americans had lost 601 men: 102 killed, 381 prisoners, and 20 interned in Switzerland.... The Germans had lost 47 planes, but only 16 men killed. Only 21 planes had fallen to the bomber's gunners, who claimed to have shot down 288! Survivors of the more savagely defended Schweinfurt mission were unanimous in regarding it as their worst experience of the war, except for those who would go on the second mission."[29]

Neither of the two attacks was the devastating blow expected. In Regensburg, workers promptly dug out undamaged machine tools and vital assembly jig and fixtures buried in the rubble; replacement tools and machinery were rushed in from nearby factories. The main plant itself was dispersed, initially to small local workshops and then to special camouflaged forest locations. In several weeks, production was back to normal. In Schweinfurt, only one of the three main plants was heavily damaged and while production was

not moved elsewhere, Minister for Armaments and War Production Albert Speer saw to it that the city got expanded antiaircraft defenses.

A second mission was sent to Schweinfurt on October 14, intended to finish the job only partly completed in August. As in the previous raid, the bombers were directed to aim for the center of the city if the factories themselves could not be seen. Bad weather hampered the start: of 383 planes that took off, a mix of B-17s and B-24s, only 291 crossed the English Channel and fewer than 230 managed to reach Schweinfurt. The air battles en route were ferocious. Over the Rhineland, when the short-range P-47s had to turn back, the main Luftwaffe attacks began. Stukas above the bombers dropped fragmentation bombs, but it was the Bf 109s and Fw 190s that were most effective, "some using rockets, mostly attacking from head-on or just off to the side. Twin-engine fighters and bombers came in from the rear. Standing off to one side to avoid the tail guns, they fired rockets and blasted away with heavy cannons…. Then the Germans hounded the planes right back to the coast, as weather prevented the arrival of the withdrawal escort. Over Europe 60 bombers went down, and another 5 crashed in England." Arnold obfuscated preposterously: "The opposition isn't nearly what it was, and we are wearing them down."[30] The *New York Times* reported on October 16: "The American loss represented 600 American fliers killed or missing and perhaps $20,000,000 worth of precision bombing and fighting equipment." The 8th Air Force never again ventured in force over Germany beyond the protection of American fighter planes.

Roosevelt reflected at his press conference on October 25 that he was not worried about the heavy losses over Schweinfurt, remarking to newsmen off-handedly, "Of course, we cannot afford to lose 60 bombers every day." On the positive side, FDR concluded that "we did put out of action an important German war plant." Arnold, too, put on his happy face, calling the mission "a spectacular air raid," and pointing to the vital importance of ball bearings to the German war effort: "In a period of a few hours we invaded German-held Europe to a depth of 500 miles, sacked and crippled one of her most vital enterprises."

Schweinfurt II, as the raid was later identified, while further damaging ball-bearing plants, had little lasting impact. Only a small percentage of the specialized manufacturing machines were permanently put out of commission and a detailed inventory check showed that industries relying on the bearings had six- to 12-month supplies on hand. The Germans also got help from their principal supplier of small bearings, Sweden, which upped it exports of the most-needed types. In addition, German engineers promptly adapted as much of their war equipment as was feasible to use plain journal bearings in place of anti-friction bearings.

* * *

Earlier, on August 1, the 15th Air Force's B-24s, flying out of bases in Benghazi, Libya, to bomb oil fields and refineries in Ploesti, Romania, had

suffered significantly heavier losses. Ploesti and environs was the principal source of natural petroleum in Axis Europe, supplying about one-third of Germany's needs, nearly all of the balance coming from the synthetic oil refineries inside Germany. Churchill dramatically referred to the city as "the taproot of German might," an exaggeration, but Ploesti was certainly a vital strategic target. The Germans treated it as such and its defenses against air attack were formidable. Mizil, 20 miles east of Ploesti, was the main Luftwaffe air base, home to *Jägergruppe 4* (Hunter Group 4) consisting of 52 Bf 109s. Based close by at Zilistea were 17 black-painted Me 110 night fighters, also crewed by well-trained Germans. There were also Romanian defensive forces scattered at bases in the immediate area, and flying a melange of German and domestic fighters. These planes represented Ploesti's inner fighter ring. There were also German fighter-plane bases on Crete and Greece and fighter groups in southern Italy that formed an outer ring of defenses. The largest force in this outer ring lay directly across the route that would be taken by the B-24s. It was a Royal Bulgarian fighter-plane regiment with more than 100 planes, mostly obsolete Czechoslovak models captured by the Nazis in 1939.

The Soviets had bombed the refineries sporadically early in the war and 12 9th Air Force B-24s from bases in Libya managed to reach the target area on a night attack in June 1943. That mission had been unsuccessful, causing no damage to the oil facilities but resulting in stray B-24s landing at various Allied fields in the Middle East. The next U.S. raid would be far larger, it would be flown in daylight, and would be carefully orchestrated. It was intended to wipe out the refineries in a single massive blow.

Plans for the raid, code-named Tidal Wave, called for a concentrated attack across the refineries with as close to 200 B-24s as could be mustered for the mission, flying at altitudes below 100 feet. Such a raid, it was viewed, would surprise the enemy as the big planes roared in from different directions to saturate the defenses, allow accurate placement of the bombs, offer only fleeting targets to flak, and pose problems to defending fighter pilots always skittish about tree-top-level interceptions. Radio silence would be mandated from takeoff to target so as not to tip off the enemy. The Norden bombsights, unusable at such low altitudes, were replaced with simple bomb-aimers not unlike the homemade Mark Twains installed in the B-25s that had raided Japan six months earlier. Auxiliary tanks were fitted in bomb bays for the 2,700 mile round trip. Bombs were equipped with delayed-time fuses so as not to explode underneath close-following planes. The bomb groups were organized into seven target forces, each assigned a separate refinery.

The plan started to unravel even before the early morning takeoffs. German radio intelligence operators had been tipped off by a routine signal between ground stations, and the vital element of surprise had gone by the board. Soon after the 177 B-24s formed up over Libya, assembled into formation, and headed north over the Mediterranean, the lead plane with its

mission commander and chief navigator unaccountably went out of control and crashed. It was followed shortly after by the backup lead which aborted. The situation rapidly deteriorated from then on, the mandated radio silence contributing to the confusion. The formation ran into towering clouds and two of the groups climbed to get above the front. The other five groups elected to fly through. As a result, the force split into two sections which lost sight of each other. As the planes swept into the Ploesti area at bombing altitude, lead planes mistook landmarks and made wrong turns. Some of the planes got lost and flew over the nearby city of Bucharest. Instead of an orderly pattern of attack, carefully rehearsed and practiced over the deserts of Libya, "chaos clearly reigned in the skies over Ploesti. Bombers attacked the refineries from all sides, crises-crossing the oilfields in an attempt to find their designated targets, but at low levels, at speeds of 200 mph and distracted by flak, navigation was extremely difficult. Some refineries were not bombed at all; others were bombed twice. Most of the bombers ranged over the general Ploesti target area and unloaded on anything that looked good."[31]

Turning the chaos into tragic disaster for the B-24s and their crews were Ploesti's powerful antiaircraft defenses. As the planes crossed into Ploesti airspace, they were met by heavy and unexpected barrages of accurate antiaircraft fire. U.S. intelligence had grossly underestimated the defenses as consisting mainly of about 100 Romanian-manned guns. Instead there were nearly 250 heavy guns—deadly German 88s and 105s—and hundreds of 20 mm and 37 mm automatic weapons, nearly all of which were handled by well-trained Luftwaffe gunners. The immediate area was also festooned with barrage balloons, or blocking balloons as the Luftwaffe referred to them, whose tether cables with attached contact explosives could—and did—rip wings off the ground-hugging B-24s.

The defenders had other surprises in store for the attackers. Antiaircraft guns were mounted in flaktowers, concrete structures up to 12 stories high, to provide antiaircraft emplacements with clear fields of fire. The towers had an upper gun platform on the roof for the heavy guns and a gallery around the outside for light automatic weapons. Their sturdy construction isolated them from the effects of anything but a direct hit. Other antiaircraft guns were well camouflaged, some in special, well-armored flak trains. For some of the planes following railway lines to their targets, their crews were astonished to see the sides of box cars on the same tracks drop and expose antiaircraft guns. Further, U.S. intelligence had understood, again erroneously, that the antiaircraft defenses were oriented east, to protect against likely Soviet air attacks. In fact, the defenders anticipated correctly that attacks were just as likely to come from Africa and so located their defenses north, west, and south as well.

Once the surviving bombers were out of range of the antiaircraft batteries and had climbed to altitude, the defending fighters closed in on them

with a vengeance. As the Tidal Wave survivors flew out of range of the inner fighter ring, they were hit with attacks from Bulgarian and Luftwaffe fighters which harried the dwindling number of B-24s all the way to the Albanian coast and into the Mediterranean.

The cost to the attackers was appalling. According to official figures at the time, 57 B-24s were lost—a stunning 34 percent loss rate—and many more were heavily damaged and written off. Over 300 aircrew had been killed and about 150 became POWs in Romania and Bulgaria. Eight planes managed to land in neutral Turkey and their crews interned (the Turks later diplomatically allowed the 79 U.S. internees to "escape").[32]

The 9th Air Force had been dealt a shocking blow from which it would never fully recover. Not so the Ploesti oilfields. Post-raid aerial reconnaissance indicated that while some of the refineries' infrastructure appeared badly damaged, others were hardly touched. A final report based on local intelligence sources concluded that while overall capacity had been temporarily reduced, little permanent damage had been done. The Luftwaffe general who had meticulously prepared Ploesti's active defenses against air attack had also developed a benign strategy for a worst-case scenario, linking individual refineries with a pipeline that would speed damage-control. Smashed facilities could be bypassed and production increased in undamaged refineries. As a result, although most of the above-ground oil storage tanks at Ploesti had been destroyed during the raid, production was back to almost normal levels within several days.

* * *

While imports of crude oil were important to Germany's war effort, the output of its giant domestic synthetic-oil industry was even more critical. This industry, the world's most advanced, produced not only fuel from coal but the raw materials for explosives manufacture. With production concentrated at large, easy-to-identify facilities, 8th Air Force planners by mid 1944 turned their focus on what became referred to as "the oil target." Among the targets struck repeatedly were the giant Ammoniakwerke Meresburg GmbH facility at Leuna, two miles long by more than a half-mile wide, covering an area of over 750 acres, and refineries at Ludwigshafen-Opau and Zeitz. The USSBS studied the results of dropping 146,000 HE bombs on these three principal oil refineries during 57 raids, concluding that "only one bomb in 29 hit the targets and did any damage. For the entire oil offensive, the Army Air Forces dropped 123,586 tons of bombs to get 19,029 tons inside the fences of the synthetic fuel plants, only 4,326 tons of which hit anything significant."[33]

Despite this abysmal record, the 8th Air Force's concentrated bombing of Germany's oil plants nevertheless seriously impacted domestic oil production, which plummeted from an average of some 660,000 tons per month at

the beginning of 1944, to 420,000 tons in June, 260,000 tons in December, and a low of 80,000 tons in March 1945. Supplies of aviation gasoline were reduced even more dramatically. Nearly all aviation fuel was made by the hydrogenation process in synthetic oil plants, and those were the most heavily bombed. Overall, the 8th flew 555 separate missions against 135 different oil targets—hitting every synthetic fuel facility and major refinery known to be in operation inside Germany.[34]

Albert Speer wrote in his memoirs that he would never forget May 12, 1944. "On that date the technological war was decided. Until then we had managed to produce approximately as many weapons as the armed forces needed, in spite of their considerable losses. But with the attack of nine hundred and thirty-five daylight bombers of the American Eighth Air Force upon several fuel plants in central and eastern Germany, a new era in the war began. It meant the end of German armaments production.... The chemical plants had proved to be extremely sensitive to bombing.... After this attack our daily output of 5,850 metric tons dropped to 4,820 ... together with our reserve of 574,000 metric tons of aircraft fuel, that could see us through [no] more than 19 months."[35]

* * *

In the beginning of 1944, a new high command was established for the conduct of strategic air operations over Europe: H.Q. U.S. Strategic Air Forces (USSTAF), commanded by General Carl E. Spaatz. Arnold also appointed new commanders to the individual Air Forces. Lt. General James H. Doolittle took over the 8th in England from General Eaker, while the newly formed 15th in Italy came under the command of Major General Nathan F. Twining. In his New Year's message to his commanders, Arnold unambiguously laid out the strategic objective for the coming year: top priority was the destruction of the Luftwaffe—in the air, on the ground, and in the factories.

Over 1,000 B-17s and B-24s were ready for such missions. For the first time, too, they would be escorted all the way to and from their targets by the long-range P-51B fighters. The only remaining requirement was a week of good-visibility weather and Operation Argument would be launched—the systematic destruction of every factory that manufactured fighter aircraft for the Luftwaffe. Weather forecasters predicted good weather in late February and Big Week was set into motion. When Big Week was officially declared over, air intelligence, based on reconnaissance photographs showing bomb-pocked factories, "figured Big Week had reduced German plane production to about 650 planes a month." This was a wildly optimistic judgment. In the spring of 1944 output was about 1,500 a month, and Luftwaffe acceptances of single-engine fighters were higher in March than they had been in January. And in the second half of the year, fighter plane production rose even higher. "Big

Week notwithstanding, deliveries in 1944 were the highest of any year of the war, reaching a total of 25,285 fighters." These numbers compared to fewer than 10,000 fighter planes built in 1943. Big Week had been extremely costly to the 8th Air Force: more than 300 planes, mostly bombers, had been lost or written off and more than 2,500 airmen killed, wounded, or become POWs.[36]

What ultimately helped to doom the Luftwaffe was not its supply of fighter aircraft that U.S. intelligence wrongly assumed to be the critical factor in the equation, but the steady attrition of experienced German aircrew. Adolf Galland, *General der Jagdflieger,* reported that between January and April 1944, Luftwaffe daytime fighter-plane pilot losses exceeded 1,000. "They included our best squadron, *Gruppe* and *Geschwader* commanders. Each incursion of the enemy is costing us some fifty aircrew . The time has come when our weapon is in sight of collapse…. With the Mustangs, especially, outclassing their opponents in speed and maneuverability, even experienced German fighter pilots had to take a risk if they hoped to prevail. All too many veterans were shot down and their replacements were of indifferent quality. With no priority claims on personnel, Luftwaffe fighter command had to take what it got; and with time pressing, adequate training had to go by the board."[37] One year earlier, the number of new fighter pilots had been doubled, but only at the expense of training hours. "From the spring of 1944 the German pilot force was composed of two disparate elements: a slowly declining core of extremely skilled veterans … and a mass of poorly trained new men, who rarely survived for long."[38]

* * *

While the bombing of German cities was never assigned top priority by any USAAF directive, this largest of all target groups was elevated to a No. 2 priority status by the end of 1944. In January 1945 in Malta, the Combined Chiefs of Staff issued a directive that purposely obfuscated the issue of indiscriminate bombing. It stated that when weather did not permit bombing operations against Germany's synthetic oil plants, at the time the top priority target, attacks were to be launched against "Berlin, Leipzig, Dresden and associated cities where heavy attacks will cause great confusion in civilian evacuation from the east and hamper reinforcements."[39] In support of this directive, Spaatz ordered a major strike on Berlin. The aiming point this time would be the city center with its high population density—not the industries of Berlin or the marshalling yards of Berlin, the previous aiming points. Doolittle was opposed to such an attack. He viewed it as terrorism, "without any justification on military grounds." The morality of such bombing, in which large numbers of civilians were certain to be killed and mutilated, had long been debated by high-level AAF commanders. "It was conducted *sotto voce,* like a family dispute you wouldn't want the neighbors to know about."[40]

Morality lost out to the exigencies of war and on February 3, about 1,000

B-17s and B-24s raided Berlin, killing some 3,000 residents and making about 120,000 homeless. There was no concealing the terror nature of the attack because the newspapers of neutral countries, Sweden in particular, had correspondents there. In fact, the raid on Germany's capital city in the path of the advancing Red Army, like the attack on Dresden a week and a half later, was also a political statement: the Russians should understand that despite U.S. Army setbacks in the recent Wehrmacht offensive in the Ardennes, America remained a military powerhouse whose bomber forces could project its strength almost at will. Churchill had also intended "to write the same lesson on the night sky on behalf of Britain with the help of Bomber Command," but bad weather had forced cancellation of that mission.

Later that month Operation Clarion was launched which called for two consecutive days of maximum-effort Anglo-American attacks by heavy and medium bombers and fighters against transportation targets in small towns all across Germany—thousands of planes day and night almost nonstop. The planes would roam all over Germany in low-level attacks, bombing and strafing "anything that moved." The intent was to bring the air war to the populations of Germany not previously bombed—terror bombings in everything but the name. Eaker wrote a letter to his commander, Spaatz, in January, arguing against such indiscriminate city bombing: "We should never allow the history of this war to convict us of throwing the strategic bomber at the man in the street," echoing Baldwin's earlier admonition (see pages 29 and 60, above).[41] Despite Eaker's plea, American bombers *were* thrown "at the man in the street." The raids were massive, with all of the available Anglo-American air forces participating. B-17s and B-24s flew nearly 2,000 sorties in small formations and tactical bombers and fighters contributed 1,100 sorties, bombing and strafing even small towns. Few bombers were shot down by the Luftwaffe, a strong indication that attrition was catching up.

The start of the massive Soviet offensive in January 1945 triggered Clarion. Spaatz wired his commanders beforehand that press communications must stress the military and industrial nature of Clarion's targets. That was, of course, a tough sell. Small Renaissance-vintage towns from the old Holy Roman Empire such as Heidelberg, Göttingen, and Baden-Baden could scarcely have targets of significant economic value "Special care should be taken," he stressed, "against giving any impression that this operation is aimed, repeat aimed, at civilian populations or intended to terrorize them."[42]

* * *

By the end of 1944, Air Force directives and memoranda were formalizing—for the first time and for the record—indiscriminate U.S. area bombing that previously had been officially covered up. The following snippet from the USAAF official history of that period summarizes such type bombing as well as rationalizes its employment:

Approximately 80 percent of all Eighth Air Force and 70 percent of all Fifteenth Air Force missions during the last quarter of 1944 were characterized by some employment of blind-bombing radar devices. Without these aids important targets would have enjoyed weeks or months of respite and on several occasions major task forces failed even with radar to reach their objectives because of adverse weather.... In mid–November, 1944, operations analysts of the Eighth estimated that nearly half the blind missions were near failures or worse.[43]

The following memorandum defining operating procedures for attacks on secondary targets, however imprecisely written and contradictory, is an example of the exceedingly loose standards aircrews were to apply during their bombing operations. In effect, bombardiers were given *carte blanche* to dump their bombs on any town or city that gave "an identifiable return" on their radar scopes.

1. No towns or cities in Germany will be attacked as secondary or last-resort targets, targets of opportunity, or otherwise, unless such towns contain or have immediately adjacent to them one or more military objectives ... railway lines; junctions; marshalling yards; railway or road bridges, or other communication networks; any industrial plant; such obvious military objectives as oil storage tanks, military camps and barracks, troop concentrations, motor transport parks, ordnance or supply depots, ammunition depots, airfields, etc.
2. Combat crews will be briefed before each mission to insure that no targets other than military objectives in Germany are attacked.
3. It has been determined that towns and cities large enough to produce an identifiable return on the H2X scope generally contain a large proportion of the military objectives listed above. These centers, therefore, may be attacked as secondary or last-resort targets by through-the-overcast bombing techniques.[44]

Practically every city in Germany with a population of 50,000 and over was estimated at the time to meet these exceedingly liberal criteria. It had become open season in any weather for the indiscriminate bombing of German cities by American bombers—finally formalized by USAAF edict.

* * *

By the middle of 1943, as the air offensive against Germany was building up, plans were being completed for an equally massive strategic bombing campaign against the Japanese home islands with the new B-29 Superfortresses. Circle segments scaled to the maximum combat range of the B-29, about 1,500 miles, overlaid on maps of the Pacific with Japan in the

center, graphically illustrated the gigantic scope of the air war in the Pacific. Falling just inside the circles were three small Japanese-held islands in the Marianas—Saipan, Guam, and Tinian—about 1,000 miles east of the Philippines.[45] These small islands would serve as the bases for the B-29s. Until they were captured in the summer of 1944, interim bases would be used. Top Air Force generals preferred that these temporary bases be located in Australia for logistics reasons but they were overruled by their commander in chief who had a political agenda. Japan would be bombed first from bases in India and China.

Roosevelt throughout his presidency was a steadfast partisan of Generalissimo Chiang Kai-Shek's corrupt and inept dictatorship and was understandably anxious to keep Nationalist China in its war with Japan. He was an "old China hand" by every definition of the term. FDR, after all, was a Delano and his maternal grandparents had made their millions in the China trade in the mid–19th century. Furthermore, he had been seduced, figuratively, by the enormously wealthy Soong clan, one of whom was Chiang's Christian wife. The Soongs and their public-relations agents roamed Washington, button-holing influential congressmen and lobbying their agenda: to maintain Chiang's tenuous hold on China and the Chinese people in the face of a growing and increasingly popular Communist insurgency under Mao Zedung. Roosevelt believed naively that air bases in China with B-29s taking off for Japan would somehow buoy the declining morale of the Chinese people. Far more important, of course, would be the enormous volume of American dollars that would be pumped into the Chinese economy—and into the coffers of Chiang's mendacious henchmen—in the construction of the bases, estimated at the time at nearly $4.5 billion.

A new Air Force Bomber Command was created, the XXI, and a code name was assigned, Operation Matterhorn, with an unrealistic goal: the destruction of the Japanese steel industry on Kyushu. The plan was a deceptively simple one; its execution would be another story. The B-29s would be staged out of supply bases near the eastern Indian seaport of Calcutta, to be constructed by the British, using advance bases in China to refuel and load bombs. The city of Chengtu was selected as the site for the new bases; it was about 1,100 miles from Calcutta, over the 21,000 foot-high peaks of the Himalayas—the infamous Hump. Chengtu was far enough inland from Japanese air bases along the coast to be immune from air attack, about 400 miles from Kunming, the terminus at the end of the Burma Road, but within B-29 range of targets on Kyushu, the southernmost of the main Japanese islands. The construction of the four new bases in Chengtu demanded some 400,000 Chinese crushing rocks with hammers, moving dirt in baskets hung from yokes, and laying paving stones by hand, one by one. The magnitude of the logistics operation was intimidating, reflected in long-range plans—never implemented—to convert about 2,000 B-24s into fuel tankers and transports

to supply the forward Chinese bases. Estimates were that it took about ten gallons of fuel to ferry one gallon from Calcutta to Chengtu for the gas-guzzling B-29s, and they each used about 8,000 gallons on a 3,000-mile mission.

The first B-29 landed in Kharagpur, India, headquarters for the 20th Air Force, on April 24, 1944, and the first mission over Japan was on June 15, when 68 B-29s attacked the giant Imperial Iron and Steel Works at Yawata on Kyushu, doing negligible damage. By January 1945, when the B-29s were withdrawn from India and China and flown to their new bases in the Marianas, only ten bombing missions had been flown over Japan from Chengtu.

Historians Craven and Cate acknowledge that "the direct results obtained ... did little to hasten the Japanese surrender or to justify the lavish expenditures poured out in their behalf, and that "the record of the Chinese armies during the Matterhorn period was not a distinguished one, but at least the Nationalist government did not withdraw from the war as had freely been predicted in the spring of 1944."[46] The USSBS report on the China-Burma-India (CBI) theater opined somewhat differently, reflecting its obvious "victory through air power" bias. It concluded that the operations from Chengtu represented a "tremendous shot in the arm for the Chinese people, and that the B-29s should take their share of the credit for stopping the total collapse of Chinese resistance."

* * *

Fundamental to U.S. war planning for an eventual war in the Pacific had been the understanding of the extreme vulnerability of Japanese cities to destruction by fire. During the 1920s and 1930s there had been frank disclosures of how American bombers might exploit the tinderbox cities in Japan if war came. Mitchell had lectured flamboyantly and often on the subject. He prophesied that U.S. bombers would one day lay waste to those cities from bases in the Aleutians and Kurile Islands.

In August 1935 the *New York Times Magazine* published an article titled "Most of All Japan Fears an Air Attack," with a subhead: "She Realizes That Planes Would Work Havoc In Her Crowded Cities, With Their Many Flimsy Buildings."[47] In the same issue was a prominent photograph of a B-17 in flight. The caption called the big bomber "the deadliest fighting machine in the world—the 'Flying Fortress,' a 15-ton four-motored bomber." The article harked back to the great earthquake of 1923 that had caused uncontrolled fires in Tokyo, killing 71,000 and turning much of the capital into "a blackened plain in which one could not even tell where the streets had run." A Japanese naval-affairs writer was quoted: "The United States aircraft carrier *Saratoga* can carry 100 planes, of which 50 will probably be bombers. If 10 percent of these should succeed in reaching Tokyo, they will do as much

damage as the historic earthquake of 1923." The article also pointed out that Soviet airmen believed that Tokyo could be burned to the ground with only three tons of incendiary bombs, delivered by bombers from airfields in Vladivostok.

The first B-29 landed on Saipan on October 12, 1944, new XXI Bomber commander Haywood Hansell at the controls. On November 24, Hansell launched his first mission from the Marianas bases, sending more than 100 B-29s to hit an aircraft plant near Tokyo. The build-up had begun for the systematic destruction of Japanese cities by incendiary bombs, high-explosive bombs, and nuclear bombs.

Soon after the first missions were flown, the tiny Japanese island of Iwo Jima, sitting astride the direct route from Isley Field in Saipan to Tokyo at about the halfway point, began to assume a strategic value out of proportion to its size. In Japanese hands, Iwo had become a bona fide threat. Iwo-based Japanese bombers were destroying B-29s on their hardstands; Iwo-based radars were picking up groups of B-29s en route to Japan and communicating this information ahead; and Iwo-based fighters were interfering with U.S. air-sea rescue teams. In American hands, the Japanese threats would be eliminated and there would be positive gains: it would become a site for navigational aids and weather information and, more importantly, it would serve as an emergency landing field for returning B-29s low on fuel or otherwise in distress. Ultimately, planners looked to Iwo (and to Okinawa) as a forward base from which to launch escort fighters and fighter-bombers in support of the planned invasion of Japan in November 1945, Project Olympia.

Throughout December, about once every five days, about 100 B-29s struck at industrial targets in Japan. The raids typically began with a dawn takeoff, the planes climbing steadily until they reached 30,000 feet as they crossed the Japanese coast. Enemy fighter-plane attacks were relentless and effective, despite the B-29s vaunted defensive firepower. Interceptors based on Iwo Jima hit the bombers on their way in and as they returned in the early afternoon. Over Japan, more than 200 of the best daylight interceptors manned with the most experienced pilots, rose to meet the U.S. bombers. By the end of the year, Hansell's XXI Bomber Command was losing about 6 percent of the planes that left the Marianas, which exceeded the theoretically acceptable maximum of 5 percent. Overall, between the end of November and early March, 22 attacks on Japanese industrial targets had heavily damaged only a single factory. In exchange, 102 B-29s and their 11-man crews had been lost. In December alone, for example, the B-29s had attacked the big Mitsubishi aircraft plant in Nagoya six times, with negligible apparent damage resulting.

Even more than over Europe, adverse weather in the Pacific region was difficult to forecast and coping with its unpredictability often demanded more than the inexperienced aircrews could give. Severe frontal systems dispersed

formations and made navigation so difficult that many aircrews missed the Japanese coast altogether, dropping their bombs into the ocean to lighten their planes for the long flight home. Abort rates reached over 20 percent of sorties. Those aircraft that managed to arrive over the target area, generally found the target shrouded in heavy clouds, with the jet stream's high winds to complicate matters. The bottom line: bombing performance was abysmal.

As 1945 began, the Joint Chiefs in Washington were becoming restless over what they rightly considered the inadequate performance of "Hansell's B-29s" over Japan. While the new plane could carry a heavy bomb load a long way, fast, and at extremely high altitudes, it remained vulnerable to enemy aircraft, particularly to ramming attacks that were becoming more frequent. More ominously, the complicated airplane, particularly its engines, was proving to be a maintenance headache, at a minimum, and a nightmare, at worst. It relied on the same old optical Norden bombsight on the rare days when there was no cloud cover. The newest radar bombing system for bombing through clouds, the AN/ANPQ-13 Eagle with its distinctive wing-like antenna hanging under the fuselage, often malfunctioned and inadequately trained radar operators compounded the problems.

Hansell could not be faulted for the adverse weather, the jet stream, the snails'-pace buildup of forces, the laggard construction of ground facilities, or the daunting logistics. But he had not given Arnold the bombing results over Japan that had been expected and a scapegoat was called for. By the end of 1944 Hansell, the planner, was out—and LeMay, the aggressive, tough-talking doer, was in. LeMay was ordered to Guam from his base in Kharagpur, India to lead XXI Bomber Command.

Curtis E. LeMay, like Arnold who appointed him commander, had always been driven by a powerful will to win. His gruff visage was a result of a mild case of Bell's palsy that had atrophied his face into a half-snarl. He was critical of his staff, his aircrews, his groundcrews, and his planes. But he pursued his goals, like Arnold again, with dedicated single-mindedness. First there was an air war to win for his nation, and he went at it with verve. He would drastically change the air war in the Pacific—for Japan, for America, and, indeed, for the world. The creation of an independent air force would have to wait.[48]

Japanese houses were mostly of wood construction, with straw floor mats and paper screens separating rooms. They would ignite easily and burn fiercely. The new M-69 incendiary bomblet had already been tested on stateside bombing ranges to establish the best aircraft speeds and release altitudes for optimum dispersion of the devices and destruction of the easy-to-kindle Japanese cities. What about the collateral incineration of women and children? The planners would stubbornly deny that the firebomb raids were intended to terrorize civilians. Americans at home were told that the Japanese economy depended heavily on home industries adjacent to the large factories. By

July 1, 1945: Maj. Gen. and 20th Air Force Commander Curtis E. LeMay, ubiquitous pipe in hand, at stopover at John Rogers Airport in Hawaii en route to the Mariana Islands. In the background, his Boeing B-29 Superfortress. (Courtesy National Archives)

destroying these critical tiny suppliers, the mantra went, war production would be severely impacted. An important plus of a city-burning raid was that fires would spread to adjacent areas containing the factories themselves. The logic was irresistible: with firebombs the war would be over much sooner, saving both American and Japanese lives.

Following the devastatingly successful firebomb raid on Tokyo on March 9/10, the low-altitude nighttime raids over Japan continued without letup for five months until the Japanese surrender. The B-29s ranged across the entire Japanese nation, mostly at night but during daytime hours as well, laying waste to Japan's largest cities and saturating industrial targets. Navy carrier-based tactical dive bombers and fighter-bombers joined in the assault, striking accurately at airfields to destroy the Kamikaze planes that were harrying

the Navy's surface fleet and hitting other military facilities in preparation for the invasion that never came. The Navy's contribution was modest: only 4 percent of all the bombs dropped. The day the war ended, Navy planes dive-bombed an airfield near Tokyo.

As far as the flyers and their commanders were concerned, the entire population of Japan had become legitimate targets of the massive night-day bombing campaign. If there was some rationale to this concept, it was that the Japanese government had ordered all its civilians into a Volunteer Defense Corps to defend their country. In one issue of the 5th Air Force's *Weekly Intelligence Review* that summer, a commanding officer commented critically of those back home who called the indiscriminate bombing "wicked and inhumane—therefore un–American. We are making war," he wrote, "and making it in the all-out fashion which saves American lives, shortening the agony which War is and seek to bring about an enduring peace. We intend to seek out and destroy the enemy where he or she is, in the greatest possible numbers, in the shortest possible time. THERE ARE NO CIVILIANS IN JAPAN."[49]

While the 20th Air Force contributed to the naval blockade of the Japanese home islands through its aerial mining program and naval aviation sank a large share of merchant shipping, it was U.S. submarines that accounted for most of the Japanese shipping losses. Over eight million tons of shipping were sunk, effectively cutting off Japanese factories from raw materials. Japanese industrial production had peaked in 1944 and began its precipitous decline months before the B-29s began hitting targets in the home islands. Even without the air attacks, Japanese production in August 1945 would have been 40 to 50 percent below its 1944 peak solely because of the blockade. In the aircraft industry, steel alloys were critically needed, and the shortage drastically curtailed engine production. Aluminum was also scarce, and the Japanese were on the verge of using steel and wood for airframe structures before the war ended. From 1943 on through the remainder of the war, sinkings were double or more the tonnage of new construction. The Japanese merchant marine began to decline as early as June 1942; that year ended with 5.3 million tons of shipping, 1943 with 4.2 million tons, and 1944 with 2.0. By August 1945, shipping amounted to only 1.5 million tons, and the 20th Air Force's B-29s were hitting a Japanese economy already disintegrating and on the verge of collapse, cut off from both food and raw materials. Japan was a sorely besieged nation, ready to surrender unconditionally.[50]

The cost in airplanes and aircrew for the U.S. strategic air offensive against Japan was considerably less than the losses for strategic bombing against Germany: 414 B-29s lost in combat—148 to enemy action, 151 to operational causes, with the remaining 115 lost to unknown causes. Nearly 90 crashed in training accidents and 12 were destroyed on the ground by enemy action. In terms of aircrew, 1,090 were killed, 1,732 were confirmed as missing in action, and 362 were returned from POW, internment, and MIA status.[51]

At the end of the war, General Arnold prepared a report dealing with the air war in the Pacific. It included a map of Japan pinpointing the cities struck by B-29 incendiary bombs. The extent of destruction in each city was listed and each paired with an American city of comparable population. The map highlighted Tokyo (39.9%—New York); Yokohama (57.6%—Cleveland); Nagoya (40%—Los Angeles); Osaka (35.1%—Chicago); and Kobe (55.7%—Baltimore). Sixty-five more Japanese cities were included. Only Kyoto (unbombed because War Secretary Stimson considered it a unique cultural center), Yokosuka, and Kokura (Fat Man's primary target but spared because it was cloud covered at the time *Bock's Car* flew over) did not appear on the map. A total of 178 square miles of the built-up areas of the bombed Japanese cities were destroyed. By comparison, in Germany, which was hit by nearly nine times the tonnage of bombs dropped on Japan, bombing devastated about 79 square miles of urban areas.

6

The Airplanes

In the First World War aerial combat had been considered a beautiful albeit deadly game, one whose intricate rules and elaborate chivalry recalled the Middle Ages. Death in the sky compared with death in the trenches had seemed somehow less horrible; it was enobling, even glorious. World War II destroyed the nobility of air warfare ... attitudes toward air warfare changed because a changed role was demanded of it. Death in the sky became death from the sky.[1]

We were sitting on Saipan one night, looking across the water watching the 313th and 58th take off from Tinian. Five B-29s caught fire, either on the runway or over the water between Tinian and Saipan. There's a story that the very last plane off Saipan, long after the war had ended, just got into the air and the number four engine burst into flames.[2]

The United States went to war in December 1941 with the most advanced and thoroughly tested heavy bomber of any of the belligerents, the four-engine Boeing B-17 Flying Fortress.[3] It had been well-publicized by the Army Air Corps in the years immediately before the war, and once America was into the conflict, the plane quickly became the darling of the media and has since been enshrined in American folklore as one of the chief weapons—if not *the* weapon—that won the war in Europe. It was soon joined by the Consolidated B-24 Liberator, a newer design of about the same size, with marginally improved performance until it was loaded down with needed retrofits. A third four-engine bomber was introduced in mid 1944 for the air war over Japan, the Boeing B-29 Superfortress. It was a more sophisticated airplane with pressurized crew compartments, larger, faster, longer ranged, and with greater bomb capacity; it was made famous as the carrier of the two atomic bombs dropped on Japan in August 1945.

These big airplanes were expensive to build, operate, and maintain. A force of several thousand such bombers required tens of thousands of aircrew and groundcrew to fly them and to keep them flying, as well as endless convoys of aviation-gas tankers. For example, it took 12 officers and 73 enlisted men on the ground to keep each B-29 flying and an average of 7,500 gallons of 100-octane gasoline for its nearly 3,000-mile round trip from bases in the Mariana Islands to Japan.[4]

By D-Day in June 1944, the 8th Air Force had more than 2,000 B-17s and B-24s in service and poised to fly combat missions from their bases in England on short notice, together with two full aircrews for each bomber. Only the wealthiest nation in the world, rich in financial, material, and human resources, could afford such weapons. It has been estimated these big-bomber airfleets accounted for about 10 percent of the total expenditures involved in the U.S. war effort—and the RAF's Bomber Command about 30 percent of Great Britain's.[5]

They were the aircraft that were intended to bring the war to the industrial heartland of the enemy, destroying the manufacturing and transportation networks vital to sustain the war effort and collaterally to strike terror among the civilian population, in turn shortening the war. They were the weapons that would implement the war-winning Douhet-Mitchell air supremacy doctrine that had been embraced by the Army Air Corps during the 1930s in its quietly determined quest ultimately to gain parity with the Army and Navy as an independent military arm.

Another adjective that further defined the kind of bombing campaigns that America would wage was "precision." The B-17s, B-24s, and B-29s were designed as daylight bombers, the better to hit specific targets, in contrast with RAF Bomber Command which area-bombed at night. Key to the planned discriminate destruction of industrial-only targets was America's secret Norden bombsight. The planes were also designed with powerful defensive armament, to enable the planes to fight their way through enemy fighter-plane attacks to the target, and fight their way home, without escort. Both precision bombing and self-defending aspects of the B-17s, B-24s, and B-29s would prove to be chimeras.

B-17 Flying Fortress

In mid 1932, the Martin B-10, a sleek twin-engine bomber that incorporated all of the latest engineering advances, began prototype testing for the U.S. Army Air Corps. The B-10 flew at over 200 miles per hour and had a ceiling of 21,000 feet, outperforming every other bomber in the world—as well as most contemporary fighter planes. As the B-10 entered production two years later, bids were accepted for an even more advanced bomber. Its general specifications were impressive: a top speed of 250 miles per hour at 14,000

feet, an unprecedented service ceiling of 30,000 feet, and a range of 2,200 miles with a bomb load of 2,500 pounds. It would be faster and fly higher than the best pursuit planes of the period.

Boeing Airplane Company's winning entry in the design competition was a four-engine, low-wing monoplane configuration of all-metal construction. Its wing span was 104 feet and its fuselage was 69 feet long, a true behemoth for its time. When the plane was first rolled out in July 1935, a reporter from the local *Seattle Times* was so impressed by the appearance of the plane's machine gun defenses that he christened it "flying fortress" in his news story the next day. Boeing's public-relations office loved the catchy and alliterative moniker and later registered it as a company trademark, Flying Fortress, righteously echoing the defensive posture and the isolationist policies of the U.S. government at that time.

There were those, however, who understood its real mission. It was not to defend America's shores from foreign invaders, as the Army Air Corps proclaimed; it was, in fact, an aggressive, intimidating weapon that would project American military power in the hemisphere in time of peace and become a dominant strategic weapon in time of war. A case could be made that Boeing's eight-jet B-52 Stratofortress that first flew in the 1950s, in the five decades following had precisely the same mission.

One year later Boeing flew the prototype Model 299 2,100 miles nonstop from Seattle to Wright Field in Dayton, Ohio, for flight testing. Pleased with the successful cross-country flight and subsequent flight testing, in 1936 the Army bought 13 planes and designated them as B-17s. Boeing, the builder, and the Army Air Corps, the user, then embarked on a joint public relations program to respond to critics of the costly airplane; its price tag was about $200,000 per early production copy. This shared effort reflected the fledgling American "military-industrial complex" that would grow to monstrous proportions and enormous political influence in the coming years and decades.

Tiny squadrons of the plane, with red-white-and-blue flag motifs emblazoned on the rudders, were flown around the country and on show-the-flag flights to South America. The B-17 was a handsome silver airplane, and drew big crowds to every airport it flew into. The highlight of the orchestrated marketing effort was in May 1938, with the successful "interception" of the Italian passenger liner *Rex* some 700 miles off the east coast by three B-17s to showcase the plane's long range and navigational capabilities of its aircrews. Lt. Curtis E. LeMay, who would soon achieve notoriety as a brigadier general and commander of B-17 air groups over Germany and B-29 air groups over Japan, was flight navigator.

On the surface, the overwater mission had been an impressive achievement. Under pressure, however, the Army later acknowledged that it had been a set-up, that the *Rex* had furnished the flyers her estimated position

the day before. There were even questions as to whether the *Rex* had radioed her exact position as the planes came near. Nevertheless, the mission was touted as proof that big bombers could defend America's coasts, and the Army, in its everlasting competition with the Navy, took advantage of the opportunity to show it could navigate accurately over water and far from land reference points.

The first B-17s to see combat were flown by crews with RAF roundels on the wings and fuselage. In the summer of 1940, when England stood alone against the Axis powers, aircraft of almost every type were high on the shopping list of military equipment sought from the United States. The U.S. Army Air Corps had its own agenda—and was eager to publicize the capabilities of its vaunted new airplane in actual combat. England's military needs thus coincided with the Air Corps' propaganda program. While America was still "neutral," a small group of pilots and technical personnel flew to England in two B-17s to train RAF crews.

These early-model B-17s, however, impressed neither their British aircrews nor their commanders. The planes had no tail gun to defend against fighter attacks from the rear and only one puny, manually slewed .30 caliber gun in the nose. Boeing engineers as late as 1939 were reluctant to add a tail gun turret because of the extensive fuselage and tail redesigns required. The B-17E finally incorporated such a turret and later models had a "chin" turret in the lower nose of the plane with twin .50s plus built-in mounts for single .50s either side of the "chin" in what were appropriately called "cheeks."

But Great Britain was working assiduously to bring America into the war, and it was sensible diplomacy and politically expedient to smile courteously and order a batch for actual combat missions. The RAF's earlier experiences in daytime high-level bombing of military targets with their own obsolescent bombers had been uniformly disastrous. Luftwaffe fighters, aided by effective ground radar systems, routinely intercepted and shot to pieces the British bombers. The only successful daylight bombing operations were high-speed, low-level attacks by the 400-mph De Havilland Mosquito, a twin-engine light bomber. By early 1940—and throughout the rest of the war—RAF heavy-bomber missions were undertaken only under cover of darkness.

The new B-17s were formed into the RAF's 90 Squadron. It was noteworthy that none of these planes was delivered with the super-secret Norden bombsight; the British had to make do with a lesser Sperry model. 90 Squadron's first mission, a three-plane flight in July 1941, to bomb docks in the port of Wilhelmshaven, was a failure. One plane had to dump its bombs short of the target because of mechanical problems; a second had its bombs hang up in the bomb bay over the target; only the third managed to release aimed bombs, but they hit far wide of the target. Throughout the summer,

90 Squadron warily experimented with the new plane over enemy territory, flying at or close to the B-17's ultimate ceiling of 32,000 feet to avoid fighter-plane interception. But at these altitudes and their accompanying well-below-zero temperatures, the British experienced dangerous and recurring problems: engines would quit, windshields would frost over, and bomb release mechanisms and machine guns would malfunction. At lower altitudes, the B-17s were easy targets for the German Bf 109s and Fw 190s, or so the British claimed.

Air Vice Marshal Robert Saundby, second in command of RAF Bomber Command, was a caustic critic and based on 90 Squadron's experiences, nurtured a laundry-list of the B-17's shortcomings, some valid, some plain chauvinistic mutterings. His biggest gripe was that the bomb load was "uneconomical in relation to the crew and technical maintenance required," i.e., the B-17 carried a small bomb load for such a big airplane. Statistically, Saundby was right. Both the B-17 and the RAF's Avro Lancaster had about the same maximum takeoff weight of about 60,000 pounds, leaving some 25,000 pounds for fuel, bombs, defensive guns and ammunition, and armor. The B-17 typically carried 3,500 pounds of bombs to Berlin, with guns and

March 20, 1944: B-17 Flying Fortress from the 452 Bomb Group at 22,000 feet over Frankfurt, Germany, leaves contrails of condensing water vapor. Thick cloud cover obscuring the ground over targets in Europe was commonplace. (Courtesy National Archives)

ammunition weighing about 6500 pounds, and a 10-man crew. The Lancaster carried defensive armament of only about 3,000 pounds, made do with a six-man crew, but could truck 8,500 pounds of bombs to the same target. To Saundby, the Fortress was an extravagance in fuel consumption, material, and men.

Earlier, Bomber Command chief Arthur Harris had told Air Force general Ira Eaker in Washington that the B-17's hand-operated guns—or "uncontrolled wobble-guns" as the Englishman put it—couldn't track fast enough to catch up with fast-maneuvering German fighter planes and that power turrets were necessary. Furthermore, the bomb bay was too small to carry the big bombs needed to destroy large targets such as dams. Harris put his finger on probably the most significant shortcoming of all (and here he was dead right) when he compared the clear, sunny climes of the American far west, where aircrews trained with their Norden bombsight, with cloud-covered Europe. He challenged Eaker with a rhetorical question: "How many days will you be able to see the ground in Europe from 20,000 feet?" He did not wait for an answer. "Damned few!" he continued.[6]

The British were never happy with their B-17s and surviving aircraft were sent to bases in North Africa where they flew unsuccessful missions against enemy shipping in the Mediterranean. Improved models of the B-17 were, however, later flown by RAF Coastal Command, along with the far better suited B-24, for long-range over-the-water reconnaissance and anti-submarine patrols. Once America was into the war, RAF Bomber Command, powerfully supported by Prime Minister Winston Churchill, pushed hard and often for the U.S. to replace its *Fortresses* with the Brits' own Avro Lancaster, and to build the plane in the United States. But national pride, among other factors, precluded such a move, and the giant Boeing Company had influential allies in the Congress to help fend off the RAF.

Most Americans, as might be expected, treated *their* B-17s with far more respect and affection. Throughout the war, and in postwar reminiscences, the B-17 got wonderful media coverage about its toughness and its ability to bring its crew home safely even when seriously damaged. The Air Force's public relations officers saw to it that the nation's newspapers were filled with photographs of the bombers with shredded wings and tails, gaping holes in fuselages, and crumpled turrets—all safely back on their home-base hardstands with their intact crews smiling into the cameras. Of course, what the PR people could not show were the smashed and fire-charred hulks of the many hundreds of B-17s littering the German countryside that never made it back to England.

One authoritative American dissenter was John Kenneth Galbraith, a key contributor to the postwar U.S. Strategic Bombing Survey (USSBS), who wrote that the plane "was much respected by all concerned," but that it "could not, in fact, defend itself, that escort aircraft would be required. It was still

arranged for its great load of men and weaponry … and in consequence, could carry no great weight of bombs; thus it was now a bad design." Galbraith recalled that Air Force general Orville Anderson, who had worked intimately with Galbraith in writing portions of the survey and had been a chief commander in Europe, "met my efforts to make this point with massive indignation. You are insulting a great airplane."[7]

By most yardsticks, however, the B-17 was a successful warplane and was improved month to month throughout the war. The B-17B, the standard model in 1941, had only five .30 caliber machine guns, lacked a belly turret and tail gun, and had scant protective armor for its crew of six. By 1945, the latest models had 12 and even 13 .50-caliber machine guns, power-driven turrets, gunners below and in the tail, some 2,000 pounds of armor plating in vulnerable sections of the fuselage to protect the crew, and bullet-resistant windshields for its two pilots. It was easy to fly and "forgiving." The plane developed a well-earned reputation for its ability to absorb heavy damage and continue to fly, and was often able to limp home on two of its four engines. It became increasingly reliable and trustworthy, perhaps its most endearing qualities to its loyal crews whose very lives depended on those simple attributes. Indeed, not all of America's World War II warplanes proved to be reliable and trustworthy.

B-24 Liberator

The second four-engine bomber to join the 8th Air Force, and to form the backbone of the 15th Air Force initially based in Africa and then in Italy, was the Consolidated B-24, named the Liberator by the British. The B-24 prototype first flew in December 1939, just six months after the contract was signed for production of prototypes. Compared to the more graceful B-17, the B-24 was squat and ungainly looking, crews referring to it as the "Flying Boxcar." A principal feature was its narrow Davis wing, named after its inventor, a laminar-flow design intended to provide low drag at cruising speed and at the same time not compromise high-speed performance. It had a tricycle landing gear for improved ground-handling capability, permitting takeoffs from shorter runways—or safer takeoffs when heavily loaded from regular runways. Its high-wing design provided a long unobstructed bomb bay so it could carry big bombs, and the plane's distinctive twin-tail allowed room for a power rear turret.

The high-wing configuration had a major drawback, however: the B-24 had terrible ditching qualities. When a B-24 came down in the water—and 8th Air Force bombers flew over water going and coming on every mission— the fuselage rather than the wing took all the forces of the impact and was liable to snap in half just behind the wing. The forward section of the

fuselage, weighed down by the heavy engines, would then sink quickly, taking with it crewmen who were unable to get out in time. Few B-24 aircrew survived ditching.

Significantly, the plane was designed to be less costly to build than the B-17 and its main components demanded less labor and fewer specialized skills. This meant that several companies across the country were simultaneously able to manufacture the B-24. All of these factors contributed to the great number built—over 18,000 by war's end, compared to about 13,000 B-17s—more than any other American warplane of any type.

There was one fundamental and serious glitch in the plane's design, traceable directly to the Davis wing. Above 20,000 feet the B-24 demanded continuous and physically demanding hands-on flying because it was prone to high-speed stalls. This problem was magnified during the tight-formation flying that was the keystone of U.S. air tactics over Germany. "You don't

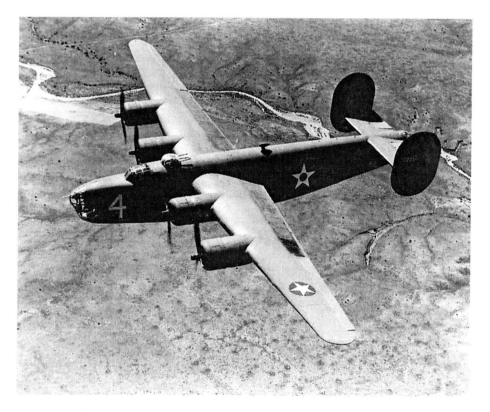

Consolidated B-24D Liberator which shared heavy-bomber missions over Europe with the more well-known Boeing B-17 Flying Fortress. More B-24s were manufactured than any other U.S. warplane during World War II. (Courtesy National Archives)

know what shit hittin' the fan means till you've seen a Liberator flip over on its side in the middle of a forty-plane formation," one pilot recalled.[8] As a result, the inherently less stable B-24s generally flew in looser formations to minimize collisions, in turn reducing the effectiveness of their massed defensive firepower. In mixed-aircraft missions, B-24s were typically flown 3,000 to 5,000 feet below formations of B-17s, exposing the B-24s to greater danger from antiaircraft fire and making them more inviting to enemy fighter aircraft. B-17 aircrews, in fact, were generally happy to fly such mixed missions knowing that the Luftwaffe would go after the B-24s first.

Compared to the B-17, the B-24 was difficult to fly. Charles A. Lindbergh, who was a civilian employee of Chance-Vought Aircraft once America was into the war, flew the latest U.S. fighter and bomber aircraft and advised high-level military and civilian authorities on what he had learned of the in-flight performance of the planes he had tested.[9] His was a well-respected and objective voice within the military, despite President Roosevelt's purposeful and vengeful decision not to grant a commission to Lindbergh as a result of his role as chief spokesman for the anti–FDR and isolationist America First Committee. In April 1942 he test-flew a B-24 for the first time. He wrote later that he had not been impressed with the airplane. He thought it was an awkward design and poorly constructed. More importantly, he recorded that he had found the plane's controls to be the stiffest and heaviest he had ever handled. He concluded: "I would certainly hate to be in a bomber of this type if a few pursuit planes caught up with it."[10]

The B-24 also proved to be not nearly as robust as the B-17 and Arnold was on record as stating that combat squadrons in Europe greatly preferred the B-17. "When we send the 17s out on a mission, most of them return. But when we send the 24s out, a good many of them don't."[11] Undoubtedly the production short-cuts compromised structural integrity, but the plane's narrow-chord Davis wing was not as sturdy as the B-17's more conventional design.

As with the B-17, the B-24's interior design made it extremely difficult for the crew to bail out safely. This reminiscence of a B-24 pilot clearly illustrates the point:

> The B-24 was a bit awkward to board, especially in combat gear. We dressed in heavy high altitude flying clothes, with the bulky wire pants and jackets over the regular uniform plus Mae West and chute harness. We looked like a bunch of Teddy Bears, and it was somewhat of a chore to squat down, bend over, slide under the open bomb bay doors, stand upright, lift a leg onto the catwalk, then crawl up on the flight deck. It was almost as much effort ... to reverse the procedure and haul oneself back out.[12]

Crew comfort and ergonomics were neglected in the plane's design as in the B-17. For example, the bombardier, navigator, and nose-turret gunner in the B-24 were squeezed together in a tiny compartment made even more cramped by their bulky flying clothes. There was scarcely room for their parachutes. Far worse off was the gunner in the ventral ball turret—a retractable Plexiglas sphere that was suspended under the belly of the B-24. He occupied the most uncomfortable and terrifying position on the plane. This gunner, who had to be small to begin with, climbed into the ball from inside the fuselage, pulled the hatch closed, and was then lowered into position. He rode into battle hunched over, looking down at the ground between his legs. If his plane was severely damaged and the crew was ordered to bale out, the gunner could open the hatch and theoretically safely tumble out. But if the hatch itself was also hit, the ball turret gunner was doomed to go down with his plane. Another deadly scenario was damage to the turret's hydraulic retracting mechanism and to the hatch opening into the fuselage, which trapped the gunner. If a belly landing had to be made or the landing gear collapsed on touchdown, the unfortunate gunner would be crushed to death. The B-17's non-retractable ventral ball turret was even more of a death trap in the event of a wheels-up landing.

When it first arrived in England, the B-24 could carry a far heavier bomb load than the B-17—typically up to 4 tons vs. 3 tons. And it could carry this load farther and faster. Once the B-24 saw action over Germany, however, its inadequate armor and armament led to major modifications that added weight and drag, seriously compromising its performance and capabilities. In January 1945, Lt. General James H. Doolittle, then 8th Air Force commander, summed up his critical views of the B-24 in a letter to Lt. General Barney M. Giles, chief of Air Staff. He wrote that by the time the B-24 had been made combat-ready, the overall utility of the plane had been "unacceptably reduced." Doolittle pointed out that the plane's longer nose (to accommodate a needed nose gun turret) reduced the plane's speed, increased fuel consumption, and limited forward visibility for the pilots which "has been the cause of frequent collisions." Doolittle added that the new nose turret "reduced directional stability and the B-24 became [even] harder to fly. Spinning out of the overcast is much more common than with the B-17 and it is not as steady a bombing platform." He concluded that it was his "studied opinion that no minor modifications will make the B-24 a satisfactory airplane for this theater."[13]

The B-24 gained dubious notoriety for the 177-plane raid conducted at "tree-top" altititude, from Libya on August 1, 1943, intended to destroy the Romanian oil refineries at Ploesti that supplied Germany with much of its oil. A fateful combination of inept navigation, poor inter-aircraft communications, and inadequate intelligence—plus plain bad luck—doomed the mission and many of its flyers (pages 69–71 above).

Was the B-24 a lesser airplane than the B-17? Over the skies of Europe, where both bombers had to contend with heavy fighter-plane opposition and intense antiaircraft fire, the B-17 was unquestionably the superior aircraft. It flew higher, carried more bombs, handled far more easily, was more rugged, could fly well enough on three engines, and generally protected its crews better. In the Pacific war theater and over the Atlantic Ocean for long-range reconnaissance and anti-submarine interdiction, where there was little need for heavy armor and defensive armament, the B-24 proved to be the aircraft of choice. Perhaps the best overall assessment of the shortcomings of the B-24 was the AAF's immediate shunting aside of the planes as soon as the war was over. "For training, proficiency, and utility purposes, there was an almost universal rejection of the B-24 in the postwar Air Force in favor of docile B-17s, or B-25s."[14]

B-29 Superfortress

> *Only those who readied this plane and flew it can fully know the harsh pains of its birth and dangerously rapid development ... of explosive decompression at altitude, of engine temperatures soaring above 300C, of props that refused to feather, of remote controlled turrets 'cooking off' and spraying wildly, of multiplied stresses from unprecedented loads.... They meant engine fires, gunners 'cannon-balled' from the cabin when their blisters blew, planes shuddering and mushing off the runway and hugging the ground until they disappeared in the distance in their pitiful attempt to gain speed and engine cooling, ships in formation riddling each other or themselves with .50 caliber bullets ... at that time, the solution of these difficulties was a life and death concern to the pilots and crews who flew these planes with soaring cylinder temperatures, runaway props on takeoff, flaming and disintegrating engines....*[15]

The strategic air war against Japan was based on a huge new airplane, the Boeing B-29 Superfortress, which first flew in September 1942. Its wingspan of 141 feet and length of 90 feet dwarfed both the B-17 and B-24, and its gross weight of nearly 70 tons was double that of the B-17. It was a beautiful, streamlined, and impressive airplane to behold—and the most expensive weapon system in America's wartime arsenal, costing over $3 billion to develop and manufacture, about $1 billion more than the atomic bomb.

The B-29 was the largest and most complex aircraft built in quantity during World War II and employed the largest engines, the most sophisticated radar, and the most advanced fire-control system. It took 27,000 pounds of sheet aluminum, over 1,000 pounds of copper, and 600,000 rivets to build one aircraft. There were about 9½ miles of wiring and 2 miles of tubing in the Superfort. To build one such aircraft was impressive enough, but to build thousands was truly a stupendous feat.[16]

Fittingly, the plane would be assigned to a new command, the 20th Air Force, activated in April 1944. The 20th was unique in two ways. There were 15 other designated U.S. air forces, but numbers 16 through 19 were skipped to give the new organization what was considered a more imposing number, in keeping with the prestige of the advanced bomber. More importantly, it was the only numbered air force commanded from Washington rather than by the theater commander.

Specifications called for a range of 3,250 miles with a bomb load of 5,000 pounds. Powering the plane were four newly engineered Wright Aeronautical R-3350 radial engines,[17] each developing 2,200 horsepower at takeoff, giving it a maximum speed of 375 miles per hour. It was the first U.S. bomber designed to operate efficiently above 30,000 feet and its crew compartments were both pressurized and heated. This created a "shirtsleeve" environment where anoxia and frostbite were no longer threats to aircrew well-being. Pressurization had initially posed a design problem because the plane had four large midsection bomb bay doors that had to be opened and closed. The solution was to pressurize the forward control cabin and the rear gunner's compartment and connect the two with a tube just large enough for an airman to crawl through.

Still fixated on its self-perpetuated myth that the strategic bomber could defend itself against enemy fighter aircraft without escorts to drive away enemy fighter planes, the Air Force had specified the most powerful and most advanced defensive armament that could be installed in an airplane. There were five power-driven gun turrets: two on top of the fuselage, two underneath, and one in the tail. The upper forward turret by itself had the firepower of a PT boat, mounting four .50 caliber machine guns. The tail turret was a hybrid: one 20 mm cannon flanked by a pair of .50 caliber machine guns. This combination cannon/machine gun proved unsatisfactory because of the different velocities and ranges of the projectiles; commanders in the field soon ordered the cannons removed. For aiming and firing, an automated computer gunsight

Wright R-3350 radial engine that powered the B-29. Engine was notoriously unreliable; more B-29s were lost due to "mechanical failure" than to enemy action. (Courtesy National Archives)

compensated for such variables as altitude, air temperature, wind, and the B-29's airspeed. Gone were the primitive but reliable ring-and-bead sights of World War I vintage. Gunners, except the tail gunner, fired from remote sighting stations that were comfortable and warm. Advanced radar systems, for both bombing and navigation, were hurriedly fitted to the planes as they came off the assembly line. B-29 aircrews arriving in the Mariana Islands in 1944 were insufficiently trained in the airplane and its sophisticated equipment. The reason was simple: there was a shortage of B-29s in the United States for training purposes. Most crew training was done in specially fitted B-17s that were inadequate at best.

The plane's two principal attributes, its high-speed/high altitude performance and its theoretically robust defensive firepower, would nevertheless prove to be paradoxes. The B-29s would be used with remarkable success over Japan at altitudes of 5000 to 7000 feet, at night, with most of the planes' .50-caliber machine gun barrels and ammunition removed as useless and heavy appendages and replaced by bombs and fuel.

Because it was rushed into production, allotted far too few hours of test flying, and perhaps most importantly because its advanced structures and systems were fabricated by inexperienced workers from all walks of life who were given as little training for their jobs as possible before being put to work on the assembly lines, the new plane suffered from an endless number of "teething" problems. As might be expected, the plane's sophisticated remote-controlled armament was plagued with mechanical and electrical problems from the get-go and the new radar systems malfunctioned much of the time.

But the most formidable problem encountered by B-29 aircrews and groundcrews alike was the deficiently designed and notoriously unreliable Wright R-3350 engines that were prone to catch fire—warming up on the ground prior to takeoff, in the air at all altitudes, but most often during acceleration on takeoff at full power. In turn, the B-29 throughout its short months of combat would turn out to be an airplane that killed far more aircrew by "mechanical failures," "operational malfunctions," and "causes unknown" than died by enemy action. Most analysts estimate that only about one-third of the B-29s that crashed were lost in combat to Japanese fighter planes and anti-aircraft. Takeoffs of the invariably overloaded B-29s, even on Guam's, Saipan's, and Tinian's 8500-foot paved runways, in 1945 the world's longest, were always hazardous. Full power was demanded of all four engines during this most-critical phase of flight. If one quit, or even faltered momentarily, the plane was likely to crash and burn, killing its entire crew.

Everyone closely involved with the B-29's development, testing, and combat performance could relate his own experiences with the "Wrong" engines, from ground crews to aircrews to the highest-ranking commander himself, General Curtis LeMay. One B-29 group commander, a quarter-century after the war, recalled: "The only thing wrong with the B-29 was that it

had a Wright engine. If it had [had] a Pratt and Whitney engine, it would have been a wonderful airplane, as later the B-50 was."[18] Ominously, the Air Force's top officials had pinpointed the origin of the problem from the earliest test-stand runups by the manufacturer but there was a war to be won and no time to correct the problems in the factory. Fixes would have to be done in the field. The original design had aimed at the elusive goal of an engine yielding one horsepower for each pound of weight. To reduce weight, engineers replaced conventional aluminum-alloy crankcases and accessory housings with lighter magnesium-alloy parts. In service, the brittle magnesium castings tended to crack under severe vibration. Furthermore, magnesium burned at extremely high temperatures, making engine fires in flight nearly impossible to extinguish. During flight testing in February 1943 of the early prototypes, an engine caught fire, rapidly spread to the wing, engulfing the plane in flames and killing Boeing's chief test pilot and his veteran flight-test crew. LeMay, who was a graduate engineer and knew the B-29 and its engines more intimately than perhaps any other high-ranking Air Force officer, candidly gave more details in his retrospective:

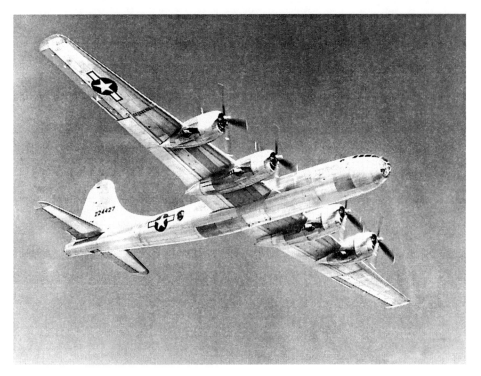

Boeing B-29 Superfortress. Flew 3,100-mile missions from bases in the Mariana Islands to Japan and back. Famous as deliverers of the two atomic bombs. (Courtesy National Archives)

The major technical problem we had with the B-29 when I got to India was with the big Wright Cyclone R-3350 air-cooled engines. A valve would burn, and the head would go off and chew up one of the engine's eighteen cylinders. Sometimes, the cylinder would, in turn, fly off and chew up the whole engine. If we lost some of the hydraulic fluid and couldn't feather the prop, then the prop would fly off. You would be lucky if *just* the prop flew off, because sometimes the whole damned engine seized and twisted right out of the wing.[19]

LeMay also told anyone who would listen that the B-29's engines were not the only source of serious concern. "There were scores of other defects, either readily apparent or—worse—appearing insidiously when an aircraft was actually at work and at altitude. They didn't have a lot of these things fixed in 1944 or even, God help us, by 1945 ... we had the buggiest damn airplane that ever came down the pike."[20]

The B-29s nevertheless flew over-water round trips of about 3000 miles on bombing missions from the Marianas, some two and a half times the average distances flown by the 8th Air Force's B-17s and B-24s over Germany. In 14 months of combat operations, the B-29s dropped nearly 170,000 tons of bombs and 12,000 aerial mines, most in the final six months of the war. The cost was 414 planes, 147 of which were combat losses. Despite its shady reputation among many of those who flew the planes in combat, the B-29 was capable enough to firebomb and raze Japan's major cities and to bring World War II to an end with nuclear bombs.

In late 1943, well before the first atomic bomb was exploded at Alamagordo in July 1945, the AAF was planning for the B-29's role as deliverer of the "special weapons." Under project Silverplate, modifications were begun on 36 special B-29s to accommodate the two different bombs that would ultimately be dropped over Hiroshima (Little Boy—the uranium bomb) and Nagasaki (Fat Man—the plutonium bomb). The plane's twin bomb bays were reconfigured to handle a single bomb of up to five tons, up to 128 inches long, and up to 5 feet in diameter. All armament except the tail guns was taken out and gun turret blisters were removed and covered with flush plates to reduce drag. Newly developed reversible-pitch propellers were installed to reduce landing roll in the event of an abort and a return landing on Tinian or perhaps Iwo Jima or Okinawa, with the bomb still in the bomb bay, a horrifying thought to those few who knew something of the power of nuclear weapons.

If the B-29 never quite caught America's fancy, it nevertheless was temporarily enshrined at the Smithsonian Institution's Air and Space Museum in a superficial and controversial "50th anniversary" exhibit during the 1990s. In a remote corner of the main level squatted the shining aluminum forward fuselage section of the *Enola Gay*, the Hiroshima bomber, painstakingly restored, as only the Smithsonian's experts can do, as it was on the early morning of August 7, 1945. Underneath the bomb bay was a replica of the ten foot

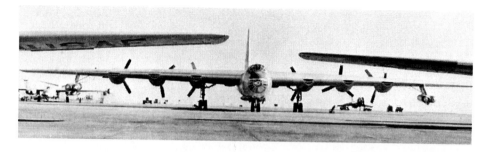

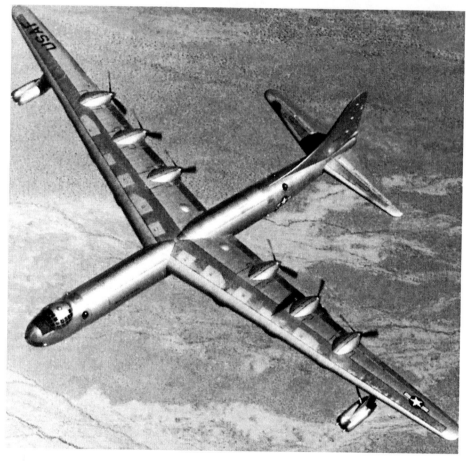

Front and top view of giant Convair B-36 Peacekeeper. Largest aircraft in quantity production for the USAF. Designed in 1941; first flew postwar; never saw combat. Unique hybrid: powered by six reciprocating engines driving "pusher" propellers, and four turbojet engines in twin pods under the wing. (*Top:* Author's Collection, *bottom:* Courtesy National Archives.)

long, two-foot diameter, 9,000 pound blunt-nosed Little Boy in olive drab, an innocuous-looking weapon that changed the world—and has threatened global civilization ever since.

Postwar, the B-29 soldiered on in the AAF and then the USAF as the nation's nuclear bomber. The plane was fitted with more powerful (and more reliable) Pratt & Whitney R-4360 engines and designated as the B-50. During the Korean War its bomb bay was reconfigured to carry conventional bombs and the planes dropped about the same tonnage over Korea as the 20th had done during World War II. At the same time, the giant Convair B-36 Peacekeeper came into service, a six piston-engine, four turbojet-engine hybrid, that was the mainstay of the new Strategic Air Command, but an aircraft that never saw combat.[21] Right on its heels was the first successful American jet bomber, the six-engine swept-wing Boeing B-47 that became the Air Force's principal long-range reconnaissance aircraft during the 1950s and 1960s. In 1952, the eight-jet Boeing B-52 made its maiden flight, replacing the B-47, and was used successfully in the Vietnam and Persian Gulf Wars and over Afghanistan to punish the Taliban. A half-century after it first flew, the remarkably durable B-52 continues as America's pre-eminent heavy bomber.

* * *

The cliches memorized by U.S. fighter pilots during the war: "Beware of the Hun in the sun. Always turn into an attack. Keep your head out of the cockpit. Eye search to the rear nine times to once forward. Wait until you see the whites of his eyes. Fools rush in where angels fear to tread. Altitude gives you the advantage. Know your airplane."[22]

The principal U.S. fighter escort over Germany was the Republic P-47 Thunderbolt, powered by a Pratt & Whitney R-2800 radial engine that generated 2,300 horsepower at takeoff and gave it a top speed of about 425 miles per hour at 30,000 feet. It was an enormous single-seater; fully loaded without external fuel tanks, it weighed 14,500 pounds, twice as much as the Messerschmitt Bf 109 and 50 percent more than the Focke-Wulf 190. Some USAAF Spitfire veterans, when they first saw the plane, mocked it as a "seven-ton milk bottle and that evasive action in a P-47 would mean running around inside its roomy cockpit."[23] With a pair of 108-gallon drop tanks, the D model had an operational radius of 475 miles, including up to 20 minutes at combat power settings. It was armed with eight .50-caliber machine guns.

The commander of the 56th Fighter Group had these general comments concerning the plane's performance: "It accelerated poorly and climbed not much better. But once high cruising speed was attained the P-47 could stand up to the opposition … above 20,000 feet, the P-47 was superior to the German fighters. In the dive, my God, the P-47 could overtake anything. Therefore I

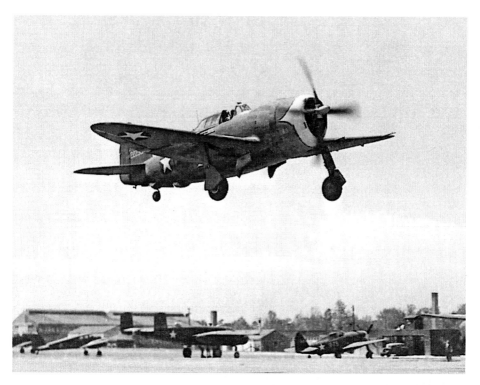

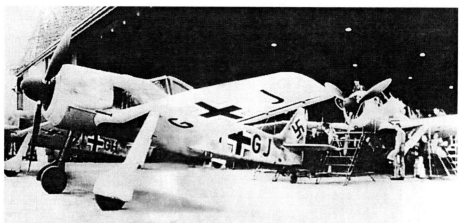

Top: Republic P-47 Thunderbolt. Fondly called "the Jug" by its pilots, the brawny P-47 was the principal U.S. fighter escort over Germany. *Bottom:* Two Luftwaffe Focke-Wulf 190 fighter planes just rolled off the assembly line at Oschersleben in 1944 await flight testing. Acknowledged as the best German piston-engine fighter, it was the equal or the better of the two top Allied fighters, the North American P-51D Mustang and the RAF's Supermarine Spitfire Mk V. (Courtesy National Archives)

made it policy in my group that we used the tactic of 'dive and zoom.' We stayed at high altitude, dived on the enemy, then zoomed back to high altitude before the next attack."[24] The newest models of the plane had water-injection to boost performance at all altitudes and an innovative paddle-wheel propeller to improve low-altitude climb rate.

The distinctive twin-boom, twin-engine Lockheed P-38 Lightning was also used as a long-range escort. It was fast; its two Allison liquid-cooled engines that developed 1425 horsepower each at takeoff gave it a maximum speed of over 400 miles per hour at 25,000 feet. It was also heavily armed, with four .50-caliber machine guns and one 20 mm cannon grouped together in the nose. But the big, heavy plane was an awkward dogfighter and was at a disadvantage in combat against the more maneuverable Luftwaffe single-engine fighters. At high altitudes, the P-38's acceleration was sluggish and its roll rate slow. The plane also suffered from "compressibility" in high-speed dives; Bf 109s and Fw 190s easily dove away from P-38s, their pilots justifiably concerned that their planes would be torn apart in such maneuvers. The cockpits of early models were inadequately heated, some pilots even suffering frostbite on the long missions, and windshields frequently frosted up. It also turned out that the plane's ability to fly home on a single engine was an overrated characteristic; when one engine was hit by gunfire, it caught fire and the pilot had to bail out.

Like the troublesome Wright R-3350 engines that powered the B-29, the Allison V-1710 engines in the P-38 were equally undependable. The Allisons were susceptible to the combination of intense cold and high humidity in the winter skies over Europe and in February 1944, VIII Fighter Command reported that 40 percent of its operational P-38s were plagued with engine trouble. The P-38 proved to be better suited for long-range reconnaissance missions in the Pacific, in a more benign climate and against a generally less capable enemy. Once the P-51 was available in sufficient numbers for operations over Germany, the P-38s were flown to the Pacific theater.

In the Pacific, Lightnings were credited with the destruction of more Japanese aircraft than any other fighter in USAAF service. The P-38's most memorable action was the long-range interception and destruction in April 1943 of the Mitsubishi G4M Betty carrying Admiral Isoruku Yamamoto, commander in chief of the Japanese Navy and one of the principal architects of the attack on Pearl Harbor. American code-breakers had learned that Yamamoto was on an inspection tour of Bougainville and knew his estimated time of arrival over the small island of Shortland where he was scheduled to land. A squadron of P-38s from Guadalcanal would make a 400-mile rendezvous with Yamamoto's group of two Bettys and their close escort of six Mitsubishi Zeros. According to a Japanese newspaper correspondent captured in the Philippines more than two years later, "the Japanese themselves credited American foreknowledge of the admiral's flight as being responsible

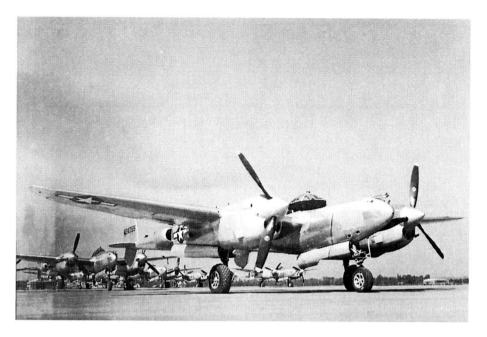

Lockheed P-38 Lightning. Distinctive twin-engine, twin-boom fighter plane was fast,
long-ranged, and heavily armed but lacked maneuverability, hence was an inadequate
escort over Europe. (Courtesy National Archives)

for his death.... When Yamamoto's plane reached Shortland and began cir-
cling the airfield, the Japanese fighter escort departed for Rabaul without
waiting to see the actual landing. Just as Yamamoto's bomber went down [to
land], American planes dived out of the sun and shot the admiral down in
flames."[25]

Unquestionably the best U.S. escort fighter was the North American P-
51B Mustang, which first saw action over Germany in December 1943. Many
military-aircraft historians credit it with being the only true long-range escort
fighter as well as the finest single-seat fighter plane of World War II. It accom-
panied B-17s and B-24s on deep penetrations into Germany, and engaged
Luftwaffe Bf 109s and Fw 190s on an equal and often better footing on the
way into the target, over the target, and on return from the target.

The history of the P-51 was unusual. The plane had been designed
quickly in 1940 by North American Aviation in response to RAF Fighter
Command's specifications for a new fighter. When they were delivered to the
British in the fall of 1941, however, the new planes were a disappointment.
The Mustang's speed dropped off sharply above 15,000 feet, the altitude at
which many of the decisive combats of the Battle of Britain were being fought,
and it was clearly inferior to the best of the Luftwaffe. The RAF reluctantly
converted it into a fighter-bomber for low-altitude missions.

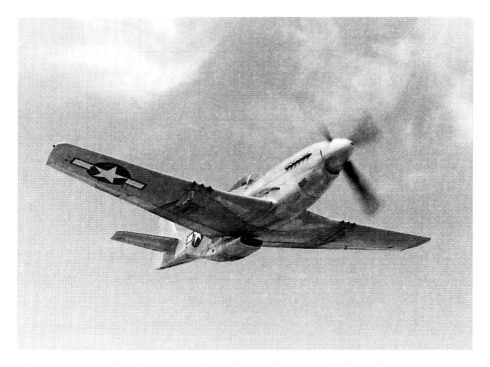

North American P-51D Mustang. Considered to be the best USAAF fighter plane of World War II. (Courtesy National Archives)

Unwilling to give up on an airplane whose aerodynamic qualities were apparent, British engineers in the summer of 1942 fitted a more powerful Rolls-Royce Merlin engine in place of the P-51's original 1,150 horsepower Allison powerplant. The results of the retrofit were spectacular. The re-engined P-51, designated the B model, powered by a Packard-manufactured version of the supercharged Merlin engine providing 1650 horsepower, had remarkable performance over the whole spectrum of combat altitudes, from 375 miles per hour at 5,000 feet, 400 miles per hour at 10,000 feet to a top speed of 455 miles per hour at 30,000 feet, faster than either the Bf 109 or the Fw 190. Its eight wing-mounted .50-caliber machine guns gave the plane plenty of firepower. The three planes had nearly identical rates of climb; in terms of maneuverability, the P-51B had a slight edge on the Fw 190 and generally outperformed the Bf 109. One drawback of the plane's design was its under-fuselage air intake—an air scoop by function—that was notoriously unsuited for ditching. Few pilots swam away from a ditched P-51 or survived a wheels-up landing. Its low-drag airframe allowed the P-51 to cruise fast at low power settings, giving it unexcelled range for a fighter plane; with increased internal tankage and two external 108 gallon drop tanks it had a remarkable combat radius of 650 miles, allowing it to operate over targets as

far east as Berlin, with sufficient fuel reserves to aggressively engage Luftwaffe fighters, or to loiter and strafe. When Reichsmarschall and Luftwaffe commander Hermann Goering first saw P-51s in the skies over Berlin in the spring of 1944 he told American interrogators after the war, colloquially and famously: "I knew the jig was up."

Also used as short-range escorts for U.S. bombers, especially in 1942 and 1943 during the 8th Air Force's buildup, were RAF Supermarine Spitfires, hallowed by the English as conquerors of the Luftwaffe and, in turn, saviors of their Empire in the much-ballyhooed Battle of Britain during the summer of 1940. The Spitfire was an outstanding performer at all combat altitudes. It was fast, highly maneuverable, and well armed—but extremely short-ranged. The RAF never saw the need to adapt it to escort missions into Germany, for their own bombers flew combat "ops" only at night when escort fighters would be superfluous.

An attempt was made to convert B-17s into long-legged escorts—YB-40s—by equipping them with extra armament, armor, and ammunition. A power-operated turret with two .50 caliber machine guns was fitted in the roof behind the radio operator's compartment from where it was controlled. Twin .50 caliber guns replaced the single guns in the two waist positions and a chin turret in the nose carried twin .50s. Additional armor plate protected the gunners and the normal ammunition load was increased by fifty percent. All this extra equipment added materially to the plane's weight which meant the ponderous YB-40s could not keep up with the squadrons they were meant to protect. They first flew in combat in May 1943; four months later—notoriously unsuccessful—they were gone, reconfigured as bombers or converted into gunnery trainers.

7

The Bombs

Overall, between June 13 and September 1, 1944, 5,890 V-1s [Ger-man] landed in England. They killed 5,835 people and seriously wounded 16,762. On average, each V-1 killed one person and seriously wounded about three more. By comparison, during the 10-day "Battle of Ham-burg," in July 1943, RAF Bomber Command and the 8th Air Force killed some 50,000 German civilians, most coming on the night of July 17/18 during a massive firestorm.[1]

A few bombers in each Air Group [8th Air Force] generally were modified to carry loads of boxes filled with propaganda leaflets instead of bombs. These planes were contemptuously referred to as "bullshit bombers." he crews who flew these planes despised such missions because they felt they were risking their lives to deliver innocuous loads on the enemy.[2]

America entered World War II with a stable of aerial bombs not significantly different from the primitive ones used 25 years earlier by the combatants in World War I. Those bombs had generally been tear- or ogive-shaped, borrowing their designs from the artillery shells from which they had been adapted. Fins attached to long conical sections affixed to the rear of the casings provided more-or-less stable flight. Their explosive fillings were principally trinitrotoluene (TNT). Between-wars testing established that simple cylindrical bomb shapes worked as well and were cheaper to manufacture. Conical fins gave way to lighter, more compact box-type fins.

By a wide margin, most of the bombs dropped over Europe by the USAAF were general purpose or GP bombs, also called high explosive or HE types. These bombs, which combined both blast and fragmentation effects, were filled with a mixture of TNT and ammonium nitrate, 50 to 60 percent of the total weight being explosives. Later in the war a more powerful

explosive material was used, Cyclonite or RDX. GPs were sized at 100 pounds, 250 pounds, 500 pounds, 1,000 pounds, and 2,000 pounds. The most popular sizes were the 500 pound M-43 with about 270 pounds of explosives, which created two-foot-deep craters nine feet in diameter in sandy loam, and the half-ton M-44 which opened a crater 45 feet in diameter and 13 feet deep in the same kind of soil. GP bombs used in early missions had 0.025-second delay tail fuzes plus a 1-second "insurance" fuze in the nose. Many of these bombs were later fitted with a shorter delay fuze of 0.01 seconds, to detonate immediately after penetration of building roofs, for enhanced damage.

Fragmentation type bombs had thicker steel casings, often with wire wrappings, to produce more and larger fragments. About 15 percent of the weight of fragmentation bombs was attributable to explosives. These bombs were more commonly used by smaller bomber aircraft such such as North American B-25s and Martin B-26s and fighter-bombers for tactical and anti-personnel missions. However, during the D-Day invasion and for several weeks after, 8th Air Force B-17s and B-24s flew hundreds of sorties in strictly tactical support of advancing Allied troops using these munitions. Preceding the 82nd and 101st Airborne divisions' drops into Holland (Operation Market Garden) on September 17, 1944, for example, thousands of small fragmentation bombs were dropped from B-17s flying at 15,000 feet. Their proximity fuses were set to trigger the bombs about 50 feet above the ground, uniformly plowing up the terrain and hopefully demoralizing exposed enemy troops.

The Army Air Forces had a broad inventory of incendiary bombs. One list includes 35 different configurations, ranging from tiny Mk-I incendiary "darts" consisting of elongated 12-gauge shotgun shells filled with an incendiary mixture, to the 750 pound M-36 incendiary cluster bomb containing 182 individual bomblets. The five most commonly used types were the M-47, M-50, M-69, M-74, and M-76.[3] Typically, incendiary-bomb raids were preceded by the dropping of HE bombs. These bombs served to drive off firefighters, crumple water mains and generally confuse the city's defenders. HE bombs caused blast damage, fragmentation, debris, cratering, and undermining, which enhanced the effect of the incendiaries which followed. It was the incendiaries that set most of the fires.

Incendiary bombs were typically configured as clusters, either aimable or quick-opening types which released the bomblets almost immediately after they left the bomb bay. Aimable clusters held the bomblets together inside a clamshell casing which opened at a predetermined altitude, concentrating the dispersion of the bomblets and somewhat improving their accuracy.

The incendiaries, filled with various mixtures of highly flammable substances, drew the most attention from U.S. war planners. The RAF had successfully kindled the first man-made firestorm in Hamburg in July 1943 using rubber/gasoline-gel filled incendiaries in 250- and 500-pound clusters and the

8th Air Force had been closely tuned into the results. Indeed, the first tentative use of incendiaries by the 8th Air Force in 1943 involved these same British configurations. Within a year, a U.S. designed four-pound magnesium-thermite bomblet, the M-17, packaged in 500-pound clusters, came into use. On ignition, it burned for six to eight minutes at a temperature of 2,300 degrees Fahrenheit. But it was a radically new and innovative American incendiary bomblet under accelerated development, the M-69, that would achieve spectacular success when used over the inflammable cities of Japan in 1945.

Planning for the testing of new-generation U.S. incendiary bombs began in February 1943 and by May the tests were under way at Dugway Proving Ground, Utah. The designs under comparative test included the M-47, a 100 pound bomb filled with a jellylike mixture of rubber, lye, and coconut oil blended with gasoline; the M-50, a 4-pound bomblet with a body of magnesium and a filler of powdered aluminum and iron oxide; and the M-69, a 6.2 pound napalm bomblet of sophisticated design. Napalm was the remarkable material that had been developed by DuPont expressly as a filler for incendiary bombs, as a substitute for commonly used magnesium, the lightweight metal increasingly used in aircraft components. The name was derived from its chemical compound, a mixture of *nap*hthene and *palm*itic acids. This new compound when mixed with gasoline produced a thick, sticky, jelly-like material. Napalm would revolutionize air-dropped incendiary weapons and would be used with equally devastating effect in flamethrowers by U.S. Marines in the Pacific war against Japanese troops. By 1945 an enhanced formula, Napalm B, had been introduced; chemists added polystyrene and benzene to the lethal brew, yielding a longer burning fire at temperatures up to 2,000 degrees Fahrenheit, and even greater stickiness.

The thorough tests at Dugway, which ran for four months, left little to the imagination. B-17s and B-24s flying in combat formations released live bombs from normal bombing altitudes over carefully replicated residential structures in two prototype "enemy villages" built by the Army's Chemical Warfare Service. The Japanese village consisted of 12 two-story row houses and the German town included six assorted-design houses. Cost had been no object and the structures were as authentic as the builders could erect. They were of the same construction and furnished as they typically were in Japan and Germany, including the same woods, same dimensions, even the same paints, interior and exterior. For example, the Japanese residences had smooth plastered walls and sliding paper screens to divide the rooms; included were tatami mats, sitting pillows, low tables, charcoal braziers, even chopsticks on the tables. The Japanese homes were lined up on narrow streets, precisely 8 feet wide, as in Japanese cities.[4]

Records were kept on each bomb hit: where it entered the building, the path it followed through the structure, where the incendiary action took place,

and the fire result achieved. The comparative effectiveness of the bombs was categorized as follows: Class A, a fire that burned out of control after six minutes of attempts by trained fire guards to put it out; Class B, a fire that was ultimately destructive if unattended; and Class C, a fire that went out when unattended, with no destruction resulting. The M-69 proved to be the clear winner, creating far more Class A fires than its competitors. They would be manufactured by the millions and delivered by ship to the Marianas for the B-29 raids in 1945.

In external appearance the M-69 was deceptively innocent looking, disguising its sophisticated destructive capabilities inside a 3-inch-diameter, 20-inch-long plain steel cylinder. There were no stabilizing tail fins to make it look like a bomb; instead it contained a 3-foot-long strip of cloth, like a kite's tail, that popped out when it deployed to prevent tumbling. As the sturdy unit punched its way through the thin roof of a house, a time-delay fuse was activated which, after 3 to 5 seconds, detonated an ejection-ignition charge. By this time, the bomblet would be at rest, on its side or its nose embedded in a floor. The exploding charge ignited a small quantity of white-phosphorous powder which instantly set fire to the napalm and at the same time blew a fiercely burning glob of gasoline gel out of the tail of the casing. The burning gel could be propelled as far out as 100 feet. Whatever the glob hit, it stuck to; if the material was combustible, it immediately started an intense, hard-to-extinguish fire.

M-69 bombs were bound together in clusters of 38 and fitted inside a finned thin-walled container that opened clamshell-like over the target, scattering the bomblets. A primacord charge ran through the container's flange that was time-fuzed to explode and open the cluster at a predetermined altitude, generally about 2000 feet, an altitude that tests had shown yielded optimum dispersion. A simpler, lighter construction was merely to strap the bombs together and attach a tail fin. The primacord cut the straps at fuze ignition, allowing the individual bombs to freely disperse. Such configurations were not as aerodynamically stable as the "containerized" bomblets, but incendiary bombs were large-area weapons and were notoriously inaccurate. Depending on aircraft speed and winds close to the ground, the bombs would be spread out over a keyhole-shaped area about 500 feet wide at its widest by about a half-mile long. A single B-29 on a firebomb raid over Japan typically would carry 40 clusters, or about 1,500 individual M-69s.

* * *

By mid 1943, top Air Force commanders in Europe were reluctantly coming to the realization that what they had been weaned on during the 1930s, the cherished concept of precision bombing, was proving to be unattainable. One obvious answer was to control the bomb during its fall—make a "smart" bomb out of a simple gravity or "iron" bomb. The first USAAF

guided bomb that came to fruition during the war was a radio-controlled tail unit fitted to a standard 1,000 pound GP bomb, code-named Azon (*azimuth only*). This device enabled the bombardier to steer the bomb laterally during its fall to the target. An extended tail-fin configuration carried a flare, a radio receiver, a gyrostabilizer to prevent rolling, and rudders for steering to right or left under the control of the bombardier in the launching aircraft who visually followed the bomb as it fell to the target.

Two factors limited its use, however: clear weather conditions were mandatory—the persistent bugaboo that plagued ordinary bombing—and Azons could not be dropped from above 20,000 feet because the bombs became uncontrollable at high velocities. At "bombs away," the bombardier transferred his attention from his Norden eyepiece to a special window cut in the floor of his compartment. He could then track the fall of the bomb from the bright light of the flare in its tail. A simple right-left toggle switch gave him control of the direction of the bomb's descent to the target through signals that adjusted two movable tail rudders on the bomb. The control allowed up to about 200 feet of deflection on either side of what would have been the normal impact point. Azon proved to be no panacea. The bombardier still had to put his bombs close to the aiming point if he was going to steer it into the target.

Azon missions were flown from May to September 1944 in the European and Mediterranean theaters, with generally unsatisfactory results. Analyses found that while the equipment functioned well enough, antiaircraft defenses made the "medium altitude" approach and long loiter time above the target during the bomb's descent particularly hazardous for aircrews. John Muirhead, a B-17 pilot with the 15th Air Force in Italy, recalls 40 years after the event in his memoir how he was introduced to the new device by his briefing officer.

"We got a special assignment—for which you boys have just volunteered." He smiled. They always smiled when they were going to give you bad news. "We have a new gadget we're going to use tomorrow, a special kind of B-17 called an Azon. That's probably misleading because the plane's not special, just the bombsight and the six bombs, thousand-pound regular-purpose bombs. All you fellows have to know is that we have a device that can control—to a limited degree—the azimuth [side to side] track of a thousand-pound bomb after it leaves the airplane. We can't control the forward rate; that is still a function of your airspeed. The Azon transmitter, responding to the bombardier's adjustment to his sight as he observes the falling bombs, can, by electrical signals, vary the pitch of the bombs' stabilizing fins, causing the missiles to drift to the left or right."[5]

Muirhead wrote that he flew one Azon mission to bomb the Avisio viaduct in northern Italy, a difficult target that was hunkered into the

Dolomite Mountains. After the bomb's release, he recalled seeing plumes of smoke coming up from the gorge below the bridge, but could not determine whether any of the four planes in his squadron had hit the target. He learned the next day from reconnaissance photographs that, in fact, four hits had been made on the viaduct. "Intelligence told us that the Avisio bridge would be out of service for a long time; of course, this didn't prove to be the case. The Germans had it back in operation in two days."[6]

* * *

Just before dawn on June 13, 1944, seven days after the D-Day invasion of Normandy, a mysterious explosion struck a railroad bridge in London. No German bomber had been observed in the vicinity at the time of the blast; instead, an extremely fast and particularly small aircraft had been tracked by radar before the entire "blip" had crashed into the bridge. The Luftwaffe had introduced an aerial weapon of startling import, heralding a major new epoch in warfare. It was the V-1 missile, called the "buzz-bomb" by the British for the unique sound of its pulse-jet engine. The Luftwaffe initially referred to it and the larger V-2 rocket as *Versuchmuster* or experimental type. That designation gave way to *Vergeltungswaffe* or revenge weapon and, indeed, the Germans were retaliating as best they could in response to the earlier indiscriminate city bombings by the RAF and the USAAF.

The V-1 could be likened to a flying torpedo. It was 25 feet long with a stubby 16-foot wingspan; it carried a one-ton warhead and a half-ton load of fuel. Its primitive guidance system was self-contained, not radio controlled, hence it could not be jammed. The V-1 was strictly a terror weapon, of practically no tactical use, capable of hitting city-size targets but not much smaller ones. It used an innovative pulse-jet engine that required no strategic materials, burned the cheapest fuels such as kerosene, and was inexpensive and easy to manufacture. Early models had a range of about 200 miles and flew at low altitude at under 400 miles per hour. The fastest RAF fighters were able to intercept the first V-1s if ground-based radar picked them up early enough as they crossed the coast. The fighters either shot them down or bumped a wingtip to tumble the V-1s gyro stabilizers and cause them to crash short of their target. Later models had ranges up to 250 miles and speeds up to 500 miles per hour, making them invulnerable to interception by piston-engine fighter planes and almost impossible to hit with antiaircraft fire. The principal drawback of the V-1s was their need for long ski-jump rails for launching that were hard to camouflage and hence made easy targets for Allied bombing. Had the war lasted longer, the Germans almost certainly would have strapped small solid-fuel booster rockets on the weapons and accelerated them off mobile truck platforms, doing away with fixed and exposed launching rails.

Three months later came the V-2 (or A4, the Luftwaffe's designation) a 12-ton liquid-propellent rocket of far greater technical sophistication. It

was the first true ballistic missile, driven into the stratosphere and coasting back into the atmosphere at supersonic speed, totally invulnerable to interception (except during the early seconds of its ponderous takeoff). It had a high-explosive warhead of one ton and a surface-to-surface range of about 200 miles. The first V-2 launched against the Allies exploded in a Paris suburb on September 8, and the second fell in London later that day. The specifications for the V-2 had been written in 1936, well ahead of the wartime development of the V-1. Unlike the V-1, the V-2 was launched vertically from a small mobile pad which could be quickly set up, dismantled, and moved to a new location. It burned ethyl-alcohol and liquid oxygen, which were brought to the launch site by special tanker vehicles.

Some military historians have suggested that if Nazi Germany had focused its immense industrial capabilities on production and range/accuracy enhancements of the V-1, to the exclusion of the far more costly and complex V-2, for example, the war might well have ended with a negotiated settlement. By the end of the war in Europe, the Germans had successfully launched over 30,000 V-weapons, some 16,000 V-1s and 14,000 V-2s, against targets in England and targets in France held by advancing Anglo-American forces. Overall, between June 13 and September 1, 1944, 5,890 V-1s had impacted in England, killing 5,835 people and seriously wounding 16,762. By comparison, during the 10-day "Battle of Hamburg" in July 1943, RAF Bomber Command and the U.S. 8th Air Force jointly killed some 50,000 German civilians, most on the night of July 17/18 during a massive fire storm.[7]

A fascinating sidebar to the story of Germany's pioneering development of long-range missiles was the clause in the 1919 Treaty of Versailles that backfired on its vindictive authors. It forbade the Germans from developing military aircraft; their military planners turned instead to missiles powered by jets and rockets. On the other hand, the Allied powers, mainly England, France, and the United States, unhampered by any such restriction, gave little thought after 1918 to the potentialities of unmanned, guided missiles.

General Arnold was understandably intrigued by the German V-1 and in mid 1944 arranged for salvaged parts to be shipped to Wright-Patterson Field in Ohio for study. Within a month, the engineers there had built a "Chinese copy" called JB-2 (Jet Bomb 2). Contingency plans called for launching hundreds of JB-2s at close-in German targets such as the Ruhr if the Germans developed new weapons that would reduce the ability of the 8th Air Force to continue its air bombardment. Despite initial teething problems in successfully flying the missile, the AAF ordered 1,000 units in August and planned for production of 5,000 per month starting in September. The project received an AA-1 production priority, the same as that for the B-29. Accuracy was disappointing to the Air Force's missiles advocates, with an

average impact error of about eight miles at a range of 127 miles using a pre-set guidance system similar to the Luftwaffe system. By the end of the war, accuracy was improved somewhat, to an average error of five miles at 150 miles range. Over 1,000 JB-2s were ultimately built, although none were flown against enemy targets. These V-1 look-alikes are scattered at American air museums throughout the country as examples of early guided-missile technology.

* * *

If retribution for the indiscriminate bombing of German cities by RAF Bomber Command and the 8th and 15th U.S. Air Forces was the catalyst for Germany's V-1s and V-2s, USAAF Project Aphrodite was counter-retribution. Strangely code-named after the ancient Greek goddess of love, Aphrodite was a scheme to fill the fuselages of "war weary" B-17s with high explosives and guide the unmanned planes to their targets by radio signals from a "mother" plane, essentially as primitive guided missiles. USAAF airfields all over East Anglia by the summer of 1944 had plenty of damaged but flyable heavy bombers scattered in remote corners of the fields. An attractive way to clean up the airfields was to load the bombers with explosives and crash them into German targets on one-way missions. The concept was

Republic JB-2 Loon (foreground), copy of the Luftwaffe's V-1 guided missile. (Courtesy New England Air Museum)

Arnold's from the beginning. The first missions were intended to strike military targets in occupied France, particularly the massive concrete bunkers at four locations along the Channel coast (Mimoyecques, Siracourt, Watten, and Wiszernes) that were thought to be secret Luftwaffe rocket launching sites.[8] Arnold's July 1 message to various commanders initiating the project called for expanding the project to the Pacific theaters on a grandiose scale: "While in the Far East such aircraft, operating to maximum range not—repeat—radius, could possibly be guided across vast stretches of water and then be steered by heat or magnetic target seeking devices into cities or ships. Before putting our scientific resources to work on this project, have your imaginative engineers take a reading on the subject and radio me your preliminary views."[9]

A volunteer crew of two, pilot and auto-pilot engineer, would fly the heavily loaded drone off the runway, climb it to altitude and to a straight and level flight path, and then establish radio communications with a "mother" aircraft close by. The crew would then bail out to safety (over England). The "mother," some miles above and well behind but with the drone in clear sight, would then guide it across the Channel and and into its target on the continent. The primacord that snaked through the fuselage would blow up simultaneously along its entire length, setting off all of the explosives aboard the plane. It was a simple concept and no untried technology was required. As with Azon, clear weather en route to and over the target was critical for success, for the remote pilot in the guiding plane had to maintain close visual contact if he was to track and precisely direct his lumbering charge to its target.

While B-17s had often been flown loaded as heavily, the loads—bombs and fuel—in ordinary planes were centered close to the plane's center of gravity, not distributed haphazardly throughout the length of the fuselage. Further, the boxes of explosives filled every available space in the stripped planes and were stacked almost to the top of the fuselage, further contributing to the planes' instability. In short, the loaded Aphrodite B-17s were tricky planes to fly—and parachuting to safety was equally so. The low altitudes at which the two-man crew had to leave the planes, about 2000 feet, was below safe parachuting altitude, especially for untrained parachutists.

By late July 1944, Aphrodite was ready: nine "weary" B-17s were each loaded with ten tons of TNT and one with ten tons of napalm. By this time, the RAF and AAF had lost nearly 3,000 aircrew and some 450 aircraft in the ongoing effort to destroy the menacing concrete bunkers, whatever secrets they held. Over 7,000 tons of bombs had been dropped in the vicinity of the targets without noticeable effect.[10] The first missions were launched on August 4 from Fersfield, the small airfield that became the home base for the one-way flights, when two drones were flown off five minutes apart. The two

"mother" B-17s had taken off earlier and were orbiting at a designated control point at 20,000 feet over the airfield. A third B-17 guided the two pilot-flown drones to a control point where the "mothers" established radio control. The drones were then test-flown by radio control at 2000 feet over a rectangular course while the controls were checked out, still over England.

The first drone's crew parachuted safely and the aircraft was successfully guided across the Channel and close to its target when control was lost and it crashed. Luftwaffe antiaircraft fire was suspected as the cause of the failure. The second drone was less successful; it crashed in England after stalling, killing the pilot. Two more drones were launched the same day, their crews parachuting safely. One flew into low cloud cover over France during its approach to the target and it crashed, missing its target. The fourth impacted short of its target, due to what was termed "controller error." Two more Aphrodite missions were flown two days later. Both experienced control problems over the Channel and crashed into the sea. Their crews had successfully exited their planes and parachuted to safety. Following these failed missions, the British, anxious to keep the project going, agreed to furnish some 500 tons of a new explosive called Torpex copied from the Germans, nearly twice as powerful as TNT and some 50 percent more powerful than the conventional nitrostarch filling in HE bombs.

The U.S. Navy, which had been experimenting with such assault drones since 1937, also got into the act based on its long-term interest in using damaged fighter-bombers flown off carriers as radio-controlled drones on one-way missions into Japanese ships. The Navy's control system was more advanced than the AAF's, with a TV camera in the robot and a monitor in the "mother" for more precise control. To avoid enemy air attacks, the "mother" planes would fly out of sight, some 50 miles behind the drones. "Compared to the modified Azon system [of the AAF] with left, right, and dump controls only, and jumpy pilots jerking wires to arm the aircraft, the Navy was light-years ahead," according to one AAF critic.[11] In July 1944 the Navy put together an elite team to adapt their experimental control system to the PB4Y-1, their designation for the B-24. The Navy's code-name was Anvil and they would fly missions in support of Aphrodite from Fersfield.

The volunteer crew for the first Anvil mission was Lt. Joseph P. Kennedy, Jr., the pilot, thoroughly experienced with the B-24 and with some 50 missions under his belt on anti-submarine patrols over the Bay of Biscay, and Lt. Wilford J. Willy, the radio-control engineer. Kennedy was the eldest son of Joseph P. Kennedy, Sr., the wealthy and powerful businessman-turned-politician who had most recently been U.S. ambassador to the court of St. James's, leaving his post in 1940 to explore a run for the presidency. Joe, Jr.'s younger brother, John, until a few months before a PT boat commander in the Pacific, would become the 35th president of the United States.

"Kennedy's mission" as it came to be called later, instead of being flown

in a war-weary bomber, was in a brand new Liberator, code-named *Zootsuit Black*.* In keeping with the celebrity status of its pilot, *Zootsuit Black* would be center stage that day, August 12, 1944, in an amazing phalanx of supporting aircraft: two twin-engine Lockheed Ventura mother ships, a B-17 radio relay plane, a B-17 navigation ship, two RAF Mosquitoes and two P-38 Lightnings functioning as weather and observation aircraft, four P-51 Mustangs flying close escort, and several light planes to spot the landings of the two parachute jumpers. It was also expected that Generals Doolittle and Partridge would be on the scene, flying in their own P-38s or P-47s, and one or two B-17s filled with high-ranking officers on a junket to observe the action.

As *Zootsuit Black* was heading toward the Channel at 2,000 feet under control of its "mother," and moments before Kennedy and Willy were scheduled to bail out, the plane disappeared in a fiery explosion. A top secret message from Doolittle to Spaatz the same day gave details:

> One Navy Task Force consisting of two mother ships, B-34s, and one robot B-24, was dispatched against the construction target at Mimoyeoques. No attack was made on the target and none of the Task Force left England, as the robot exploded in mid-air a few miles south of Halesworth at 1902 hours.
>
> The robot had made the take off and first leg of the course in good shape. Lead mother ship had taken control about two miles before the first control point; had checked all equipment and controlled the robot on the first left turn. No word was heard from the robot after the control signal was given and there was no indication of anything wrong. The robot was flying at 2000 feet, about one mile ahead of the mother ship, which was flying at the same altitude.
>
> After making the first left turn under control the robot suddenly exploded in mid-air near the river and wooded area, a few miles south of Halesworth at approximately 5220 N-0130 E at 1820 hours. Two distinct explosions were heard and felt by the mother ship crews. The robot was suddenly enveloped in a large circular ball of flame and white smoke and disintegrated in the air. No chutes were seen.... The robot crew of two were known to have been lost in the explosion.[12]

A search of the the widely scattered wreckage revealed "nothing that could suggest a cause; detonation of 24,240 lbs. of high explosive had

*For those of later generations who never saw a zoot suit, it was a long jacket and matching trousers of extreme tailoring, with broadly padded shoulders, extremely wide lapels, blossoming trousers and narrow cuffs, so-called "pegged pants," some so constricting that they had zippers at the cuffs to allow the feet to pass through. A common accessory was a long gold key chain, or variation on the theme, that looped well below the jacket bottom. Zoot suits, typically in garish colors and stripes, were popular during the war years among the ultra fashion-conscious and the somewhat disreputable.

fragmented almost everything but the engine blocks. Subsequent investiga-
tions concluded that the most likely cause was a fault in the electrical system,
switched in before the crew was due to parachute."[13] A second Navy mission
that day destroyed some facilities on Heligoland, the small fortified island off
the coast of Germany, but missed its target. That mission would be the Navy's
last Anvil.

As might be imagined, the death of the son of a prominent American
diplomat caused concern at the highest levels of the USAAF. What had gone
wrong? Who was to blame? A panel of nine officers wrote a report that listed
13 possible causes of the premature explosion, with a defective arming panel
as the likely culprit. Then there was a month-long more detailed investiga-
tion. General Spaatz flew over to the little airbase in his P-47 to ask ques-
tions. A complete dry run of the mission was made. Nothing anyone could
put his finger on as the cause turned up. Veteran electronics officers from the
U.S. also flew in to analyze the circuit designs for the explosives and civilian
specialists from the major electronic suppliers to the Air Force studied the
suspect arming system. The tentative final conclusion: Kennedy and Willy
had been killed by an improperly designed arming panel.

Kennedy's commanding officer recommended that he be awarded the
Congressional Medal of Honor, the nation's highest military award. The
Navy's Board of Medals and Awards, however, did not see it quite that way,
and perhaps had not come under sufficient political pressure to do so, and the
Congressional Medal was disallowed. Instead, Kennedy and Willy would
receive the lesser Navy Cross posthumously. The repercussions of Kennedy's
death reverberated throughout Washington. FDR demanded a full report and
Navy Secretary James Forrestal wrote a condolence letter to Joseph, Sr.
Destroyer No. 850, launched in the fall of 1945, was renamed *Joseph P.
Kennedy, Jr.* after the hero, and his younger brother, Robert F. Kennedy, was
ordered to report to her as a seaman.[14]

But the Air Force program died a slower death. Perhaps the most telling
indicator of Arnold's fundamental belief in indiscriminate bombing destruc-
tion was a staff memo he wrote explaining that he did not care whether the
drones "were actually radio-controlled or just pointed at the enemy and
allowed to run out of gas."[15] In November 1944, a variation on the scheme
was given a new code name: Willie Orphan. Plans called for flying robots close
to the front lines in Germany. When the single pilot bailed out, a ground
controller would take over and guide the explosives-laden plane to its target.
As might be imagined, there was concern at the highest military levels that
such missions might kill friendly troops and Willie Orphan was put aside. By
that time, Luftwaffe fighter attacks had dwindled in numbers and frequency,
and the streams of B-17s and B-24s were razing area targets throughout Ger-
many with few losses.

What finally finished off Aphrodite was the British concern that the

Germans would retaliate in kind. Churchill wrote a letter to President Harry S. Truman, shortly after the latter took office, pointing out eloquently that his countrymen had already suffered much hardship on the home front and that the continued use of war-weary planes against Germany might well backfire. Truman's sensible response was to immediately suspend further Aphrodite flights. The war-wearies never flew again. The weapon had been used 19 times and had scored the same number of misses!

The Luftwaffe, too, had "war weary" bombers they were also looking to use for some worthwhile purpose. Charles A. Lindbergh wrote that in June 1945, when he was touring German aircraft facilities and meeting with important Luftwaffe officers and civilian aircraft executives, he asked about the piggyback Fw 190/Ju 88s (code-named *Mistel*—[Mistletoe]) he had noticed scattered around bombed-out airfields. He recalled saying that "using a bomber for a bomb would be too expensive to be practical." He was told the Germans had many worn-out Junkers 88 twin-engine bombers, "too old for combat," and that the Air Ministry had said some way should be found to use them, otherwise they would be destroyed. Lindbergh learned that the drone could carry up to 4,000 kg (8,800 pounds) of explosives since there was no need for armament, armor plate, crew, or fuel for a return flight. The pilot, flying the Fw 190, controlled the drone electrically and would release it from a shallow glide some two or three miles from the target. It was not radio-controlled but simply continued on its aimed course through its autopilot.[16] As it turned out, Churchill need not have been concerned: there are no records of these Luftwaffe hybrids ever flying in combat.

* * *

The spirit of Aphrodite was kept alive at the insistence of General Arnold. He had long been intrigued with pilotless aircraft whose development had been stimulated during World War I with the invention of the automatic gyroscope stabilizer by Elmer A. Sperry. Arnold had worked with Sperry during testing of the first radio-controlled "aerial torpedoes" in December 1917, using modifed Navy Curtiss N-9 trainers. The planes could carry 300 pounds of bombs and had a range of 50 miles.[17] A more sophisticated unmanned plane was designed by Charles F. Kettering. The "Kettering Bug," as it was called, was a tiny biplane with a wing span of barely 12 feet. The Bug was designed to carry 180 pounds of explosives. Instead of wheels it had skids and was launched from a wheeled carrier than ran along a portable track. It was programmed to fly at a constant altitude, controlled by a simple aneroid barometer. The Bug flew until a simple mechanical counter sensed a predetermined number of engine revolutions, at which point fuel to the engine was cut off and the Bug glided to its target. During tests in the last weeks of the war, the Bug proved unreliable and the secret project was quietly shelved. In 1938 Arnold renewed his interest in the Bug. About 50 were in storage and

a production scheme already existed. It was an inexpensive weapon and it was figured that hundreds could be built for the cost of a single B-17. The problem was still limited range, between 200 and 400 miles, insufficient to support U.S. war planners' offensive schemes envisioned at the time, and the project was permanently shelved.

* * *

If project Aphrodite proved a failure in actual service, there was another American bombing scheme that arguably was hare-brained from the beginning: Project X-Ray. X-Ray would use live bats fitted with miniature napalm incendiary devices strapped to their tiny bodies. The bats would be released over Japanese cities in cannisters that would open at low altitude and the bats would then fly into the dark attics of homes and buildings where the napalm would be ignited. Self-immolation taken to extraordinary new levels!

The bat species selected obviously had to be available in the hundreds of thousands. The only bat that fit this specification was the Mexican free-tailed, widely distributed in the U.S. Southwest. It was estimated that more than 50 million free-tails summered every year in Texas. A chief problem was that this bat weighed only about 10 grams. What payload could such a sub-miniature "bomber" carry? The payload had to include the napalm and a container to hold it, an igniter, a time-delay fuze, a safety device to prevent premature ignition, and a harness to attach the whole shebang to the bat. Fitting the miniscule packages to squirming bats was a manual job that would required hundreds of accommodating personnel. There were other unresolved questions: how do you capture the bats in the quantities required?—and how do you care for them while they await "transportation" to far-off Japan? Early tests established that a free-tail in prime condition and able to fly and "maintain controlled maneuvers" could carry an incendiary bomblet weighing 15 to 18 grams.[18]

The X-Ray test crew went to Dugway Proving Ground where simulated Japanese and German structures had already been erected to test conventional incendiaries. Preposterously, the reports of the tests were positive. One test concluded that the 15-gram payload "is satisfactory as an incendiary" and "that on a weight basis X-Ray is more effective than any of the standard incendiary bombs." The chief of incendiary testing at Dugway added his personal encomium: "A reasonable number of destructive fires can be started in spite of the extremely small size of the units. The main advantage of the units would seem to be their placement [by the bats] within the enemy structures without the knowledge of the householder or fire watchers, thus allowing the fire to establish itself before being discovered."[19]

Sanity was finally applied to X-Ray in mid February 1944 when the chief of Naval Operations cancelled the scheme: "This decision was based on the large number of uncertainties that would have to be evaluated before an

operation was definitely scheduled. These uncertainties involved the behavior of the animal...."[20] Animal rights advocates, had they known about the secret project, would have been relieved.

There was a final wild-eyed variation on the theme: that the bats be released offshore from submarines. But this idea was killed early on because it was considered that the bats did not have the "range" to reach the shore so heavily loaded, they would not have been able to "warm up" on their descent to recover from a lethargic condition, and finally most would not be able to orient themselves and would fall into the sea. There were apparently no studies dealing with how U.S. submarine crews would have reacted to cages filled with smelly bats in their tight quarters.

* * *

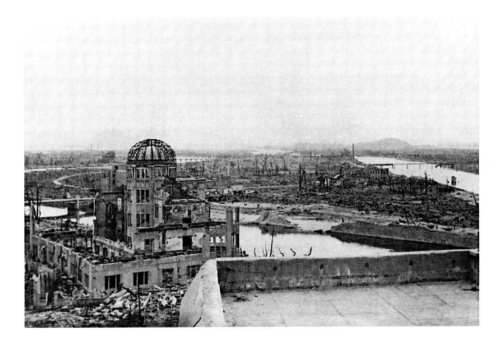

Hiroshima after Little Boy was detonated in an air burst. The skeleton of the city's Agricultural Exposition Hall, directly below "ground zero," remains as a somber memorial to the city's estimated 130,000 casualties. (Courtesy National Archives)

No more forceful arguments for peace and for the international machinery of peace than the sight of the devastation of Hiroshima and Nagasaki have ever been devised. As the developer and exploiter of this ominous weapon, our nation has a responsibility, which no American should shirk, to lead in establishing and implementing the international guarantees and controls which will prevent its future use.[21]

In 1905 physicist Albert Einstein had published his special theory of relativity which postulated the relationship between mass and energy: a tiny amount of matter was equivalent to an enormous amount of energy. This momentous concept remained just that, an abstract theory of litttle practical value except, perhaps, to a few theoretical researchers—until 1938. In that year it was announced that in the Berlin laboratories of chemists Otto Hahn and Fritz Strassmann the uranium atom had been split into two roughly equal parts by bombardment with neutrons. By early 1939, word of the epoch-making accomplishment had spread to nuclear researchers around the world, giving fresh impetus to experimenters probing nuclear reactions that could lead to weapons of almost inconceivable power. The $2 billion U.S. Manhattan Project to build a nuclear bomb came to fruition in July 1945 in Project Trinity in Alamagordo, New Mexico, when the prototype Fat Man plutonium bomb was successfully tested. Less than one month later, Little Boy, a uranium bomb, was dropped on Hiroshima with a yield estimated at 12.5 kilotons equivalent of TNT, followed three days later by Fat Man over Nagasaki, with an estimated yield of 22 kilotons. Both were fission bombs.[22]

Little Boy's design was essentially a giant-bore rifle that fired a uranium 235 "bullet" with three uranium 235 target rings fitted to its muzzle, forming the medium of critical mass required for the explosion. The assembly,

Little Boy, the gun-assembly bomb using uranium 235 was dropped on Hiroshima, August 6, 1945, by *Enola Gay*. It was 28 inches in diameter, 120 inches long, and weighed about 9,000 pounds. (Courtesy National Archives)

Fat Man, the implosion bomb using plutonium 239, was dropped on Nagasaki, August 9, 1945, by *Bock's Car*. It was 60 inches in diameter, 128 inches long, and weighed about 10,000 pounds. Its prototype had been tested in New Mexico. (Courtesy National Archives)

enclosed in a ten-foot-long, two-foot-diameter steel casing with a blunt nose and a conventional box fin to stabilize its flight, weighed about 9,000 pounds. Fat Man was a plutonium bomb using an implosion design to establish critical mass. A jacket of precisely machined explosives would be triggered to drive the outer plutonium elements into the inner "core," achieving instantaneous criticality much like Little Boy's gun. Fat Man resembled a giant football, nearly five feet in diameter at its midsection, with a hefty four-vane box fin welded at the back. It weighed close to 10,000 pounds.

Secretary of War Henry L. Stimson* and Major General Leslie Grove, manager of the Manhattan Project, had appointed an *ad hoc* interim committee to advise the president on issues relating to the atomic bomb. This committee had agreed—by no means unanimously—that the bomb be used

When America had gone to war Stimson was 75. He had been Secretary of War under Taft (1911–1913) and Secretary of State under Hoover (1929–1933). FDR had asked him to serve again as Secretary of War in 1940 and Stimson, although an active Republican, accepted readily. During his confirmation hearings in the Senate, he was asked whether he approved of Roosevelt's politics. He answered immediately—that politics were not his concern; his concern was for the nation's defense.

against an appropriate Japanese "civilian/military" target—as soon as possible and without warning. Sixty-four Manhattan Project scientists, in the meantime, differed and petitioned Roosevelt through Stimson that the new weapon not be used until its power was demonstrated to Japanese officials in a remote location, a desert or an unpopulated island. Stimson then turned to the blue-ribbon scientific panel that served as advisors to the interim committee: Arthur A. Compton, Enrico Fermi, Ernest O. Lawrence, and J. Robert Oppenheimer. They supported the interim committee's recommendation, giving as their reason the infeasibility of such a demonstration; direct military use was the only viable alternative. It was a momentous decision by these four men—and many would say later that it was a disaster for the future of human civilization.

A weapon that would end the war quickly in the Pacific would solve two main problems faced by U.S. military strategists at the start of 1945, when it became clear that Japan was a defeated nation. It would avoid the need to invade the Japanese home islands, with horrendous anticipated loss of life (on both sides), that seemed inevitable when the firebombing of Japanese cities had failed to bring Japanese surrender. There was also the thorny issue of Soviet intervention against Japan. In January the U.S. had welcomed a Soviet promise to declare war against Japan within three months of the surrender of Germany (which took place in May) but Russian Communism was beginning to be perceived in the United States and England as a serious postwar threat to western capitalism. Besides, would not a nuclear bomb serve two purposes? It would almost certainly hasten unconditional surrender from Japan—which it did—and at the same time cow the expansion-minded Soviets—which it did not. Others have postulated that the United States, after spending $2 billion on the bomb's development, could *not have not* dropped it. Had it been necessary, after all? For all of the remaining 20th century and into the 21st, this issue of "opening Pandora's box," and its portent for humankind, has been debated by scientists and laymen alike, in America and elsewhere.

8

The Bombsights

It was learned more gradually that to find a target was not necessarily to hit it. Nothing in World War II air operations was subject to such assault as open agricultural land.[1]

A total of over 85,000 bombs were dropped on the Leuna synthetic oil refinery, by any measure wholly different from the nine bombs prewar planners had estimated it would take to knock out the Sault Ste. Marie locks. Indeed, what was precise about the 7,431,001 bombs dropped on Germany [at an estimated cost of $30 billion]—except perhaps the exact number?[2]

Out of every 100 bombs dropped on oil plants, 87 missed the target completely, 8 landed in open spaces inside the plant causing no damage, 2 landed on the plant, but failed to explode, 1 hit pipelines or other utilities causing repairable damage, and 2 hit buildings and important equipment.[3]

To drop an unguided bomb, or an "iron bomb" in current-day Air Force parlance, from a fast-flying airplane and hit a small target some five miles below, a factory building, a bridge, a rail junction, a power plant, or a petroleum cracking tower—the essence of precision bombing— is a far more difficult and complex problem than is apparent. The number and complexity of variables that must be taken into account are daunting. The aircraft's speed over the ground, its horizontal distance to the aiming point at the instant of release, and its vertical distance above the target or altitude must be determined with small margins of error. The instant-to-instant yawing, pitching, and rolling motions inherent in the flight of an airplane, while they can be minimized by an autopilot, impart their own accelerations to the bomb at the instant of its separation from the airplane

and contribute to errors that are magnified many times during the bomb's fall to the target.

The wind speeds and directions beneath the bomb bay and all the way to the ground also significantly affect the bomb's trajectory; the bombardier over enemy territory has no way of obtaining this vital information. He must guess. Further complicating the problem is that bombs do not fall in a vacuum. A bomb's fall is retarded by air resistance which depends on the air density, a function of its temperature, humidity of the air, atmospheric pressure, and speed of the falling bomb. Finally, there are the ballistics characteristics specific to the bomb itself: size, weight, shape, fin type, even the surface roughness of the casing.

These ballistics data, which comprise what were called the bombing tables used by the bombardier, are obtained by extensive testing over instrumented bombing ranges using bombs without explosive fillings. When these bombing tables do not match the conditions of the mission, extrapolation is required of the bombardier to compensate. For example, on the first B-29 mission from the Marianas to the main Japanese islands on November 24, 1944—target, the Musashino aircraft plant outside Tokyo—the aircrews were baffled by an astonishing phenomenon. Orders called for bombing altitudes from 27,000 to 33,000 feet. As the planes made their turns over world-famous Mount Fuji, the highest mountain in Japan at 12,300 feet some 60 miles from downtown Tokyo—and the bombardiers' always-visible initial point—for the run into their targets, the aircrews experienced an enormous drift in the direction of their turn. It was caused, they quickly concluded, by an extraordinarily powerful wind from the west, giving them a nearly 150 miles per hour tailwind—and groundspeeds close to 450 miles-per-hour. Their bombing tables and bombsight computers were unable to compensate for these unprecedented speeds. That factor coupled with the crews' inexperience resulted in only a few of the planes dropping their bombs in the general target area. Most released their bombs over the docks or overshot Tokyo and dumped them in Tokyo Bay. The mission was a failure.

The flyers had discovered the jet stream, a band of air originating in Siberia, moving at altitudes of 30,000 to 40,000 feet and reaching speeds up to 500 miles per hour over Japan as it swung around the Northern Hemisphere. "With the wind," existing bombing tables were useless because no testing had been conducted at such high speeds; "against the wind" bombing runs made the slow-moving B-29s particularly ripe targets for enemy fighters and anti-aircraft fire. Crosswind approaches to the target were equally unsatisfactory, since there was no reliable way for the bombsight to correct for the enormous drift, up to 45 degrees and even more from the planes' headings. If a slight navigation error brought a squadron downwind of the target, the jet stream often made it impossible for the planes to attack their target.

The need to hit the target was always traded off or balanced against the

defense of the bomber and its crew from fighter aircraft and from ground-based antiaircraft fire—flak. Flying at high altitude reduced the accuracy of flak and made fighter interception more difficult—but at the same time reduced bombing accuracy. Penetration by single bombers somewhat increased accuracy and minimized flak effectiveness; individual aircraft, however, were dangerously vulnerable to fighter attack. Large formations gave most protection against fighters but provided bigger targets for flak—and increased the area of the bomb patterns.

So-called precision bombing—striking an individual factory building, a railroad junction, a dockyard, or a bridge, for example—was a gold standard which some few crews achieved only rarely. Conditions had to be optimum: cloudless skies, minimum meteorological disturbances, little antiaircraft fire to rock the plane, and few enemy fighter attacks to disrupt the final straight-and-level bomb run of about ten minutes. Area bombing, at the other extreme, was the saturation of the general vicinity of the target with hundreds of bombs, with the expectation that some few would impact on the target. As late as 1944, the 8th Air Force's so-called radius factor, or average miss distance, was about two miles.

In 1942 at the start of the heavy-bomber campaign in Europe, General Eaker had predicted, based on his own experiences over instrumented bombing ranges in the United States at altitudes around 10,000 feet, that about 40 percent of bombs dropped by the 8th "might be expected" to fall within a radius of 500 yards from the aiming point—or nearly one-third of a mile. For aircraft bombing at much higher altitudes, 20,000 feet and up, to avoid flak and attacking fighter planes, which became the norm in Europe, such precision "however clear the weather, however weak the opposition, and however skillful and resolute the bomber crews ... was demanding a really fantastic degree of accuracy ... nothing corresponding to Eaker's prediction ever came to pass."[4]

Until September 1943 when special Pathfinder bombers were fitted with air-to-ground radar to find targets for their combat groups and mark them with incendiary bombs, 8th Air Force missions were flown only when there were weather predictions for visual sighting of the targets with the Norden bombsight—and for sufficiently cloudless weather for the safe forming-up of combat groups, navigation to the target area, and safe return to bases in England. All aircraft in a combat box formation would release their bombs when they observed their Pathfinder drop his bombs, often rigged with bright silk streamers to increase visibility. One authoritative summary of 8th Air Force daylight raids concluded: "Gross errors in bombing were a constant concern, with 70% of all mission failures caused by navigation errors. Airborne radars did not have sufficient resolution to find way points consistently, unless there was high land-water contrast and crews were experienced and well briefed."[5]

In fact, the AAF had turned to radar and to the British whose radar-based navigation aids and bomb-aiming instruments were well advanced, only when it finally became obvious that the optical Norden was useless over cloud-covered Europe. RAF Bomber Command flying at night was not interested in precision bombing, however the Yanks chose to define the term. Their cup-of-tea was bombing cities. Thus, radar navigation came first and in 1941 a system called GEE was fitted to RAF bombers. This system enabled the navigator to establish his position by calculating the time it took for radar signals to arrive at his receiver from three different ground stations in England. Luftwaffe electronic countermeasures soon made GEE unusable and the RAF replaced it with Oboe, which got its name from radar pulses that sounded like the deep-voiced instrument when the navigator was tuned to the proper frequency. Deviations from the plane's correct course caused recognizable changes in the pulse frequency. A specific signal apprised the navigator when to release the bombs.

Both these systems, however, were limited in range and target discrimination. For the deep penetrations of eastern Germany planned by the AAF, U.S. bombers would be fitted with a self-contained radar that provided a map-like image of the ground features beneath the aircraft on a display in front of the bombardier. This was adapted from the British H2S system, renamed H2X. This system could sharply delineate coastal targets because the radar signal feedback between water and land was readily distinguishable. In the fall of 1943, sufficient numbers of H2Xs were available and bombardiers trained to mount the first missions using radar bombing. In December, the Air Force announced the success of the new system as an enhancement of America's commitment to the doctrine of precision bombardment. The *New York Times*, in a front-page story by well-respected correspondent Drew Middleton on December 29, "Bomb Accuracy in Clouds Mastered by 8th Air Force," embellished the communiqué. The article acknowledged that the new system, "while not equal to that attained in high-altitude attacks when the target can be seen," was "satisfactory." Middleton gently tweaked RAF Bomber Command's nose, writing that the U.S. Army Air Forces were still devoted to daylight bombing, "as opposed to the night bombing favored by the Royal Air Force."

At the same time, Arnold, always concerned with the AAF's image, was unhappy with the term "blind bombing" which had come into use. He felt that it would create the wrong impression in the United States, and directed that henceforth the term be stricken from Air Force usage. Press censors had already stopped news announcements that even implied American bombing strategy was moving away from precision bombing to area targeting. Soon after, when LeMay, who had flown on the first H2X missions over Germany, arrived in America for a publicity tour, he was cautioned to not even mention that the 8th Air Force was bombing through cloud cover.

In late 1944, one major political factor was driving U.S. military decision making: with U.S. ground forces stalled at the Rhine River, the menacing Red Army was sweeping west all before it. It was rapidly becoming gospel that the Western Allies had better get the war finished quickly before the Soviets overran all of Europe. Chief of Staff General George C. Marshall, in Europe in October, stubbornly insisted in meetings with top Air Force commanders that insufficient bombing pressure had been applied in the right places. It was time to abandon officially the hallowed USAAF doctrine of precision bombing, although in practice area bombing had become the norm. Marshall demanded that German targets—in particular, cities—be hit indiscriminately every day it was possible to fly, not only on the days when visual bombing was possible.

Two other factors smoothed the way. Following the Wehrmacht's surprise Ardennes Offensive in late December, which resulted in over 7,000 American deaths and over 21,000 captured or missing, with enormous losses of equipment, a new sense of pessimism enveloped Anglo-American staffs. Germany might well hold out for all of 1945 and even longer. The Nazis still controlled important sections of Europe and the German population gave no hints of giving in. U.S. flyers were beginning to encounter the Luftwaffe's new and dangerous jet fighters that might put an end to AAF air superiority. There was also concern that Nazi scientists were about to unveil "death rays" that would burn American bombers out of the sky. It was also known that the Germans were hurrying production of new types of high-speed "electric" submarines that could turn the tide in the Atlantic. The Wehrmacht, too, appeared to military planners to be growing stronger, with the addition of new divisions and a so-called "people's force." The Germans were fighting inside their own borders with short supply lines and the combat qualities of their ground forces remained high. Regardless of the severe winter weather, Spaatz intended to pound Germany from the sky, precision bombing or no. He embraced the current thinking that "blind" bombing was better than no bombing!

* * *

At the start of the Great War in 1914, pineapple-size bombs had been dropped by hand over the sides of airplanes flying close to the ground and aimed by guesswork. Soon, larger bombs were carried in racks under the wings of more specialized bombers, but aiming was still "by eye" or with the aid of improvised sighting gadgets. Toward the end of the war, as airplanes became more capable, bombers flew at altitudes up to about 15,000 feet, carried half-ton bombs, and used simple optical bombsights. The German Gotha G.IV, the heavy bomber that terrorized London in 1918, used a bombsight with a vertical telescope over three feet long. As the war ended, the Royal Air Force was preparing its riposte, the four-engine Handley-Page V-1500 that could

carry one-ton bombs to cities in Germany. The bombers then and even the bombs, were far more advanced than the primitive bombsights that were intended to deliver the weapons onto a particular target.

In the immediate postwar years, work went forward in Europe, particularly in England and more discreetly in Germany, which was bound by Versailles Treaty restrictions, to produce more effective bombing instruments to take advantage of fast-paced aircraft developments. The United States Army Air Corps was also looking to the role of the strategic bomber as a war-winning weapon and it, too, sought a modern bombsight.

Enter Carl Lukas Norden. A Dutch citizen by birth, he had graduated from the Federal Polytechnic School in Zurich, Switzerland, in 1904 as a mechanical engineer. At the school, according to his son, he had met Vladimir Ilyich Ulyanov, later Nikolai Lenin; the two were "ruthlessly self-disciplined with outstanding powers of concentration."

Norden had emigrated to the United States after he graduated and in 1910 was hired by Elmer Sperry, the founder of the Sperry Gyroscope Company, to work on projects related to the gryroscopic stabilization of ships. Three years later, he quit in a disagreement with Sperry and established his own office as a consulting engineer in Brooklyn. The two men nurtured unrelenting animosity toward one another for the rest of their lives. In 1915, he founded the Norden Company, and turned his considerable talents and energies to the development of a bombsight and in 1923 delivered his first experimental model to the U.S. Navy. Five years later, after testing of a series of prototypes, he was awarded a contract for 80 Mark XI bombsights for $384,000.

Because the reclusive, pompous Norden was not an easy man to work with, Navy officials suggested that he link up with a business associate who would serve as an efficient go-between. Theodore H. Barth, also a mechanical engineer by training, became Norden's partner. He was also a savvy public-relations practitioner and a wheeler/dealer salesman. It would be Barth who would transform the tiny Norden Company into a major military contractor and at the same time create and perpetuate the myth surrounding the company's chief product, a fable that is alive and well more than a half-century later. If it was not Barth who dreamed up the catchy phrase of dropping bombs "into a pickle barrel" with the Norden bombsight, he indefatigably exploited it everywhere he went and to anybody who would listen. Just before Pearl Harbor, Barth went on record, absurdly: "We do not regard a fifteen foot square ... as being a very difficult target to hit from an altitude of 30,000 feet, provided the new Army M-4 Bombsight [Norden's], together with the Stabilized Bombing Approach Equipment [Norden's] is used." During the war, super-promoter Barth had an executive dining room called the "Pickle Barrel Conference Club" at the company's Brooklyn headquarters, which included a bank of then-illegal slot machines reserved for business guests, all rigged to pay off handsomely.

Norden's early Mark XI, developed in the late 1930's, was an automatic tachometric or speed-sensitive instrument, representative of the most advanced bombsights of the period. It relied on determination of the speed of the airplane over the ground through a tiny electric motor driving the crosshairs of a telescope through which the bombardier viewed the ground. Accuracy depended on the aircraft maintaining an absolutely horizontal attitude during the final run-in to the target. In addition, all course changes had to be made in "flat" turns, increasingly difficult with newer and faster aircraft which continued to skid sideways after the heading had been changed.

Norden's next big step forward was an instrument with a gyroscope-stabilized platform supporting the instrument's 2-power telescope that was designed to eliminate errors resulting from the plane's rolling and pitching motions. Equally important, the newer design contained a rudimentary analog computer to process windspeed, altitude and bomb ballistics data input by the bombardier. The bombardier viewed the target continuously through the telescope during the final bomb run to the target. The telescope was motor driven as in the earlier model, and the bombardier manually operated controls to fix the telescope's cross-hairs on the target. The act of holding the telescope's cross-hairs on the target fed data on the aircraft's movement over the ground into the computer. These computer-generated course-correction signals were, in turn, transmitted to the airplane's autopilot. The autopilot could maintain an airplane's heading and altitude better than a pilot. This meant that it was the bombardier rather than the pilot who flew the aircraft to the bomb release point. The bombs were released automatically at the release angle calculated by the bombsight's computer. The British and Germans had comparable, if not equivalent, designs.

While this more advanced instrument, essentially the bombsight that went to war in 1941 for both the Navy and the Army Air Corps, achieved improved accuracy, it still had two critical limitations. The target had to be acquired from many miles away, requiring a continuous clear view of the target during the approach, which had to be straight and level for ten minutes or more. This mandatory undeviating final approach would become well known by attacking fighter pilots in the air and antiaircraft battery commanders on the ground during combat operations in the years immediately ahead, and would contribute directly to the horrendous losses suffered by U.S. heavy bombers over Europe.

Most significantly, the Norden was an optical device, which depended entirely for its sucessful performance on the bombardier seeing his target through a telescope. When targets were hidden by clouds, haze, or smoke—as they were, routinely, over Europe and Japan—the bombardier could not hit his target. This "no see, no hit" paradigm governed all of U.S. bombing operations during World War II and put the indelible lie to the concept of precision bombing. Radar bombsights which were intended to overcome this inherent deficiency, proved to be even less accurate.

Yet, it was in the national interest that the AAF's loudly proclaimed doctrine of precision bombing not be compromised. American heavy bombers, uniquely, were able to thread needles with their bombs thanks to a wonder weapon, the Norden bombsight. And all Americans would be so conditioned. An important element in the propaganda campaign was the security cloak thrown over the instrument, to help create an aura of mystic omnipotence. Moviegoers in the early months of World War II can remember the Movietone newsreels showing an armed enlisted-man guard walking next to an officer as he left his B-17 or B-24. The officer was identified as the bombardier and he carried a bulky dark cloth bag. Inside the bag, the narrator said, was America's top-secret bombsight, *the Norden,* an instrument like none other in the world. The two were headed for the special bombsight safe on the air base. When the bombsight was not in the airplane, it was in a safe. The Norden was so critical to the nation's security, it was understood, that its secrets must never be allowed to fall into the hands of an enemy. Fixed in the nose of the supposedly invincible Flying Fortress, it was destined to win the war for the United States, Americans were lectured again and again.

Norden bombsight. Vaunted optical instrument that demanded that the bombardier "see" his target, proved to be unable to deliver bombs accurately over typically cloud-covered Europe. World War II radar bombsights that came later were even less precise. (Courtesy National Archives)

The bombardiers themselves during their twelve weeks of training were treated to the same orchestrated hokum of the unique capabilities of the bombsight and therefore the need for unwavering security. Incredibly, the trainees were not even allowed to take notes during classes; everything they were told about the Norden had to be memorized. Additionally, commanders required that bombardiers in their training outfits swear to and then sign, indicating that they had read and understood, what was known as "the bombardier's oath":

Mindful of the secret trust about to be placed in me by my Commander in Chief, the President of the United States, by whose direction

I have been chosen for bombardier training ... and mindful of the fact that I am to become guardian of one of my country's most priceless military assets, the American bombsight ... I do here, in the presence of Almighty God, swear by the Bombardier's Code of Honor to keep inviolate the secrecy of any and all confidential information revealed to me, and further to uphold the honor and integrity of the Army Air Forces, if need be, with my life itself.

Regulations also specified how the bombardier should destroy the bombsight to prevent its capture intact: "Two rounds with a .45 caliber service pistol into the rate end mechanism ... and one round through the telescope." Indeed, three heavy .45 caliber lead bullets would certainly disable the aluminum-housed instrument, but would such a fusilade hide the secrets of its innards? Better yet was a hefty "bombsight killer," consisting of an 18-inch-long steel cylinder, nearly 6 inches in diameter, packed with 15 pounds of a special incendiary mixture. Aimed at the bombsight and ignited by a fuse by a nervous bombardier, the device supposedly acted like a blow torch to quickly turn the instrument—and only the instrument!—into a glob. There are no records of this infernal machine ever being tested in the tight confines of a bombardier's compartment.

All of this hyperbole was contradicted by the downgrading of the instrument's security classification. The Navy, with authority over the bombsight's security, had initially classified it "Secret," lowering its classfication from "Confidential" in 1935, and to the minimum "Restricted" at the end of 1942. Even after the bombsight's reclassification, nevertheless, bombardiers were still required to destroy the instrument to prevent its secrets from falling into enemy hands. Finally, in late 1944, the Norden, its innermost "secrets" by then no "secret" to the enemy, went on public display in the United States.

In fact, as early as 1938, it was later learned, German engineers had gotten all of the technical details of the American invention from a spy who worked at Norden as a final inspector.[6] Germany's aerial strategy, however, differed from America's. It was based upon tactical support of its ground forces with dive bombers; the Luftwaffe never developed a four-engine bomber for high altitude strategic bombing. Furthermore, German electro-optical technology led the world at that time and there was little useful engineering information to be gleaned from the Norden design that could be applied to their far different bombsight requirements

It was also obviously not possible to retain the secrets of the Norden, whatever they were purported to be, once the American bombers that carried them began flying over German-occupied France and Germany, starting in October 1942. As soon as the first B-17 was shot down relatively intact, the bombsight and, indeed, the entire airplane itself became available for study. Even earlier, in February 1942, a Norden-equipped B-24, low on fuel, made an unscheduled landing in Spanish Morocco, with its bombsight very much

intact. General Franco's officials there gave permission to the German consul to inspect the plane thoroughly before it was fueled up and permitted to depart. Presumably, the diplomat had his Leica camera with him and sent along to Berlin by courier his rolls of exposed 35 mm film of the Norden. And by 1943 the Luftwaffe was gingerly flying captured B-17s (and B-24s) in not-too-close formation with attacking 8th Air Force squadrons to eavesdrop on their tactics and communications.

Security hype aside, how reliably and accurately could the Norden put bombs on intended targets? While most of the supporters of precision strategic bombing were as mesmerized by the Norden as super-promoter Barth, not every Air Corps planner was lulled to sleep by the optimistic accuracy data from loose peacetime-standards testing during the 1930s. In the eight-year period, 1930 to 1938, the Air Corps had dropped nearly 250,000 practice bombs over instrumented ranges, nearly all at altitudes of 4,000 to 11,000 feet. Reliable radiosondes—radio-transmitting packages carried aloft by a balloon—had been developed by that time. The instruments were a compact combination of temperature, pressure, and humidity sensors. The movement of the balloon also indicated wind directions and speeds at various altitudes. These data, which were relayed to ground receivers, were incorporated into the bombing tables that were supposed to eliminate most of the variables that contributed to bombing inaccuracy.

However, less than three percent of the practice bombs were released at altitudes above 16,000 feet, the altitudes from which most bombs would be dropped over Germany. By the last year, the best crews were able to achieve accuracies of about 100 feet (radial error) from 7,000 feet altitude and 235 feet from 15,000 feet.[7] These data gave the Air Corps a false sense of achievement, because the bombing tests were, in fact, quite unrealistic as events were shortly to prove. Bombing was conducted over instrumented ranges in the far west desert areas where the weather was cloudless, at clearly defined targets sited in wide-open terrain, at low speeds—and unrealistically low altitudes. Data on wind velocities all the way to the ground were available and input to the bombsight. The targets obviously were defended by neither antiaircraft guns nor fighter aircraft.

In the last half of 1941 as war loomed for the United States, some 50,000 more practice bombs were dropped under more realistic conditions. The new test results were disappointing to those who studied them. One such analyst was Colonel Laurence S. Kuter, who shortly would be one of four Army Air Corps officers selected to develop AWPD-1. He had begun to doubt some earlier calculations he had made on the bombing force that would be required, hypothetically, to destroy the canal locks at Sault Ste. Marie in Michigan. He had figured it would take nine 500-pound bombs on the target to do the trick. Kuter's up-dated analysis called for no fewer than 120 bombers dropping more than 1,000 bombs to get the requisite nine hits. He summarized

his new findings by writing gloomily that "Such a mission is beyond the capability of all our bomb groups today."[8]

It would be 11 months before the first U. S. bombers flew combat missions over Europe. During this period, the AAF appparently benefitted little from the RAF's real-world combat experiences—namely, that aggressive fighter-plane opposition and accurate antiaircraft fire would exact terrible tolls of bomber aircraft and aircrews, and that the combined difficulties of nighttime navigation and inherent bombing inaccuracies made a mockery of precision bombing. American commanders continued to believe that U.S. tactics and aircrew training were superior to the RAF's, that U.S. bombers were better able to defend themselves, and furthermore the Norden bombsight was better than anything the Brits had.[9] Besides, U.S. missions would be flown in daylight, considerably simplifying navigation to the target area, or so the AAF planners thought.

Reflecting these stubbornly unrealistic views was General Ira Eaker, the first commander of the 8th Air Force, who optimistically predicted, as his flyers were preparing for their first missions over occupied France, that about 40 percent of bombs dropped by his flyers "might be expected" to fall within a circle 1000 yards in diameter—or more than one-half mile. For aircraft bombing at altitudes of 12,000 feet and higher, such precision, "however clear the weather, however weak the opposition, and however skillful and resolute the bomber crews ... was demanding a really fantastic degree of accuracy. Nothing corresponding to Eaker's prediction ever came to pass."[10] For example, early in January 1943, 68 8th Air Force bombers attacked submarine pens in St. Nazaire, the heaviest raid mounted to that date. "There was no attempt at precision bombing. The planes flew a close formation and dropped when bombs fell from the plane carrying the lead bombardier. The AAF oxymoronically hailed this as *formation* (author's italics) precision bombing." The 1000-yard circle soon gave way to a tighter 1000-foot circle and an 8th Air Force study in late 1944, based on bombing missions during 1943 and 1944, claimed that its B-17s and B-24s were putting 14 percent of their bombs inside this smaller target area. The factors that caused this imprecision, according to the study, were "poor visibility, fighter attacks, inadequate training, flak, and camouflage." The study's compilers might have added "mechanical errors and sloppy formation flying," factors that were included in another study based on two missions in mid 1943 over occupied France in which the average circular error had been 3,550 feet and 5,000 feet. The official history of the AAF later admitted that those results were "disappointing to all those ... trained in the pickle-barrel school of bombing."

In the Pacific, the Army was anxious to demonstrate the prowess of its high-level B-17s with their Norden bombsights on maneuvering ships at sea, and claimed many successes, nearly all undocumented. When it came to the Battle of Midway, the Army wanted to share the glory with the Navy. Arnold

audaciously claimed 22 hits and 47 near-misses out of a total of 322 bombs dropped on Japanese aircraft carriers and battleships. Postwar Japanese records indicated otherwise: no hits and no damage. Bombs from B17s missed the carriers *Soryu* and *Hiryu* by up to 650 feet.[11] By Midway, the Navy had given up on high-level horizontal bombing with the Norden. Vice Admiral William F. "Bull" Halsey, Commander of the Pacific Fleet's Air Force, recommended in late 1942 that the Nordens be removed from Navy planes because they were "useless."[12]

Early bombing missions by B-29s over Japan also were unsatisfactory by nearly any measure that could be applied. A study, based on the performance of the 20th Air Force in 1944, estimated that bombing accuracy by visual Norden averaged five percent hits within 1,000 feet of the aiming point from 31,000 feet, 12 percent from 24,500 feet, and 30 percent from 20,000 feet. Blind bombing through overcast skies with radar bombsights was even less precise, with less than one percent of bombs dropped from 31,000 feet hitting within 1,000 feet of the aiming point. One analyst estimated an even lower number: one-quarter of one percent. Bombing by radar, it was concluded, "in its present stage of development, can produce but insignificant damage and that radar bombing can best be described as wholly indiscriminate in respect to accuracy."[13]

There were other reasons why the AAF could not hit their targets accurately. The mechanically complex Norden bombsight itself was a sensitive instrument which could be likened to an oversized Swiss watch. It was a mechanical assembly of some 2,000 separate parts, miniature gears, shafts, bearings, and motors, each manufactured individually to extremely tight tolerances and then meticulously assembled. Accumulation of dirt, lack of proper lubrication, and microscopic wear of internal parts seriously degraded accuracy. Regular maintenance was critical, both first-echelon maintenance by bombardiers themselves—external cleaning, lubrication, and simple parts replacement—and higher-echelon maintenance which included fault diagnosis, disassembly and replacement of sophisticated parts, and recalibration by specialized maintenance crews.

The tight tolerances of the parts in the Norden also made it difficult to manufacture in the quantitites needed in wartime and on schedule. In 1944, for example, almost 80 percent of the Nordens delivered did not meet specifications. The average error of those bombsights was about six times greater than called for in the specifications. But the Air Force had no choice but to take delivery of all of Norden's production. "By August 1944 the Army Air Forces had acquired over 40,000 bombers and trainers using these inferior Norden bombsights. It was too late to make changes."[14]

Another factor that contributed to bombing inaccuracy was the necessity of bombing from tight defensive formations. One top commander described it this way: "Experience showed that pattern bombing by formations

against a precision target 1,000 feet square was roughly one-third as efficient as bombing by individual bomb runs. Formation bombing was necessitated by the intensity of German fighter attacks during the crucial bomb run, and it naturally had an adverse effect on bombing accuracy."[15] Tight formations also meant many planes over the target at nearly the same time, with trailing aircraft and late arrivals often finding the target obscured by smoke and the debris of exploding bombs. A corrollary to the issue of tight formation flying during the final bomb run was the significant collision hazard that resulted. The bombardier with his eye glued to the bombsight's eyepiece—and flying the airplane through the autopilot at the same time—was oblivious to airplanes close by.

A partial solution lay in the development in the spring of 1943 of the combat-box formation, consisting of three 21-plane groups. The top group flew above and slightly to the right of the middle group; the bottom group flew below it and slightly to the left; the middle group flew slightly ahead of the other two. In theory, the combat box uncovered every gun in every plane, with minimal risk to friendly planes. Twenty planes in every group would bomb on a signal from the lead bombardier who essentially aimed for the entire squadron. Some bomb groups removed bombsights and replaced them with an extra nose gun. The signal to drop was a radio tone from the lead aircraft, a visual cue such as a flare, or watching the lead aircraft's bombs drop away. This technique eliminated the bombardier's function and the need for a bombardier and a bombsight in every plane. The bombardier was replaced by the forward gunner who would simply hit a toggle switch to release the bombs at approximately the right moment. He became a "togglier" and a new word was added to the American language. However, the combat-box sacrificed bombing accuracy for the enhanced safety of the plane and its crew. A single second's reaction time, for example, meant an overshoot of 220 feet for a bomb released from an airplane traveling at 150 miles per hour, which was the typical airspeed during the bomb run by a B-17 or a B-24. Nevertheless, by mid 1943, the 8th Air Force had the bombsights removed from all planes except the lead and deputy-lead bombers. A year later, the 8th Air Force requested delivery of its next 1,000 bombers without bombsights because it had nearly 400 spares.[16]

Bombing accuracy was further degraded by ever-higher bombing altitudes. Every extra foot of altitude extended the variables the Norden's analog computer had to handle, and the instrument proved unable to do so consistently. Additionally, bombing tables were generally inadequate, most having been developed from data compiled up to only about 10,000 feet. There was also the unpredictable trajectory of bombs falling from high altitudes, where their velocities approached the speed of sound as they neared the ground. At the start of the war, there were no wind tunnels in which to check out bomb and bomb-fin performance at near-supersonic speeds.

But the most significant obstacle to bombing accuracy was cloud cover—the immutable "no see, no hit" paradigm that bedeviled the AAF throughout the war. General Arnold in 1940 had euphemistically identified "bombing through the overcast" as the Army Air Corps' number one problem, and it would remain unsolved throughout the war. It took just a little while for American airmen stationed in Britain to get used to the weather, where "year round the sun shines only one hour out of every three it is above the horizon." One analyst wrote that he had "heard British meteorologists claim that on not more than *twelve* (author's italics) days per year can you expect perfect weather conditions for precision bombing—that is, clear weather at the base airdromes and no clouds, ground mist, or industrial haze from the height of 20,000 feet above the target down to the ground."[17]

Then there was human error. The bombsight could be only as accurate as the information the bombardier dialed into it. For example, at 20,000 feet, an altitude miscalculation of 250 feet meant an error of 136 feet in range and deflection. An error in wind speed determination of 20 miles per hour added another 120 feet of error. These two "judgments," for example, were based on other instruments in the airplane, with their own built-in errors. An AAF study later estimated that typical "human error" added some 1,300 feet—a full quarter of a mile—of error to the typical bombing mission!

Of course, as a first requirement it was necessary that the bomber groups be able to navigate to the target. Navigation by aircraft flying in daylight through clear skies, using visible and identifiable ground features, is straightforward . However, the picture changes drastically when the aircraft flies above solid cloud cover, at night, or over the ocean. Under such conditions, more typical than not for the bomber crews, electronic navigation aids become mandatory. During the 1930s, there had been rapid growth in development of such instruments to support the burgeoning commercial aviation industry. Radio direction finders were the first of the new systems, allowing airliners over land to fly from city to city by homing in on specific radio beams transmitted from each city. The next step was a series of directional beacons with beams focusing on preset routes, establishing a sort of "highway in the sky." The German Lorenz system was such a scheme; it used a short-range ground transmitter that radiated a twin beam with Morse-code dots on one side and dashes on the other. These beams overlapped and the dots and dashes interlocked so that there was a narrow path down which a steady-note signal was transmitted. By the end of the 1930s, Lorenz systems were used at airports throughout the world to direct aircraft approaches under conditions of poor visibility.

At the same time, the Luftwaffe was adapting the Lorenz system to its bombers, code-named *Knickbein* (bent knee). *Knickbein* used a giant aerial to create an extremely narrow steady-note lane only ⅓rd-degree wide. For example, at a distance of 180 miles, the flight path was only one mile wide.

A second *Knickbein* transmitted another beam that intersected the first one at the predetermined bomb release point. This meant that Luftwaffe bombardiers could be signalled precisely when to release their bombs. The resulting accuracy of the twin *Knickbein* was termed "reasonable," according to one source, even in darkness or when the target was hidden under clouds.[18]

The Germans further refined their Lorenz-type system by narrowing the steady-note lane, in a system they called X-Gerät, through use of a shorter wavelength. This more accurate system used four beams, an approach beam and three cross beams which intersected the approach beam at preset positions just before the target. Early in 1941, the Luftwaffe brought into operation another beam system, Y-Gerät, which needed only a single ground station. While potentially even more precise than its predecessor, Y-Gerät was effectively jammed by British countermeasures. The Royal Air Force, relative latecomers in the field of electronic navigation, introduced its own system in 1942 similar to Knickbein, called GEE.

Radar arrived on the scene in early 1943, with the RAF's Oboe. This system used two ground stations. One tracked the aircraft as it flew along an arc of constant range running into the target and transmitted correction signals to the aircraft if its flight path deviated from the arc. At the same time, the second station measured the range and when the aircraft was observed to be at the previously computed bomb release point, a signal was given to release the bombs. Oboe proved to be accurate and the Germans found it difficult to jam. The Luftwaffe copied Oboe for their own Egon system which was used during bombing attacks on England early in 1944. The U.S. Shoran system was similar to Oboe, except that Shoran's transmissions were initiated from and computations made in the aircraft. All of these electronic navigation and bombing aids were limited in their applications to targets in an area about 280 miles from the ground transmitters. If the bombers were to accurately strike at greater ranges, a system was required that would be independent of ground transmitting stations.

Nevertheless, bombing accuracy improved as the war wound down. By 1945, the Luftwaffe had been effectively swept from the skies over Germany, bombing altitudes had been decreased, and American aircrews were surviving long enough to apply their acquired skills to their less hazardous jobs. According to one source, "the most accurate bombing in the history of the Second Air Division" took place over the marshaling yards at Passau, a small Danube city, a month before the war ended. The weather was clear and the B-24s bombed visually with the Norden. "Strike photos showed that all three squadrons in the group had placed at least 70 percent of their bombs within five hundred feet of the aiming point and 100 percent within one thousand feet."[19]

* * *

By mid–1943 it was becoming apparent to Air Force commanders in the field that the Norden, in the crucible of the air war over Germany, could not

do the job it had been designed to do. The instrument's inability to function over cloud-cover had crept into their consciousnesses slowly, for these men had been weaned on the Norden's infallibility for nearly a decade. RAF Bomber Command, far less interested in precison bombing than the USAAF, had begun using a radar bombsight in its Pathfinder aircraft, code-named H2S. Radar technology appeared to be the answer to the "no see, no hit" paradigm, and the AAF turned to the British, whose radar-based navigation aids and radar bomb-aiming instruments were ahead of anything the Americans then had in production.

The Radiation Laboratory at the Masschusetts Institute of Technology had been begun development of a radar bombsight in late 1941. The project was assigned the acronym EHIB—for "Every House in Berlin"—which "said volumes about the expected accuracy and object of the device."[20] EHIB was more formally designated as AN/APQ-13 and, in a later enhancement, as AN/APQ-7, code-named Eagle, the most advanced radar bombsight used by the AAF during the war. According to Hansell, LeMay's predecessor as head of the 20th Air Force over Japan, even Eagle "was inadequate for precision bombing." Hansell wrote that before LeMay adopted his city-destroying night bombing campaigns over Japan in March 1945, "there was every reason to believe he [LeMay] would have welcomed an effective tactic to destroy selective targets as well as urban areas...."[21]

In the interim, as the American system underwent testing and prototype production, the 8th Air Force installed British H2S radars in selected aircraft for crew training and evaluation and then H2X systems (designated APQ-15) that were adaptations better suited to American aircraft. H2X was first used over Europe in the fall of 1943.

H2X was a method of radar map-reading that was used as both an aid to navigation and as a means of "blind bombing." The system was based on radar transmissions returning as echoes which were affected by ground features. The radar echo from a city, for example, was distinctly different from that produced by open country; the echo from a land surface was different from a water surface; and the echo from a ship could be distinguished from the sea around it. H2X-equipped bombers had downward-looking rotating radar transmitters in the belly of the aircraft (that replaced the ventral gun turret) that scanned the surface directly underneath the plane. Returning echoes were displayed on a circular cathode-ray tube corresponding to the circular rotation of the transmitter. Because the radar response of water and land was particularly distinctive, coastlines, larger rivers, and broad lakes could easily be identified. By measuring the bearing and estimating distance from identified features on both sides of his track, the navigator could reasonably precisely fix his position. As the airplane approached the target and if the target could be defined on the cathode-ray readout, the final bombing run and the bomb drop could be blind.

H2X had serious inherent limitations. The shapes of coastlines, rivers, and lakes were typically indicated accurately, but built-up areas gave indistinct reflections. While it was easy for the navigator (or bombardier) to establish whether his plane was near a city or over open counry, identifying *which city* he was flying over was another story. The radar image did not necessarily correspond with the actual shape of a city and the image reproduced depended on the angle from which it was viewed by the radar scanner. Identification of the target was only possible at all if the navigator already knew from other sources approximately where he was. H2X interpretation therefore, demanded a highly skilled and experienced radar operator. Too few bombardiers and radar operators lived long enough in 1943 and early 1944 to become proficient! A second major drawback was that over large cities, the entire screen was filled with an intense blaze of radar response so that it was generally impossible for the operator to discriminate among individual targets within the city.

In his ongoing public-relations campaign to build a bogus reputation for his command and at the same time hoodwink the American public, "Hap" Arnold cautioned Spaatz and the 8th's public information officers to avoid using the term "blind bombing" when referring to H2X missions because it gave "both the military and the public an erroneous impression." Such euphemisms as "overcast bombing technique," "bombing through overcast," and "bombing with navigational devices over clouds extending up to 20,000 feet" were to be strictly avoided. At the same time, he nagged his commanders to document the positive results of the bombing campaigns. Pictures and more pictures was what Arnold insisted on. "People believe more readily what they see than what they hear," he wrote to Spaatz, adding: "Every daily paper in the United States will feature the pictures if you can get them to us…. Nine months have passed since Pearl Harbor, and the American public wants to see pictures, stories, and experiences of our Air Force in combat Zones."[22] Arnold personally oversaw the production of *Impact*, a widely circulated security-classified Air Force publication filled with photographs of targets bombed.

Most telling regarding the inaccuracy of radar bombing was the 8th Air Force's policy to prohibit the use of H2X bombing methods over occupied countries in Europe, reflecting the understanding that bombing through cloud cover was indiscriminate bombing and certain to kill civilians. Despite its being an electronic wonder of sorts for its time, according to one analyst, "H2X bombing was at best only half as accurate as visual bombing. It was really area bombing by another name."[23]

However, in December 1943, the Air Force flamboyantly announced the the new system as a great success and an important enhancement of America's unswerving commitment to its doctrine of precision bombardment. The *New York Times*, in a front page story by authoritative correspondent Drew Middleton on December 29, headlined "Bomb Accuracy in Clouds Mastered

by 8th Air Force," embellished the announcement. The report waffled, sur-
prisingly, acknowledging that the accuracy of the new radar system "while
not equal to that attained in high-altitude attacks when the target can be
seen," was "satisfactory." It was not quite the dramatic propaganda block-
buster that Arnold had hoped for, but remarkably the story did not hood-
wink *Times* readers. Respected military historians Wesley Frank Craven and
James Lea Cates agreed in their postwar retrospective, writing that by the
end of 1943 "it was becoming clear that radar aids had not worked, and were
not likely to work, miracles of accuracy." But the two writers balanced that
mild critique by suggesting, nevertheless, that there were advantages to radar
bombing, which "had allowed the daytime bombers to resort during bad
weather to a type of area bombing which presumably kept pressure on the
enemy at a time when he might have been recuperating."[24]

U.S. Army chief of staff Marshall enthusiastically endorsed the AAF's
area-bombing strategy that was implemented in 1944. The final months of
the war in Europe were characterized by around-the-clock indiscriminate
bombing of the rubble of German cities by both RAF Bomber Command
and U.S. 8th and 15th Air Forces—supporting the doctrine of unconditional
surrender, the inability of American and British ground forces to advance
into Germany late in 1944, and the new menace of a Red Army sweeping
west all before it. This latter reason was almost a reprise of the Paris Peace
Conference in 1919, when the peace treaty for Germany which became the
infamous Versailles Treaty, was hurried through—to the detriment of West-
ern civilization—in the face of a feared Red tide of Bolshevism sweeping west.
On a visit to the European theater in October 1944, Marshall lectured his air
commanders that insufficient pressure had been applied in the right places,
that it was time to abandon precision bombing and switch over to terror tac-
tics that would force an early end to the war.

By the end of 1944, despite the acknowledged inaccuracy of radar bomb-
ing, such attacks by the 8th Air Force had become commonplace.[25] Reflective
of the AAF's understanding of radar bombing's relative inaccuracy compared
to visual bombing with the Norden was the so-called "safety band" that had
been established around Switzerland. The band was 50 miles during visual
bombing and 150 miles during radar bombing. Even so, the Swiss border
town of Schaffhausen was hit in February 1944 by an 8th Air Force attack.
During operation Clarion a year later fighter-bombers hit the same town
again and several days later there were more flagrant examples of inaccurate
bombing when nine B-24s bombed Basel and six B-24s dropped bombs on
Zurich, 34 tons in all.[26] The target had been Freiburg, 25 miles from Basel
and 45 miles from Zurich.

If radar bombing was proving to be a disappointment to top Air Force
commanders, aircrews were of a different mindset. With the new radars, they
could accumulate missions more quickly and much more safely. Heavy cloud

cover made it difficult for attacking German daylight fighters to home in on the bomber streams. Statistics bore out this fact: an aircrew's chances of getting home safely from such a mission were nearly six times as great as from a visual-bombing mission.[27] RAF Bomber Command, always willing to denigrate AAF equipment and tactics compared to their own, noted in their post-war Bombing Survey Report the very high percentage of attacks using non-visual means during the autumn of 1944, when the USAAF was desperately striving to hit precision oil targets. When using non-visual methods the American bombers were actually less accurate by day than the RAF was bombing non-visually at night."[28]

9

The Aircrews

Men who have never fought, chauvinists who pipe the tune of moral invincibility and the courage of their "brave boys," would be shocked to find the enemy is neither craven nor irresolute; neither is he stupid. He fights as well as you do, and often better. He bleeds and dies in lonely agony, as you do. He, like you, is given to jokes, small wonders, dreams, love, and the pleasing taste of warm beer. He, like you, knows the bile of fear, the unbearable terror of battle and the shaking exhaustion of those who survive it. He knows all this, as you do. And he goes on and you go on until it is over for him and over for you, or until they tell you to stop.[1]

Actual "kills" compared to claims by 8th Air Force bomber gunners was a controversial subject throughout the war. The number claimed always exceeded the number actually lost by the Luftwaffe by a factor of eight or nine to one.... For morale and propaganda purposes the AAF could not admit that men using pointed sticks would have been hardly less effective than .50 caliber machine guns in killing German fighters.[2]

Air combat was hazardous and cruel for U.S. bomber aircrews and life expectancy was startlingly short. In early 1943, when B-17s and B-24s began to bomb targets in Germany, replacements from the United States learned that they could expect to complete only five and a half combat missions before becoming statistics: killed in action, missing in action, wounded, or prisoners of war. A year later a report by the Office of the Air Surgeon for the European Theater pointed out that during the first six months of 1944, out of each 1000 crewmen who had flown combat missions during that period, 712 were killed or missing and 175 were wounded—an 89 percent casualty rate. It closely matched an individual assessment by a B-24 crewman who disclosed that only 27 out of the 250 men in his July 1943 gunnery class had completed 25 missions.[3]

The missions over Germany from bases in England were grueling—eight to ten hours and sometimes longer, starting at dawn. The planes were stark war machines, icy-cold and cramped for their crews of ten, expensive weapons but carrying explosives that more often than not ended up scattered over the German countryside. They and their crews were expendable. Starting at takeoff, crewmen faced many enemies that killed and maimed: Luftwaffe fighter planes and antiaircraft fire, adverse weather, sub-zero temperatures at altitude in summer and winter, ditching in the icy-cold waters of the English Channel and North Sea, anoxia, their own squadrons' inept machine gun fire, ferocious German civilians watching their parachutes descend, and the ever-present hazards of tight-formation flying.

Initially Luftwaffe fighters took the heaviest toll of U.S. aircrew, until late in 1944 when air superiority was finally wrested from a depleted and outmanned German air force; from then until the end of the war in Europe, antiaircraft fire was the bigger menace. The well-trained and aggressive Luftwaffe pilots fought tenaciously, seeing themselves as principal defenders of their homeland—and their families. This was not true for the Americans, some of whom were not sure what they were risking their lives for, despite insistent U.S. government anti–German propaganda. A significant percentage of GIs were of German ancestry and it had not been Germany that had bombed Pearl Harbor, although it had been Germany that had declared war on the United States. Furthermore, anti–Semitism, covert and overt, was not unusual in the U.S. military during World War II, reflecting American society in general. If Hitler was killing Jews in Europe, there were many flyers who felt it was his business, not America's.

The air battles between American bombers and German fighters were brutal and terrifying. What could be more horrifying to U.S. flyers than watching a bomber from their squadron suddenly explode into a fireball after a high-speed attack by a cannon-firing Fw 190? Or counting parachutists from a B-17, staggering out of formation, one wing engulfed in flames, then plunging out of sight? Or trying desperately to keep alive a mortally wounded crewman during the long flight home?

Perhaps the most vivid description of aerial combat during World War II was Lt. Colonel Beirne Lay, Jr.'s official report as co-pilot of *Picadilly Lilly* on a mission to bomb Regensburg, the site of Messerschmitt's main factory. He began his narrative some 90 minutes from the target at an altitude of 17,000 feet when his Bomb Group's short-legged P-47 escort fighters turned for home for lack of fuel, and the Luftwaffe slashed in. That mission has been described as the "anniversary disaster" because it took place a year to the day of the 8th Air Force's inaugural mission over Europe—and because 60 B-17s were downed.

> Near Woensdrecht [Holland] I saw the first flak blossom out in our vicinity, light and inaccurate. A few minutes later, two Fw 190s appeared at one o'clock

level and whizzed through the formation ahead of us in a frontal attack, nicking two B-17s in the wings and breaking away beneath us in half rolls. Smoke immediately trailed from the B-17s, but they held their stations.

Three minutes later, the gunners reported fighters climbing up from all around the clock, singly and in pairs, both Fw-190s and Me-109Gs.... A coordinated attack followed, with the head-on fighters coming in from slightly above, the nine and three o'clock attackers approaching from about level, and the lead attackers from slightly below. Every gun from every B-17 in our group and the one ahead was firing, crisscrossing our patch of sky with tracers to match the time-fuze cannon-shell puffs that squirted from the wings of the Jerry single-seaters. I would estimate that seventy-five percent of our fire was inaccurate, falling astern of the target—particularly the fire from the hand-held guns. Our group leader pulled us up nearer to the group ahead for mutual support.

A few minutes later, we absorbed the first wave of a hailstorm of individual fighter attacks that were to engulf us clear to the target. The ensuing action was so rapid and varied that I cannot give a chronological account of it. Instead, I will attempt a fragmentary report, salient details that even now give me a dry mouth and an unpleasant sensation in the stomach when I recall them. The sight was fantastic and surpassed fiction. It was over Eupen that I looked out of my copilot's window after a short lull and saw two whole squadrons, twelve Me 109s and eleven Fw 190s, climbing parallel to us. The first squadron had reached our level and was pulling ahead to turn into us and the second was not far behind. Several thousand feet below us were many more fighters, with their noses cocked at maximum climb. Over the interphone came reports of an equal number of enemy aircraft deploying on the other side. For the first time, I noticed an Me 110 sitting out of range on our right. He was to stay with us all the way to the target, apparently reporting our position to fresh squadrons waiting for us down the road. At the sight of all these fighters, I had the distinct feeling of being trapped—that the Hun was tipped off, or at least had guessed our destination and was waiting for us. No P-47s were visible. The life expectancy of our group suddenly seemed very short, since it already appeared that the fighters were passing up preceding groups in order to take a cut at us.

Swinging their yellow noses around in a wide U-turn, a twelve-ship squadron of Me 109s came in from twelve to two o'clock in pairs and in fours, and the main event was on. A shining silver object sailed over our right wing. I recognized it as a main exit door. Seconds later, a dark object came hurtling through the formation, barely missing several props. It was a man, clasping his knees to his head, revolving like a diver in a triple somersault. I didn't see his chute open. A B-17 turned gradually out of the formation to the right, maintaining altitude. In a split second, the B-17 completely disappeared in a brilliant explosion, from which the only remains were four small balls of fire, the fuel tanks, which were quickly consumed as they fell earthward. Our airplane was endangered by falling debris. Emergency hatches, exit doors, prematurely opened parachutes, bodies, and assorted fragments of B-17s and Hun fighters breezed past us in the slipstream.

I watched two fighters explode not far beneath, disappearing in sheets of orange flame, B-17s dropping out in every state of distress, from engines on fire to control surfaces shot away, friendly and enemy parachutes floating down, and, on the green carpet far behind us, numerous pyres of smoke from fallen fighters, marking our trail. On we flew through the strewn wake of a desperate air battle, where disintegrating aircraft were commonplace and sixty chutes in the air at one time were hardly worth a second look. I watched a B-17 turn slowly to the right with its cockpit a mass of flames. The co-pilot crawled out of his window, held on with one hand, reached back for his chute, buckled it on, let go and was whisked back into the horizontal stabilizer. I believe the impact killed him. His chute didn't open.

Ten minutes, twenty minutes, thirty minutes, and still no letup in the attacks. The fighters queued up like a breadline and let us have it. Each second of time had a cannon shell in it. The strain of being a clay duck in the wrong end of that aerial shooting gallery became almost intolerable as the minutes accumulated toward the first hour. A B-17 ahead of us, with its right Tokyo tanks on fire, dropped back to about 200 feet above our right wing and stayed there while seven of the crew baled out successfully. Four went out the bomb-bay and executed delayed jumps, one bailed from the nose, opened his chute prematurely, and nearly fouled the tail. Another went out the left waist-gun opening, delaying his chute opening for a safe interval. The tail gunner dropped out of his hatch, apparently pulling the ripcord before he was clear of the ship. His chute opened instantaneously, barely missing the tail, and jerked him so hard that both his shoes came off. He hung limp in his harness, whereas the others had shown immediate signs of life after their chutes opened, shifting around in the harness. The B-17 then dropped back in a medium spiral and I did not see the pilots leave. I saw it just before it passed from view, several thousand feet below us, with its right wing a sheet of yellow flame.

After we had been under constant attack for a solid hour, it appeared certain that our group was faced with annihilation. Seven had been shot down, the sky was still mottled with rising fighters and target-time still thirty-five minutes away. I doubt if a man in the Group visualized the possibility of us getting much further without 100 percent loss. I know that I had long since mentally accepted the fact of death, and that it was simply a question of the next second or the next minute. I learned firsthand that a man can resign himself to certainty of death without becoming panicky.[4]

Ground-based antiaircraft fire—flak—was the second deadly peril. U.S. fliers generally preferred to face German fighters rather than intense flak. There were at least countermeasures to be taken against enemy fighters: defensive firepower and perhaps evasive maneuvers. Against flak, there were no defenses. During the final bombing run, from the IP (initial point) to the AP (aiming point), which took up to ten minutes and sometimes longer, when the plane had to maintain a straight and level course into the target, the big bombers were particularly vulnerable to flak. Those crew members who had views forward typically saw an ugly panorama of what appeared to be small

black clouds ahead, at their particular altitude, but were in reality intense concentrations of anti-aircraft fire that the plane *had* to fly through.

The chief German antiaircraft weapon against the heavy bombers was the deadly 88-millimeter cannon, accurate, reliable, and with a high rate of fire, unquestionably the best artillery piece of the war. In its antiaircraft configuration, the 88 could deliver up to twenty 20-pound time-fuzed, high-explosive shells per minute to an altitude of up to 20,000 feet. When a shell detonated, some 1500 chunks of red-hot steel shrapnel were spewed through an effective arc of about 60 feet. The "fireballs" of disintegrating bombers that appeared suddenly and randomly among bomber formations, so demoralizing to nearby aircrews, were typically a result of a direct hit from flak. Even a "close miss" disabled engines, slowing down the airplane, and forcing it out of its protective formation, making it easy prey for Luftwaffe predators. Or the shrapnel would cut fuel lines and rip open fuel tanks that would quickly cause uncontrollable fires that would either explode the plane in the air or send it flaming into the ground. Or it would tear apart wings and tail surfaces that meant loss of control that also doomed the aircraft.

Bad weather was also a constant companion. Long range tight-formation flying and "successful" bombing—however loosely applied—required clear conditions at takeoff and assembly over home base, over the target, and during the approach and landing at the end of the mission. Even if the weather at takeoff was forecast to be satisfactory throughout the mission, hours later changes could be expected. One B-17 pilot, who completed 31 missions in 1943 and 1944, remembers that what he feared most of all was the low-lying fog over England at his base in East Anglia on his way back from missions over Germany. He recalls hugging the ground after he crossed the English Channel, straining to see through the fog. Often as not, he landed at a base other than his own.[5] Wet takeoffs meant wheels picking up mud from taxiing along narrow perimeter tracks adding yards to already marginal takeoff rolls. The mud, which soon froze on the tires, could slow a plane down by five miles per hour, in turn causing difficulty for the pilot to stay in formation and to maneuver when attacked.

"Forming up" over the field was not the simple procedure it implied and low-hanging clouds contributed to the frequency of collisions that generally killed all personnel in the two or more planes involved. The operation demanded skillful flying not only from individual pilots but particularly from the group commander. As he gathered his flock, his climbing turns had to be "gentle and perfectly controlled: not so fast that the outside planes had to pound their throttles to keep up, and not so slow that the inside planes had to endure the terror of trying to hold their positions with their airspeeds dropping dangerously close to a stall." As one pilot graphically recalled, "An over-loaded B-17 stalling out under a thousand feet met its spectacular end in seconds.... Three tons of bombs, twenty-seven hundred gallons of high-octane

fuel, about six thousand rounds of fifty-caliber ammunitions along with oxygen tanks, hydraulic and lubricating oil, all hitting the ground at over two hundred miles an hour, left nothing but a steaming black smear."[6]

Once the big bombers were airborne and climbing to their cruise altitude, anoxia or oxygen deprivation became an insidious problem, causing disability and even death, especially among new aircrews with too few hours of high-altitude flying experience. Regulations called for use of oxygen starting at 10,000 feet. Without oxygen at that altitude, crewmen would experience a progressive increase in fatigue, loss of vision, and reduced mental alertness. Most missions were flown above 20,000 feet; at such altitudes cutoff of the oxygen supply could be fatal if not quickly attended to. Freezing of the face mask was the main mechanical cause of anoxia—which was a common occurrence among the waist, ball turret, and tail gunners who were most exposed to the cold. Radio operators were also at high risk because their duties required them to move away from their normal station where they were plugged into the plane's central oxygen supply, and to carry an inefficient portable bottle. It was not until 1944 that improved masks were issued and more reliable oxygen equipment was fitted to new B-17s and B-24s planes and retrofitted to existing. By then, too, better trained aircrews were arriving in England.

Cold proved to be an even more formidable adversary in the unheated planes, and crippling frostbite of susceptible oxygen-deprived tissues was commonplace. In fact, more injuries in the 8th Air Force were a result of frostbite than from enemy action.[7] At about 20,000 feet altitude and higher, with some missions flown at 32,000 feet, the plane's ceiling, outside air temperatures, on average, ranged from minus 30 degrees F to minus 40 degrees F, but sometimes fell as low as minus 60 degrees F. The cold adversely affected mostly the same victims in every airplane: waist gunners at open windows with hurricane-velocity winds blasting over their faces; tail gunners who removed protecting canvas gun covers because the covers got wet and froze, impeding the movement of their guns; ball turret gunners who dared not leave their stations while over enemy territory and reluctantly urinated into their pants, freezing their backs, buttocks, thighs, genitals.

Suiting up for protection against the cold was a meticulous ritual. Most men put on cotton underwear next to their skin, then woolen "long johns," then the mandatory wool uniform of shirt (with ties for officers!) and trousers that the crew wore to the pre-flight briefings. On the hardstand before boarding came the outer layers: the electrically heated flying suit, honeycombed with thin, insulated wires. These suits "were much like an electric blanket, with a rheostat, and were very comfortable in the subzero temperatures at high altitude. The only problem was that if you had to bail out you lost your electrical system and were sure to be awfully cold. And if you survived bail out, you might have to spend the rest of the war in a prisoner-of-war camp in that funny looking suit."[8]

Over two pairs of socks, electrically heated shoe inserts were slipped on and plugged into receptacles at the ankles of the flying suit. Then came a pair of lightweight windproof pants which were tucked into fleece-lined boots. The fleece-lined leather outer jacket came last, over which were fastened the Mae West yellow inflatable life preserver and the straps of the parachute harness. A leather flying helmet came last. The gunners had electrically heated gloves.[9]

Candid descriptions of the frostbite problem among B-17 and B-24 aircrews are found in a report written by an 8th Air Force Flight Surgeon:

> When the first Fortresses lifted off their East Anglia runways and pointed their noses toward *Festung Europa*, the men who flew them were tense. They thought of angry Messerschmitts, wing guns blinking; of flak-struck planes disappearing in a red flash; of grinding collisions in too-tight formations. But they didn't think of one enemy, invisible, waiting for them above 20,000 feet. Waiting to snap at their hands, feet, faces. Waiting for one of them to let down his guard for an instant. Always waiting. The enemy was Cold. Cold, which became as tangible and real to them as any Focke-Wulf; as feared and respected as flak....[10]
>
> Flight Surgeons, sweating out the planes' return, breathed sighs of relief as the last plane came into the final approach without shooting the red flare of "wounded aboard," [but] returned to find dispensaries jammed with men with frozen hands, feet, faces. Soon station dispensaries, then evacuation and general hospitals began to fill.... Arctic-wise explorers have droned "A wet foot is a frozen foot." Men who walked through the rain to their aircraft; who slept in heated suits; who played sweaty games in their flying clothes were wet when they took off. They were casualties when they came back.[11]

The wounded were in exceptional jeopardy. Those who wore electric suits which were sometimes disabled by the same piece of flak or cannon-shell shard which hit them, would lie on the freezing floor, their hands and feet growing numb despite frantic attempts by fellow crewmen to keep them warm on the four- or five-hour return flight. Prompt first aid often saved the lives of disabled crewmen who were only to have their frozen hands and feet later amputated. Sometimes desperate aircrews bundled the severely wounded into their parachutes, wrapped their fingers around the ripcord handle and eased them overboard, hoping they would make it safely to the ground and be picked up promptly by compassionate German military personnel and given medical attention.

"Friendly fire" also contributed its share to casualties and downed bombers. Contrary to the American myth of every young man growing up a Daniel Boone or Davy Crockett, most GIs had never fired a rifle in their lives before putting on a uniform. With each plane mounting ten .50 caliber machine guns, each capable of firing 700 rounds per minute, a 36-plane formation of B-17s or B-24s could fire about a quarter of a million rounds in 60 seconds out to an effective range of about 3,500 feet. But filling the sky with bullets

was not the same as aimed gunnery. Hitting small, fast, and evasively maneuvering fighters from a jouncing platform was a demanding skill that few gunners ever achieved. During head-on attacks, a favorite tactic of the Luftwaffe, closing speeds were 500 miles per hour and faster, giving the bomber gunner scarcely two or three seconds visually to acquire his target, swing his gun or rotate his turret to cover the target, and squeeze the trigger. There were also the twin problems of first seeing and then immediately identifying black specks in a big sky, which typically bore in from out of the dazzling sun. "Friend?" or "Foe?"—the gunner had better make up his mind quickly! German Bf 109s with their liquid-cooled in-line engines had silhouettes like U.S. P-51s and British Spitfires, and Fw 190s with their air-cooled radial engines looked like P-47s. Gunners sometimes withheld their fire until too late or opened fire on "friends." The gunsights, too, were primitive ring sights, scarcely better than those on the swivel-mounted machine guns on the biplanes in an earlier war. In the tight defensive combat-box formation, with planes above and below and to the right and left, it was no wonder that friendly planes were sometimes riddled by careless and nervous gunners.

In fact, aerial gunnery had been given short shrift treatment by the Army Air Corps in the late 1930s, despite its commitment to self-defending bombers. Three gunnery schools had been opened but the program was perfunctory and few instructors had been trained. Any man aboard a bomber who was not otherwise occupied when the plane was attacked was expected to man a nearby gun. With America in the war, four more gunnery schools were established and a more rigorous six-week training regimen was instituted. "The first half was mainly ground school: theory of ballistics, machine gun maintenance, ammunition handling…. Training moved on from BB guns to twenty-two calibers, to shotguns, to machine guns. They spent hours shooting clay pigeons, so they'd learn how to lead a target. They fired at moving targets from moving trucks. In the second three weeks they spent much of their time in the air, firing at towed targets."[12] Initially all prospective aerial gunners were volunteers. The numbers needed, however, proved to be so great, some 300,000 by war's end, and the combat casualty rate so high, that the volunteer program was soon canceled, and individuals were assigned to be gunners whether they liked it or not.

Higher even was the casualty rate for bombardiers, who were commissioned officers. Entry to bombardier school required a high school diploma and passing a battery of stiff aptitude tests. When he was not on the bombing run, literally only a few minutes per mission, he was the nose gunner and coordinator of the plane's defensive fire—and in the part of the airplane most exposed to enemy machine-gun and cannon attack, surrounded by clear Plexiglas. From the start the AAF found it difficult to find qualified volunteers for bombardier training.[13]

How good were the gunners? If you asked *them*, as they were during every debriefing, they were damn good and getting better every mission. Since the

first shallow penetrations into French airspace the Eighth's gunners had been putting in astounding claims for enemy fighters downed. For example, on a mission to Lille on October 9, 1942, in which 108 B-17s were sent off, the gunners claimed 56 fighters destroyed, 26 probably destroyed, and 20 damaged. These numbers actually exceeded the entire strength of the German fighter *Staffels* defending the area. However, an American victory had been proclaimed and President Roosevelt quoted the fantastic figures in a radio broadcast. In fact, the Luftwaffe had suffered only one casualty. The British, as might be expected, derided the exaggerated American claims, but Eaker loyally supported "his boys." At the high-level Casablanca Conference in mid January 1943 to plan joint U.S.-British airwar strategy for the coming year, Eaker reported to Arnold's deputy, Colonel Barney M. Giles, that his bombers maintained a "kill ratio" of six to one over the Luftwaffe. All he needed, he told Giles, were more B-17s and B-24s and he would promptly gain total air superiority over Germany.

One outspoken commander of an 8th Air Force bomb group in a report on gunnery, painted a radically different picture:

> I really felt that the gunners, in some cases, were more a hazard than they were a protection. I do not think we will ever know how many airplanes we shot down ourselves by this wild spraying of .50 caliber machine guns.... Certainly, we got rid of the waist gunners, and I think practically everybody did that in due course.... I wanted to dump the ball turrets. I do not really think they did that much good either.[14]

If the gunners were sometimes more a hazard than a protection, what about other aircrew members? In fact, all bomber aircrew members that arrived in England in 1942 and early 1943 were inadequately trained by nearly every standard that could be applied. While pilots and copilots had learned to fly, they were not prepared for the tight-formation flying that started at forming-up right after takeoff, nor did they have the experience to handle their airplanes with control surfaces shot to pieces and engines shut down. "Many radio operators could neither send nor receive Morse code."[15]

Another trial faced by bomber aircrews was when the pilot hit the bail out alarm in a mortally damaged plane, or one the plane's commander thought was mortally hit. Bomber aircrew did not wear their parachutes during combat because of their bulk. They did, however, wear their chute harnesses and stowed the parachute bundles nearby. If the aircraft was still under control and flying level there would be enough time for the men to clip on their parachutes and work their way to the nearest exit hatch and make an orderly exit. It was otherwise if the plane was on fire or in an uncontrollable spin, pinning the men against bulkheads and seats. Then every fraction of a second counted— and too many of the encumbered men were never able to scramble to escape

hatches, the shrieking, tumbling bomber becoming their tomb—or their incinerator. Escape hatches were afterthoughts by the designers and were often poorly located, difficult to unlatch with heavy gloves, and at best marginally large enough for rapid egress by crewmen in their clumsy flying suits with their parachutes fastened. A ghastly sight for aircrews was a direct hit by flak on a nearby squadron-mate that blew up the plane before its crew could get to their chutes. "The concussion would blow the parachutes apart and, with no weight on the chutes, they would flutter through the sky like leaves in an autumn breeze, while all the bodies, guns, and engines fell like rain earthward."[16]

Experienced crews wore uncomfortable flak vests, canvas aprons with steel inserts, which weighed about 20 pounds. The vests were stowed with their parachutes and were put on when the aircraft entered enemy air space. Some men, nervously concerned about flak injuries to their "lower extremities," chose to sit or stand on the vests, or to wear one and sit on one.

Some airmen neither knew how nor took the trouble to adjust their chutes for proper fit, which contributed to severe injuries when they were forced to jump. And fewer still knew how to exit correctly from a plane when parachuting.

Those managing to reach an escape hatch or dropping out of an open bomb bay were subject instantly to another brief series of life- and limb-threatening ordeals that demanded cool judgment, often missing in those who were terrified. If the crewman pulled his ripcord too soon, the deploying parachute could snag on a wing or tail, dooming him. If the plane was flying in a top position in the formation, the flyer had to make sure he was clear of the closely spaced planes below before he opened his parachute. It was always advisable to free-fall for some brief period before opening the chute, depending on altitude, to avoid suffering exposure to the cold and to oxygen deprivation; aircrew who had never parachuted before (and nearly all were complete neophytes) tended to open their chutes prematurely, and suffered the consequences.

With the big white canopy fully deployed overhead and eerie quiet prevailing in a quickly emptying sky, the flyer was as yet far from reaching safety, literally and figuratively. While it was not common Luftwaffe practice to shoot American aircrew in their parachutes, both sides sometimes did gun down their opposites before they reached the ground; this acknowledged atrocity was generally limited to pilots of fighter aircraft, in a sort of an "eye-for-an-eye" retribution. One such incident is recorded in Luftwaffe records of August 7, 1944:

> Gefr. Hans Thran bailed out successfully but, according to ground witnesses was shot in his parachute by a P-47 pilot while only sixty feet above the ground. German pilots had a fear of being killed when hanging helpless in their parachutes, and every such report was investigated and carefully

documented. These incidents were especially common during the summer and autumn of 1944.[17]

Newcomers to German combat squadrons were warned that if they had to bail out, they should be aware that American fighter pilots were known to shoot Luftwaffe personnel in their parachutes. They were admonished to free-fall to about 200 meters to make sure of their survival. The Luftwaffe officer who gave that advice claimed he "had seen one of my best friends torn to bits by enemy cannon fire while still hanging in his chute. A hard man, he swore that he would kill any enemy pilot he caught in the same situation."[18]

There were also the vengeful German civilians waiting on the ground, watching the American parachutists floating down under their distinctive white canopies (Luftwaffe parachutes were cream-colored). In the eyes of those Germans, the American airmen were the killers of young children. There are obviously no records of how many U.S. airmen were rounded up by civilians, beaten to death or worse and quickly disposed of in unmarked graves—becoming permanent MIAs—before German military authorities could arrive at the scene to take them prisoner. Aircrew were issued pistols for defense, but many elected not to take them along, knowing they would stand little chance in a shootout; better to surrender meekly and perhaps survive.

There are, however, numerous documented examples of "close calls" as indicators of the likelihood of a violent end at the hands of angry German civilians. One such example comes from the retrospectives of a surviving member of the 8th Air Force's 457th Bombardment Group. From February 1944 to the end of April 1945, that group flew 236 missions, losing 91 B-17s in combat. One crewmen dictated his remembrances to the compiler of his group's history:

> I saw this opening, it was right in front of the church, so I steered the chute and came right down in the opening. Remember, it was Sunday and all the people in the church came outside when they heard all the ruckus. That was the ugliest, meanest bunch of 'Christians' I've ever seen in my life! Well, I'll tell you, they came out of the church and circled around me. Man! They had clubs and rocks and anything they could pick up. They were spittin' and throwing rocks at me and one fellow yelling and making motions to hang me. An SS officer showed up about that time....[19]

Nevertheless, thousands of 8th and 15th Air Force crewmen parachuted to safety, were captured by German military authorities, and spent the rest of the war as POWs in the many *Stalaglufts* scattered around Germany. Generally, the wounded were professionally treated by Luftwaffe physicians. In the *Stalaglufts*, too, the Luftwaffe guards almost universally adhered to the protocols of the Geneva Conventions and most American POWs suffered little more than the ennui of boring months in captivity.

Crews in damaged or fuel-short bombers faced a significant hurdle before they could touch down at their home bases. Every combat flight from England had to cross and recross the English Channel or the North Sea, sometimes both, depending on the target. These waters were icy the year around, and a flyer floating in his busty, bright-yellow inflatable Mae West life jacket—arguably, worn mostly for psychological purposes—would freeze to death in minutes. Since most training had been conducted over land in the United States, crewmen had been instructed to jump when emergencies arose; over the Channel and the North Sea, the injunction to parachute was plain bad advice. Far better than a parachute drop into the water that spelled almost certain death by exposure, was ditching, a controlled crash that would hopefully allow the crew sufficient time to deploy their two inflatable rafts, climb in, and await rescue.

For a ditching to be successful, the pilot had to be both skillful and lucky—and the waves calm. The B-17 with its low wing tended to be a far better ditching aircraft than the high-wing B-24 whose fuselage would strike the water first and break up and sink quickly. Emergency exits were designed for baling out rather than ditching and some of them were on the bottom of the fuselage. Unfortunately for the downed crews, the 8th Air Force had no formal rescue organization until mid 1943. The Royal Air Force did have such a sea-rescue organization and was ready to help American aircrew, but amazingly U.S. flyers were not at first familiarized with the radio procedures to contact the RAF rescue groups. More importantly, the Americans did not know how to ditch their aircraft properly and did not know how to remain afloat once successfully ditched. Only about one-third of all aircrews who were forced to ditch their B-17s or B-24s in the waters between Europe and Great Britain were ever rescued. For the few who survived ditching, the ordeal proved to be traumatic. An 8th Air Force medical study of 320 officers who had ditched concluded that 35 became "psychiatric casualties," about tenfold the rate for the air force as a whole. Sixteen of the 35 who developed the crippling anxiety reactions never flew a combat mission again. The remaining 19 continued flying, averaging six more missions, before they were permanently removed from flying status.[20]

In 1943 a study was made of losses among heavy-bomber crews, using detailed operational histories of 2,085 individuals. These men were tracked from their first mission until "loss"—through enemy action, death in non-combat accidents, permanent removal due to physical disability, or completion of tour of duty. The study showed that "approximately 75 percent failed to complete the 25-mission tour. Fifty-seven percent were killed or missing-in-action, and 17 percent were lost because of physical disability, lack of moral fiber, death in nonoperational aircraft accidents, and by other causes." These gruesome statistics could not be kept from the flying crews and replacements from the United States coming into the depleted squadrons learned them quickly. "Learning the 'facts of life' applied the first real stress to men newly arrived. In some the knowledge served to precipitate unmitigated fear with a

request for removal from flying duties, or to precipitate functional symptoms which would be cause for removal from flying duty."[21]

Lastly, safely landing a crippled bomber with shredded or inoperative control surfaces, no brakes, and with two engines out, a not uncommon scenario, was a Herculean task beyond the capabilities of many pilots. Some of these planes came wobbling uncontrollably out of the sky to smash into the runway and burst into flames; others came in too fast, overran the runway and crashed into the ditches and trees bordering the typical airfield in England. Either circumstance was often fatal to all or some of the aircrew.

Despite the warm propaganda images fostered back home that bomber aircrews were "family," purposefully kept together in the interests of harmony and mutual support, like the crew of the *Memphis Belle,* many squadron commanders found that such policies were not only inefficient in terms of aircrew utilization but also contributed to morale problems when men were killed or wounded. "It was a matter of depressing the incidence of crew over-identification I think they called it. The sad realities of combat had to be accommodated: crew members had to be replaced, and this attrition contributed to the squadron's decision that it was not possible to retain discrete elements of aircrew. We were pilots, navigators, bombardiers, and gunners, and, as squadron operations saw it, we need not know the other men in order to function as a crew. A B-17 required the hands and minds of ten men; ten men were provided. Neither the plane nor the mission needed anything else."[22]

While there was certainly a measure of camaraderie among bomber aircrews at their bases and on weekend passes, in the air during combat, planes and their crews were on their own. General LeMay, known widely as "a hard ass," spelled out what he called the ground rules of the 8th Air Force. "We would go over a target at 155 miles per hour indicated airspeed, and when we left the target we throttled back to 150 miles per hour—that was just the point where an airplane which had lost an engine could stay in the formation. But if he's lost more than one engine, or if he had suffered other structural damage which caused him to slow down and fall out, it was just too bad. Positively we could not endanger the other planes just to accommodate that one."[23] LeMay was no armchair commanding officer. He was a thoroughly experienced pilot of four-engine airplanes, going back to 1935 when he flew the first B-17s. He was qualified as a navigator, bombardier, and even gunner. He knew what his planes were capable of doing and he knew what his crews could accomplish when properly trained.

* * *

How did the young flyers—brave men, indeed—cope with these terrifying scenarios? Their views of themselves as part of an elite fraternity certainly contributed to their endurance. Typically better educated, and drawn from a higher socio-economic base than other GIs, they were given more demanding training and treated with more dignity during training and generally received

better treatment throughout their periods of combat. There was a high ratio of officers to enlisted men and a dominance of higher ranks among enlisted men, which further contributed to their bravado. Airmen also got more rapid promotions and more decorations. Most of the aircrews soldiered on, as a result, their dedication to their squadron mates perhaps the key driving force. Yet many were unable to do so and cracked emotionally. And some deliberately flew their planes into internment into the two neutral countries, Switzerland and Sweden, that closely bordered their flight routes into and out of Germany.

Could bomber aircrews be compared to the Navy's submariners, who suffered far greater losses proportionally, crash-diving as fast Japanese destroyers rushed in, submarine crews listening in expectant horror to the swish-swish-swish of the propellers of the hunters on the surface above, and then the splashes of the depth charges followed by the thunderous, jarring explosions of near misses? Or to Marines charging ashore from their landing craft onto beaches traversed by withering enemy fire, bent over to make smaller targets, the acid taste of bile in their mouths? Or to their fellow fighter-plane pilots who also routinely flew to their deaths in the skies over Germany, P-47 pilots in particular with a fuel tank right behind their seat? Courageous young men, too, and volunteers all.

A perhaps typical flight surgeon for B-17 squadrons reported his experiences in Italy from 1943 to 1944. He recorded that anxiety rather than fear governed the lives of the aircrew members he closely monitored. Intermingled was a "conglomeration of emotions and desires: a longing to be with loved ones, a feeling of wrath against slackers back home, indignation at seemingly poor leadership on his combat missions, an overpowering fear of flak, and dissatisfaction with living conditions in the squadron."[24] Another flight surgeon pointed to specific factors that contributed to the flyers' fear and anxiety. "Some fear takeoffs, while others fear formation flying, especially if the weather is bad or rough. Flak causes many considerable anxiety. The first experiences with flak do not usually arouse much fear; but when one receives physical injury, or his plane is badly shot up resulting in a forced or crash landing, or if planes in the formation are shot down in flames, the individual's fear of flak takes marked strides."[25]

To boost morale among the crews who clearly were able to assess their bleak prospects for survival, especially during 1943 and early 1944, the USAAF took a page out of the RAF Bomber Command's operations book and es-tablished a bogey of combat operations called a "tour." Soon after the start of the war in 1939, the British tour had been 200 hours after which crew-men qualified for a "rest." This was promptly changed to 30 combat sorties, regardless of flying time, when it became known that some pilots were throttling back their engines or lowering their landing gear on the way home to slow down and thus add time to their missions. After their "rest," generally as flight instructors which was also dangerous work, the crewmen were assigned a second tour of

20 combat missions. If an RAF crewman somehow miraculously completed 50 combat missions—and "statistically no one could expect to survive beyond fourteen operations"—he could opt for 20 more.[26]

Starting in the spring of 1943 the 8th Air Force instituted its own combat tour. The first tour was 25 combat missions. Airmen completing this tour would be assigned to new duties in the United States; for them the war was over. This tour was increased to 30 missions in April 1944 on orders from Arnold, with the arrival of the long-range North American P-51B Mustang escort fighter. Doolittle took the responsibility as well as the scorn. In September, with losses below two percent per mission in the European theater, when the depleted Luftwaffe rarely challenged U.S. air supremacy, the tour was raised to 35 and remained at that level until the end of the war. Men in the 15th Air Force in the Mediterranean theater had to complete 50 combat missions before becoming eligible for reassignment; that war zone was considered less hazardous to the longevity of bomber aircrews.

Statistically, U.S. bomber aircrews well into 1944 had only about a 25 percent chance to complete their tours unscathed, about the same as their RAF counterparts. The tour represented their "light at the end of the tunnel" and it was the key element in maintaining morale. Every investigation conducted by the Department of Psychiatry of the 8th Air force revealed that "the large majority of the flyers sought to preserve their own self-respect and to merit the respect of their teammates, and to finish the combat tour. Few of them hated the enemy and few apparently had strong idealistic motives for fighting."[27]

The War Department produced an hour-long propaganda film in 1943 about the 8th Air Force, aimed at the population at home. It was titled *Memphis Belle*, the name of the B-17 that was the film's star. The plane and its crew had completed 25 combat missions and both were headed back to the United States. It was such a special occasion that England's king and queen visited the base to thank the crew and wish them well.

In contrast, German and Japanese aircrew, brave young men too, flew combat missions until they were killed or so grievously wounded they would later be assigned to desk duties. Many Luftwaffe flyers flew three and four missions every day U.S. bombers were in the air over Germany, against increasingly unfavorable odds. From mid 1944 on, the 60-mile-long bomber streams were escorted by hundreds of P-51, P-47s, and P-38s and only rarely could the Bf 109s and Fw 190s penetrate the fighter screens to strike at the bombers. Few veteran German flyers survived the war.

The second category of U.S. flyers included those who professed to their squadron commander and flight surgeons, and sometimes to their chaplains, their "fear of flying" or their downright insistence that they could no longer fly combat missions and that they were a danger to their fellow crewmen. On a mission to Saint-Nazaire in France in January 1943, one flyer, filling in for a hospitalized fellow navigator, many years after the war wrote of the

mission that had shattered him and sent him home for emotional rehabilitation. On the flight back to base, he recalled vividly that his emasculated squadron had run into 120-miles-per-hour headwinds, slowing the planes to what seemed to him like a crawl. His recounting—almost a requiem—contrasts sharply with Lay's (see pages 143–145 above) who had written more as a somewhat dispassionate observer rather than as a participant.

> I see the clouds, the clouds building up so that we couldn't see the ground, we had no sign of movement, the B-17s standing still and the Focke-Wulfs and Messerschmitts coming in to meet them, coming in to knock us out of the sky. For a moment, for a long moment, I was not navigating. I was watching the planes falling, the head-on crash of a fighter into a B-17, the exploding, burning, war-torn planes, all too often no chutes in sight, the lonely men held to their seats, to the walls, to the roof of the plane as it twisted and fell, sometime with machine guns blazing, and a spume of smoke for a long moment. It seemed endless. It seemed as though we would never get home. I was looking out the window at the endless blue sky and white cloud beneath us. We waited for the Focke-Wulfs and the Messerschmitts and we watched the Fortresses fall. I wanted to hold them. I prayed.[28]

These emotionally crippled aircrew posed a dilemma to their commanders. On the one hand, there was a surfeit of increasingly well-trained replacements in the pipeline from the U.S. to England; on the other hand, to simply acquiesce to those flyers' weaknesses was to send a dangerous signal to the squadron or group as a whole. The RAF typically used bare knuckles in treating such airmen as cowards, stigmatizing them as waverers. Frequent aborters were also liable to be investigated as waverers. There was also the RAF euphemism that was adopted by the AAF: "Lack of Moral Fibre." By RAF directive, aircrewmen categorized as LMFers were individuals "whose conduct may cause them to forfeit the confidence of their commanding officers in their determination and reliability in the face of danger." At a minimum, the individual's flying brevet was removed from his uniform. There were no longer the front-line trenches of the Western Front of World War I to which recalcitrants of one form or another could be banished, to their likely death or dismemberment. Indeed, LMFers from Bomber Command understood they faced almost certain death if they continued flying. One station commander was blunt: "Every case before me was punished by court-martial and where applicable by an exemplary prison sentence."[29] Generally American flyers were given the benefit of the doubt, and commissioned officers categorized as LMFers were ordered to undergo psychiatric evaluation; those declared unfit to fly were reassigned to the United States to a demeaning staff job. Enlisted men, on the other hand, were summarily assigned to onerous duty and kept on base as examples to their peers.

Other more compassionate commanders ordered individuals who showed

signs of "battle fatigue" to mandatory leave at special rest homes in the country to relax and recuperate. The homes were typically large mansions that provided the equivalent of hotel service. Food was excellent, typified by two real eggs for breakfast. Sports and amusement facilities were on the premises. Despite the circumstances of their being there, though, the "guests" were free to come and go as they chose. The period of stay was generally one week, depending on the recommendation of the group's medical officer. A total of 14 such facilities were ultimately made available by war's end, and they were accorded high marks by the attendees.[30]

Not nearly as popular, apparently, was a program of rest and recuperation instituted in the summer of 1944 in the far-off sunny climes of Miami Beach, Florida, and Santa Monica, California, with their lonesome bathing beauties. "Most of them did not enjoy their vacations, or so they said, because of the prospect of an early return to combat. And they often expressed their resentment of civilians and of military personnel who had not yet been sent overseas. Some of their remarks were interpreted as revelations of bitter hatred of their senior officers and as opposition to the prosecution of the war."[31]

Finally, there were those few airmen who either "couldn't take it any longer" for a variety of reasons or who had developed serious reservations about the war and their part in it. Certainly some flyers must also have acquired moral scruples about the indiscriminate bombing of cities and their civilian populations in which they were active participants. They could decide to "fly into internment." As far as the top brass was concerned, knowledge of such unpatriotic actions could spread like a contagious disease and affect the morale of all AAF personnel and hamper the effectiveness of the entire American strategic bombing effort. In July 1944 a report written by an American consulate official in Sweden brought the issue to a head. At that time there were 94 8th Air Force crews interned in Sweden and 101 in Switzerland—nearly 2,000 men—along with their impounded B-17s and B-24s, and rumors had been circulating "literally on a global scale, wherever U.S. armed forces were," about the comfortable vacation out of harm's way—with full flight pay as if they were POWs—enjoyed by those men.[32]

One example of these "rumors" were these harsh comments by an outspoken 15th Air Force pilot:

> The great harbor of Venice went under my left wing, and we crossed the coastline east of Lido di Lesolo.... The mountains below us were magnificent, great towering wind-swept crags that invited us beyond them to the west where they held the quiet haven of Switzerland. Many crews had gone in there to be interned for the duration; a few of them had to, but many were men who sought to live another day by any means and had no compunction about feathering a good engine and limping down in this pitiful deceit to live forever among the lotus eaters.[33]

Had those aircrews purposely flown intact airplanes into neutral countries to escape the war? It was understood, too, that some flyers had bailed out over neutral territory, also becoming internees; had those men been forced to leave crippled planes or were they also voluntarily leaving the war for a safe refuge? The U.S. diplomat had interviewed the interned U.S. flyers and wrote that those he had talked with told him they did not want to fly again, and seemed to him to be cynical about the war. Moreover, some said they hated their top commanders whom they felt had been callously sending them on suicide missions. He summed up his findings by suggesting that "a disproportionate number of the emergencies which caused the forced landings were not genuine, that cowardice was a major factor."[34]

This report, with its devastating conclusion, landed like a demolition bomb on the desk of General Spaatz, who by then was overall commander of both the 8th and 15th Air Forces, and understandably sensitive about aircrew morale. He immediately sent a team of his staff officers to Sweden clandestinely to interrogate the flyers. Their report contradicted the earlier allegations of disloyalty, and apparently Spaatz was satisfied. But General Arnold in Washington, who had also learned about the original report and Spaatz's follow-up was not nearly so sanguine. He cabled Spaatz that it was his view that such landings in neutral countries were "intentional evasion of further combat service." Spaatz didn't see it Arnold's way. He angrily wired back that his report indicated that nearly all the aircraft had experienced major battle damage such as ruined engines and shot-up control surfaces. There had been many seriously wounded crewmen, some still in hospitals. He defended the patriotism and high morale of "his boys" by reminding Arnold that beginning in January 1944 for six months, the 8th Air Force had flown 51,457 sorties, losing 2,128 aircraft shot down and 15,346 returning with battle damage. Less than half of one percent had landed in Switzerland or Sweden.[35]

Still skeptical, Arnold ordered a secret survey of his own among aircrews in England to learn about the prior records of the men detained in Sweden and Switzerland. Apparently the results of those investigations finally satisfied the Air Force's leader and he turned to more pressing problems. When interviewed by Air Force historians in 1950, Gen. Ira Eaker, Spaatz's predecessor as 8th Air Force chief, disclosed that he had talked with many of the interned crews after their release, and insisted that he was convinced that there "was not a single case" of what he called "unwarranted landing."[36] Presumably, many 8th and 15th Air Force veterans who knew better would later be astonished when they learned of Eaker's hyperbolic deception.

Aborting was a far more common "out," albeit a temporary one, for those pilots and their crews unable to face a particular mission. It was simply a matter of turning out of formation en route to the target before engaging enemy aircraft and returning to base, claiming mechanical or personnel "failure." Aborts could be as high as 10 to 15 percent and even higher if the mission

promised to be especially hazardous. The missing plane with its ten or more .50 caliber machine guns weakened a formation's defense, and for that reason there was a stigma attached to every abort, regardless of its justification.

Aborting was also a galling issue for group commanders. High abort rates meant reduced tonnage of bombs dropped over targets, reflecting negatively on the command's ability to sustain high morale and the effectiveness of its maintenance procedures. Nevertheless, aborting was generally not an easy decision for most flight crews. Once airborne, crews typically wanted to complete the mission so it could be chalked up against the total needed to complete a tour. Further, and increasingly as casualties mounted, commanders would put pilots and copilots on the carpet and demand valid reasons for their aborts. One commander reported that he considered it was "his duty to meet any airplanes to see why they returned and to determine what penalties if any were to be given to the crews that returned early for insufficient reasons. Fear was the reason for most of them, and the smallest mechanical failure, such as high cylinder head temperatures on takeoff or climb-out, would bring a nervous pilot home early every time. These early returnees were called abortions. The pilot of one early returnee that I recall gave me the excuse that he was temporarily blinded. He told me that out over the Channel he was unable to see the other airplanes in his formation. I asked him how he managed to land his airplane, and he explained that when he got back down to sea level he had regained his eyesight! I assessed him three extra missions.... Only by holding each pilot personally responsible could we control the abortion fever."[37]

As of January 1944, 8th Air Force statistics showed that only 26 percent of aircrews beginning tours could expect to complete 25 missions; 57 percent would be dead or missing; the remaining 17 percent would fail to complete their tours because of "combat fatigue," accidental death, or "administrative" causes. The 8th's loss rate from July through November 1944 was 3.8 percent per mission. This meant that out of every 100 aircrew in July, by December 64 would be dead, seriously wounded, or prisoners of war. Even with only a 2 percent loss on every mission, an exceptionally low figure, a crew at the start would have only a 50 percent chance of finishing its tour.[38]

* * *

In the Pacific, aircrews of the newly constituted 20th Air Force flying from bases in Saipan, Tinian, and Guam in the Marianas[39] to strike targets on the main islands of Japan faced a different set of circumstances. On the positive side, their roomy B-29s were more comfortable than B-17s and B-24s. They were pressurized and heated, creating essentially a "shirt-sleeves" environment. This meant that the men on their long missions could smoke, sleep, eat, and move about unencumbered by heavy flying clothing. Anoxia was almost unheard of and oxygen masks were required as a safety precaution only close to the target when the planes were in danger of being holed

by enemy fire that could cause decompression. Frostbite, so common over Germany, disappeared.

The flip side of the coin for the aircrews was the nature of the missions: 3,100 miles round trip, all over the vast reaches of the Pacific, unpredictable weather, return flights at night, and in an airplane with dangerously unreliable engines to boot. Navigators got lost, planes ran out of fuel due to unexpected headwinds or succumbed to enemy damage or had multiple engine failures. By the spring of 1945, aircrews "faced greater risks from the hazards of flying than they did from the enemy, who accounted for only one-fifth of the B-29s downed."[40] If the pilot had to land in the ocean, his B-29 with its broad mid-wing was an excellent airplane for ditching. And ditching was commonplace. Nevertheless, postwar statistics show that overall, 20th Air Force crew who went down at sea had only a 50/50 chance of survival. When a thoroughgoing air rescue operation was finally put into effect in the late spring of 1945, using submarines, surface ships, and special "Super-Dumbo" B-29s carrying lifeboats to be parachute dropped to survivors, the odds were far better for rescue. In mid March, when organized resistance ended on Iwo Jima—halfway between the Marianas and Japan—practically overnight it became a stopover for B-29s. By war's end, 2,251 B-29s had made emergency landings on the tiny volcanic island. The cruel tradeoff: 6,891 dead U.S. marines for perhaps as many or even more Air Force crewmen.[41]

Overall, costs in men and airplanes for the B-29 operations against Japan were far less than for the strategic air offensive over Germany: 1,090 flyers were listed as killed in action, 1,732 as missing in action, and 362 returned from prisoner, internment, or missing-in-action status. The 20th Air Force lost 414 B-29s in combat, 151 of which were attributed to "operational causes," 148 to enemy action, and 115 to "unknown causes."[42]

Life and living conditions on the barren islands of Tinian, Guam, and Saipan were considerably different from those at 8th Air Force bases in East Anglia where nearby towns, their pubs, and particularly their lonesome young women beckoned to U.S. airmen. London, that great tourist city, was a short train ride away and a perfect destination for a three-day pass for GIs with money to spend. On the Pacific islands it was stifling hot and humid, day after day, and the landscape was as boring as the tropical climate. The closest the flyers typically got to women were their weekly glimpses of full-page illustrations of Betty Grable, Rita Hayworth, and other Hollywood pinups wearing sexy lingerie or swimsuits and come-hither expressions in *Yank* magazine. Aircrews in the 20th Air Force counted their missions—initially 40 but later reduced to tours of 35—as zealously as those in the 8th and 15th.

B-29 flyers could expect barbaric treatment if they were forced to parachute over Japan. Japanese cruelty had been demonstrated well before the fire-bombing of Japanese cities, by the shooting by firing squad of three of

the eight captured fliers from Doolittle's B-25 raid over Japan in April 1942. Tokyo Rose's broadcasts warned that captured airmen would be treated, not as war prisoners, but as war criminals, tried as such, and if found guilty, promptly executed. Some B-29 airmen were "shot, bayonetted, decapitated, burned alive, or killed as boiling water was poured over them," according to one source. The Geneva Convention, which had set uniform standards for treatment of war prisoners among its many "rules of war," was universally ignored by the Japanese military starting in the 1930s in its war with China and throughout World War II. In fact, the Japanese government was not a signatory of the international agreement. The United States was, but clearly violated provisions of the Geneva protocols that specifically banned indiscriminate area bombings of city centers.

As over Europe, some U.S. aircrew suffered emotional breakdown under combat stress or acted as if they had, and refused to fly. Some said they were opposed to the policy of indiscriminate bombing on moral grounds, while others said their fears prevented them from doing their jobs. One apologist historian categorically states, "It must be emphasized that they were few in number.... Such stories are numerous, but few can be documented." B-29 aircrew flying individual missions at night and unseen by squadron-mates, sometimes dumped their bomb loads into the ocean before they made landfall over Japan; "when they returned to bases, those crews claimed their cameras had malfunctioned and they received mission credit. One pilot who flew 32 missions recalls seeing 'splashes of fire' on several occasions."[43]

* * *

Did the crews of U.S. bombers have any compunction about killing civilians with their bombs? The small sampling of World War II Army Air Force veterans asked this question by the author more than a half-century after they had flown over Germany and Japan typically responded evasively: they were following orders, there was a war to be won, and they wanted to get it over with and get home. One of those interviewed, a B-29 pilot, still maintained his angry World War II stance by asking rhetorical questions: who started the war?; what about the Bataan Death March?; who was responsible for the murder of the Doolittle flyers? The author of *Bock's Car*, a factual account of the B-29 mission that dropped Fat Man on Nagasaki, perhaps spoke for most of the courageous American flyers who put their lives on the line every mission in this brief soliloquy:

> Glancing back, Sweeney [Major Charles Sweeney, the plane's commander] could see the top of the bomb, yellow with black tail fins and obscene and explicit messages written on it, and he began to speculate on the immense power that lay within that shell. The decision of whether or not to drop the bomb was one with which he had never concerned himself. That was a moral,

a political, a grand-strategy decision, and he was simply a soldier trying to do his job as well as he could. He was like most bomber pilots who have formed a defensive armor about their particular role in war. Their function is to drop bombs on targets, not on people ... a target didn't live or breathe or hurt.[44]

10

The Defenses

By early 1944, the Luftwaffe's strength had been gradually and irrevocably worn down. There had not been any decisive air battles or clear-cut victories. Rather, the American pressure put the German fighters in a meat grinder battle of attrition both in terms of pilots and material. It was the cumulative effect of that intense pressure that in the final analysis enabled the Western Powers to gain air superiority over Europe; that achievement must be counted among the decisive victories of World War II.[1]

We never lost a B-29 in any attack that could be attributed to one [Japanese night fighter] ... one of the reasons I took the guns out of the night bombers in early March was that I was more worried about our guys shooting each other than I was about the night fighters.... Most of the bombers we lost in the Pacific came down due to mechanical malfunctions.[2]

The principal defenders of the Third Reich from the USAAF bomber streams, 1,000-planes strong and 60 miles long by mid 1944, and their hundreds of fighter escorts, were two Luftwaffe single-engine interceptors, the Messerschmitt Bf 109 and Focke-Wulf 190. Twin-engine, twin-crew Messerschmitt Bf 110 Zerstörers (Destroyers); their newer replacements, Me 410s; and Junkers Ju 88s were also used but were fewer in number and relatively vulnerable to the more maneuverable U.S. P-51s and P-47s. Both the 109 and 110 kept their original Bf abbreviations (for Bayerische Flugzeugwerke) even though in July 1938 the company had become Messerschmitt Allgemeine. Luftwaffe flyers and ground crews were well-trained, patriotic Germans—if not necessarily "fanatic Nazis" as Allied propaganda stressed—and many had combat experience as German "volunteers" in the Condor Legion in the Spanish Civil War.

By nearly any yardstick, the Bf 109 was the most successful military air-craft in history. Over 33,000 were produced, surpassed in numbers only by the Soviet Union's Ilyushin II (Shturmovik) ground attack plane, over 36,000 of which were manufactured. The first prototype flew in 1935, the same year as the Boeing B-17; the last one to come off an assembly line was in Spain in 1957. The plane served in the air forces of several nations throughout the 1950s as first-line fighters until jets made them obsolete. Paradoxically, the fledgling Israeli air force used cast-off German Bf 109s brilliantly in the 1948–49 war.

The Bf 109 was an excellent dog-fighter, nimble and fast, but its stan-dard armament early in the war—two 7.9 mm machine guns and a single 20 mm cannon firing through the propeller hub—which was ideal for fighter-to-fighter combat, proved to be too light against American heavy bombers. It took cannons and plenty of rounds—an average of 20–25 hits with 20 mm shells, for example—to bring down a B-17 or B-24. Later model Bf 109s mounted two 20 mm cannons in streamlined blisters under each wing specifically for use against U.S. bombers.[3] But loading down fighters with heavy cannons (and heavy ammunition) put the planes at a disadvantage in dogfights with U.S. escorts, a dilemma never quite solved by the Luftwaffe.

The Bf 109 was powered by a Daimler Benz liquid-cooled inverted V engine; configured for the G-6 (Gustav) model, it produced 1,474 horsepower at takeoff. The engine was fuel-injected rather than carbureted as in Ameri-can and British engines, giving it a number of important performance advan-tages including immunity to centrifugal effects. Mustang and Spitfire pilots, for example, had to half-roll before diving to ensure that fuel from the car-buretors was thrown *into* and not *out* of their engines; but this took a split second that could spell disaster. The Gustav had a top speed of 386 miles per hour at 22,000 feet; more importantly, it could climb to that altitude in a brief six minutes. Despite being a dated design, the latest Bf 109s up to the end of the war in the hands of experienced pilots—increasingly rare due to attri-tion—could hold their own against P-51s. The Bf 109K, introduced in 1945 and available only in small numbers, had a top speed of over 450 miles per hour and a service ceiling of 41,000 feet.

The Focke-Wulf 190 was a younger design aircraft, first flown in 1939, and considered to be generally superior to the Bf 109, and the equal of the best of the Allied fighters—the Spitfire V and the Mustang P-51B. Its rate of roll, a critical performance parameter in dogfights, was the fastest of all fighter aircraft during the war. In the advanced A-8 version, it was powered by a BMW air-cooled radial engine, also with fuel injection, that developed 1,700 horsepower at takeoff, giving a maximum speed of 408 miles per hour at 20,000 feet. This model took ten minutes to reach that altitude but when it got there its powerful armament—delivering 74 pounds of shells and bullets in three second bursts from two 20 mm and two long-range 30 mm cannons

along with twin 13 mm machine guns—could readily knock down a B-17 in a single pass. Special squadrons, *Sturm Staffelln,* were equipped with A-8s specifically to tackle U.S. bombers. These planes had armor-plated cockpits with bullet-resistant canopies. Pilots were trained to close to just out of the range of the .50 caliber machine guns of the bombers' aft turret and open fire—typically with devastating effect. The latest version, the Fw 190K, introduced just before war's end, was powered by an in-line liquid-cooled engine that gave it a top speed of 452 miles per hour and a service ceiling of 41,000 feet.

The heavy twin-engine Luftwaffe fighters, Bf 110s, Me 210s and Me 410s, packed lethal wallops. Most were armed with two 30 mm and four 20 mm cannons with plenty of ammunition for sustained bursts. Some also carried two huge 21 centimeter (8.2 inch) diameter "rockets," actually mortar shells, in launching tubes under the wings that were seven feet long and weighed about 250 pounds. These shells could be fired from a distance of more than a half-mile and were lobbed into the tight box formations of B-17s and B-24s, from out of the range of the bombers' .50 caliber machine guns. The heavy explosions blasted apart the formations, resulting in disabled bombers and stragglers that became easy pickings for the lurking Bf 109s and Fw 190s. Throughout the war, 8th and 15th Air Force aircrews feared these early air-to-air missiles most of all, for they could mount no defense. Parachute fragmentation bombs, time-fuzed to explode among the bombers, also were dropped from above the formations, intended to disperse the formations. Introduced later were smaller 5 centimeter (2 inch diameter) rockets, R4Ms, that were mounted on wooden rails below the wings, and fired in salvos of 24 much like a shotgun. They were launched outside the range of the bombers' guns and proved devastatingly effective; their piecemeal introduction in 1945, however, was too late to have an impact on the air war.

To counter RAF Bomber Command's nighttime missions, the Luftwaffe sent aloft specially equipped Bf 110s each of which mounted a pair of 20 mm cannons almost upright in the fuselage, dubbed *schräge Musik* (slanting music or jazz). These planes slipped stealthily beneath RAF bombers, none of which had ventral gun turrets, and at point-blank range set afire the fuel tanks in the wings; the bomb bay was avoided since an explosion of the bomb load could destroy the attacking plane. These as well as other heavy nightfighters— Dornier 217s, Junkers 88s, Heinkel 219s, and Me 410s—were also hurled into the daylight air battles with the AAF in 1944 and 1945. Configured for nighttime roles, they were encumbered by their radar aerials and flame dampers, but more importantly their crews had little experience and training in daylight interceptions, limiting their effectiveness.

In August 1942, when the 8th Air Force first began operations over Europe, only about one-quarter of the Luftwaffe's day fighters were on the western front; the balance were fighting in Russia. Even at the start of 1943,

only about 350 fighters were available to confront the growing numbers of B-17s and B-24s. By mid 1943, however, when the U.S. bombing offensive was beginning to be recognized as a serious threat, the number of Luftwaffe fighter aircraft rose to about 600 and more were on their way.

Numbers alone, however, do not tell the whole story of the growing peril to the B-17s and B-24s. The Luftwaffe adapted its tactics to reflect its increasing numbers and its growing confidence and skill. The individual fighter attacks of 1942 became coordinated, slashing assaults in twos and threes and in squadron and multi-squadron strength. The Luftwaffe concluded that frontal attacks—"12 o'clock high" in bomber crew parlance—where the bombers' defensive armament was weakest, offered the best chance of downing a bomber by killing or severely wounding its two-man cockpit crew. Such tactics, at closing speeds of 500 miles per hour, gave the bomber gunners precious few moments to respond. Fighters also approached from directly behind the bombers. These tactics were more dangerous to the attackers because overtaking a bomber exposed the fighter to defensive fire for longer periods. For example, an assault that began 1,000 yards behind a bomber typically took the Luftwaffe plane about 20 seconds to close to about 100 yards, the ideal distance for the pilot to initiate his burst of fire. But if the rear gunner were killed or disabled in a first pass, subsequent attacks were almost invariably lethal for the bomber.

The average flying time of the German day fighters, without reserve tanks, was between 60 and 90 minutes, depending on whether the planes intercepted the bombers and engaged in combat. Reserve tanks increased flying times by up to two hours, but compromised performance. Typically, the fighters landed, were rearmed and refueled, and immediately took off from the nearly 500 camouflaged airfields across Germany to subject the bomber streams to almost continuous attack on both legs of their missions.

Fuel shortages had begun to limit Luftwaffe pilot training from the spring of 1944 on. As a consequence, new Luftwaffe pilots were sent into combat with only about 100 hours of flight training, compared to their American equivalents who had 250 hours or more. The Luftwaffe strained to make up for its dwindling numbers of experienced pilots with radical new equipment, particularly with the most spectacular fighter plane of the war: the twin-turbojet-powered Messerschmitt Me 262 Schwalbe (Swallow). It boasted a maximum speed of 540 miles per hour at 20,000 feet and clustered four heavy 30 mm cannons in the nose. Its rate of climb was equally impressive, 4,000 feet per minute, as was its service ceiling of 40,000 feet. About 1,300 Me 262s were produced but only about one-quarter ever flew in combat and thus the jet did not have a serious impact on the air war over Germany. The sleek, swift jets nevertheless were feared by the 8th Air Force's top commanders and bomber aircrews alike after they first appeared in combat in small numbers in 1944. On March 18, 1945 when 1,250 bombers attacked Berlin, in the heaviest raid

on the German capital during the war, 37 Me 262s were sent aloft to defend against them:

> Though the bombers were escorted by no less than 14 fighter groups of the recently so superior P-51 Mustang, the jets pierced their defensive screen without trouble. Outclassed by the easy, elegant flight of the Me 262s, the Mustangs had suddenly become ponderous and outmoded airplanes. The jets claimed 19 certain victories, plus two probables, for the loss of two of their own aircraft. The American figures were 24 bombers and five of their fighters lost.[4]

Messerschmitt Me 262 Schwalbe (Swallow). The first turbojet-powered fighter plane to see combat in World War II and by far the war's most spectacular performer. Plane shown, at Rheinman Airport near Frankfurt in early 1945, had been flown over U.S. lines and surrendered to U.S. forces by its Luftwaffe pilot. (Courtesy National Archives)

Contrary to popular myth that Adolf Hitler's insistence that the jet be configured as a bomber was the cause for the plane's delayed introduction as an interceptor, in fact delays were imposed by engine shortages, not by aircraft modifications on the production line. The revolutionary Junkers turbojet engines required exotic high-nickel and -molybdenum alloy steels to resist

the extreme operating temperatures of highly stressed compressor and turbine blades and combustion-chamber components, and these materials were scarce. Indeed, German engineers were never able to come up with satisfactory substitute materials and had to settle for conventional alloy steels that required engine replacement typically after only 12 hours' operation.

An even more revolutionary Luftwaffe interceptor was the Messerschmitt Me 163 Komet, a tiny rocket-engine-powered plane of astonishing performance. Like the Me 262, the Me 163 was accorded low priority by the Luftwaffe when it first flew in 1940. By January 1944, as 8th Air Force daylight raids grew in intensity, the Me 163 was rushed into production. A *Staffel* was equipped with the first models off the assembly line and the new plane first saw combat in May 1944. Available in only tiny numbers, the 163 was rarely seen by U.S. aircrews. It had a top speed of over 600 miles per hour and a phenomenal rate of climb of over 5,000 feet per minute. Its one serious limitation was its brief flight endurance: only about seven minutes. This meant that it could generally make only a single pass through a bomber formation before it had to disengage and return to its base.

German early-warning and tracking radar as well as radio-intercept capability also improved rapidly. By the end of 1942, the Germans monitoring 8th Air Force radio communications found that any large increase in activity on U.S. radio frequencies pointed to an imminent raid. And by the time the 8th Air Force had begun mounting major missions into the heart of Germany in mid 1943, Luftwaffe intelligence was routinely intercepting radio communications in real time, coded and uncoded. As the airborne units were forming up over England and the Channel in the early morning hours, the Germans were learning details of squadron strength and deployment. Even earlier, since relatively cloud-free conditions at altitude were mandated for safe assembly into combat formations, German high-altitude reconnaissance aircraft overflew both bomber bases and assembly areas. Once the massive formations crossed the Channel and were over France, the excellent German Freya radar systems picked them up and tracked them into Germany. Until as late as April 1944, when long-range P-51B escort fighters came onto the scene in numbers, Luftwaffe fighters safely flew alongside the bomber streams outside the range of the bombers' machine guns, since their escorts were forbidden to leave the bombers. These "scouts" radioed precise running reports of course headings, altitudes, and numbers and types of escorts to ground control. When the short-ranged escorts had to turn back, the Germans launched their attacks.

Luftwaffe fighters accounted for about three-quarters of all 8th Air Force bomber losses until the end of 1943, during which time the loss rate per mission of B-17s and B-24s averaged 5.2 percent. During the first half of 1944, when the bombers were first given fighter escort all the way to their targets deep into Germany and back again, Luftwaffe fighters were responsible for

about 60 percent of combat losses, which averaged about 2.5 percent per bomber sortie. In April, the 8th lost the most heavy bombers it would lose in a single month of the war, 409. From July 1944 until the end of the war, the overall loss rate was far lower, 0.8 percent, with antiaircraft fire accounting for more than 60 percent of all losses.

By 1945, there were far fewer German fighter planes in the air to contest American air superiority and correspondingly fewer bomber losses. One B-17 pilot who completed 24 combat missions over Germany during 1945 told the author that he remembers glimpsing only a single Luftwaffe fighter plane during all of his missions to targets deep into Germany. It was an Me 262 and he recalls seeing it "for only an instant." On one mission, his plane was hit by antiaircraft fire which severed a main electrical cable, cutting off power to his instruments and radio, but he managed to return to his base. He pointed out that pilots would try to "get home" at all costs, rather than have the crew bail out—especially close to their targets—because they understood that civilians would often kill downed American flyers before they could be "rescued" by the military.[5]

* * *

As the comparative fighter-plane strength of the Luftwaffe ebbed during 1944 relative to the 8th Air Force, German air defenses focused increasingly on antiaircraft fire or flak. This commonly used acronym was derived from the German *Fliegerabwehrkanone* or antiaircraft gun. The *Flakartillerie* had been part of the Luftwaffe since 1935, from which it gained important insights into bomber aircraft tactics and performance. The number of personnel—men, women, and boys—manning flak batteries rose from some 255,000 in 1940 to nearly 900,000 in 1945, directing the fire of some 49,000 antiaircraft guns. "At their prime, the flak forces collectively could fire 5,000 tons of shells per minute into the skies over Germany."[6]

Most of these guns were formidable 88 mm (3½ inch diameter) cannons. The 88 was feared equally by outgunned U.S. Army tank forces, who encountered it—rarely more than once!—as the main armament on the Wehrmacht's fearsome Tiger and Panther panzers, and as a stand-alone trailered gun where the flat trajectory of its antitank rounds gave it outstanding accuracy and killing effectiveness at long ranges. These versatile cannons were also deck-mounted on U-boats. As antiaircraft weapons, the 88s were typically configured in radar-controlled batteries of four to eight individual cannons and emplaced in concentric circles around all important targets, especially Germany's largest cities, and in a belt across Germany's western border. The Germans also had 120 mm and even heavier guns that could reach up and destroy the highest-flying U.S. bombers.

The 88's shells were time-fuzed to burst at the estimated altitude of the bomber stream; they traveled at 1,000 feet per second and were destructively

effective up to 20,000 feet and even higher. It did not take a direct hit from an 88 mm burst to cripple a big bomber: a "close miss" sufficed. Clouds of red-hot steel shards would tear into engine nacelles, disabling the engines and slowing the plane, forcing it to drop out of its tight defensive formation and leading to almost certain destruction by Luftwaffe fighters. Or it would sever fuel lines or rip open fuel tanks that would cause uncontrollable fires that would demolish the plane in the air or send it hurtling to the ground. Or it would tear apart wings and tail surfaces that meant loss of control that also doomed the plane. The shrapnel would also cut through the cardboard-thin aluminum-alloy fuselages and wound, dismember aircrew, or kill them outright. By the middle of 1944, flak accounted for more losses of U.S. bombers than Luftwaffe fighter aircraft. For example, in January 1944, flak shot down 27 bombers; in June, the 8th Air Force lost 2½ bombers (201) to flak for every one lost to enemy fighters (80).[7]

Fortunately for the USAAF and RAF Bomber Command, what the Germans did not have in their flak inventory was proximity fuzes, which did away with the guesswork of time fuzing. Developed first by British radar technicians, these fuzes contained a tiny battery-driven radio that transmitted a signal which in "proximity" to its target (an aircraft, or the ground when used in an air-burst artillery shell) reflected the signal back to the fuze, triggering a signal that detonated the shell. The electronics package was miniaturized to fit inside a shell and made rugged enough to survive the enormous accelerations of being fired from a gun. U.S.-manufactured proximity fuzes, based on the British invention, were designated VT or variable-time fuzes in an attempt to obscure their true function. The VT fuze radically increased the effectiveness of antiaircraft fire. The fuze was first used by the U.S. Navy in the Pacific against kamikaze attacks and against V-1s in the summer of 1944. The Germans tested their own proximity fuzes toward the end of the war, based on acoustic and infrared sensors, but never perfected one.

Albert Speer, the Reich's Armaments Minister, estimated that 30 percent of total gun output and 20 percent of heavy ammunition output was intended for air defense and that about the same percentage of Germany's weapons manufacture went to antiaircraft production. Additionally, about 50 percent of electro-optical production and 30 percent of the optical industry was devoted to radar and signals equipment for antiaircraft installations. He summed up the growing role of antiaircraft defense in August 1944, touching on an important advantage: "In the last few months flak has shown that in the massed attacks on our cities it has brought down more aircraft than hitherto thought possible.... In view of the shortage of aircraft fuel which we must expect we cannot say what are our prospects, both in home defense and in dealing with enemy air forces at the front. But we can say at any rate that flak drives the enemy higher and higher and his accuracy is correspondingly diminished."[8]

With a surplus of planes and a shortage of fuel in 1945, the Luftwaffe in desperation turned to *Sonderkommandos* (special detachments) whose volunteer pilots had a focused mission: ram enemy bombers. Most of these pilots were former fanatical Hitler Youth. As the politically indoctrinated *Sonderkommando* pilots closed on the bomber streams, they were exhorted to do their duty by women announcers over their headsets. Martial music and reminders that the B-17s and B-24s were killing innocent German women and children on the ground below contributed to the pilots' machismo. The Luftwaffe pilots were instructed to bail out after contact with the bombers, unlike Japanese Kamikaze pilots who were expected to die in their fiery crashes. For all their fervent patriotism, the *Sonderkommandos* achieved few successes.

* * *

At the end of 1944 when the 20th Air Force's B-29s began bombing Japan in earnest, the Japanese had only about 500 modern fighter aircraft, split between separate Army and Navy air forces, to defend their entire homeland. Few of these planes were the equal of the best of the Luftwaffe's. Structural strength of Japanese airframes and armor protection for the pilots had been sacrificed earlier in the war for range and maneuverability and these performance parameters were no longer significant. The Japanese needed fighters that could climb rapidly to the daylight cruising altitude of the B-29s, normally about 30,000 feet, and have sufficient fuel when they were at that altitude to make multiple attacks on the fast bombers. These performance characteristics demanded effective engine superchargers, which too few of the Japanese defenders possessed. When the B-29s launched their low-level nighttime firebombing assaults in March 1945, aircraft performance became secondary to radar tracking and target acquisition, neither of which were strong suits of the Japanese. Ground-to-air and air-to-air communications were also inferior compared to the Luftwaffe's.

Over Japan, the Japanese Army relied on three fighter-aircraft types. The best was the Kawasaki Ki-61, called Hien (Swallow) and code-named Tony by the AAF. Tony had a top speed of 348 miles per hour, a service ceiling of 33,000 feet, and mounted twin 20 mm cannons and two 7.7 mm machine guns. Next in high-altitude intercepting capability was the less well-armed Nakajima Ki-44 Shoki (Demon), code-named Tojo after the premier and war minister at the time. The third Army plane that could credibly defend against the B-29s was the Kawasaki Ki-45 Toryu (Dragon Killer), code-named Nick. This plane was twin-engined and twin-crewed, and mounted a formidable 37 mm cannon and three machine guns.

The Japanese Navy used its Mitsubishi Type-O carrier-based fighter, the legendary A6M Zero or Zeke, that had dominated the air war in the Pacific in 1942 because of its extraordinary range and outstanding maneuverability.

It had been manufactured in greater numbers and had served longer and in more theaters than any other Japanese fighter plane, but by 1945 was all but obsolete. Like the Tony, it carried a pair of 20 mm cannons and two 7.7 mm machine guns.

By 1945, two new and much-improved fighters began to see action over Japan, but their numbers were too few to affect the air battles. Both planes suffered reliability problems, particularly with their new engines, the Achilles heel of Japanese aircraft manufacture throughout the war. The Nakajima Ki-84 Hayate, code-named Frank, was essentially equivalent to the best of the U.S. Navy's and the USAAF's fighters. It was fast, with a top speed pf 392 miles per hour, well armored and with self-sealing fuel tanks, and powerfully armed with twin 20 mm cannons and two 12.7 mm machine guns. The second plane, the Kawanishi NIK1-J Shiden, code-named George, was some 30 miles per hour faster than the Zero but not as maneuverable.

Japanese antiaircraft artillery and radar fire-control systems were comparatively crude compared to Germany's, and Japan was never able to develop an up-to-date air defense command. Each Army air group, for example, was responsible for the defense of a single local prefecture. If Tokyo was struck, the nearby Nagoya-based air group would not be called into action. Compared to the heavy concentrations of powerful radar-directed 88 mm cannons that ringed German cities, the Japanese made do with inferior 75 mm cannons with an effective range of only about 22,000 feet, well below the cruising altitude of the B-29s. The Japanese had a copy of the German 88 in a mobile configuration but only a few of them. Even scarcer were heavy 120 mm guns that could reach the high-flying B-29s, but they were not mobile weapons and were in fixed emplacements around only a few of the major cities. Ground-to-air radars, again available in only small numbers, instead of guiding their night fighters, mainly served to train searchlight batteries onto the night bombers. Antiquated sound locators were also used right up to the end of the war for this purpose.

Germany provided some technological assistance to its Axis partner in the field of radar. An up-to-date Wurzburg radar was shipped by U-boat to Japan, along with technicians to assemble and demonstrate it. The powerful Wurzburg could serve either for ground-controlled interception or fire control but the Japanese never copied the design. In fact, the few radar models the Japanese had were typically held in low esteem by their operators, many of whom did not understand the concept of radio-ranging.

Japanese radar operated at a lower frequency than German systems in Europe. There, chaff—short, narrow strips of aluminum foil—was dropped by the bombers to confuse the radar systems as the planes approached the target. Over Japan, "rope" was used for the same purpose; it was also aluminum foil strips but wider, about one inch wide, and longer, 100 to 400 feet long. Toward the end of the war, every B-29 on night missions carried a 600-pound

load of rope to disorient defensive radar. During day missions, to jam gun-laying radar, special electronic countermeasure equipment was carried in selected B-29s, operated by specially trained officers called Ravens. This equipment intercepted and analyzed Japanese radar signals and, in turn, broad-cast jamming signals. Initially, only a few planes in each mission had Ravens and their sophisticated electronic equipment aboard, but by war's end, nearly all B-29s on daylight missions carried this extra crew member.

Compounding Japanese air-defense problems was the severe shortage of veteran pilots, most having been lost in the intensive air battles with supe-rior U.S. carrier forces in the previous months. Their replacements were hur-riedly trained newcomers, some of whom were formed into special "ramming" teams called *Shinten Seikutai* (Heavenly Air-Superiority Unit). The 10th Fly Division, responsible for defending the Tokyo-Yokohama region, was the first air-defense group to incorporate these "not-quite-kamikaze" flyers.[9] The program was quickly expanded to cover Japan's other large industrial centers such as Osaka, Kobe, and Nagoya. The aircraft for these ramming missions were stripped of armor, radios, and often armament to lighten them for enhanced performance. The pilots flying the *taitatari* (body-crashing) mis-sions often survived the attacks. The Japanese also turned to special suicide aircraft, known as *bakas*, to counter low-flying B-29s on night missions. These were tiny rocket-powered planes with a large explosive charge, carried aloft by a "mother" plane and released when searchlights illuminated the big bombers. The pilot then aimed his plane at the nearest B-29 and flew directly into it. *Bakas* had a small fuel supply that was good for only one pass through bomber formations, not unlike the Luftwaffe's rocket-powered Me 163.

German war-production managers had had far more foresight than their Japanese allies. In planning for the likelihood of air attacks, Germany's air-craft and engine production facilities were thoughtfully dispersed through-out the Reich. Structures were purposefully widely spaced and often built with walls configured at irregular angles to minimize bomb-blast effects. Buildings were made independent of one another with separate utilities when feasible and bomb-resistant basements were provided for workers. Not so in Japan.

Considering that the Japanese understood well that their tinderbox cities were acutely vulnerable to destruction by fire—dating from the giant earth-quake of 1923 that burned down much of Tokyo—and that they had had four years to study the air war over Europe and prepare for what was certain to come their way, Japanese passive air defenses were shockingly inadequate. For example, the Japanese aircraft industry—airframes, engines, and pro-pellers—was highly concentrated geographically. Nearly three-quarters of all output came from plants within a 350 mile radius of three of Japan's largest cities: Tokyo, Nagoya, and Osaka. Four companies manufactured two-thirds of all aircraft built during the war; three factories of two manufacturers

produced over 90 percent of all propellers and the two largest plants were in Osaka. Most engines were made in two plants, the Nakajima Musashi facility near Tokyo and the Mitsubishi plant in Nagoya. The Mitsubishi-Nagoya facility totaled 4.2 million square feet, one of the world's largest aircraft plants.[10] As events transpired in 1945, the Japanese would pay dearly for their sloth.

11

The Five Cities

Destruction would win the war.... The formula for unconditional surrender has been faulted often enough for making the enemy fight on. At least as plausible, it led the Allies to fight on. It seemed only to indicate that the path to unconditional surrender lay through unconditional destruction.[1]

...temperatures high enough to melt metal and bricks and to consume all the oxygen in the center of the city [Hamburg], asphyxiating and incinerating 45,000 people. The bodies of small children looked like fried eels on the livid pavement. In air-raid shelters people became bones suspended in congealed fat.[2]

Of the hundreds of bombing missions and thousands of individual bomber sorties conducted by British and American air forces on German and Japanese cities and their civilian populations from 1939 to 1945, five stand out as pinnacles of man's inhumanity to man: the firestorms in Hamburg, Dresden, Tokyo, Hiroshima, and Nagasaki.

The first of history's man-made firestorms was kindled on the night of July 17/18, 1943, in Hamburg, Germany's second-largest city with a pre-war population of about one and a half million, in a 728-plane incendiary-bomb raid by the RAF's Bomber Command. The next day, 252 American B-17s flew over, ostensibly to hit such industrial targets as shipyards and factories, but found the city obscured by the smoke rising from the still smoldering rubble; their bombs contributed little to the devastation—which by then had completely burned out about eight square miles of the city, an area about half as large as the island of Manhattan.

Earlier, on May 27, RAF Air Marshall Arthur Harris, in a Most Secret operation order no. 173 to his six group commanders, established his plan for

the destruction of the city, calling it the "Battle of Hamburg." He prefaced his directive for what later was code-named Operation Gomorrah in a straightforward manner:

> The total destruction of this city would achieve immeasurable results in reducing the industrial capacity of the enemy's war machine. This, together with the effect on German morale, would be felt throughout the country, and would play a very important part in shortening and in winning the war.... It is estimated that at least 10,000 tons of bombs will have to be dropped to complete the *process of elimination* [italics added]. To achieve the maximum effect of air bombardment, this city should be subjected to sustained attacks. It is hoped that the night attacks will be preceded and/or followed by heavy daylight attacks by the United States VIIIth Bomber Command [they were].[3]

Creating a bonafide firestorm demanded the confluence of two principal factors: the weather had to be dry with low humidity and many large individual fires had to be started at the same time. Fire fighters also had to be driven into shelters, if only temporarily, to allow the fires to build up. This meant blanketing the city area with a mix of bombs: tens of thousands of incendiaries and hundreds of high-explosive bombs. The HE bombs were also intended to smash water mains, create road blocks, break windows, hole roofs, and open up building walls. Unlike a large fire, which starts at a single point and spreads by stages over perhaps several hours, a firestorm starts with incredible speed.

For example, within only 20 minutes of the first attack wave striking Hamburg, two out of three buildings in a nearly five square mile area were on fire. This rapid build up made fire fighting extraordinarily difficult. As flames broke through roofs, a column of superheated air shot up to a height of about 13,000 feet, sucking in cooler air at its base, creating a street-level draft of gale-force velocity. The resultant winds carried burning material and sparks down the streets and heated all combustibles in the area to their ignition points. The fire consumed the free oxygen in the area and replaced it with the products of combustion, one of which, carbon monoxide, heavier than air, seeped into basement bomb shelters killing the huddled, terror-stricken occupants painlessly and silently. It was estimated that 70 percent of the deaths in the fire storm came as a result of carbon-monoxide poisoning.[4]

A more comprehensive summary of the raids, from the perspective of a biased yet remarkably dispassionate on-the-ground observer, the police president of Hamburg, appeared in a later official report:

> The cause of the enormous extent of the heavy damage and particularly of the high death rate in comparison with former raids is the appearance of firestorms. In consequence of these a situation arose in the second large scale raid during the night July 27th/28th which must be regarded in every respect

new and unpredictable. As a result of H.E. (high explosive) bombs and land mines, roofs were laid bare in large numbers, windows and doors blown in and the Self Protection Services were driven into the cellars. The incendiary bombs of all kinds then dropped in great concentration found ample food among the destruction already caused.

...Thus in a very short time there developed a hurricane of fire probably never known before, against which all human resistance seemed vain and was in point of fact, despite all efforts, useless.... The struggle by all personnel against the fire as an overpowering enemy increased in the course of the raids. It reached its climax in the last heavy raid during the night of August 2nd/3rd, in which the detonation of exploding bombs, the peals of thunder and the crackling of the flames and ceaseless downpour of the rain formed a veritable inferno.

...People who now attempted to leave their shelters to see what the situation was or to fight the fires were met by a sea of flames. Everything round them was on fire. There was no water and with the huge number and sizes of the fires all attempts to extinguish them were hopeless from the start.

One eyewitness report says: "None knew where to begin firefighting." The constant dropping of H.E. bombs and land mines kept driving people back into the shelters. The heat, which was becoming unbearable, showed plainly that there was no longer any question of putting out fires but only of saving lives. Escape from the sea of flames seemed already impossible. Women, especially, hesitated to risk flight from the apparently safe shelter through the flames into the unknown. The continual falling of H.E. and incendiary bombs increased their fears. So people waited in the shelters until the heat and the obvious danger compelled some immediate action, unless action was forced upon them by rescue measures from outside. In many cases they were no longer able to act by themselves. They were already unconscious or dead from carbon monoxide poisoning. The house had collapsed or all the exits had been blocked. The fire had become a hurricane which made it impossible in most cases to reach the open.... Only where the distance to water or to open spaces of sufficient size, was short, was flight possible, for to cover long distances in the redhot streets of leaping flames was impossible.

Many of these refugees even then lost their lives through the heat. They fell, suffocated, burnt or ran deeper into the fire. Relatives lost one another. One was able to save himself; the others disappeared. Many wrapped themselves in wet blankets or soaked their clothes and thus reached safety. In a short time clothes and blankets became hot and dry. Anyone going any distance through the hell found that his clothes were in flames or the blanket caught fire and was blown away in the storm.

Numbers jumped in the canals and waterways and remained swimming or standing up to their necks in water for hours until the heat should die down. Even these suffered burns on their heads. They were obliged to wet their faces constantly or they perished in the heat. The firestorm swept over the water with its heat and showers of sparks so that even thick wooden posts and bollards burned down to the level of the water. Some of these unfortunate people were drowned. Many jumped out of windows into the water or the street and lost their lives.

The destruction was so immense that of many people literally nothing remains. From a soft stratum of ash in a large air raid shelter the number of persons who lost their lives could only be estimated by doctors at 250 to 300. The scenes of terror which took place in the firestorm are indescribable. Children were torn away from their parents' hands and whirled into the fire. People who thought they had escaped fell down, overcome by the devouring force of the heat and died in an instant. Refugees had to make their way over the dead and dying. The sick and infirm had to be left behind by the rescuers as they themselves were in danger of burning.

The enemy attacked with ceaseless raids until the work of destruction was complete. The Utopian picture of a city rapidly decaying, without gas, water, light and traffic connections, with stony deserts which had once been flourishing residential districts had become reality.

The streets were covered with hundreds of corpses. Mothers with their children, youths, old men, burnt, charred, untouched and clothed, naked with a waxen pallor like dummies in a shop window, they lay in every posture, quiet and peaceful or cramped, the death-struggle shown in the expression on their faces. The shelters showed the same picture, even more horrible in its effect, and it showed in many cases a final protracted struggle against a merciless fate. Although in some places the sheltered sat quietly, peaceful and untouched as if sleeping in their chairs, killed without realization of pain by carbon monoxide poisoning, in other shelters the position of remains of bones and skulls showed how the occupants had fought to escape from their buried prison.

No flight of imagination will ever succeed in measuring and describing the gruesome scenes of horror in the many buried air raid shelters. Posterity can only bow its head in honour of the fate of these innocents, sacrificed by the murderous lust of a sadistic enemy.[5]

Estimates of the number of people who died in the Hamburg firestorm vary widely but local records total about 46,000, including about 22,000 women and 5,000 children. The reports from city officials, such as the above, were so ghastly that Hitler ordered a news blackout. Speer later wrote: "Hamburg put the fear of God into me. At the meeting of Central Planning on July 29, I pointed out that if the air raids continued on the present scale, within three months we shall be relieved of a number of questions we are at present discussing. We shall be coasting downhill, smoothly and relatively quickly."[6]

The Hamburg raid had been mostly an RAF "show." The Dresden incendiary bomb attack 19 months later, which achieved a second man-made firestorm, would be a joint AAF/RAF operation.

<center>* * *</center>

The Eighth Air Force was treated more gently [than RAF Bomber Command], both by the politicians in Washington and by the American public ... to this day [November 1963] it has never been officially admitted that by the end of the war they were bombing city centers and residential areas as wantonly by day as the RAF was by night ... the myth

was maintained that on every mission the Flying Fortresses aimed exclu-
sively at military targets, and this is still part of the official American
legend of World War II.[7]

Dresden was one of Europe's principal Renaissance-period cities, renowned for its art and architecture and commonly referred to as "Florence on the Elbe." In early February 1945, the Red Army was less than 100 miles to the east driving resolutely toward Berlin, their blooded troops raping and pillaging promiscuously. Ahead of the Soviets was a small army of fleeing German civilians, seeking refuge wherever they could find it and Dresden was in their path. Dresden was essentially undefended from air attack, almost like Guernica in Spain 8 years previously.[8] The city's antiaircraft batteries had long since been removed to defend other more important Reich cities and by that time of the war the Luftwaffe had neither the fuel nor the trained pilots to contest the air space over a city that the German high command did not consider to be a strategic target.

An internal RAF memorandum, issued to squadrons on the evening of the Dresden raid, established the *raison d'être* for the massive RAF/AAF attacks that would cremate and flatten a second German city and many of its occupants:

> Dresden, the seventh largest city in Germany … is also the largest unbombed builtup area the enemy has got. In the midst of winter with refugees pouring westward and troops to be rested, roofs are at a premium, not only to give shelter to workers, refugees, and troops alike, but to house the administrative services displaced from other areas. At one time well know for its china, Dresden has developed into an industrial city of first-class importance.… The intentions of the attack are to hit the enemy where he will feel it most, behind an already partially collapsed front … and incidentally to show the Russians when they arrive what Bomber Command can do.[9]

Noted British historian Max Hastings suggests otherwise: "Much of this, of course, was fantasy. Dresden was not a city of major industrial significance. And unlike so many of Bomber Command's targets of the past five years which had been mere names to the British public, symbols of Nazi power such as Nuremberg or of enemy industrial might such as Essen, Dresden was a city of which an important section of educated Englishmen had heard, read, even seen. Since the eighteenth century, the old town had stood for all that was finest, most beautiful and cultured in Germany, a haven where Trollopian heroines sought exile, visited by generations of young English noblemen on the Grand Tour."[10]

On the night of February 13/14, in two waves about three hours apart, over 1,300 British bombers dropped some 650,000 incendiary bombs on the city. The first wave of 244 Lancasters passed over Dresden within a period

of 10 to 15 minutes, saturating the firefighting defense and leaving it too little time to react to the rapidly spreading fires. The ensuing firestorm was visible 200 miles away to late arriving and departing aircraft. The next day, almost the same number of U.S. heavy bombers targeted the city's "railroad marshaling yards"—not untypically the euphemism used in AAF communiqués for the populated center of a city. The day after that, 211 U.S. bombers returned; they had been diverted from their primary oil targets where visibility had been poor to their secondary target, dropping nearly 500 tons of bombs on the still smoldering city. After the bombers departed, the Mustang fighters that had escorted the B-17s to Dresden were freed to make low-level strafing attacks on the prostrate city, as long as their fuel held out, machine-gunning "everything that moved" according to their standing orders. In the total absence of antiaircraft fire, the fighters swooped over the city so "low and slow" that survivors remember seeing the faces of the American pilots. There could be little question that the pilots, in turn, were able to distinguish Wehrmacht troops (scarcely any) from civilian women and their children.[11]

"The attack on Dresden indeed attained all that could possibly have been desired of it; over sixteen hundred acres of the city had been devastated in one night, compared with the rather under six hundred acres destroyed in London during the whole war." Furthermore, for the first time in the war (but not for the last time), "an air raid had wrecked a target so disastrously that there were not enough able-bodied survivors left to bury the dead."[12] Remarkably the railroad marshalling yards and railway stations remained virtually undamaged!

There was no concealing the destruction because newspapers of neutral countries had correspondents in Dresden and nearby cities. American officials defended the bombing, characteristically pointing out that there were important transportation targets in the city and that, furthermore, the mission was intended to support the Soviet ground offensive. The raid was, in fact, a political statement—that the Russians should understand that, despite temporary setbacks during the recent Wehrmacht offensive in the Ardennes, America remained a military powerhouse, especially its far-ranging bomber forces. Arguably, both the Western Allies were naive to think that destroying a German city from the air would somehow intimidate Soviet leaders and the Red Army which had marched through many flattened cities en route to Berlin. The Soviets ultimately took Berlin, but at a horrendous cost: some 100,000 Red Army troops died in the "no-quarter-given, non-asked" battle—almost a reprise of the desperate Stalingrad struggle.

Kurt Vonnegut, Jr., one of about 2,000 American prisoners of war and some 25,000 other Allied POWs, held in camps in the city and its suburbs, was an intimate witness to the attacks. His novel *Slaughterhouse-Five* (which referred to a "nice new cement-block hog barn," originally for pigs awaiting slaughter, providing comfortable housing, wrote Vonnegut, for about 100 of

the American POWs) presented unusual insights into the air attacks.[13] "The first fancy city I'd ever seen," he recalled after his capture by the Germans. "A city full of statues and zoos, like Paris. We went to work every morning as contract labor in a malt syrup factory. The syrup was for pregnant women.... There were very few air-raid shelters in town and no war industries, just cigarette factories, hospitals, medicine factories. Then a siren went off—it was February 13, 1945—and we went down two stories under the pavement into a big meat locker.... When we came up the city was gone.... They burnt the whole damn town down. Every day [afterward] we walked into the city and dug into basements and shelters to get the corpses out, as a sanitary measure. When we went into them, a typical shelter, an ordinary basement usually, they looked like a street car full of people who'd simultaneously had heart failure. Just people sitting there in their chairs, all dead.... We brought the dead out.... The Germans got funeral pyres going, burning the bodies to keep them from stinking and from spreading disease."[14]

"It wasn't a famous air raid back then in America. Not many Americans knew how much worse it had been than Hiroshima, for instance. I didn't know that, either. There hadn't been much publicity.... I wrote the Air Force back then [in 1966], asking for details about the raid on Dresden, who ordered it, how many planes did it, why they did it, what desirable results there had been and so on. I was answered by a man who, like myself, was in public relations. He said that he was sorry, but the information was top secret still."[15]

The international repercussions of the Dresden raids led to what one historian has provocatively termed "the most amazing turnabout of Winston Churchill's long political career." He sent a remarkable (for him) memorandum on March 28 to the Chief of Staffs Committee, the leaders of Britain's three military services:

> It seems to me that the moment has come when the question of bombing of German cities simply for the sake of increasing the terror, *though under other pretexts* (author's italics), should be reviewed. Otherwise we shall come into control of an utterly ruined land.... The destruction of Dresden remains a serious query against the conduct of Allied bombing. I am of the opinion that military objectives must henceforward be more strictly studied in our own interests rather than that of the enemy.... I feel the need for more precise concentration upon military objectives ... rather than on mere acts of *terror and wanton destruction* (author's italics), however impressive.[16]

Some historians have since wondered whether this brief memo was the Prime Minister's carefully thought-out first step in his rewriting of history— to shift the burden of responsibility on his military commanders for the devastation of German cities he had ordered. Arguably, it was one thing to talk about indiscriminate bombing of civilians privately, but another to put into words that would form a permanent record of Great Britain's high-level

wartime decision making. Churchill's advisors interpreted the memo as the latter and pressured him to water it down. On April 1, he rewrote it, omitting any reference to Dresden and deleting such inflammatory words as "terror" and "wanton destruction."

> It seems to me that the moment has come when the question of the so-called 'area bombing' of German cities should be reviewed from the point of view of our own interests. If we come into control of an entirely ruined land, there will be a great shortage of accommodation for ourselves and our Allies.... We must see to it that our attacks do not do more harm to ourselves in the long run than they do to the enemy's immediate war effort.[17]

American press coverage of the Dresden bombings focused on the alleged purpose of the raids: to support the Red Army's push westward. The *New York Times* ran such headlines and subheads as: "RAIL CITY BLASTED TO HELP RUSSIANS"; "500 U.S. 'Heavies' Bomb Town in the Direct Path of Soviet Troops"; "The powerful aerial support of the Russian advance connoted a degree of collaboration not hitherto obtained."[18]

The USAAF's postwar history was unambiguously upbeat: "If casualties were exceptionally high and damage to residential areas great, it was also evident that [Dresden's] industrial and transportation establishments had been blotted out." However, the German report at the time concluded quite the opposite, that the "importance of Dresden as a railroad centre ... was not diminished by more than three days as a result of these three air raids."[19] Postwar analyses, both Communist and non–Communist, support this latter view. Furthermore, despite the destruction of Dresden's city center, ostensibly to disrupt rail traffic, the Wehrmacht was able to transfer from the Ardennes area to the eastern front "the entire 6th SS panzer Army, with its army troops, two corps commands, four SS panzer divisions, both the Fueher Escort and Grenadier Brigades, and all its massive artillery and bridging columns."[20] On February 22, 1953, the respected Munich newspaper *Suddeutsche Zeitung* published in a mocking retrospective that "one is amazed at the extraordinary precision with which the residential sections of the city were destroyed but not the important installations."[21]

Air Marshall Harris, apparently still fixated on destruction for destruction's sake, wrote in his retrospective that, following the Dresden raids, he personally did not regard "the whole of the remaining cities of Germany as worth the bones of one British Grenadier," to paraphrase German chancellor Otto von Bismarck's famous statement, adding a callous postscript that "the feeling ... over Dresden could easily be explained by any psychiatrist. It is connected with German bands and Dresden shepherdesses."[22] Harris' deputy, Sir Robert Saundby, who did not agree, later described the attack as "a great tragedy."

The international furor over the destruction of what has been generally recognized as anything but a principal military target led to a specially commissioned U.S. report, the *Historical Analysis of the 14–15 February 1945 Bombings of Dresden*. The report was classified secret until December 1978, when Cold War pressures forced its declassification. It was the Soviets who were at fault, according to the report. "...the Communists have with increasing frequency and by means of distortion and falsification used the February 1945 Allied bombings of Dresden as a basis for disseminating anti–Western and anti–American propaganda. From time to time there appears in letters of inquiry to the United States Air Force evidence that American nationals are themselves being taken in by the Communist propaganda line...."[23]

It is not the Soviets, it is the United States and Great Britain that should be blamed for the wanton destruction of Dresden, one American historian has written, pointing his finger first at RAF's Harris and then at AAF's Spaatz. In the years since the bombing of Dresden, four questions recur, bearing on Spaatz's decisions and responsibility.

1. Who ordered the bombing? "Churchill must bear the responsibility for shifting the heavy-bomber effort to the Eastern Front. Harris, always eager to strike a German city he knew was poorly defended, selected Dresden. Spaatz, the chief U.S. official at the time involved in establishing strategic bombing priorities, went along with Harris."
2. Did the Soviet Union request the bombing of Dresden? "No, the Soviets never specifically asked for it.... Nor at any time did the Soviets express a wish to halt the bombing of Dresden."
3. Was Dresden a legitimate military target? It had many small factories and workshops, with "perhaps 50,000 workers employed in the arms industry." Until February 1945, none of those targets had been of interest to Allied targeting officers—but by then, the city had become an important communications element in the southern part of the eastern front, with rail lines from other east German cities converging on it.
4. Did the Allied attacks on Dresden deviate from established Allied bombing policies? Author Richard Davis writes that they did not. The RAF, as it had frequently done before, hoped to start a firestorm, achieved only once over Hamburg 25 months before. Two weeks after the Dresden attack, following a major raid on Pforzheim, the RAF's last major assault of the war, Harris boasted to his commanders that "the whole place had been burned out. This attack had been what was popularly known as a deliberate terror attack." He further noted that his Bomber Command "had now destroyed 63 German towns in this fashion." Nor did the two follow-up 8th Air Force attacks "deviate from established AAF policies." More than a full generation

later, in 1969, Spaatz obstinately defended his command's Dresden missions: "When the Dresden operation came down, we bombed the military targets ... some marshaling yards.... Now maybe some of the bombs fell on Dresden, but the target was a military target." On both days the weather over Dresden was overcast, requiring bombing by radar. This meant that only about 30 percent of the bombs could be expected to fall within a half-mile of the bombardier's aiming point.[24]

On January 6, 1992, the *New York Times* announced that veterans of RAF Bomber Command would erect a larger-than-life sculpture of their former commander, Air Commodore Sir Arthur Harris, in central London later that year. The British, as every tourist visiting London quickly learns, dearly love their war heroes, and statues and memorials of them seem to be everywhere. But plans for this statue to commemorate "Bomber" Harris struck some officials in Germany as being totally inappropriate, even after a half-century. Mayors of the cities and towns that were the targets of RAF bombing raids, particularly those in the last weeks of the war when Germany's imminent defeat was a certainty, enlisted the support of their foreign minister to register a formal protest.

The *New York Times* reported that one British newspaper, the *Independent* had devoted a critical editorial to the issue, which commented that "history has not vindicated Sir Arthur. He was not just obeying orders. He was the chief advocate of his policies. And the policies were wrong on both moral and practical grounds. There is a moral difference between accidentally and deliberately killing civilians." The editorial noted that more than 50,000 Bomber Command aircrew (more than 62,000, according to official estimates) had been killed over occupied France and Germany. "Their lives, skills, and courage were squandered in an enterprise that failed to achieve its purpose and has troubled the British conscience ever since. It is to them that a memorial should be raised, not to the commander who sent them to their deaths."

The campaign against the commemorative was strongest in Dresden, where the ruins of a single church have been left untouched as a permanent memorial to the tens of thousands of civilians incinerated in the raids. Dresden's mayor put the issue into correct perspective: "We aren't going to be able to stop it [the Harris statue]. Let's face it, they won the war." In the same news story, the *Times* suggested that because Dresden had been clogged with refugees from the east, fleeing the Soviet advance, "the exact number of victims cannot be determined. Estimates vary widely, from 35,000 ... to 135,000 ... and even higher." Vonnegut, drawing on data available in 1966, had written then that "about one hundred and thirty thousand people would die."[25]

* * *

Then we bombed Tokyo, not just military targets, but set out to wipe out the place indiscriminately. The atomic bomb is the last word in

this direction. All ethical considerations are gone.... And it was we, the civilized, who have pushed standardless conduct to its ultimate.[26]

Three weeks after Dresden, on the night of March 9/10, from their bases in the Mariana Islands, 334 B-29s dropped nearly 1,700 tons of incendiary bombs on Tokyo, creating a firestorm of unprecedented proportions that razed 15 square miles, about one quarter of the city, destroyed nearly 300,000 buildings, and made over 1 million of its residents homeless. Official reports listed 83,793 killed and 40,918 wounded. It took 25 days to remove all the dead from the ruins. While the loss of life was less than in Dresden, the physical destruction exceeded that of any of the previous giant conflagrations of the western world: London, 1666 (436 acres, 13,200 buildings); Moscow, 1812 (38,000 buildings); Chicago, 1871 (224 acres, 450 buildings); San Francisco, 1906 (4 square miles, 21,124 buildings). Only the great earthquake that had struck Tokyo and nearby cities in 1923, killing 110,00 and razing about 20 percent of its dwellings, matched it.[27] The USSBS later concluded that "probably more persons lost their lives by fire at Tokyo in a 6-hour period that any [equivalent period of] time in the history of man."

Concerned that its B-29s might be viewed as terror bombers, the XXIs Bomber Command's report of the mission included a new propaganda twist: "The object of these attacks was not to indiscriminately bomb civilian populations. The object was to destroy the industrial and strategic targets concentrated in the urban areas." On March 14, LeMay received a message from Washington pointing out that American "editorial comment is beginning to wonder about blanket incendiary attacks upon cities." The message went on, urging LeMay to continue "hard hitting your present line that this destruction is necessary to eliminate home industries and that it is strategic bombing." It concluded with a firm admonition: "Guard against anyone stating that this is area bombing."[28]

"Yet this raid on Tokyo," in the view of a patriotic British historiographer seemingly embittered by the generations-long excoriation of "Bomber" Harris and his role in the Dresden attack, "is virtually unknown outside of Japan. It is a fair assumption that every reader of this book [*The Bomber War*] will know about Dresden but that not one in a hundred—at a generous estimate—will know what happened to Tokyo on 10 March 1945, just three weeks later."[29]

If Dresden had been hardly a legitimate industrial target, Japan's capital city of Tokyo was certainly a bonafide one. Tokyo was the nation's principal city in nearly every respect. It was home to the Emperor and the Imperial Court; the civil government and armed forces infrastructure were headquartered there; its population of nearly seven million equaled that of the next five great cities of Japan together: Osaka, Nagoya, Kyoto, Yokohama, and Kobe. It was the financial, commercial, and communications heart of the

nation. Together with its suburbs, Tokyo was an enormous manufacturing center, producing a wide diversity of consumer and military products, with huge aircraft plants, steel mills, and metalworking, machinery, chemical, communications equipment, and textile factories. Scattered throughout the city were many hundreds of smaller factories and home workshops—"cottage industries," so-called—that provided components and subassemblies for the larger plants. Living literally in and among these feeder facilities were dense concentrations of the city's industrial workers. In 1945, Tokyo, like all of Japan's cities, was a virtually solid mass of one- and two-story wooden buildings, with few modern multi-storied structures.

Fundamental to U.S. war planning for an eventual war in the Pacific had been the understanding of the extreme vulnerability of Japan's cities to destruction by fire. During the 1920s and 1930s there had been frank and well-publicized discussions of how American bombers might exploit the tinderbox cities in Japan if war came. Billy Mitchell had talked flamboyantly and often on the subject. He prophesied that one day U.S. bombers would lay waste to those cities from bases in the Aleutians and the Kurile Islands. In 1935 the *New York Times Magazine* published an article titled "Most Of All Japan Fears An Air Attack," with a subhead: "She Realizes That Planes Would Work Havoc In Her Crowded Cities, With Their Many Flimsy Buildings." The story coincided with the B-17's first flight tests and pointed out that Soviet airmen believed that Tokyo could be burned to the ground with only three tons of incendiary bombs, delivered by bombers from airfields in Vladivostok.[30]

Well before the March 9/10 raid on Tokyo, interest had been growing in Washington for expanding the use of the "fire weapon." What about the psychological effects of firebomb raids against Japanese cities? was one question that needed answers. William M. McGovern of the OSS was asked to give his views to the AAF's Incendiary Committee. McGovern was a modern-day Renaissance man of sorts: a political scientist, a war correspondent, an explorer, but more importantly, a self-proclaimed expert on Japan and Japanese culture. He told his audience that the bombing attacks should be powerful, rapid ones, directed at what he called the "psychological heart" of the country, the Tokyo-Yokohama and Osaka metropolitan regions. After just a few such raids, McGovern sagely intoned, the affected people would certainly panic because Japanese had always been terrified by fire. Indeed, the Japanese had good reasons to fear fire. During the earthquake of September 1, 1923, three of Japan's largest cities—Tokyo, Yokohama, and Nagoya—were ravaged by uncontrollable fires. In Tokyo alone, estimates were that as many as 200,000 buildings had been burned to the ground and about 100,000 residents killed.

McGovern also pointed out that there would be grave economic consequences beyond the destruction of factories and infrastructure. The Japanese

people, he claimed he had found from personal experience, depended on paperwork and written orders. Loss of such records and directives would result in administrative chaos that would resonate nationwide.

A directive in mid November called for test incendiary raids before mass attacks were made. Incendiaries had been used on earlier missions, but they were only a small portion of the B-29's bomb loads. Nagoya, Japan's second largest city, would be the target of the first such test attacks and would be made as soon as 100 B-29s could be flown to the target. Air Force general Hansell did not like the idea. He had "with great difficulty implanted the principle that our mission is the destruction of primary targets by sustained and determined attacks using precision bombing methods both visual and radar."[31] On January 3, with Hansell out of the picture and LeMay in command, the test mission was ready to go. The planes carried mixed loads: incendiary clusters with M-69s fuzed to open at 8,000 feet and fragmentation clusters to open almost immediately after leaving the bomb bay. Fewer than 60 planes hit the target area and while there were fires, there was no hint of even a small-scale firestorm.

LeMay was on the spot and he knew it. It was time to take a page out of the RAF's book and run his B-29s at night. The dress rehearsal was on the night of February 25, when B-29s dropped some 400 tons of incendiaries on Tokyo. Reconnaissance flights the next day came back with photographs that showed an entire square mile of the city had been burned out. Sweet success at last!—the kind of results Arnold was looking for. LeMay was ready to gamble. Detailed planning for a full-scale raid on Tokyo went ahead at full speed. He would mount the major effort as soon as the weather looked reasonably good.

The mission would be contrary to accepted Air Force doctrine and practice in nearly every way. It would be flown at night and at low altitudes in an airplane designed and configured to fly at high altitudes and to bomb in daylight. LeMay had a host of sound reasons for switching to such a radically new bombing regimen, however, and he had the guts to put his career on the line for what he believed in. Takeoffs and landings would be during daylight hours. Weather at night was generally better during the winter and early spring, and after sundown cloud cover over Japan tended to thin out, improving visibility. Winds were also less formidable below 10,000 feet. Attacks would be at altitudes of 5,000 to 7,000 feet, three to four miles lower than normal, using less fuel and enabling heavier bomb loads to be carried. Strain would be reduced on the vulnerable engines since there was no need to climb to altitude. Bombing accuracy would improve, but this parameter was relatively unimportant— the bombers would simply unload their bomb bays into the infernos below. Since the planes would stage individual attacks, there would be no loitering or jockeying to keep formation, using up fuel. B-29s coming in over the target singly and from all directions would be expected to confuse antiaircraft gunners.

Except for the tail gunner and his tail guns, all of the planes' machine gun barrels and ammunition would be removed and so would gunners, saving nearly 3,000 pounds per B-29; as a result, each plane could carry about six tons of bombs to Japan. The Japanese were known to have only rudimentary ground-to-air radar systems and few Japanese fighter aircraft were equipped with air-to-air radars. Navigation at night was simpler; if the skies were clear, celestial methods could be used and the new Loran navigation system had a longer range at night. Finally, returning planes would greet the dawn about halfway home,[32] buoying spirits and simplifying emergency landings.

Three types of incendiaries would be carried: the M-47, a 100 pound napalm bomb to kindle marker fires; the M-50, a magnesium bomb, about a quarter of which were fitted with an explosive warhead to keep firefighters at a distance; and nearly a half-million 6.2 pound M-69s in 500 pound clusters. The heavier incendiaries would be dropped first by pathfinder aircraft to start marker fires.

At the pre-flight briefings, the aircrews were stunned; nearly everything they had been taught and trained for had gone by the board. Without guns they would be defenseless; at such unheard-of low altitudes, their big silver planes would easily be captured by searchlights and antiaircraft fire would be devastating; flying individually at different directions over the target at the same time would cause collisions. Many of the crews also secretly harbored reservations of their navigators' skills; this would be the first time they would be on their own, en route to and back from Japan. The only compensation the aircrews could see was that they would be approaching their home runways in broad daylight.

On schedule at dusk on March 9, the small force of pathfinder B-29s took off on the fateful mission. Over Tokyo, their aiming point was the center of a rectangle about 3 miles by 4 miles in the heart of the city. They were followed by the main force which dropped canisters of M-69s at 50-foot intervals, fuzed to open and disperse the individual bomblets at 2,000 feet above the ground. It was a windy, dry night in Japan's biggest city, ideal for the kindling of a firestorm!

For more than three hours, the planes dumped their bombs into a growing inferno. The air over the city became so violent that B-29s at 6,000 feet were turned completely upside down and the heat so intense some crews had to put on oxygen masks. Aircrews leaving Japan reported that the glow in the sky from the firestorm could be seen more than 150 miles away.

None of the aircrews' apprehensions became reality. As the B-29s swept in low, Japanese antiaircraft gunners were taken by surprise. Few night fighters rose to challenge the fast bombers. The B-29s came over the general target area in pre-arranged stacks at different altitudes, minimizing the collision hazard. Only 14 planes were lost, for a quite acceptable loss rate of just over

4 percent. It was learned after the war that one of the reasons Japanese fighter planes rarely attacked the B-29s in the spring of 1945 was that the Japanese were hoarding their aircraft and their aviation fuel. They hid them—as many as 8,000—in remote areas adjacent to camouflaged runways for the day when the U.S. would invade the home islands. Plans called for many of these planes to be flown by kamikaze pilots.

Buoyed by the success of the Tokyo raid, LeMay ordered his night bombers to strike Japan's next largest cities in quick succession over the next two weeks. On March 12, 1,790 tons of firebombs gutted 2.1 square miles in Nagoya. On March 17, Kobe was hit with 2,312 tons of bombs that burned out 2.9 square miles. On March 19, Nagoya was struck again, with 1,842 tons of bombs that burned an additional 3 square miles. Then Osaka was hit with 1,733 tons, burning an area of 8.1 square miles.[33]

These firebomb raids were only the beginning. They continued almost without letup right up to, and even after, the Hiroshima and Nagasaki cataclysms. For example, on August 7, 151 B-29s hit the Toyokawa Arsenal, and that night a 32-plane mission sowed 200 tons of sea mines over seven different target areas. The next night 245 B-29s dropped incendiaries into Yawata, while a 60-plane mission struck Tokyo again. On the night of August 14, hundreds of B-29s took off to firebomb cities across Japan, and aircrews were alerted to listen to their radios en route to the targets. They had been instructed to drop their bombs into the ocean and abort their missions—if they received word that the war was over. The message never came and the B-29s completed their last combat missions. Japan formally surrendered on the morning of August 15.

<p style="text-align:center">* * *</p>

The purposeful switch to raids obliterating cities with showers of thousands of firebombs had been one of the most important decisions of the Pacific War. The decision had not been made by America's political leaders, or by AAF command in Washington. Remarkably, it had been LeMay's decision alone. There was no government announcement of the abandoned "precision bombing" policy and the ushering in of a new and tragically amoral one. The American media simply went about its business of supporting the war in routine patriotic fashion, matter-of-factly reproducing, typically word for word, the daily communiqués from military spokesmen. Nor was there any surface outrage on the part of the American people; they had become inured to destruction, especially of the despised "Japs," the "monkeys" and the "little yellow bastards," synonyms that had found their way into everyday speech. Stimson, however, in a conversation shortly after the Tokyo raid with J. Robert Oppenheimer, the doyen of the Manhattan Project, said that he "thought it was appalling that there should be no protest in the United States over such wholesale slaughter."[34]

* * *

When United States occupation forces arrived in Tokyo after Japan's defeat in August 1945, Prime Minister Naruhiko Higashikini voiced a plaintive even pathetic wish. If the Americans would try to forget Pearl Harbor, he said, he and his compatriots would try to forget Hiroshima and Nagasaki.[35]

At the end of 1944, Arnold and his staff in the newly completed Pentagon in Washington, at the time the biggest building ever constructed, had drawn up a short list of targets for the nuclear bombs then in the final phases of their development that included the largest Japanese cities that were least damaged by earlier bombings: Hiroshima, Kokura, Kyoto, and Niigata. It was thought that the bombs' destructive effectiveness could be better measured on such "virgin" cities. Stimson objected to Kyoto on the grounds that it was a national religious shrine and an important Japanese cultural center and President Harry Truman concurred, agreeing that to destroy it might tend to drive the Japanese into the arms of the Soviets in the postwar world. LeMay substituted Nagasaki for Kyoto, although its hilly topography made it a less than an optimal target. Hiroshima was selected as the first target and Kokura as the second, with Nagasaki as the alternative.

Hiroshima early in the war had been a busy port but the U.S. Navy's intensive mining effort had considerably diminished the city's importance by 1945. Mass evacuations had reduced its population from over 300,000 to about 250,000. The city had many military facilities and its economy was closely tied to the war effort. U.S. intelligence understood, incorrectly as it was later learned, that there were few if any Allied prisoner-of-war camps in or around Hiroshima.

Six B-29s of the special 393rd Bombing Squadron were assigned to the Hiroshima mission. *Enola Gay*, named after pilot Paul Tibbets' mother, would carry Little Boy, the gun-type uranium bomb. No scantily clad pin-up painted on the nose for straight-laced Colonel Tibbets, just foot-high black letters at a 30-degree angle below the pilot's window. When asked later about the name he had chosen, he said his mother's self-assurance had helped him overcome adversity when he was a boy. Two B-29s would fly as close escorts filled with observers, cameras, and scientific instruments to permanently record what was anticipated to be a momentous historic event; one of the escorts was *The Great Artiste* piloted by Major Charles W. Sweeney who would carry Fat Man to Kokura and Nagasaki three days later. Three of the B-29s were weather aircraft which would leave Tinian hours earlier to reconnoiter over the target area and radio weather data to the oncoming *Enola Gay*.

On schedule, *Enola Gay* took off from Tinian on its fateful sortie at 2:45 A.M. on August 6. A little after 8, nearing the coast of Japan, Tibbets received the message he and his anxious crew had been waiting for: weather and

particularly visibility over Hiroshima were excellent. It was a sparkling clear day. There were no enemy fighters or antiaircraft fire to disturb the bombardier on his straight and level run into the target. The aiming point was the Aioi Bridge, a T-shaped structure spanning the Ota River in the downtown area. At precisely 9:15, at 31,000 feet, bombardier Major Thomas W. Ferebee released the bomb, which was slowed in its descent by a parachute. Little Boy exploded 43 seconds after it fell away, detonating approximately 1,900 feet above the courtyard of Shiima Hospital, about 800 feet southeast of the Aioi Bridge.[36] Immediately at bomb release, Tibbets banked sharply left setting his plane on a reciprocal course, and went into a shallow dive to pickup airspeed and to put maximum distance between *Enola Gay* and the impending explosion—exactly as he had rehearsed so many times. Tibbets in later years when questioned about his feelings when he observed the monstrous, fiery mushroom cloud that obscured the destroyed city, would comment laconically; "It was all impersonal." The "Hiroshima Maidens," the grotesquely disfigured young survivors of the atomic blast who had been invited to America for reconstructive surgery, would have respectfully disagreed.

Bock's Car, named after the plane's original commander, was the second B-29 to be recorded in history as an aircraft that dropped a nuclear bomb "in anger," this one the implosion-plutonium design, Fat Man. *Bock's Car* flew off Tinian on August 9, its primary target the Arsenal in Kokura on the north coast of Kyushu. The secondary target was the port city of Nagasaki, considered the San Francisco of Japan and home of the nation's largest colony of Christians. Unlike the *Enola Gay* mission, which had gone according to plan, *Bock's Car* experienced a series of glitches. The pilot discovered soon after takeoff that the fuel selector valve did not work; it would have allowed him to tap into an auxiliary 600-gallon fuel tank in his aft bomb bay. An early weather plane had reported 3/10th low cloud cover over Kokura, with no intermediate or high-level clouds, but with improving conditions. Like *Enola Gay*, *Bock's Car* was under orders to bomb only visually, with the optical Norden; the plane's advanced Eagle radar bombsight was not to be used under any circumstance, although both planes carried radar bombing officers. If the bombardier could not see his aiming point, he would not drop Fat Man, but would carry the weapon back to base—an order that did not sit well with the crew members who were privy to it. By the time *Bock's Car* arrived over Kokura, a thick ground haze obscured the ground on its first run over the target.

Two more bombing runs were made and the bombardier still was unable to see his aiming point; it was then decided to strike the secondary target. Nagasaki also turned out to be cloud-covered as the plane approached, low on fuel, with just enough for a single run over the city and an emergency landing at Okinawa. According to the flight crew, a hole in the cloud cover opened

up just in time, uncovering a new aiming point, a stadium some miles from the original AP. Fat Man, its descent slowed, like Little Boy, by a parachute, exploded about 1,600 feet above the steep slopes of the city at 11:02 A.M., an astonishing three miles from its intended target. Luis Alvarez, a prominent Manhattan Project civilian scientist who flew on the mission in an observation B-29 stated later that it was his judgment that *Bock's Car* had bombed by radar and not visually with the Norden as claimed by the plane's officers, because he had not observed the supposed opening in the cloud cover.

Of the approximately 250,000 persons in Hiroshima when Little Boy detonated, "between 130,000 and 150,000 had died by December 1945, and the total, including delayed deaths from radiation poisoning, is estimated at 200,000. The fatalities at Nagasaki were about half as many because that explosion was off target."[37]

Certainly the most influential apologia in the years immediately after the war concerning the dropping of the two atomic bombs on Japan was former Secretary of War Henry L. Stimson's article in the February 1947 issue of *Harper's Magazine*, "The Decision to Use the Atomic Bomb." Stimson, then close to 80 and in frail health, contributed little to the essay that bore his name. Rather, it was meticulously crafted by one of the best government public-relations men then in the business, McGeorge Bundy, and selectively placed in a prestigious publication that reached large numbers of movers and shakers. To give the piece maximum credibility, Bundy paraded the long list of names of the principal government, military, and scientific officials who had played roles in the decision-making process. Much in the article was difficult to disagree with, as this excerpt illustrates:

> As we understood it in July, there was a very strong possibility that the Japanese government might determine upon resistance to the end.... In such an event the Allies would be faced with the enormous task of destroying an armed force of five million men and five thousand suicide aircraft, belonging to a race which had already amply demonstrated its ability to fight literally to the death.

The article projected that if America had to carry through its planned invasion of Kyushu in November and of Honshu in the spring of 1946, "such operations might be expected to cause over a million casualties, to American forces alone." Stimson's "chief purpose," according to his ghostwriter, "was to end the war in victory with the least possible cost in the lives of the men in the armies" he had helped to raise. Behind Stimson's decision to recommend the use of the two bombs to President Truman, was his belief that "no man ... holding in his hands a weapon of such possibilities for accomplishing this purpose and saving those lives, could have failed to use it and afterwards looked his countrymen in the face."

Iconoclast historian Gar Alperovits has chosen to disagree, vehemently

and authoritatively. His book *The Decision to Use the Atomic Bomb*, published in 1995, is a thorough study of the still hotly debated issue. He suggests to his readers, rhetorically: "Ask nine out of ten people why the United States used the atomic bomb at the end of World War II and the answer almost always is 'To save perhaps a million lives by making an invasion unnecessary.'" Alperovitz then asks, "Where did this idea come from? How did it become so widespread? If, in fact, the bomb was not needed to prevent an invasion— and especially, of course, if this was known at the time—the notion that it was the only way to save large numbers of lives is clearly a myth. And clearly, too, in a very general sense the public has been misled."[38]

12

The Surveys

The Survey was much like the Bible in one respect. If you reach deeply enough you can find substantiation for almost any preconceived notion or prejudice.[1]

Based on a detailed investigation of all the facts, and supported by the testimony of the surviving Japanese leaders involved, it is the Survey's opinion that certainly prior to 31 December 1945, and in all probability prior to 1 November 1945, Japan would have surrendered even if the atomic bombs had not been dropped, even if Russia had not entered the war, and even if no invasion had been planned or contemplated.[2]

The United States Strategic Bombing Survey (USSBS) had its origins in the fall of 1944. Actually, there were two separate, overlapping surveys: one analyzing the effects of the joint USAAF and RAF Bomber Command campaigns over Germany and occupied Europe; and one assessing the effects of the U.S.-only bombing of the Japanese home islands by Air Force B-29s from the Marianas and Navy single-engine bombers from aircraft carriers ranging unmolested off the coasts of Japan.

Earlier, in June 1944 following D-Day, George Ball, counsel to the Foreign Economic Administration, had been charged with evaluating the support given by the AAF to the Anglo-American landings in France. Ball subsequently suggested a broadening of his study to encompass the overall results of the strategic bombing campaigns against Fortress Europa, which coincided with a similar proposal by the Air Force. Such a study, the Air Force anticipated, would strengthen—if not clearly establish—its right to loudly advertise that its bombers had won the war. As far as the USAAF was concerned, little was open to question. It was the bombers, American principally but British also, grudgingly, that had destroyed Germany's factories,

industrial infrastructure, and transportation networks. It was the bombers, too, that had dehoused workers and crushed the morale of civilians in cities and towns throughout Germany. And it was the bombers that had pulverized and burned out German cities with high-explosive bombs and incendiaries, killing hundreds of thousands and maiming countless thousands more. These latter contributions were better left unsaid. In turn, the study was expected to lead inexorably to a postwar Air Force independent of the U.S. Army and on a par with the U.S. Navy.

In November, Secretary of War Stimson established the USSBS "pursuant to a directive from President Roosevelt." In an attempt to maintain objectivity and establish an independent body, prominent civilian "experts" rather than military officers were named directors. They would be advised and supported by Air Force personnel. The two top civilian appointees, each with impeccable management credentials, were Franklin D'Olier, president of the Prudential Insurance Company of America, who was named chairman, and Henry Clay Alexander, president of J.P. Morgan and Company, who became vice-chairman. D'Olier was a former captain in the U.S. Army Field Artillery in 1917 and was discharged a lieutenant colonel. He was the American Legion's first national commander when it was chartered by the Congress in 1919. There were nine directors, each responsible for a particular aspect of the studies.[3] The final table of organization included 350 military officers, 500 enlisted personnel, and 300 civilian specialists. By September 1945, there were over 1,400 military personnel assigned to the survey.

Perhaps the best summary of the intent of the survey came out of a discussion in the Pentagon among D'Olier, General Arnold, and Assistant Secretary of the Army Robert A. Lovett in October 1944. It was agreed that the "long range goal was to obtain an impartial report, untainted by preconception or bias, that could be used as a basis for planning the postwar composition and strategical principles of the Army Air Forces ... written so that it would be meaningful to the man in the street, but should also be of such caliber as to withstand the scrutiny of Congress and other interested parties." Arnold also added, as an addendum of sorts, that the final report would be helpful to those planning the bombing campaigns against Japan which many predicted would last well into 1946.

The survey was conducted on a huge scale. In addition to the extensive probing of enemy wartime records inside Germany and Japan, more than 8,000 questionnaires were distributed to industrial managers in more than 50 cities, and hundreds of government and military officials were interviewed. Most of the analyses were finalized in the summer of 1946 although detailed reports were still being completed as late as May 1947. Over 300 individual reports were written and an immense trove of statistical data compiled for researchers to digest more thoroughly at a later date.

For the European survey, not only would British participation be

rejected—they would form their own, far less comprehensive British Bombing Survey Unit (BBSU)—but that of the U.S. Navy as well. As far as the Air Force was concerned, the Navy had not been involved in the bombing offensive in the European theater, and therefore could contribute nothing of value. Even involvement of high-level naval officers in the interests of sensible interservice diplomacy was rejected because such cooperation "quite possibly might impair the paramount interests of the AAF" and "serve to afford the Navy another rung in their ladder reaching toward the domination of American Air Power, " according to a letter by Air Force general Laurence S. Kuter sent to his staff as the survey was getting under way. The lines were being drawn for a protracted and bitter struggle among all of the military services to establish their postwar positions in the pecking order.

There were a number of fundamental principles involved. The knowledge gained would be valuable short-term in the bombing campaigns then planned for Japan. Perhaps of more importance to the AAF was that America's future air policies, and the size, scope and "mission" of a future powerful and independent Air Force would be shaped by the survey's findings. Finally, had the results, tangible and otherwise, been commensurate with the enormous expenditures in manpower and materiel?

As might be imagined, many of the survey's published findings were more advocacy than scientific assessment. Individuals with their personal agendas could be expected to grind their own axes. While most of the military personnel involved had started out with the intent of producing analytical presentations, postwar budget struggles loomed large. Further, for the Air Force to dwell on the vulnerability of the heavy bomber and its mission of strategic bombardment would jeopardize its case for independence. For if squadrons of bombers could be forced to turn back short of their targets—a scenario that never occurred—or if the defense could inflict unsustainable losses of aircraft and aircrews—a scenario that nearly occurred over Germany during 1943—then the entire concept of strategic bombardment was seriously flawed. Collectively the reports were contradictory and individually, often ambiguous. Historian David MacIsaac spoke for many of his colleagues when he noted that the "very malleable" reports remain "a pliable source for scholars, pundits, and journalists alike."[4]

Four such examples of grossly contradictory conclusions that found their way into the survey's final reports are as follows:

...it would appear that the air attacks which laid waste to these cities must have substantially eliminated the industrial capacity of Germany. Yet this was not the case. The attacks did not so reduce the German war production as to have a decisive effect on the outcome of the war.[5]

Allied air power was decisive in the war in Western Europe.[6]

The mental reaction of the German people to air attack is significant... Their morale, their belief in ultimate victory or satisfactory compromise and

in their leaders declined, but they continued to work efficiently as long as the physical means of production remained.[7]

Bombing appreciably affected the German will to resist. Its main psychological effects were defeatism, fear, hopelessness, fatalism, and apathy.... War weariness, willingness to surrender, loss of hope in a German victory, distrust of leaders, feelings of disunity, and demoralizing fear were all more common among bombed than among unbombed.[8]

* * *

The survey reports showed again and again that the Americans (and the British, too) had, from the beginning of the war, totally misread the German economy. Nazi Germany had been viewed simplistically—and incorrectly— as an armed camp, dedicated solely to the business of war. It followed then, that destruction by bombing would thus represent a direct and tangible loss to the German war effort. What Allied planners apparently did not know— but what they should have known—was that while Adolf Hitler had created a powerful military machine in a few short years, significantly he considered war an instrument of short-term policy. He hoped to employ minimum economic resources to meet these short-term military needs. Concerned as well about maintaining his domestic political support, Hitler was also intent on preserving high standards of living for the German people. In fact, until 1942, he was able to provide both "guns and butter." A remarkable example of this business-as-usual attitude by the Nazi government throughout the war is documented by British historian Max Hastings:

> Originally a biologist by training, Zuckerman [Solly Zuckerman, a member of the BBSU] had been staggered to discover, on arriving in Germany at the end of the war, that most zoos which had not suffered direct damage were still feeding a full complement of animals. In Britain such useless mouths had been ruthlessly destroyed early in the war. It was a striking example of the gulf between the desperate plight of Germany as Allied Intelligence had perceived it and the reality as it now emerged.[9]

When survey interrogator Guido R. Perera talked with Kurt Tank, president of the Focke-Wulf Aircraft Company in Bremen, in mid–April 1945, Tank related what Perera considered a "startling story." It contradicted the long-held American (and British) economic intelligence view that Germany had entered the war with its main war industries operating at full capacity. Such a "stretched-tight" economy would therefore be extremely susceptible to damage by bombing. He also told his interviewer that at no time during the war did his company's production of Fw 190s, Germany's premier propeller-driven fighter, suffer from "lack of plant capacity, labor, raw materials or components."[10]

The Germans also proved exceptionally resourceful in repairing bomb-damaged factories and infrastructure and dispersing particularly critical industries, such as ball-bearing plants. Although costly and labor intensive, underground assembly lines immune to bombing were constructed for key weapons such as the V-1 missile and the Me 262 jet fighter. The survey showed that the most damaging of the heavy bombings were on rail transport and synthetic oil plants—neither of which could be put underground. Germany's transportation system, rails and roads, were bombed more heavily by the 8th Air Force than any other target category. By the end of 1944, when unquestioned air superiority had been achieved by the Allied air forces, the movement of troops and equipment within Germany had been seriously curtailed, except under cover of darkness. By that time, too, Germany's oil production had plummeted from an average of about 660,000 tons per month, to 420,00 tons in June, 260,000 tons in December, and 80,000 tons in March 1945. The impact on supplies of aviation gasoline was more dramatic. Nearly all German aviation fuel was made by the hydrogenation process in synthetic oil plants and those plants were the first to be bombed in the heavy attacks that began at the end of June and lasted until March 1945. There were 555 separate missions flown against 135 different targets—every synthetic fuel facility and major refinery known to be in operation in Germany.[11]

Particularly troubling to the survey members were data uncovered that concerned airframe production in 1944. For a month, starting in February of that year, particularly heavy attacks were leveled against these facilities. In January, before the strikes, 2,077 combat aircraft were produced; in March, after the attacks, production increased to 2,243 planes. By September, when the peak was reached, Germany was manufacturing nearly twice the number it had produced before the intensive raids. Survey director John Kenneth Galbraith recalled discussing those numbers with General Orvil Anderson, who was an Air Force member of Galbraith's team, and observing that Anderson's voice broke as he asked, "Did I send those boys to do that?"—knowing intimately how many had died en route to, over, and returning from such cities as Regensburg, home to Messerschmitt's main factory.[12]

As far as Galbraith, the head of the "Overall Effects and Area Bombing" department, was concerned, based on his group's "patiently gathered data," the strategic bombing offensive was a "disastrous failure." Strategic bombing had not won the war in Europe: "At most it had eased somewhat the task of the ground troops who did. The aircraft, manpower, and bombs used in the campaign had cost the American economy far more in output than they had cost Germany. However, our economy being much larger, we could afford it."[13] Postwar studies also showed conclusively that the expectations for major disruption of submarine construction (targets in that field were struck repeatedly) were also not realized. The giant steel-reinforced concrete submarine pens along the occupied French coast were scarcely damaged; in fact,

many of these massive structures with ten-foot-thick roofs, still stand 60 years later as mute testimony to their essentially indestructible design and construction. The U-boat menace in the Atlantic was not defeated by Allied heavy bombers. It was coordinated naval action—principally airborne radar, strongly escorted convoys including small aircraft carriers, long-range air reconnaissance, and broken German naval codes—that by May 1943, "Black May" in the eyes of the German admirals, had convincingly and permanently turned the tide of battle against the Nazi wolf packs.

Galbraith would prove to be the loudest and most insistent critic of the survey's work in his area of responsibility as well as one of its most cogent contributors. He had been a professor of economics at Harvard and Princeton before being recruited by the survey in 1944. He was over six feet, six inches tall and for that reason alone had been deferred from the draft. In 1949 he returned to Harvard and then served as U.S. ambassador to India from 1961 to 1963. He was a prolific and lucid writer, and acquired international fame as the author of a series of important and popular books on economics including *American Capitalism* (1951) and *The Affluent Society* (1958). He recalled that soon after he and his team had begun to dig into the records in Germany, he concluded that German war management was for most of the early years of the war "half-hearted and incompetent." Even more importantly, like Perera he discovered that the nation's economy had not been the "tightly stretched drum" erroneously assumed by U.S. Intelligence.

Nevertheless, Galbraith pointed out, despite the acrimonious disagreements over targeting between the USAAF and the RAF in 1944 and 1945, there was unanimous agreement that the bombing was doing major damage to Germany's war economy. Not so—absolutely! he wrote. For example, the factories producing tanks and self-propelled guns—the panzer vehicles at the heart of the Wehrmacht—were never a high-priority target for the bombers. But production of these vehicles required machine tools, steel, transportation, and labor. If the German economy had been disrupted, as the Anglo-American analysts steadfastly believed, almost as a matter of religious faith, then panzer production would have been slowed. The records the researchers uncovered show otherwise: "In 1940, the first full year of war, the average monthly production of panzer vehicles was 136; in 1941, it was 316; in 1942, 5,167. In 1943, after the bombing began in earnest, average monthly production was 1,005, and in 1944, it was 1,583. Peak monthly production was not reached until December 1944 and it was only slightly down in early 1945. For aircraft and other weaponry the figures were similar."[14] Overall, the USSBS concluded that the losses in total German production that were attributable to strategic bombing were 2.5 percent in 1942, 9.0 in 1943, 17.0 in 1944, and 6.5 in 1945.[15]

Other disturbing facts were unearthed early during the investigations. The 1000-plane RAF Bomber Command firebomb raids on Hamburg on

three successive nights in July and August 1943, that killed tens of thousands of its inhabitants and burned out the business center of the city, had left the factories and shipyards on the city's outskirts essentially undamaged. Before the raids, these facilities had been short of labor; afterward, the clerks, waiters and shopkeepers—their old jobs eliminated—flocked to the war plants, not only for the jobs made vacant by death but to obtain ration cards that the government thoughtfully distributed to the new workers. Quite simply, the RAF bombers had eliminated the labor shortage.

In Nazi Germany few industries operated a night shift during the war and the work week was only slightly lengthened. Expanded production was a result of added plant capacity and additional day shifts. Few German women were mobilized for factory work, in sharp contrast to their counterparts in America, the "Rosie the riveters" who moved into war plants by the millions, permanently changing, incidentally, the social fabric of America. In September 1944, for example, Germany still had 1.3 million domestic servants for its affluent families, compared with 1.6 million in May 1939. At the end of 1943, Hitler had decreed the importation of an additional half-million young women from the Ukraine to bolster this number. German *Kultur* circumscribed the woman's role, particularly the mother's; for women it remained *Kuche, Kirche, Kinder*—kitchen, church, children.

Despite the limited mobilization of the German economy during the first years of the war, Galbraith put his finger on the remarkable paradox of the nation's war productivity, namely, that as Anglo-American bombing intensified, war production increased significantly. In the fall of 1944, with American and British forces pressing in from the west and the Red Army from the east, the Third Reich's overall war production peaked. It was three times as large as in early 1942, when Albert Speer became Minister of Armaments. Earlier he had been Hitler's architect. Only 36 at the time, his appointment is considered by most historians to have been the outstanding executive appointment of the Nazi regime.

In October 1943, Speer, in a speech to manufacturers, noted that during 1942, the Reich had produced 120,00 typewriters, 200,000 radios, 150,000 electric blankets, 3,600 refrigerators, 512,000 pairs of riding boots, and 360,000 spur straps. At the same time, Hitler's paramour, Eva Braun, "ordinarily so unassuming, had no sooner heard of a proposed ban on permanent waves as well as the end of cosmetic production when she rushed to Hitler in high indignation." In turn, Hitler advised Speer that instead of an outright ban he should "quietly stop production of hair dyes and other items necessary for beauty culture and stop repairs upon apparatus for producing permanent waves."[16]

Speer, who was thoroughly interviewed by survey interrogators prior to going before the Nuremberg war-crimes tribunal and being sentenced to a 20-year prison term, had authoritative words on the effects of bombing on

Germany. In November 1944 he had sent a report to Hitler that the aerial attacks on Germany's railroads were seriously affecting Germany's war effort. He also gave a vivid picture to his interrogators of the effectiveness of the bombings of chemical and synthetic oil plants and of the miseries inflicted on the civilian populations resulting from the bombings of German cities.

Galbraith recorded that the secretariat of the survey had written a summary report of the overall findings "that was as the Air Force would have wished it. Our patiently gathered data on the disastrous failure of strategic bombing were extensively ignored. There were no serious failures mentioned." However, "the abysmal level of literacy of the biased summary report" as Galbraith candidly put it, led to him personally being assigned the task of rewrite: "once more the awesome power from being one who can write." The editing job, he later commented, became a regular war of attrition, with sentence-by-sentence review by colleagues "who chose to interpret the data differently." The summary report's thesis was that German war production had expanded during the bombing. The much-ballyhooed 8th Air Force raids on the ball-bearing plants (Schweinfurt) and airframe plants (Regensburg) were costly failures. Raids against oil and rail targets, however, did have military impact. Galbraith concluded vehemently that strategic bombing had not won the war; at best, it had smoothed the road for the ground troops who did win the war. History and future American foreign policy would have been served better if the USSBS findings had been more critical, he added, "for this would have better prepared us for the costly ineffectiveness of the bombers in Korea and Vietnam."[17]

There were other influential voices with other interpretations. At a Pentagon press conference in October 1945, survey vice-chairman Henry Clay Alexander, the author of the "Overall Report, European War" and "Summary Report, European War," reported, fulsomely:

> ...It was the judgment ... that allied air power was decisive in the war in Western Europe. Hindsight inevitably suggests that it might have been employed differently or better in some respects.... In the air its victory was complete. At sea, its contribution combined with naval power, brought an end to the enemy's greatest naval threat—the U-boat; on land, it helped turn the tide overwhelmingly in favor of Allied ground forces. Its power and superiority made possible the success of the invasion. It brought the economy which sustained the enemy's armed forces to virtual collapse, although the full effects of this collapse had not reached the enemy's front lines when they were overrun by Allied forces. It brought home to the German people the full impact of modern war with all its horror and suffering. Its imprint on the German nation will be lasting.[18]

Historian David MacIsaac has written that the above "represented the most-quoted paragraph from the Survey's findings in Europe."[19] Remarkably,

there is not even a hint in Alexander's brief summary that the Red Army had even existed, much less played a role in the defeat of the Wehrmacht and Nazi Germany. Less chauvinistic and more objective observers, however, have been comfortable assessing the Soviets' contributions as having been perhaps *the most decisive* factor in the war in Europe.

Ironically, as the 20th Air Force's B-29s were running out of meaningful targets over Japan and began razing smaller cities, the USSBS was completing its reports analyzing the bombing of German cities. It was concluding that obliteration bombing had not contributed as much to the defeat of Nazi Germany as had originally been projected. U.S. investigators found, to their surprise, that even in Hamburg, which had suffered the most destructive raids of the European war, weapons production resumed near-normal levels within several weeks.

Of the total tonnage of bombs dropped on German targets by the U.S. 8th and 15th Air Forces, almost one-quarter had been aimed at the centers of large cities, nearly double the amount dropped on all manufacturing targets combined. While the stated purpose of the city attacks had been mainly to erode the morale of the civilian population, particularly industrial workers, the USSBS found that the effect of the bombing upon the behavior of the workers and, in turn, upon their productivity, was small. German workers, angry and discouraged as they may well have been, kept on working. Their will to resist remained firm until well past the 11th hour. For example, in the last weeks of the war, workers were attempting to repair rail yards already under artillery fire from the advancing Allied armies.

* * *

The English, having been spurned by their wartime compatriots in an overall assessment of the air war over Germany, formed their own British Bombing Survey Unit (BBSU). It focused on what they called the great offensive — the euphemistic area bombings which accounted for nearly half of the entire effort put forth by RAF Bomber Command during the war. Under the command of Air Marshall Sir Arthur Harris, the RAF had purposefully targeted German city centers. "It was calculated that some 300,000 Germans were killed and a further 780,000 wounded; 82,000 acres of built-up area in Germany were devastated."[20]

British war planners in the late 1930s, sensitive to their nation's vulnerability to air attack from the continent, had viewed with trepidation the growing strength of the Luftwaffe. They had closely followed its activities during the Spanish Civil War and had developed two heavily armed fighters, the Hawker Hurricane and the Supermarine Spitfire, expressly to counter German bombers, augmented by a supporting network of airfields and early-warning radar systems along the Channel coastline. But the proper defense, in the event of war with Germany, was considered to be a counteroffensive

and the role of Bomber Command was unambiguous: "1) to demoralize the German people, 2) to attack targets whose security was regarded by the Germans as vital to their survival, 3) to attack the bases, communications and maintenance organizations of the German bomber force."[21]

British strategic bombing policy had been based on two fundamental premises, as stated candidly in the BBSU's final report: "That destroying German towns would interfere with German war production; and that the intangible effects of bombing, coupled with de-housing, would lead to such demoralization of the civilian population and of the industrial workers of Germany that her rulers would be forced to capitulate." The report's conclusion was unambiguous: "Evidence collected since the end of the war shows that neither premise 'possessed any real substance,' for the truth is that the German home front did not resemble in any particular the broad picture drawn of it by our economic experts.... However totalitarian may have been the political and military aspects of German life, the fact is that the German war economy and the organization of production in Germany, were less totalitarian than [those of] either their British or American counterparts."[22]

The BBSU also concluded that "area attacks against German cities could not have been responsible for more than a very small part of the fall which actually had occurred in German production by the spring of 1945 and ... in terms of bombing effort, they were also a very costly way of achieving the results which they did achieve." Furthermore, the reason Bomber Command's attempts to "de-house" German workers proved to be a failure was because German cities had an elasticity of about 25 percent. This meant that the population of a city remained unchanged, its remaining housing absorbing the homeless, until more than 25 percent of its housing was destroyed.[23]

By May 1945 RAF Bomber Command had flown 298,000 sorties by night and 67,000 by day, and had dropped almost 1 million tons of bombs over Germany. More than 8,000 bombers had been lost during combat and over 46,000 bomber aircrew killed; additionally, 8,000 aircrew had died during training and other non-combat operations. These gruesome statistics were put even more graphically: "Out of every 100 aircrew who joined an OTU [operational training unit], on average 51 would be killed in operations, nine would be killed flying in England, three would be seriously injured in crashes, twelve would become POWs, of whom some would be injured, one would be shot down but evade capture, and 24 would survive unharmed."[24] Shades of the Great War and its notorious "wastage," the grotesque term coined by British army officers to account for the hundreds of Tommies killed each day in the trenches in France by random enemy shelling and mindless frontal attacks against dug-in German machine guns. A half-century later, one can wonder if the surviving widows and spinster lovers of the young RAF volunteers who determinedly clambered aboard their black-painted Lancasters at dusk on one-way flights into Germany still believe their deaths were somehow worthwhile.

* * *

Survey teams were redeployed to the Pacific immediately after the official surrender papers had been signed by the Japanese delegation where General Douglas MacArthur so indicated aboard the U.S. battleship *Missouri* anchored in Tokyo bay. Its researchers faced a generally simpler task than the one being completed in Europe. The scale of air attacks over Japan had been far smaller as had been the duration. Whereas some three million tons of bombs (U.S. and British combined) had been dropped inside Germany, over a period of more than five years, about 160,000 tons had been dropped on the Japanese home islands over only a five-month period. Complicating the analyses, however, was the necessity of factoring in the two atomic bomb assaults. Furthermore, while the U.S. Navy's role in the European theater had been strictly circumscribed by geography, the war in the far reaches of the Pacific Ocean was principally a naval war from the opening air strikes by Admiral Chiuchi Nagumo's carrier-based bombers and torpedo planes on December 7, 1941. This meant that the Japanese study had to include the effects of the Navy's tactical strikes from its carriers, as well as the effects of the AAF's B-29s from the Marianas, on the Japanese home islands

General LeMay's rationalization that Japan's war production relied mainly on so-called "cottage industries," linking the majority of the civilian population directly with the country's war machine and thus making them legitimate targets for bombing, was found to be a self-serving exaggeration. USSBS stated clearly: "By 1944 Japan had almost totally eliminated home industry in the war economy." On the other hand, the USSBS analysts learned that the firebomb raids on Japanese cities had had a far greater impact on both civilian morale and war production than had similar raids over Germany. It was also discovered that many of the factories destroyed had already been put out of action by the effective U.S. naval blockade which had cut off the supply of vital raw materials. Those manufacturing plants still at work were faced with the inexorable breakdown of Japan's internal transportation networks upon which the factories depended for moving parts and finished goods.

Unlike the chairman's report for Europe, which became a document of over 100 pages, a summary report of 30 pages was sufficient for the war over Japan. The survey's work in the Pacific also represented the opening round in a no-holds-barred postwar fight between Air Force and Navy flyers, referred to then as the "great Anderson-Navy war," which continued through the acrimonious "B-36 controversy" in 1949, and remains a source of friction even today. Anderson was Army major general Orville Anderson. His counterpart was Admiral Ralph A. Oftsie, the Navy's chief representative on the survey. In fact, this "war" was actually only a skirmish in the broader conflict of "who"—which military service—had won World War II for America. The fledgling Army Air Forces had in just a few years grown into a noisy and brash

colossus. Was the organization to be disbanded or somehow meshed into a reorganized U.S. Army? What about the Navy's air arm and its mighty fleet of carriers?—not ready to be subordinated to another military service. What about the prideful Marine Corps, that fought so valiantly in the Pacific islands, suffering enormous casualties? Oftsie's plan was a simple one: to establish that it was the Navy's critical job to make it possible for the USAAF to do its job, namely to get the B-29s within bombing range of Japan. Indeed, there was no dispute that it had done this job well. Just how high the stakes were perceived to be is illustrated by a memorandum he wrote on September 16, 1945, to staffers of his Naval Analysis Division:

> The assigned mission requires a parallel and equally thorough study of all operations which brought us within striking distance of the Japanese home-land, and without which there would have been no successful conclusion of the war.... The results of the Survey's effort may well be the basis for major decisions respecting our post-war national security. This may include the form of our military-naval organization, the relative "weight" of our respective armed forces—ground, sea and air—and the means of integrating all forces to the end of national preparedness. This imposes a grave responsibility on all personnel selected for the job. It will require of every man his utmost initiative, skill and effort."[25]

The battle lines had been drawn for a protracted struggle.

As for the two atomic bombs, Galbraith stoutly insisted they were not decisive, despite the almost unanimous view otherwise, at all levels of American society. It was a myth that their employment made an invasion of the Japanese home islands unnecessary, supposedly saving the lives of thousands if not hundreds of thousands on both sides, he wrote. "These are the facts," Galbraith declared:

The bombs fell after the decision had been taken by the Japanese government to surrender. That the war had to be ended was agreed at a meeting of key members of the Supreme War Direction Council with the Emperor on June 20, 1945, a full six weeks before the devastation of Hiroshima. The next steps took time. The Japanese government had the usual bureaucratic lags between decision and action. The means for approaching the Allies had also to be agreed upon. And there was need to ensure the acquiescence or neutralization of recalcitrant and suicidal officers and their military units. The atomic bombs only advanced the decision.[26]

The survey's figures on Japanese merchant shipping losses highlighted the important role of the U.S. Navy in defeating Japan. Japan's merchant fleet at the start of the war totaled some six million tons. One year later, it had been reduced to five million tons, to about three million tons by 1944, and by war's end to about two million tons. Over 60 percent of the losses were estimated to have been a result of U.S. submarine attacks and most of the

balance of carrier-plane operations. Aerial mining of the waters around Japan by B-29s contributed only in a minor way to the sinkings.[27]

Even the apparent total destruction of Hiroshima was not what it initially appeared to be, since most of the city's industrial production came from plants in the suburbs, with about half coming from only five companies. The USSBS concluded: "Of these larger companies, only one suffered more than superficial damage. Of their working force, 94 percent were uninjured. Since electric power was available, and materials and the working force were not destroyed, plants ordinarily responsible for three-fourths of Hiroshima's industrial production could have resumed normal production within 30 days of the attack had the war continued."[28]

Epilogue

Modern war cannot be limited in its destructive methods and the inevitable debasement of all participants.... A fair scrutiny of the last two World Wars makes clear the steady intensification in the inhumanity of the weapons and methods employed by both the aggressors and the victors. In order to defeat Japanese aggression, we were forced, as Admiral Nimitz has stated, to employ a technique of unrestricted submarine warfare, not unlike that which 25 years ago was the proximate cause of our entry into World War I. In the use of strategic air power the Allies took the lives of hundreds of thousands of civilians in Germany and Japan.... We as well as our enemies have contributed to the proof that the central moral problem is war and not its methods, and that a continuance of war will in all probability end with the destruction of our civilization.[1]

On September 2, 1945 aboard the battleship U.S.S. *Missouri* in Tokyo Bay a 12-man Japanese delegation, military personnel and civilians (the civilian members incongruous in top hats), surrendered formally and unconditionally to the Allies, General Douglas MacArthur regally presiding in the solemn 20-minute ceremony. It marked the first military defeat in Japan's 2,600-year history. World War II was over.

Promptly after the Japanese had signed the surrender articles and scurried off the ship, tight formations of U.S. warplanes thundered low overhead. It was an impressive display of American air might and what one American reporter theatrically reported as "a breathtaking climax to the solemn consummation of Japan's defeat ... the aerial cavalcade was a fitting and just close to the proceedings, for this war with Japan began with the thunder of alien wings as hordes of Japanese planes bombed Pearl Harbor."[2]

Leading the air armada were 50 B-29s making their final flights over

Japan. The big bombers, along with hundreds of others in the Marianas and on Okinawa, would soon be flown by their crews back to the United States; those in best repair would be moth-balled, and lined up wingtip to wingtip at remote airfields in the arid southwestern states for the time when they would be called again to combat. The veteran B-29s would not sit long: the Korean War was just around the corner. Before then, in September 1947, the United States Army Air Forces gained its independence as the United States Air Force.

Then would follow the Vietnam War, the Persian Gulf War, and "police actions" overt and covert for the remainder of the 20th century in support of an aggressive American foreign policy. Ushering in the 21st would be a self-proclaimed "War Against Terrorism" in Afghanistan and elsewhere following the September 11, 2001, aerial attacks on the World Trade Center in Manhattan and the Pentagon in Washington.

In all these conflicts military air power would be the weapon of choice by the United States—typically a blunt fist but routinely pronounced a surgical scalpel.

* * *

In 1991, a controversial issue was resurrected by political journalist Yasuo Kurata of the influential Japanese newspaper *Tokyo Shinbun.* In an article in the May 5 *Kansas City Star,* Kurata pointed his finger at Americans as being insensitive to civilian casualties because America had never been bombed. He used as his example, the recent destruction of a large air raid shelter in downtown Baghdad during the Gulf War by U.S. bombers that "slaughtered more than 400 people, including about 100 infants and young children." Kurata mocked such euphemisms as "collateral damage" and reference to loss of civilian lives as the "inevitable byproduct of aerial warfare."

Later that month, in a lead editorial in the May 24 *New York Times,* titled "The Damage Was Not Collateral," the findings of a United Nations team described the allied bombings of Iraq as one of "catastrophic devastation." Most of the destruction found by the U.N. inspectors was neither accidental nor collateral, "but the intended consequence of the successful air campaigns to destroy Iraq's war machine by attacking its industrial base and urban infrastructure." The U.N. team found that most modern life support systems in Iraq had been destroyed or rendered tenuous, including such essentials as food supply, power generation, water purification, and sewage treatment. The editorial asked rhetorically if the bombing of Iraq had been important to the outcome of the brief war, and pointed out that the U.S. Air Force "continues to believe in strategic bombing," the doctrine intended to bring surrender of an enemy without a ground war, "by destroying industry and infrastructure by sapping the enemy's will to resist." In fact, the bombing of city targets did not make Saddam Hussein surrender. Nearly one-third of all air force sorties were aimed at cities, according to the *Times,* "with predictably

deplorable results for civilians. The U.N. report quotes Iraqi estimates that 8,000 homes were destroyed, leaving some 72,000 people homeless. How many civilians died is not known. Based on air force figures, 70 percent of the bombs dropped in the war missed their targets. Even precision-guided bombs missed their targets 10 percent of the time."

A news report in the *New York Times* of October 7, 1999, datelined Incirlik Air Base, Turkey, announced that the U.S. Air Force stationed at that base has been regularly bombing targets in Iraq with what the *Times'* headline preposterously called a "defter weapon." The supposedly more dexterous new weapon, in fact, was a concrete bomb—a 2,000-pound laser-guided bomb filled with cement! American military officials at Incirlik were cited as stating they were dropping these "innovative" bombs on military targets near populated areas and wanted to avoid hitting civilians. A spokesman for the U.S. operation in Incirlik said: "It [the concrete bomb] can stub your toe. But there's no chance of collateral damage," using the military's popular euphemism for civilian casualties. Shades of the 8th Air Force's "bullshit bombers" of more than a half-century earlier!

A column-one news story on the front page of the October 27, 2001, issue of the *New York Times*, titled "U.S. PLANES BOMB A RED CROSS SITE," stated that "American warplanes bombed and largely destroyed the same Red Cross compound in Kabul [Afghanistan] that they had struck 10 days ago, an error the Pentagon admitted, saying it occurred because military planners had picked the wrong target.... One of the American aircraft that had been ordered to hit the Red Cross supply warehouses missed its target and hit a residential neighborhood instead."

Chapter Notes

Preface

1. Robin Neillands, *The Bomber War: The Allied Air Offensive Against Nazi Germany* (Overlook Press, Woodstock, New York, 2001), 30.

2. Stephen L. McFarland, *America's Pursuit of Precision Bombing. 1910–1945* (Smithsonian Institution Press, Washington, 1995), x.

3. *New York Times,* May 18, 1940.

4. Later Edwards Air Force Base and the U.S. Air Force Flight Test Center. The bomb test facility was then referred to as the Precision Bombing Range and was operated by the U.S. Army Ordnance Corps, Aberdeen Proving Ground, Maryland. The author spent two years, 1954–1956, as a U.S. Army enlisted man/project engineer with the Aberdeen Bombing Mission. In 1956, operation of the bombing range was transferred to the jurisdiction of the Air Force.

5. Conrad C. Crane, *Bombs, Cities, and Civilians:American Airpower Strategy in World War II* (University Press of Kansas, Lawrence, Kansas, 1993), 33.

6. Hastings, *Bomber Command: The Myths and Reality of the Strategic Bombing Offensive 1939–1945* (Dial Press, New York, 1979), 339–340.

Introduction

1. Stephen L. McFarland, *America's Pursuit of Precision Bombing, 1910–1945* (Smithsonian Institution Press, Washington, 1995), x.

2. Williamson Murray, *The Luftwaffe, 1933–45—Strategy for Defeat* (Brassey's, Washington, 1983), 132.

3. Oron P. South, *Medical Support in a Combat Air Force* (Air University, Maxwell Air Force Base, Alabama, 1956), 2.

4. *New York Times,* June 4, 2000 (U.S. Dept. of Defense). By comparison, the Royal Air Force lost over 79,000 dead, with Bomber Command alone over 44,000 dead, 22,000 wounded, and 11,000 missing. These losses exceeded casualties of the British Army during the cross–Channel invasion and the conquest of Europe. Mae Mills Link and Hubert A. Coleman, *Medical Support of the Army Air Forces in World War II* (Office of the Surgeon General, USAF, Washington DC, 1955), 707.

5. Kenneth P. Werrell, *Blankets of Fire: U.S. Bombers over Japan during World War II* (Smithsonian Institution Press, Washington, 1996), 239.

1—The Beginnings

1. H.G. Wells, *War in the Air* (G. Bell and Sons, Ltd., London, 1908), 63.
2. Lee Kennett, *A History of Strategic Bombing* (Charles Scribner's Sons, New York, 1982), 9.
3. Ibid., 9.
4. Christopher Chant, *The Zeppelin* (Barnes & Noble, Inc., New York, 2000), 27. The biggest zeppelin, the *Hindenburg*, was 804 feet long. It was destroyed in a spectacular fire, during a landing in Lakehurst, New Jersey, in 1937, effectively ending the era of the rigid airship.
5. Ibid., 52.
6. Ibid., 108–111.
7. This actual machine, painstakingly restored and lovingly maintained by the experts at the Smithsonian Institution's Air and Space Museum in Washington, hangs from the ceiling at the main entrance.
8. Wells, op. cit., 68.
9. Ibid., 133.
10. Ibid., 109.

2—The Great War

1. Douglas H. Robinson, *Giants in the Sky* (University of Washington Press, Seattle, 1973), 91.
2. Harvey A. De Weerdin, *President Wilson Fights His War* (The Macmillan Company, New York, 1968), xx.
3. Helium was first isolated in the laboratory in 1895 and remained a scientific curiosity even after the substance was identified as a constituent of natural gas in wells in Kansas and Texas. Because it is a nonflammable gas, it is preferable to hydrogen as a "lifting agent" in terms of its safety for use in dirigibles, balloons, and blimps, even though it has only 92 percent of hydrogen's "lifting power" and weighs twice as much.
4. There is overwhelming evidence that in 1914 Belgium was not "neutral." When the German army occupied Brussels in September 1914, secret official documents were discovered in the archives of the Belgian government that clearly incriminated Belgium as an active party to Allied war plans. As early as January 1906, for example, the military attache of the British legation in Brussels had discussed with the chief of the Belgian general staff joint steps to be taken by Belgium, Great Britain, and France in the event of war with Germany. Stewart Halsey Ross, *Propaganda for War: How the United States was Conditioned to Fight the Great War of 1914–1918* (McFarland & Company, Inc., Jefferson, North Carolina, 1996), 47–48.
5. Not quite 30 years later, ironically the tables would be turned 180 degrees. After the British army had been driven to the beaches of Dunkirk and forced to retreat ignominiously back across the English Channel at the end of May and early June 1940, the only way the British could bring the war back to Germany promptly was through the air using RAF heavy bombers.
6. Robinson, op. cit., 78.
7. *New York Times*, June 8, 1913.
8. Robinson, op. cit., 79.
9. Ibid., 81.
10. Ibid., 108. *Kölnische Zeitung*, January 21, 1915.
11. Ibid., 77.
12. Ibid., 88.
13. Francis K. Mason, *Battle Over Britain* (Doubleday & Company, Inc., Garden City, New York, 1969), 223.

14. Robinson, op. cit., 94
15. Ibid., 129
16. Near the end of World War I, the British began intensive development of dirigibles stimulated by anticipation of availability of nonflammable helium from the U.S. which held a monopoly on the gas. The 650 foot long *R34* was commissioned in 1919 and flew across the Atlantic. In 1921, the larger *R38* was put into service. Both crashed that same year. In 1923, the U.S. Navy commissioned the *Shenandoah*, the first dirigible built in the U.S. It made a number of extended and successful flights before being wrecked in a storm in 1925. In 1924, the Navy took delivery of the *ZR3* made in Germany as a partial payment of war reparations. Renamed *Los Angeles*, it made about 250 flights before it was decommissioned in 1932. In 1928 the German *Graf Zeppelin*, the largest dirigible yet built, made its maiden voyage. It flew more than 1 million miles in nine years of commercial service, crossing the Atlantic 139 times and circumnavigating the globe. At the same time, the British resumed building dirigibles, launching the *R100* and the *R101* in 1929; a year later, the R101 crashed in a storm en route to India, and *R100* was scrapped, ending British construction and flying of dirigibles. In 1928, the U.S. Navy commissioned the *Akron* and the *Macon*. Both airships had a hanger compartment inside the envelope that could house five scout airplanes, which could be flown off and retrieved in flight. The *Akron* crashed in a storm in 1933 and the newer *Macon* was wrecked in 1935. After ten transatlantic flights in commercial service in 1936, Germany's *Hindenburg* was destroyed in a spectacular fire coming in for a landing at Lakehurst, New Jersey, in 1937, confirming the general view that hydrogen-filled airships were dangerous to fly. Germany subsequently scrapped its *Graf Zeppelin*. The United States turned to its pressure airships, its blimps.
17. Mason, op. cit., 39.
18. John H. Morrow, *The Great War in the Air: Military Aviation from 1909 to 1921* (Smithsonian Institution Press, 1993), 266.
19. William Mitchell, *Memoirs of World War I: From Start to Finish of our Great War* (Random House, New York, 1960), 59.
20. Richard G. Davis, *Carl A. Spaatz and the Air War in Europe* (Center for Air Force History, Washington, 1993), 17. The totals were 1,554,463 tons over Germany and 502,781 tons over Japan. These figures do not include the much smaller U.S. Navy totals.
21. Stephen I. McFarland, *America's Pursuit of Precison Bombing, 1910–1945* (Smithsonian Institution Press, Washington, 1995), 81.

3—The Seers

1. Giulio Douhet, *The Command of the Air* (Office of Air Force History, Washington, 1983. Originally published: New York, Coward-McCann, 1942), 181.
2. Lee Kennett, *A History of Strategic Bombing* (Charles Scribner's Sons, New York, 1982), 9.
3. George H. Quester, *Deterrence Before Hiroshima* (Transaction Books, New Brunswick, New Jersey, 1966), 127.
4. *New York Times*, November 11, 1935.
5. The General Report of the Commission of Jurists at the Hague (*American Journal of International Law*, XVII, Oct. 1923) as cited by Kennett. Article 24 was more detailed: 1) Aerial bombardment is legitimate only when directed at a military objective, the destruction or injury of which would constitute a distinct military advantage to the belligerent. 2) Such bombardment is legitimate only when directed exclusively at the following objectives: military forces; military works; military establishments or depots, factories constituting important and well known centres engaged in the manufacture of arms, ammunition, or distinctively military supplies; lines of communication or transportation used for military purposes. 3) The bombardment of cities, towns, dewellings,

or buildings not in the immediate neighbourhood of the operations of land forces is pro-hibited. In cases where the objecives specified in paragraph 2) are so situated that they canot be bombarded without the indiscriminate bombardment of the civilian popula-tion, the aircraft must abstain from bombardment. 4) In the immediate neighbourhood of the operations of land forces, the bombardment of cities, towns, villages, dwellings, or buildings is legitimate provided that there exists a reasonable presumption that the military concentration is sufficiently important to justify such bombardment, having regard to the danger thus caused to the civilian population. 5) A belligerent State is liable to pay compensation for injuries to persons or property caused by the violation of any of its officers or process of the provisions of this article.

6. Hilton P. Goss, *Civilian Morale Under Aerial Bombardment, 1914–1939, vol. 1* (Air University Libraries, Maxwell Air Force Base, Alabama) December 1948, 111. The undeclared war had begun on July 7, 1937, with a clash between Chinese and Japanese troops on the Marco Polo Bridge near Peiping (Peking).

7. Ibid., 116–117.

8. Ibid., 139.

9. Robin Neillands, *The Bomber War: The Allied Air Offensive Against Nazi Ger-many* (Overlook Press, Woodstock, New York, 2001), 31.

10. Goss, op. cit., 191. The protest was signed by seven U.S. senators, two state governors, and
such political leaders as Henry L. Stimson, Newton D. Baker, and Alf Landon.

11. Hans Rumpf, *The Bombing of Germany* (Holt, Rinehart and Winston, New York, 1963), 18–19.

12. B.H. Liddell Hart, *The Revolution in Warfare* (Yale University Press, New Haven, 1947), 86–87.

13. *New York Times*, September 2, 1939.

14. Ibid., September 3, 1939.

15. Michael S. Sherry, *The Rise of American Air Power* (Yale University Press, New Haven, 1987), 30.

16. H.H. Arnold and Ira C. Eaker, *Winged Warfare* (Harper & Brothers, Pub-lishers, New York, 1941), 133–134.

17. H.C. Englebrecht and F.C. Hanigan, *Merchants of Death: A Study of the Inter-national Armament Industry* (George Routledge & Sons, London, 1934); Walter Millis, *Road to War: America 1914–1917* (Houghton Mifflin, New York, 1935).

18. Alfred Price, *The Bomber in World War II* (MacDonald and Jane's, London, 1976), 15–16.

19. Burke Davis, *The Billy Mitchell Affair* (Random House, New York, 1967), 29–30.

20. Douhet, op. cit., 6–7, 19.

21. Ibid., 196.

22. Ibid., 59.

23. Ibid., 52.

24. Ibid., 33.

25. Davis, op. cit., 144–145.

26. As early as 1905, U.S. war planners had conceived and had continued to refine over the years secret War Plan Orange, the code name for an anticipated war with Japan. From America's perspective, the fundamental cause for the coming war was Japan's drive for national greatness by attempting to dominate the land, people, and resources of the so-called "Pacific Rim." This region America regarded as its economic fiefdom. It was expected that Japan would mobilize every element of its society for a war that it perceived to be for national survival. The United States would work clandestinely to force Japan to strike the first blow (albeit, not an "undeclared" first strike). While Japan was expected to initially seize key objectives in the western Pacific, the war would become one of attrition, and it was believed, mistakenly, by Japanese military leaders that Amer-icans would quickly tire of a war in a faraway region and demand a peace that would

concede many of Japan's territorial gains. With Japan painted by U.S. propaganda as the clear-cut aggressor—indeed, the surprise attack on Pearl Harbor proved to fit precisely into America's scheme—and a committer of atrocities to boot, Americans would mobilize in rage and would persevere for a cause they considered just. The U.S.population (double Japan's) would be harnessed to a giant army, navy, and air force backed by America's unsurpassed industrial might (some ten times larger than Japan's)—to regain lost territories, crush Japan's military forces, and invade and occupy Japan's home islands. Postwar, America would emerge as the dominant power in the region and would maintain its hegemony into the third millenium.

27. William Mitchell, *Memoirs of World War I: From Start to Finish of our Greatest War* (reprinted Random House, New York, 1960), 3.

28. Davis, op. cit., 198.

29. Mitchell, *Memoirs*, 30.

30. Norman Longmate, *The Bombers* (Hutchinson, London, 1983), 28.

31. Ibid., 30.

32. Colonel Blimp was a humorous cartoon character originated by the British cartoonist/satirist David Low. Blimp was a buffoon—stubborn, pompous, and altogether an arch-conservative.

33. B.H. Liddell Hart, *Paris, or the Future of War* (Garland Publishing , Inc., New York , 1972), 43.

34. Sherry, op. cit., 130.

35. Alexander P. de Seversky, *Victory Through Air Power* (Simon and Schuster, New York, 1942), 145.

36. Ibid., 146.

37. Henry Morgenthau, Jr. took up where his fervently anti–German father had left off. Henry, Sr., had been ambassador to Turkey early in World War I and had resigned his post in 1916 to return to Washington to pursue a run for the post of Secretary of the Treasury. He failed in his quest and instead turned his energies, along with those of the renowned Germanophobe journalist Burton J. Hendrick, to publishing an anti–German propaganda book titled *Ambassador Morgenthau's Story*. One historian has written: "Morgenthau's tale featured one of World War I's most most carefully crafted lies, a lurid hoax whose political fallout far exceeded the wildest expectations of its author and his ghostwriter." In the book, Morgenthau fabricated the famous legend of the Potsdam Crown Conference of July 5, 1914—a conference that many reputable historians say never took place. Morgenthau's book had a lasting impact. It was cited by the Commission of Reparations at the Paris peace conference in 1919 as one justification for the infamous "sole war guilt," Article 231 of the Treaty of Versailles. Stewart Halsey Ross, *Propaganda for War: How the United States was Conditioned to Fight the Great War of 1914–1918* (McFarland & Company, Inc., Jefferson, North Carolina, 1996), 166, 254–258.

4—The Planners

1. Stephen L. McFarland, *America's Pursuit of Precision Bombing, 1910–1945* (Smithsonian Institution Press, Washington, 1995), 103.

2. Thomas A. Bailey and Paul B. Ryan, *Hitler vs. Roosevelt—The Undeclared Naval War* (Free Press, New York, 1979), 209–210.

3. Walker was later killed over Rabaul, the Japanese naval stronghold in the Pacific, in an action that won him the Medal of Honor posthumously. Hansell would be called on to implement both AWPD-1 and AWPD-42, programs he had helped develop; Kuter retired as a four-star general.

4. Perry McCoy Smith, *The Air Force Plans for Peace, 1943–1945* (Johns Hopkins Press, Baltimore, 1970), fn. 31.

5. Richard Davis, *Carl A. Spaatz and the Air War in Europe* (Center for Air Force History, Washington, 1993), 60.

 6. Haywood S. Hansell, Jr., *The Air Plan that Defeated Hitler* (Higgins-McArthur/Longino & Porter, Inc., Atlanta, 1972), 91.
 7. Thomas H. Greer, *The Development of Air Doctrine in the Army Air Arm 1917–1941* (Office of Air Force History, U.S. Air Force, Washington, 1985), 125.
 8. Hansell, op. cit., 83–84.
 9. McFarland, op. cit., 102.
 10. Hansell, op. cit., 88.
 11. Alan J. Levine, *The Strategic Bombing of Germany, 1940–1945* (Praeger, Westport, Connecticut, 1992), 77.
 12. James C. Gaston, *Planning the American Air War: Four Men and Nine Days in 1941* (National Defense University Press, Washington, 1982), 108. The U.S. Army operated 13 combat air forces during World War II. The 6th and 7th served in the Panama Canal Zone and Alaska. The 8th flew from bases in England. The 9th, 12th, and 15th were based in the Mediterranean area and North Africa. The 5th, 7th, 10th, and 14th ranged over the Pacific and the China-Burma-India region. The 20th was activated in November 1944, expressly for the B-29s operating against the Japanese home islands from three bases in the Mariana Islands: Guam, Saipan, and Tinian.

5—The Crucibles

 1. Excerpt from press statement by General Arnold regarding second attack on Schweinfurt, October 14, 1943. *New York Times*, October 16, 1943.
 2. Stephen L. McFarland, *America's Pursuit of Precision Bombing, 1910–1945* (Smithsonian Institution Press, Washington, 1995), 175.
 3. *New York Times*, December 13, 1941.
 4. Ibid., March 7, 1942.
 5. The North American B-25, a twin-engine medium bomber with a five-man crew, had never been intended to fly off an aircraft carrier. It later saw yeoman service in the Southwest Pacific (5th Air Force); in the China-Burma-India theater (10th Air Force); in China (14th Air Force); in the Aleutian Islands (11th Air Force); in the Central Pacific (13th Air Force); and in North Africa and Italy (12th Air Force).
 6. Carroll V. Glines, *The Doolittle Raid: America's Daring First Strike Against Japan* (Orion Books, New York, 1988), 24.
 7. Ibid., 55.
 8. Ibid., 33–34.
 9. Harold Nicholson, *Why Britain Is at War* (Penguin Books, Ltd., London, 1940), 128.
 10. *New York Times*, November 11, 1935.
 11. Williamson Murray, *The* Luftwaffe *1933–45: Strategy for Defeat* (Brassey's, Washington, 1996), 322.
 12. Raymond H. Fredette, *The Sky on Fire* (Harcourt Brace Jovanovich, New York, 1976) xviii.
 13. Alastair Revie, *The Lost Command* (David Bruce & Watson, London, 1971), 90.
 14. British Bombing Survey Report, 7.
 15. Anthony Verrier, *The Bomber Offensive* (The MacMillan Company, London, 1969), 123.
 16. Mark K. Wells, *Courage and Air Warfare—The Allied Aircrew Experiences in the Second World War* (Frank Cass, London, 1995), 49.
 17. Revie, op. cit., 132
 18. Ibid., 132–133.
 19. Ibid., 133.
 20. Vera Brittain, *Seeds of Chaos* (New Vision Publishing Company, London, 1944), 29.

21. Murray, op. cit., 128.

22. Noble Frankland, *The Bombing Offensive Against Germany*, vol. 2 (Faber and Faber, London, 1965), 201.

23. Gwynne Dyer, *War* (Crown Publishers, Inc., New York, 1985), 92.

24. Haywood Hansell, *The Strategic Air War Against Germany and Japan: A Memoir* (Office of Air Force History, United States Air Force, Washington, 1986), 269.

25. Following the signing of the armistice on November 11, 1918, Great Britain vindictively kept in place its naval blockade of German ports until July 7, 1919, ostensibly to keep pressure on Germany to sign the onerous Treaty of Versailles. In fact, the British used the subterfuge, along with the burdensome reparations clauses of the treaty, to keep Germany's economy stalled, in order to allow more time for the victors' economies, France's included, to recuperate. Some 900,000 German women, children, and the elderly—already weakened by the earlier wartime blockade—starved to death as a result of what came to be known as the "food blockade" and countless thousands more malnourished young children were permanently scarred, both physically and intellectually. C. Paul Vincent, *The Politics of Hunger: The Allied Blockade of Germany, 1915–1919* (Ohio University Press, 1985).

26. Thomas Fleming, *The New Dealers' War: F.D.R. and the War Within World War II* (Basic Books, New York, 2001), 173–174.

27. Ibid., 176.

28. The term "ball bearing" refers to the rolling members in an "anti-friction" bearing as compared to a common "journal bearing" which depends entirely on fluid pressure to reduce contact, friction, and wear between mating members. In general, balls are used as the rotating parts where high speeds and thrust-bearing loads must be resisted; rollers and tapered rollers are used for heavier loads. Both types of such anti-friction bearings are vital components in aircraft engines which operate at high speeds under heavy loads.

29. Charles Webster and Noble Frankland, *The Strategic Bombing Offensive Against Germany 1939–1945*, vol. IV (Her Majesty's Stationery Office, London, 1961), 380–384.

30. Wesley Frank Craven and James Lea Cate, eds., *The Army Air Forces in World War II*, vol. III (Office of Air Force History, Washington, 1983), 8.

31. Leroy Newby, *Target Ploesti* (Kensington, New York, 1986) 216.

32. Ibid., 308.

33. McFarland, op. cit., 177.

34. Bernard Brodie, *Strategy in the Missile Age* (Princeton University Press, Princeton, New Jersey, 1965), 111.

35. Albert Speer, *Inside the Third Reich* (The MacMillan Company, New York, 1976), 346.

36. Geoffrey Perret, *Winged Victory: The Army Air Forces in World War II* (Random House, New York, 1991), 288.

37. Cajus Bekker, *The Luftwaffe War Diaries—The German Air Force in World War II* (Doubleday & Company, Inc., Garden City, New York, 1968), 350–351.

38. Ibid., 351.

39. Craven and Cate, op. cit., 668, 731.

40. Perret, op. cit., 369

41. Eaker to Spaatz, January 1, 1945, Library of Congress, Spaatz Papers, Box 20.

42. Ronald Schaffer, *Wings of Judgement:American Bombing in World War II* (Oxford University Press, New York, 1985), 94.

43. Richard Davis, *Carl A. Spaatz and the Air War in Europe* (Center for Air Force History, Washington, 1993), 508.

44. Craven and Cate, vol. V, 171.

45. The three archipelagos of Micronesia—the Marianas, the Carolines, and the Marshalls—consist of some 100 individual islands totalling just over 700 square miles,

sprinkled across a region of the North Pacific about equal in area to the continental United States. The Marianas had been Spanish colonies since 1521 when Magellan had discovered them and the Carolines since the 1600s. German planters had colonized the Marshalls in the 1800s and Germany formally annexed them in 1885. Guam, the largest of the Mariana Islands, was ceded to the United States in 1898 after the Spanish-American War. Until World War I, Japan's military had taken no interest in such tiny islands of seemingly no strategic value. The war in Europe, however, offered an opportunity to acquire territory at little cost. As the war opened, there was a German cruiser squadron in the Pacific and England needed protection for troops and cargo heading to France from Australia. Japan, already an ally of England, declared war against Germany and one by one invaded and occupied the German islands of the North Pacific. As part of the post–World War I settlement, former German colonies north of the equator were ceded to Japan; those south of the equator went to Australia.

46. Craven and Cate, op. cit., 640

47. *New York Times Magazine*, August 4, 1935.

48. Curtis Emerson LeMay went from commander of the 20th Air Force in the Pacific to head of the U.S. Air Force in Europe in 1947 and was one of the architects of the Berlin airlift in 1948–1949. He returned to Washington to become commander of the new Strategic Air Command. He became vice chief of staff in 1957 and chief of staff in 1961, and retired in 1965 with 35 years' service. In October 1968, George C. Wallace, American Independent Party candidate for president, named LeMay his running mate. The ticket lost to Republicans Richard Nixon and Spiro Agnew.

49. Col. Harry F. Cunningham, *Weekly Intelligence Review*, 5th Air Force, Summer 1945, 1452.

50. Kenneth P. Werrell, *Blankets of Fire: U.S. Bombers over Japan during World War II* (Smithsonian Institution Press, Washington, 1996) 230.

51. Ibid., 237–238.

6—The Airplanes

1. Theodore A. Wilson, *WW 2: Readings on Critical Issues.* (Scribner, New York, 1974) 79.

2. A flight crew's comments (869th Bombing Squadron, 497th Bomb Group) recording one evening's observations in 1945. David A. Anderton, *B-29 Superfortress at War* (Charles Scribner's Sons, New York, 1978) 159.

3. *Generalmajor* Walther Wever, who was the Luftwaffe's first chief of the Air Staff, in 1934 envisioned a German long-range heavy bomber. Such a weapon would be a key element by which Germany could attack every corner of Europe. The specifications he issued called for an aircraft that could reach northern Scotland or the Ural mountains from bases in Germany, carrying a three-ton bomb load. First to fly was the Dornier Do 19, a four-engine bomber with a wing span of 115 feet (11 feet wider than the B-17's). The prototype had a top speed of 199 miles per hour, a range of 994 miles with a bomb load of 6,600 pounds. The larger Junkers Ju 89 was the second to fly; it also had four engines, a top speed of 242 miles per hour, and a range similar to that of the Do 19 but with a bomb load of 8,800 pounds. One RAF analyst summarized the two bombers as having been "remarkable, not so much for their performance and load-carrying ability—though impressive in all conscience—but for the fact that the German aircraft designers, so long isolated from free and open interchange of technical information, were able to produce aircraft more advanced than anything under development for Western air forces." Francis K. Mason, *Battle Over Britain* (Doubleday & Co., Inc., Garden City, New York, 1969), 66–67. Wever was killed in an aircraft accident in June 1936. His replacement was Albert Kesselring, a former Wehrmacht staff officer who had joined the Luftwaffe in 1933. He believed that the Luftwaffe should serve

as a tactical support arm for the Army—not as a strategic strike force. One of Kesselring's first decisions, with *Reichsmarschall* Hermann Goering's backing, was cancellation of both heavy bomber programs. An often quoted comment, attributed to Goering: "The Fuherer will not ask how big the bombers are, but how many there are"—may well have been behind the fateful decision. Kesselring estimated that three twin-engine bombers, such as the Heinkel 111 which became the Luftwaffe's principal bomber throughout the war, could be built for the same cost as two four-engine planes. The Kesselring/Goering decision gives rise to a provacative historical "what if?" If Wever's plan for a big-bomber force had come to fruition, would Nazi Germany by 1940 have had the capability of delivering devastating air attacks against England's vulnerable cities, perhaps forcing Great Britain into a "negotiated peace" with the Third Reich, ending the "second European War" before it became a global holocaust, and changing world history?

4. Wilbur H. Morrison, *Fortress Without a Roof* (St. Martins Press, New York, 1982), 184, 232.

5. Kenneth P. Werrell, *Blankets of Fire: U.S. Bombers Over Japan During World War II* (Smithsonian Institution Press, Washington, 1996), 31.

6. Thomas M. Cofffey, *Decision Over Schweinfurt* (David McKay Company, Inc., New York, 1977), 111–112.

7. John Kenneth Galbraith, "After the Air Raids," *American Heritage*, April/May, 1981, 80.

8. Thomas Childers, *Wings of Morning* (Addison-Wesley Publishing Company, New York, 1995), 21.

9. Two weeks after the Japanese attack on Pearl Harbor, Lindbergh wrote to General Arnold (Letter, Lindbergh to Arnold, December 20, 1941; Reel No. 16, Arnold Papers, Library of Congress) saying he was "ready and anxious to be of service" to the Air Corps and that there was "nothing I would rather do." He stated he fully realized "the complications created by the political stand" he had previously taken and by "past incidents" connected with that stand. Lindbergh had prefaced his letter by calling it a personal note, intending that his request "would remain confidential." The letter did not remain confidential and it can be assumed that Arnold had passed it on promptly to his commander in chief, directly or indirectly. FDR despised Lindbergh for a multiplicity of reasons: his prewar isolationist stand, his vocal leadership of the antiwar America First Committee, and his attacks on the Democratic adminstration and on Roosevelt himself. Here was an opportunity to strike back at his tormenter. Lindbergh was not offered a high-ranking commission in the Army Air Corps. Instead, he applied his experiences and expertise on airplanes as a civilian employee of Chance-Vought Aircraft, builder of the F-4U Corsair, touring aircraft plants, test flying the latest military aircraft, and advising high-level military and civilian authorities on what he had learned of the in-flight performance of the planes he had tested. He went to the Pacific in 1944 to help iron out the teething problems of the Corsair. Lindbergh went on "Technician Status," which meant he could "observe" military combat but could not directly engage in military combat. In fact, contrary to international law, Lindbergh eagerly flew combat missions in the Pacific, dive bombing, strafing, and even shooting down a Japanese fighter plane. He wore a naval officer's uniform without insignia of rank. Arnold's papers included dozens of what can be assumed to have been "typical" letters in response to Lindbergh's request after it was made public. He was called a "Quisling," a "traitor," and "a danger to the United States." The consensus of the letters Arnold chose to retain was overwhelmingly opposed to giving Lindbergh a commission in the Air Corps. One angry writer opined that he be taken in as an enlisted man and "work for his commission" like everyone else. Such short memories! Only 14 years before, after his memorable solo flight across the Atlantic in his *Spirit of St. Louis*, he had been lionized as a national icon of supreme proportions and given a ticker-tape parade through New York City's "Canyon of Heroes" attended by crowds never before seen and not since equaled in size.

10. Charles A. Lindbergh, *The Wartime Journals of Charles A. Lindbergh* (Harcourt Brace Jovanovich, Inc., New York, 1970), 613.

11. Henry "Hap" Arnold, *Global Mission* (Harper & Brothers, Publishers, New York, 1949), 149.

12. Steve Birdsall, *The B-24 Liberator* (Arco Publishing Company, Inc., New York, 1968), 14.

13. William N. Hess, Frederick A. Johnsen, Chester Marshall, *Great American Bombers of World War II* (MBI Publishing Company, Osceola, Wisconsin, 1998), 217.

14. Ibid., 251.

15. Anderton, op. cit., 159. Anonymous historian of the 58th Bomb Wing's 444th Bomb Group summarizing the experiences of the men in his group.

16. Anderton, ibid., 19.

17. U.S. reciprocating aircraft engines were designated R for radial, meaning the cylinders were arranged radially around the crankcase and thus were aircooled, followed by the displacement in cubic inches. If the engines were in-line and thus water-cooled, they were designated V for the arrangement of the cylinders, also followed by displacement in cubic inches.

18. Werrell, op. cit ., 72. Pratt and Whitney Aircraft, Hartford CT, was the other U.S. manufacturer of large-displacement radial engines. Pratt built an engine of similar performance, its R-2800, also an 18 cylinder, twin-row design. Compared to the R-3350, the R-2800 had a fine reliability record throughout the war (and commercially for years afterward), powering such single-engine warplanes as the Republic P-47, Chance-Vought F-4U, and Grumman F-6F. Pratt later became one of America's two principal manufacturers of large axial-flow turbojet engines, General Electric being the other.

19. Curtis E. LeMay, Superfortress: *The B-29 and American Air Power* (McGraw-Hill Book Company, New York, 1988), 78.

20. Ibid., 343.

21. The B-36 was an airplane of superlatives. Its wingspan was 230 feet with a wing-root thickness of 6 feet to allow crewmen to walk inside the wing to perform routine maintenance on the plane's six reciprocating engines during flight; the fully pressurized fuselage was 162 feet long; its tail fin stood 47 feet high. Empty weight was 171,000 pounds; maximum take-off weight was 410,000 pounds. It was designed to fly 6,800 miles (unrefueled) carrying 10,000 pounds of bombs, Maximum speed was 400 miles per hour and service ceiling was 39,000 feet. The plane was uniquely configured, with six reciprocating engines (Pratt & Whitney R-4360's of 3,800 horsepower each) buried in the wing, driving "pusher" propellers 12 feet in diameter, plus two pair of turbojet engines (General Electric J-47s of 7,000 pounds thrust each) mounted in pods hung outboard of the main engines.

22. Stephen L. McFarland and Wesley Philip Newton, *To Command the Sky—The Battle for Air Superiority Over Germany, 1942–1944* (Smithsonian Institution Press, Washington, 1991), 91.

23. Webster and Franklin, op. cit., 80–81.

24. Ibid., 80–81.

25. *New York Times*, September 10, 12, 13, 14, 1945.

7—The Bombs

1. Jeffry Ethell & Alfred Price, *Target Berlin—Mission 250: 6 March 1944* (Jane's, London, 1981), 22.

2. Richard Davis, *Carl A. Spaatz and the Air War in Europe* (Center for Air Force History, Washington, 1993), 426.

3. M-47: 70 lbs.; weight of fuel, 40 lbs., heat liberated, 670,000 Btu; striking velocity, 760 ft./sec.; penetration, 5 in. reinforced concrete; not clustered. M-50: 3 lbs. 9 oz.; weight of magnesium 1.1 lbs.; heat liberated, 13,000 Btu; striking velocity, 475 ft./sec.; penetration, up to 4 in. reinforced concrete; number in cluster, 110 M-69: 6.2 lbs; weight of fuel (tail ejected), 2.6 lbs.; heat liberated, 44,000 Btu; striking velocity, 225

ft./sec.; penetration, up to 3 in. concrete, not reinforced; number in cluster, 38. M-74: 8.4 lbs.; weight of fuel ("goop" mix, tail ejection), 2.8 lbs.; heat liberated, 38,000 Btu; striking velocity 250 ft../sec.; penetration, up to 3 in. concrete, not reinforced; all-ways fuse; number in cluster, 38. M-76: 473 lbs.; weight of fuel, 175 lbs.; heat liberated, 2.2 million Btu; striking velocity, 1000 ft./sec.; penetration, 12 in. reinforced concrete; not clustered. National Fire Protection Association, *Fire and the Air War* (Boston, 1946), 75.

 4.　Conrad C. Crane, *Bombs, Cities and Civilians: American Airpower Strategy in World War II* (University Press of Kansas, Lawrence, Kansas, 1993), 92.

 5.　John Muirhead, *Those Who Fall* (Random House, New York, 1986), 163.

 6.　Ibid.,165.

 7.　Wesley Frank Craven, and James Lea Cate, eds., *The Army Air Forces in World War II*, Vol. III (University of Chicago Press, 1955), 85.

 8.　Jack Olsen, *Aphrodite: Desperate Mission* (G.P. Putnam's Sons, New York, 1970), 255. There was concern that the bunkers would become launch sites for super-rockets, such as a weapon that could strike New York. Once the Allies crossed the Channel and had captured the four sites, they discovered that inside the thick steel-reinforced concrete structures was only debris and there were no signs that scientists or technicians had recently inhabited the empty living quarters underground. There was evidence of repair from the bombings but most of the repairs were merely cosmetic touches to make it appear in reconnaissance photographs that the bunkers mattered to the Germans and that they were worth bombing repeatedly. No V-1 or V-2 missiles had ever been launched from those facilities. By the end of the war, Allied intelligence finally pieced together the true story. Watten had been heavily bombed long before Aphrodite, and the Germans had been forced to abandon it and build a new one at Wizernes, also destroyed by Allied bombers. The site at Siracourt had suffered the same fate. The Mimoyceques facility had been designed for two ultra-long-range cannons that were intended to fire artillery shells into London at the rate of several thousand per day. It, too, had been abandoned well before the first Aphrodite mission.

 9.　Ibid., 47.

 10.　Ibid., 150.

 11.　Ibid., 175.

 12.　Top secret letter, Doolittle to Spaatz, August 12, 1944. Spaatz Papers, Library of Congress, Box 193.

 13.　Ibid., 103

 14.　During the Cuban missile crisis of October 1962, the *Joseph P. Kennedy, Jr.* figured prominently—and dangerously—in the nuclear confrontation between the U.S. and the Soviet Union. Together with another U.S. destroyer, the *John Pierce*, the two ships stopped and boarded the Panamanian-owned steamer *Murucla*—a clear violation of international law—to demonstrate America's firmness in enforcing its announced "quarantine" of Fidel Castro's Cuba. The ship was found to have no weapons aboard and was allowed to proceed to Cuba.

 15.　Dik Alan Daso, *Hap Arnold and the Evolution of American Airpower* (Smithsonian Institution Press, Washinton, 2000), 186–87.

 16.　Charles A.Lindbergh, *The Wartime Journals of Charles A. Lindbergh* (Harcourt Brace Jovanovich, Inc., New York, 1970), 985.

 17.　Hugh McDaid and David Oliver, *Smart Weapons—Top Secret History of Remote Controlled Airborne Weapons* (Welcome Rain, New York, 1997), 10.

 18.　Jack Couffer, *Bat Bomb: World War II's Other Secret Weapon* (University of Texas Press, Austin, 1992), 51.

 19.　Ibid., 210–211.

 20.　Ibid., 226.

 21.　USSBS Official Report, *The Effects of Atomic Bombs on Hiroshima and Nagasaki*, 240.

 22.　A nuclear weapon is rated by its yield of energy, expressed in terms of the

weight of the commonly used chemical explosive TNT (trinitrotoluen) that would release the same amount of energy. The *fission* of one kilogram (2.2 pounds) of "nuclear explosive" releases the same energy as the chemical explosion of 17,000 tons of TNT. The *fusion* of one kilogram of "thermonuclear explosive" releases the same energy as the chemical explosion of between 50,000 and 100,000 tons of TNT.

8—The Bombsights

1. John Kenneth Galbraith, *A Life in Our Times* (Houghton Mifflin Company, Boston, 1981), 204. Galbraith in his interviews with principal Nazi leaders like Goering, von Ribbentrop, and Speer, came away with an intimate understanding about the inaccuracy of U.S. bombing.

2. Richard Davis, *Carl A. Spaatz, and the Air War in Europe* (Center for Air Force History, Washington, 1993), 505

3. *Army Air Force Statistical Digest, World War II,* Washington DC, Office of Statistical Control, 1945.

4. Anthony Verrier, *The Bomber Offensive* (The MacMillan Company, London, 1969), 123.

5. Frank W. Heilenday, *Daylight Raids by the U.S. Eighth Air Force: Lessons Learned and Lingering Myths from World War II, P7917* (Rand, Santa Monica, California, 1995), 17.

6. In September 1941, Hermann Lang, the alleged spy, and 15 other German-Americans were tried in a Brooklyn, New York, court, accused of espionage and failure to register as agents of a foreign government. Acccording to the prosecuting attorney, the secret of the Norden bombsight, considered "this country's most jealously guarded air defense weapon" by the *New York Times* journalist writing the front-page story, had been in the hands of the German government since 1938 when Lang had gone to Germany and sold the information to German authorities. "We will prove," added the prosecutor, "that on deposit right now in Germany for Lang are 10,000 marks as part payment for his work here." A government informer who had worked with Lang told the jury that he (Lang) knew Hitler and Reich Air Marshal Hermann Goering, and that he regarded the Norden as "the most important thing in the world." An FBI special agent told of hearing a conversation between Lang and the same informer in which he said he had carried engineering details of the American bombsight "across in his head" to Germany and with the help of German engineers had reconstructed it in the three weeks he was there.

7. Stephen I. McFarland, *America's Pursuit of Precision Bombing, 1910–1945* (Smithsonian Institution Press, Washington, 1995), 95.

8. Ibid., 97– 98.

9. At the start of the 21st century, some military writers still wax poetical about the Norden bombsight. "The intricate 50-pound collection of gyros, motors, gears, mirrors and levers [what about knobs?] was beyond doubt the finest optical bombsight ever invented," according to an overly enthusiastic reviewer (*Air & Space*, February/March, 1995). In almost the same breath, the author writes that it contained "some 2,000 precision parts ... a marvelously complex machine...." One wonders how reliable such a "marvelously complex machine" could have been when bolted into the nose of a pitching, yawing, and rolling airplane, buffeted by radical temperature changes and pressures, subjected to severe shock loads during landings, assaulted by the vibrations of four big engines and nearby machine guns, and generally banged around in an inhospitable environment.

10. McFarland, op. cit., 155.

11. Ibid., 92.

12. Ibid., 192–193.

13. Kenneth P. Werrell, *Blankets of Fire: U.S. Bombers Over Japan During World War II* (Smithsonian Institution Press, Washington, 1996), 113.

14. McFarland, op. cit., 143, 195.

15. Haywood S. Hansell, Jr., *The Strategic Air War Against Germany and Japan, A Memoir* (Higgins-McArthur/Longino & Porter, Inc., Atlanta, 1972), 252.

16. Davis, op. cit., 297.

17. McFarland, op. cit., 168.

18. Alfred Price, *The Bomber in World War II* (Macdonald and Jane's, London, 1976), 70.

19. Allan A. Michie, *The Air Offensive Against Germany* (Henry Holt and Company, New York, 1943), 90–91.

20. Thomas Childers, *Wings of Mornng* (Addison-Wesley Publishing Company, New York, 1995), 187.

21. Hansell. op. cit., 231.

22. Arnold was an indefatigable promoter of air power and nagged Spaatz and his other commanders at every opportunity to document the results of the bombing compaigns. Pictures and more pictures was what Arnold insisted on. "People believe more readily what they see than what they hear," he wrote to Spaatz, adding: "Every daily paper in the United States will feature the pictures if you can get them to us…. Nine months have passed since Pearl Harbor, and the American public wants to see pictures, stories and experiences of our Air Force in combat zones." Davis, op. cit., 101–102. Arnold oversaw the production of *Impact*, a security-classified Air Force publication filled with photographs of targets bombed. It was circulated widely within the AAF and in government agencies in Washington.

23. Perret, op. cit., 292.

24. Wesley Frank Craven and James Lea Cate, eds., *The Army Air Forces in World War II*, vol 3 (Office of Air Force History, Washington 1983), 20.

25. Ibid., 753.

26. Anthony Verrier, *The Bomber Offensive* (MacMillan Company, London, 1969), 287.

27. Conrad C. Crane, *Bombs, Cities, and Civilians: American Airpower Strategy in World War II* (University Press of Kansas, Lawrence, Kansas, 1993).

28. *The Strategic Air War Against Germany 1939–1945: Report of the British Bombing Survey Unit* (Frank Cass, London, 1998), xxv.

9—The Aircrews

1. John Muirhead, *Those Who Fall* (Random House, New York, 1986), 108.

2. Richard Davis, *Carl A. Spaatz and the Air War in Europe* (Center for Air Force History, Washington, 1993), 372.

3. Conrad C. Crane, *Bombs, Cities, and Civilians: American Airpower Strategy in World War II* (University Press of Kansas, Lawrence, Kansas, 1993), 52.

4. Beirne Lay, Jr., "Regensburg Mission," *Air Force Magazine*, December 1943. Lay was with the 100th Bomb Group and on his fourth mission and had been assigned to chronicle the events of that mission and recommend improvements in tactics. Lay later wrote screenplays for a number of movies that were released during the war and co-authored a popular postwar novel, *Twelve O'Clock High*, published in 1947, based on his personal experiences as a flyer In 1948, Hollywood made it into an award-winning movie. Like the book, the movie was a sensible and non-polemical re-creation of an 8th Air Force bomb group. The Air Force stubbornly managed to get in an important plug for its still-vibrant doctrine in the opening text. It began: "This motion picture is humbly dedicated to those Americans, both living and dead, whose gallant efforts made possible *daylight precision bombing*" (author's italics).

5. Lt. Robert H. Mueller, USAAF. Interview with author.

6. Muirhead, op. cit., 134.

7. J. Kemp McLaughlin, *The Mighty Eighth in World War II* (The University Press of Kentucky, Lexington, 2000), 184.

8. Oron P. South, *Medical Support in a Combat Air Force* (Air University, Maxwell Air Force Base, Alabama, 1956), 7.

9. Thomas Childers, *Wings of Morning* (Addison-Wessley Publishing Company, New York, 1995), 77.

10. Mae Mills Link and Hubert A. Coleman, *Medical Support of the Army Air Forces in World War II* (Office of the Surgeon General, USAF, Washington, D.C., 1955), 64. Capt. William F. Sheeley of the Central Medical Establishment.

11. Ibid., 65.

12. Geoffrey Perret, *Winged Victory—The Army Air Forces in World War II* (Random House, New York, 1993), 124.

13. During the war, bombardiers suffered 17.6 percent of bomber crew casualties, tail gunners 12.5 percent, navigators 12.2 percent, waist gunners 10.5 percent, pilots 7.4 percent, and co-pilots 6.6 percent. Stephen McFarland, *America's Pursuit of Precision Bombing, 1910–1945* (Smithsonian Institution Press, Washington, 1995), f/n 14, 276.

14. Mark K. Wells, *Courage and Air Warfare—The Allies' Aircrew Experience in the Second World War* (Frank Cass, London, 1995), Col. Claude E. Putnam, 40.

15. McLaughlin, op. cit., 181.

16. South, op. cit., 65.

17. Donald L. Caldwell, *JG 26—Top Guns of the Luftwaffe* (Ballantine Books, New York, 1991), 249.

18. Ibid., 26.

19. Ronald O. Byers, ed., *Black Puff Polly* (Pawpaw Press, Moscow, Idaho, 1991), 18.

20. South, op. cit., 11.

21. Ibid., 26.

22. Muirhead, op. cit.,15–16.

23. Curtis E. LeMay, *Mission with LeMay* (Doubleday & Company, Inc., Garden City, New York, 1965), 307.

24. Robin Cross, *The Bombers* (MacMillan Publishing Company, New York, 1987).

25. Gerald Astor, *The Greatest War—Americans in Combat 1941–1945* (Presidio, Novato, California, 1999), 298–299. Jon Schueler.

26. Alastair Revie, *The Bomber Command* (Ballantine Books, New York, 1971), 247–248.

27. Wesley Frank Craven and James Lea Cate, eds., *The Army Air Forces in World War II*, Vol. III, (Office of Air Force History, Washington, D.C., 1983), 306.

28. Wells, op. cit., 107–109.

29. David G. Wright, ed., "Observations on Combat Flying Personnel," for the Air Surgeon, Army Air Forces, Josiah Macy, Jr. Foundation, New York, October 1945, 13.

30. Craven and Cate, op. cit., 306.

31. Ibid., 307.

32. Ibid., 838, f/note 129.

33. Muirhead, op. cit., 47.

34. Wesley Frank Craven and James Lea Cate, eds., *The Army Air Forces in World War II*, Vol. V (Office of Air Force History, Washington, D.C.,), 607.

35. Wells, op. cit., 107–109.

36. Richard Davis, *Carl A. Spaatz and the Air War in Europe* (Center for Air Force History, Washington, 1993), 288.

37. McLaughlin, op. cit., 122–123.

38. R. Ernest Dupuy and Trevor N. Dupuy, *The Encyclopedia of Military History* (Harper & Row, Publishers, New York, 1970), 1192.

39. The battle for Saipan ended July 9, 1944, after Admiral Nagumo, who had

begun Japan's war so brilliantly over Pearl Harbor, committed *hara-kiri* along with the island's commanding general. U.S. casualties were high, with over 3,400 killed or missing in action. By August 12, Guam and Tinian were in U.S. hands.
 40. Michael S. Sherry, *The Rise of American Air Power* (Yale University Press, New Haven, 1987), 212.
 41. Richard B. Frank, *Downfall—The End of the Imperial Japanese Empire* (Random House, New York, 1999), 162. In a later war in the Pacific against another enemy, North Korea, one USAAF bomber crew had these comments: "Those of us who were based on Okinawa envied the 98th Bomb Wing. They were stationed at Itazuki, Japan, and that was the lap of luxury. They had fresh milk, fresh eggs, fresh women. So when we were coming back from a mission we'd think of any excuse we could to put in at Itazuki—engine trouble, radio trouble, whatever—just to get some decent food like fresh eggs and bacon. Ol Tex would get on the intercom and say, 'Engineer! We're thirty minutes out of Itazuki: time to feather number four!' So I'd feather an engine, and he'd call Itazuki to report engine trouble. We'd go in, land, have a great breakfast, and then fly back to Okinawa, where the food was lousy." Anderton, 158.
 42. Kenneth P. Werrell, *Blankets of Fire: U.S. Bombers Over Japan During World War II* (Smithsonian Institution Press, Washington, D.C., 1996), 206.
 43. Werrell, ibid., 237–238.
 44. Frank W. Chinnock, *Nagasaki: The Forgotten Bomb* (World Publishing Company, New York, 1969), 33–34.

10—The Defenses

 1. Matthew Cooper, *The German Air Force 1933–1945* (Jane's, London), 359.
 2. Curtis LeMay, *Mission with LeMay* (Doubleday & Company, Inc., Garden City, New York, 1965), 139–140.
 3. *The Luftwaffe* (Time-Life Books, Alexandria, Virginia, 1982), 70.
 4. Williamson Murray, *The Luftwaffe 1933–45: Strategy for Defeat* (Brassey's, Washington, 1996), 277.
 5. First Lt. David Mills, 398th Bomb Group, 601st Squadron, based at Nuthampstead, a small town, then, some 40 miles north of London.
 6. Stephen L. McFarland and Wesley Phillips Newton, *To Command the Sky—The Battle for Air Superiority Over Germany, 1942–1945* (Smithsonian Institution Press, Washington, 1991), 52.
 7. Richard Davis, *Carl A. Spaatz and the Air War in Europe* (Center for Air Force History, Washington, 1993), 590.
 8. Albert Speer, *Inside the Third Reich* (Macmillan Company, New York, 1970).
 9. Suicide attacks were flown by what the Japanese called *Shimpu Tokubetsu Kogekitai*, or the Divine Wind Special Attack Corps, referring to the hurricane that in 1570 had destroyed a Mongol emperor's invasion fleet as it neared Japanese waters. The Japanese abbreviated this to *Tokko*, but the name later became engraved in American history as the Kamikaze Corps. The Kamikaze idea was not new in the fall of 1944. Some Japanese military officers had suggested the use of suicide planes in the summer, when the Japanese navy had been decisively defeated in the battle of the Philippine Sea in June 1944. Japanese planes had dived into American warships earlier, when their pilots, critically wounded or with planes severely damaged, had no hope of destroying their targets otherwise. During the battle for Okinawa in April–June 1945, Japanese *Kamikazes* sank 21 ships, damaged 43 others so badly they were scrapped, and forced another 23 out of action for over a month. The U.S. Navy's personnel losses in the Okinawa campaign exceeded those it had incurred in all the wars prior to World War II: 4,907 men killed and 4,824 wounded, most due to the *Kamikazes*. While official U.S. government announcements covered up the intensity and effectivness of the *Kamikaze* attacks, there

was a more ominous outcome than the casualties. The suicide attacks raised the specter of what would happen to U.S. forces during the planned invasion of the Japanese home islands starting in November 1945. There, the ranges would be much shorter and there were more airfields from which the suicide planes could be used. Intelligence sources indicated that Japan was producing airplanes at the rate of nearly 30,000 per year, which could provide a potential *Kamikaze* force some ten times greater than that at Okinawa.

10. Jerome Bernard Cohen, *The Japanese War Economy, 1937–1945* (University of Minnesota Press, Minneapolis, 1949), 208–209.

11—The Five Cities

1. Michael S. Sherry, *The Rise of American Air Power—The Creation of Armageddon* (Yale University Press, New Haven, 1987) 251.

2. Alexander McKee, *Dresden 1945: The Devil's Tinderbox* (E.P. Dutton, Inc., New York, 1982) 111.

3. Martin Middlebrook, *The Battle of Hamburg—Allied Bomber Forces Against a German City in 1943* (Charles Scribner's Sons, New York, 1981) 95.

4. Max Hastings, *Bomber Command: The Myths and Reality of the Strategic Bombing Offensive 1939–1945* (The Dial Press, New York, 1979) 339.

5. Charles Webster and Noble Frankland, *The Strategic Air Offensive Against Germany* (Her Majesty's Stationery Office, London, 1962). Excerpts from the Report by the Police President of Hamburg in July and August, 1943 (dated December 1, 1943). Vol. IV, Appendix 30, 310–315.

6. Albert Speer, *Inside the Third Reich* (The MacMillan Company, New York, 1970) 284.

7. R. H. S. Crossman, *Apocalypse at Dresden: The Long Suppressed Story of the Worst Massacre in the History of the World* (Esquire, November 1963).

8. The destruction of the undefended Basque city of Guernica, a stronghold of the Loyalist forces, on April 26, 1937 by Luftwaffe bombers supporting General Francisco Franco's Nationalists in the Spanish Civil War set the stage for what became routine indiscriminate city bombing by all the combatants during World War II. The attacks were purposefully intended to terrorize the cities' populations. "At twenty minutes to five Heinkel 111s began to appear, first bombing the town and then machine-gunning its streets.... People began to run from the town. These also were machine-gunned. Incendiary bombs, weighing up to 1000 lbs. and also high explosives, were dropped by waves of aircraft arriving every twenty minutes until a quarter-to-eight ... 1654 people were killed and 889 wounded." Stockholm International Peace Research Institute, *Incendiary Weapons* (The MIT Press, Cambridge, Massachusetts, 1971) 28

9. Excerpt from an internal RAF memo, 1945, "Review of the work of INT I." McKee, op. cit., 46.

10. Hastings, op. cit., 343.

11. David Irving, *The Destruction of Dresden* (Holt, Rinehart and Winston, New York, 1963) 154–155.

12. Ibid., 158

13. Kurt Vonnegut, Jr.'s brief "stream of conciousness" novel is often difficult to comprehend. One wonders whether his avowed intent to communicate an antiwar message might not have been better served by a straight nonfiction narrative such as John Hersey's powerful *Hiroshima*.

14. Vonnegut, op. cit., 148–149.

15. Ibid., 10–11.

16. McKee, op. cit., 269

17. Irving, op. cit., 132.

18. *New York Times*, February 16, 1945.

19. Irving, op. cit., 177.

20. McKee, op. cit.,109.

21. Irving, op. cit., 177.

22. Ibid., 178.

23. Prepared by Joseph W. Angell for the USAAF Historical Divisions of the Research Studies Institute of the Air University at Maxwell Air Force Base.

24. Davis, op. cit., 563–564.

25. Vonnegut, op. cit., 165.

26. Gar Alperovitz, *The Decision to Use the Atomic Bomb and the Architecture of an American Myth* (Alfred A. Knopf, New York, 1995), 217. (Diary of David E. Lillienthal, Chairman of the Atomic Energy Commission, 1947.)

27. Wesley Frank Craven and James Lea Cate, *The Army Air Forces in World War II*, Vol. V, *The Pacific: Matterhorn to Nagasaki* (The University of Chicago Press, Chicago, 1953), 617. Tokyo remained the XX Air Force's favorite Japanese target for firebombing right up to the end of the war. B-29s systematically bombed areas in the city that had not been destroyed in previous raids. The final toll was 56 square miles of Tokyo gutted, more than half the city's area.

28. Kenneth P. Werrell, *Blankets of Fire: U.S. Bombers Over Japan During World War II* (Smithsonian Institution Press, Washington, 1996), 157.

29. Robin Niellands, *The Bomber War: The Allied Air Offensive Against Nazi Germany* (Overlook Presss, Woodstock, New York, 2001), 378.

30. Craven and Cate, op. cit., 171.

31. Steve Birdsall, *Saga of the* Superfortress (Doubleday and Company, Inc., New York, 1968), 131.

32. The halfway point between the Marianas and Japan was approximately over the tiny volcanic island of Iwo Jima, only eight square miles in area, that would be captured from the Japanese after nearly a month of ferocious combat that ended on March 16 when organized resistance ended. The next day, 16 B-29s returning from Japan made emergency landings on the new U.S. base. By the end of the war B-29s had made 2,251 emergency landings on Iwo. Total U.S. Marine casualties resulting from the capture of the island were 6,891 killed and 18,070 wounded, the costliest campaign in the history of the service. Immediately after the war, the AAF was forced to go on the defensive over the issue of Marine Corps lives expended in the capture of Iwo Jima in "exchange" for Air Force lives "probably" expended, estimated at some 25,000. R. Ernest Dupuy and Trevor N. Dupuy, *The Encyclopedia of Military History* (Harper & Row, Publishers, New York, 1970), 1192. Craven and Cate suggest this Air Force figure "seems a gross exaggeration. Indeed, possession of Iwo offered a constant temptation to B-29 crews in difficulty to use the midway point when there was more than a reasonable chance of making the home base." Craven and Cate, vol. 5, op. cit., 598. Too, if the chow was better at Iwo than on Saipan, Guam, or Tinian, perhaps that would also have been an incentive to the aircrews to land at Iwo. But Marine Corps objections, public and private, were soon muted as photographer Joseph Rosenthal's "planting the flag" on Mount Suribachi by five marines became perhaps the most famous combat photograph in American history. The follow-on public-relations benefits for the Marine Corps in subsequent years have been incalculable, typified by the larger-than-life-size sculpture of the photograph that stands impressively at the entrance to Arlington National Cemetery just outside Washington.

33. Edwin P. Hoyt, *The Battle of Leyte Gulf: The Death Knell of the Japanese Fleet* (Weybright and Talley, New York, 1972), 83.

34. E. Bartlett Kerr, *Flames Over Tokyo* (Donald I. Fine, Inc., New York, 1991), 243.

35. John W. Dower, "The Innocence of Pearl Harbor," *New York Times*, June 3, 2001.

36. Richard Rhodes, *The Making of the Atomic Bomb* (Simon and Schuster, New York, 1986), 474.

37. Ibid., 34.
38. Alperovitz, op. cit., 10–11.

12—The Surveys

1. Haywood S. Hansell to David MacIsaac, July 27, 1970. "A-Bombs, Budgets, and Morality—Using the Strategic Bombing Survey," Gian P. Gentile, *Air Power History*, Spring 1997, f/n 2.
2. David MacIsaac, *Strategic Bombing in World War II—The Story of the United States Strategic Bombing Survey* (Garland Publishing Company, New York, 1976), 54.
3. The directors of the survey and their departments were as follows: Transportation: George Ball, Office of Lend-Lease Administration; Physical Damage: Prof. Harry Bowman, Drexel Institute; Overall Effects and Area Bombing: Prof. John Kenneth Galbraith, Harvard, Princeton and Office of Price Administration; Morale: Rensis Lickert, Dept. of Agriculture and Adviser to the Treasury Dept.; Civil Defense: Frank A. McNamee, Dep. National Director, Office of Civilian Defense; Bearings, Abrasives, Machine Tools, Electrical Engineering, Electronics, and Optical and Precision Machinery: Paul H. Nitze, Partner Dillon and Read, Foreign Economic Admininstration; Oil, Rubber and Chemicals: Robert P. Russell, President of Standard Oil Development Co.; Heavy Industry: Ordnance, motor vehicles, tanks, submarines: Fred Searls, Jr., Office of War Mobilization; Aircraft, light metals, V-weapons: Theodore P.Wright, Civil Aeronautics Administration; Secretary: Judge Charles C. Cabot.
4. MacIsaac, op. cit., 226.
5. *United States Strategic Bombing Survey* (USSBS), vol. 31 (Washington, Government Printing Office, 1945–1947), 2.
6. Ibid., Overall Report, 107.
7. Ibid., Overall Report, 108.
8. Ibid., Overall Report, 95.
9. Hastings, op. cit., 348.
10. Guido R. Perera, *Leaves from My Book of Life*, vol. II (privately printed, Boston, 1975), 135.
11. Bernard Brodie, *Strategy in the Missile Age* (Princeton University Press, Princeton, 1965), 111.
12. John Kenneth Galbraith, , *A Life in Our Times* (Houghton Mifflin Company, Boston, 1981), 76.
13. Ibid., 76.
14. Stockholm International Peace Research Institute (SIPRI) Monograph, *Incendiary Weapons* (MIT Press, Cambridge, Massachusetts, 1971), 35.
15. Solly Zuckerman, *From Apples to Warlords* (Hamish Hamilton, London, 1978), 33.
16. Albert Speer, *Inside the Third Reich* (MacMillan Company, New York, 1970), 346.
17. Galbraith, op. cit., 80.
18. USSBS, Overall Report (Europen War), Washington, 1945, 71.
19. MacIsaac, op. cit., 141–142.
20. Charles Messenger, *'Bomber' Harris and the Strategic Bombing Offensive, 1939–1945* (St. Martin's Press, New York, 1984), 191.
21. Hastings, op. cit., 347.
22. Ibid., 215.
23. Ibid., 226.
24. MacIsaac, op. cit., 124–125.
25. Ibid.

26. Galbraith, op. cit., 232.

27. Guido R. Perera, *Leaves from My Book of Life, vol. II* (Privately printed, Boson, 1975) 111.

28. Mark K. Wells, *Courage and Air Warfare—The Allies' Aircrew Experiences in the Second War War* (Frank Cass, London, 1995), 35.

Epilogue

1. Henry L. Stimson, "The Nuremberg Trial, Landmark in Law," *Foreign Affairs,* 1947.

2. *New York Times,* September 3, 1945.

Bibliography

Manuscript Repositories and Library Collections

Library of Congress, Manuscript Division: Carl Spaatz Papers; Henry H. Arnold Papers.

Newspapers

Nashville Banner
New York Times.
Dissertations
"The B-36 Controversy: A History of Air Force-Navy Rivalry Over Strategic Bombardment," Elliott L. Johnson. Thesis submitted in partial fulfillment of the requirements for the degree of Master of Science (History), University of Wisconsin, 1961.

Books

Alexander, Joseph H., *Utmost Savagery: The Three Days of Tarawa* (Naval Institute Press, Annapolis, Maryland), 1995.
Alperovitz, Gar, *The Decision to Use the Atomic Bomb and the Architecture of an American Myth* (Alfred A. Knopf, New York), 1995.
Ambrose, Stephen E., *The Wild Blue: The Men and Boys Who Flew the B-24s Over Germany* (Simon & Schuster, New York), 2001.
Anderton, David A., *B-29 Superfortress at War* (Charles Scribner's Sons, New York), 1978.
Andrews, Marshall, *Disaster Through Air Power* (Rinehart & Company, Inc., Toronto), 1950
Arnold, H. H., *Army Flyer* (Harper & Brothers, Publishers, New York), 1942.
_____. *Global Mission* (Harper & Brothers, Publishers, New York), 1949.
_____, and Ira C. Eaker, *Winged Warfare* (Harper & Brothers, Publishers, New York), 1941.
Astor, Gerald, *The Greatest War—Americans in Combat 1941–1945* (Presidio, Novato, California), 1999.

232 Bibliography

_____. *The Mighty Eighth* (Donald I. Fine Books, New York), 1997.
Avery, Derek, *Fighter Aircraft of World War II*, (Wordsworth Ltd. Hertfordshire, U.K.), 1994.
Bacque, James, *Other Losses* (Stoddard Publishing Co., Ltd., Canada), 1989.
Bailey, Thomas A., and Paul B. Ryan, *Hitler vs. Roosevelt—The Undeclared Naval War* (Free Press, New York), 1979.
Baldwin, Hanson W., *United We Stand!* (Whittlesey House, New York), 1941.
Beck, Earl R., *Under the Bombs—The German Home Front 1942–1945* (University Press of Kentucky), 1986.
Bekker, Cajus, *The Luftwaffe War Diaries*—The German Air Force in World War II (Doubleday & Company, Inc., Garden City, New York), 1968.
Bergerud, Eric M., *Fire in the Sky* (Westview, Boulder, Colorado), 2000.
Berry, Paul, and Mark Bostridge, *Vera Brittain, A Life* (Chatto & Windus, London), 1995.
Bidinian, Larry J., *The Combined Allied Bombing Offensive Against the German Civilian, 1942–1945* (Coronado Press, Lawrence, Kansas), 1976.
Bird, Kai, and Lawrence Lifschultz, (edited by), *Hiroshima's Shadow* (Pampleteer's Press, Stony Brook, Connecticut), 1998.
Birdsall, Steve, *The B-24* Liberator (Arco Publishing Company, Inc., New York), 1968.
_____. *Saga of the* Superfortress (Doubleday & Company, Inc., Garden City, New York), 1980.
Blair, Clay, *Silent Victory* (J. B. Lippincott Company, Philadelphia), 1975.
Blanchard, William H., *Aggression American Style* (Goodyear Publishing Company, Inc., Santa Monica, California), 1978.
Bond, Brian, *Liddell Hart—A Study of His Military Thought* (Cassell, London), 1976.
Bond, Horatio, ed., *Fire and the Air War* (National Fire Protection Association, Boston), 1946.
Boyer, Paul, *By The Bomb's Early Light* (Pantheon Books, New York), 1985
Boyle, Andrew, *Trenchard* (W.W. Norton & Company, Inc., New York), 1962.
Boyne, Walter J., *Clash of Wings: World War II in the Air* (Simon & Schuster, New York), 1994.
Brittain, Vera, *Seed of Chaos* (New Vision Publishing Company, London), 1944.
Brodie, Bernard, *Strategy in the Missile Age* (Princeton University Press, Princeton, New Jersey), 1965.
Buchanan, A. Russell, *The United States and World War II*, Vol. II (Harper Torchbooks, New York), 1964.
Butow, Robert J.C., *Japan's Decision to Surrender* (Stanford University Press, Stanford, California), 1954.
Byers, Roland O., ed., *Black Puff Polly* (Pawpaw Press, Moscow, Idaho), 1991.
Caidin, Martin, *Black Thursday* (Bantam Books, New York), 1960.
_____. *The Ragged, Rugged Warriors* (E.P. Dutton & Co., Inc., New York), 1966.
_____. *A Torch to the Enemy: A Fire Raid on Tokyo* (Ballantine Books, New York), 1960.
Caldwell, Donald L., *JG 26—Top Guns of the Luftwaffe* (Ballantine Books, New York), 1991.
Chant, Christopher, *The Zeppelin: The History of German Airships from 1900 to 1937* (Barnes & Noble, Inc., New York), 2000.
Childers, Thomas, *Wings of Morning* (Addison-Wesley Publishing Company, New York), 1995.
Chinnock, Frank W., *Nagasaki: The Forgotten Bomb* (World Publishing Company, New York), 1969.
Clark, Ronald W., *The Role of the Bomber* (Coroell, New York) 1971.
Coffey, Thomas M., *Decision Over Schweinfurt* (David McKay Company, Inc., New York), 1977.
Cohen, Jerome Bernard, *The Japanese War Economy, 1937–1945* (University of Minnesota Press, Minneapolis), 1949.

Comparato, Frank E., *Age of the Great Guns: Cannon Kings and Cannoneers who Forged the Firepower of Artillery* (Stackpole, Harrisburg, Pennsylvania), 1965.

Cook, Fred J., *The Warfare State* (Macmillan Publishing Co., Inc., New York), 1962.

Cooper, Matthew, *The German Air Force 1933–1945* (Jane's, London), 1981.

Couffer, Jack, *Bat Bomb: World War II's Other Secret Weapon* (University of Texas Press, Austin), 1992.

Crabtree, James D., *On Air Defense* (Praeger, Westport, Connecticut), 1994.

Crane, Conrad C., *Bombs, Cities, and Civilians: American Airpower Strategy in World War II* (University Press of Kansas, Lawrence, Kansas), 1993.

Craven, Wesley Frank, and James Lea Cate, eds., *The Army Air Forces in World War II*, Vol. III, *Europe: ARGUMENT to V-E Day* (Office of Air Force History, Washington, D.C.), 1983; Vol. V, *The Pacific: MATTERHORN to NAGASAKI* (University of Chicago Press, Chicago), 1953; Vol. VI, *Men and Planes* (University of Chicago Press, Chicago), 1955.

Cross, Robin, *The Bombers* (Macmillan Publishing Company, New York), 1987.

Cuneo, John R., *The Air Weapon 1914–1916* (Military Service Publishing Company, Harrisburg, Pennsylvania), 1947.

Daniels, Gordon, ed., *A Guide to the Reports of the United States Strategic Bombing Survey* (Offices of the Royal Historical Society, London), 1981.

Daso, Dik Alan, *Hap Arnold and the Evolution of American Airpower* (Smithsonian Institution Press, Washington), 2000.

Davis, Burke, *The Billy Mitchell Affair* (Random House, New York), 1967.

Davis, Richard, *Carl A. Spaatz and the Air War in Europe* (Center for Air Force History, Washington), 1993.

Daws, Gavan, *Prisoners of the Japanese*, (William Morrow and Company, Inc., New York), 1994.

Deighton, Len, *Fighter: The True Story of the Battle of Britain* (Alfred A. Knopf, New York), 1978.

Dennis, Jack (ed.), *The Nuclear Almanac: Confronting the Atom in War and Peace* (Addison-Wesley Publishing Company, Reading, Massachusetts), 1984.

De Seversky, Alexander P., *Victory Through Air Power* (Simon and Schuster, New York), 1942.

De Weerdim, Harvey A., *President Wilson Fights His War* (Macmillan Company, New York), 1968.

Douhet, Giulio, *The Command of the Air* (Office of Air Force History, Washington), 1983. Originally published: New York, Coward-McCann, 1942.

Dower, John W., *War Without Mercy* (Pantheon Books, New York), 1986.

Dugan, James, and Caroll Stewart, *Ploesti—The Great Ground-Air Battle of 1 August 1943* (Random House, New York), 1962.

Dupuy, R. Ernest and Trevor N. Dupuy, *The Encyclopedia of Military History from 3500 B.C. to the Present* (Harper & Row, New York), 1970.

Dyer, Gwynne, *War* (Crown Publishers, Inc., New York), 1985.

Earle, Edward Mead, ed., *Makers of Modern Strategy: Military Thought from Machiavelli to Hitler* (Princeton University Press, Princeton), 1943.

Edoin, Hoito, *The Night Tokyo Burned* (St. Martin's Press, New York), 1987.

Englebrecht, H.C. and F.C. Hanigan, *Merchants of Death: A Study of the International Armament Industry* (London, George Routledge & Sons), 1934.

Ethell, Jeffry, and Alfred Price, *Target Berlin—Mission 250: 6 March 1944* (Jane's, London) 1981.

Feis, Herbert, *The Atomic Bomb and the End of World War II* (Princeton University Press, Princeton), 1961.

_____. *The Road to Pearl Harbor* (Atheneum, New York), 1966.

Fili, William J., *Passage to Valhalla* (Filcon Publishers, Media, Pennsylvania), 1991.

Fleming, Thomas, *The New Dealers' War: F.D.R. and the War Within World War II* (Basic Books, New York), 2001.

Frank, Richard B., *Downfall—The End of the Imperial Japanese Empire* (Random House, New York), 1999.

Frankland, Noble, *The Bombing Offensive Against Germany* (Faber and Faber, London), 1965.

Fredette, Raymond H., *The Sky on Fire* (Harcourt Brace Jovanovich, New York), 1976.

Freeman, Roger A., *B-17 Flying Fortress* (Wing & Anchor Press, New York), 1983.

_____. *Mighty Eighth War Manual* (Motorbooks International, Osceola, Wisconsin), 1991.

_____. *The U.S. Strategic Bomber* (Macdonald and Jane's, London), 1975.

Fuller, J. F. C., *The Second World War—A Strategical and Tactical History* (Eyre and Spottiswoode, London)

Fussell, Paul, *Wartime* (Oxford University Press, New York), 1989.

Galbraith, John Kenneth, *A Life in Our Times* (Houghton Mifflin Company, Boston), 1981.

Galland, Adolf, *The First and the Last—The German Fighter Force in World War II* (Champlin Museum Press, Mesa, Arizona), 186.

Gaston, James C., *Planning the American Air War: Four Men in Nine Days in 1941* (National Defense University, Washington), 1982.

Gavreau, Emile, *The Wild Blue Yonder* (E.P. Dutton & Company, Inc., New York), 1944.

_____, and Lester Cohen, *Billy Mitchell—Founder of Our Air Force and Prophet Without Honor* (E.P. Dutton & Co. Inc., New York), 1942.

Gallucci, Robert L., *Neither Peace Nor Honor—The Politics of American Military Policy in Viet-Nam* (Johns Hopkins University Press, Baltimore), 1975.

Gaylor, Neil, *Hiroshima's Shadow* (Pamphleteer's Press, Stony Creek, Connecticut), 1998.

Giovannitti, Len, and Fred Freed, *The Decision to Drop the Bomb* (Coward-McAnn, Inc., New York), 1965.

Glines, Carroll V., Jr., *The Compact History of the United States Air Force* (Hawthorne Books, Inc., New York), 1963.

_____. *Doolittle's Tokyo Raiders* (D. Van Nostrand Company, Inc., Princeton, New Jersey), 1964.

Goss, Hilton P., *Civilian Morale Under Aerial Bombardment, 1914–1939*, Vols. 1 and 2 (Air University Documentary Study, Maxwell Air Force Base, Alabama), December 1948.

Grant, Zalin, *Over The Beach* (W.W. Norton & Company, New York), 1986.

Greer, Thomas H., *The Development of Air Doctrine in the Army Air Arm, 1917–1941* (Office of Air Force History, U.S. Air Force, Washington), 1985.

Gunston, Bill, David Anderton, and Bryan Cooper, *Air Power* (Exeter Books, New York), 1979.

Harrison, Tom, *Living Through the Blitz* (Schocken Books, New York), 1976.

Hansell, Haywood S., Jr., *The Air Plan That Defeated Hitler* (Higgins-McArthur/Longino & Porter, Inc., Atlanta), 1972.

_____. *The Strategic Air War Against Germany and Japan: A Memoir* (Office of Air Force History, United States Air Force, Washington, D.C.), 1986.

Hart, B. H. Liddell, *The Revolution in Warfare* (Yale University Press, New Haven), 1947.

Hastings, Maj. Donald W., Capt. David G. Wright, and Capt. Bernard C. Glueck. (*Psychiatric Experiences of the Eighth Air Force—First Year of Combat* (Office of the Air Surgeon, Army Air Forces, Josiah Macy, Jr. Foundation, New York), 1963.

Hastings, Max, *Bomber Command: The Myths and Reality of the Strategic Bombing Offensive 1939–1945* (Dial Press, New York), 1979.

Heilenday, Frank W., *Daylight Raids by the U.S. Eighth Air Force: Lessons Learned and Lingering Myths from World War II, P-7917* (Rand, Santa Monica, California), 1995.

_____. *Night Raids by the British Bomber Command: Lessons Learned and Lingering Myths from World War II, P-7916* (Rand, Santa Monica, California), 1995.

Herken, Gree, *The Winning Weapon—The Atomic Bomb in the Cold War 1945–1950* (Princeton University Press, Princeton, New Jersey), 1981.

Hersey, John, *Hiroshima* (Alfred A. Knopf, New York), 2001.

Hess, William N., Frederick A. Johnson, and Chester Marshall, *Great American Bombers of WW II* (MBI Publishing Company, Osceloa, Wisconsin), 1998.

Hough, Richard, and Denis Richards, *The Battle of Britain* (W.W. Norton & Company, New York), 1989.

Hoyt, Edwin P., *The Battle of Leyte Gulf: The Death Knell of the Japanese Fleet* (Weybright and Talley, New York), 1972.

_____. *Inferno: The Firebombing of Japan, March 9–August 15, 1945* (Madison Books, New York), 2000.

Huie, William Bradford, *The Fight for Air Power* (L. B. Fischer, New York), 1942.

Infield, Glenn, *Big Week—The Classic Story of the Crucial Air Battle of World War II* (Brassey's, Washington), 1993.

Irving, David, *The Destruction of Dresden* (Holt, Rinehart and Winston, New York), 1963.

_____. *Nuremberg: The Last Battle* (Focal Point Publications, London), 1996.

Jablonski, Edward, Flying Fortress (Doubleday & Company, Inc., Garden City, New York), 1965.

Jackson, Robert, *Bomber! Famous Bomber Missions of World War II* (St. Martin's Press Inc., New York), 1980.

Johnson, David, *V-1 V-2: Hitler's Vengeance on London* (Stein and Day, New York), 1981.

Jones, Neville, *The Origins of Strategic Bombing* (William Kimber, London), 1973.

Kato, Masuo, *The Lost War* (Alfred A. Knopf, New York), 1946.

Kennett, Lee, *A History of Strategic Bombing* (Charles Scribner's Sons, New York), 1982.

Kerr, E. Bartlett, *Flames Over Tokyo* (Donald I. Fine, Inc., New York), 1991.

Kohn, Richard, and Joseph Harahan, *Air Superiority in World War II and Korea* (United States Air Force Warrior Studies, Washington), 1983.

Ksesaris, Paul L., ed., *Ultra and the History of the United States Strategic Air Force in Europe vs. the German Air Force* (University Publications of America, Frederick, Maryland), 1980.

Lawson, Ted. W., *Thirty Seconds Over Tokyo* (Random House, New York), 1943.

Lay, Beirne, Jr., and Sy Bartlett, *Twelve O'Clock High* (Harper & Brothers, New York), 1948.

LeMay, Curtis E., *Mission with LeMay* (Doubleday & Company, Inc., Garden City, N.Y.), 1965.

_____. *Superfortress: The B-29 and American Air Power* (McGraw-Hill Book Company, New York), 1988.

Levine, Alan J., *The Strategic Bombing of Germany, 1940–1945* (Praeger, Westport, Connecticut), 1992.

Lifschultz, Lawrence, and Kai Bird, eds., *Hiroshima's Shadow* (Pamphleteer's Press, Stony Creek, Connecticut), 1998.

Lindbergh, Charles A., *The Wartime Journals of Charles A. Lindbergh* (Harcourt Brace Jovanovich, Inc., New York), 1970.

Linenthal, Edward T., and Tom Engelhardt, *History Wars—The Enola Gay and Other Battles for the American Past* (Metropolitan Books, New York), 1996.

Littauer, Raphael, and Norman Uphoff, eds., *The Air War in Indochina* (Beacon Press, Boston), 1972.

Link, Mae Mills, and Hubert A. Coleman, *Medical Support of the Army Air Forces in World War II* (Office of the Surgeon General, USAF, Washington), 1955.

Longmate, Norman, *The Bombers* (Hutchinson, London), 1983.

Loosbrock, John F., and Richard M. Skinner, eds., *The Wild Blue—The Story of American Airpower* (G.P. Putnam's Sons, New York), 1946.

The Luftwaffe, by the Editors of Time-Life Books (Time-Life Books, Alexandria, Virginia), 1982.

MacIsaac, David, *Strategic Bombing in World War Two—The Story of the United States Strategic Bombing Survey* (Garland Publishing, Inc., New York), 1976.

Markusen, Eric, and David Kopf, *The Holocaust and Strategic Bombing: Genocide and Total War in the 20h Century* (Westview Press, San Francisco), 1995.

Mason, Francis K., *Battle Over Britain* (Doubleday & Company, Inc., Garden City, New York), 1969.

McDaid, Hugh, and David Oliver, *Smart Weapons—Top Secret History of Remote Controlled Airborne Weapons* (Welcome Rain, New York), 1997.

McFarland, Stephen L., *America's Pursuit of Precision Bombing, 1910–1945* (Smithsonian Institution Press, Washington,) 1995.

_____. and Wesley Phillips Newton, *To Command the Sky—The Battle for Air Superiority over Germany, 1942–1944* (Smithsonian Institution Press, Washington), 1991.

McKee, Alexander, *Dresden 1945: The Devil's Tinderbox* (E.P. Dutton, Inc., New York), 1982.

McLaughlin, J. Kemp, *The Mighty Eighth in World War II* (University Press of Kentucky, Lexington), 2000.

McManus, John C., *Deadly Sky: The American Combat Airman in World War II* (Presidio Press, Inc., Novato, California), 2000.

Messenger, Charles, *'Bomber' Harris and the Strategic Bombing Offensive, 1939–1945* (St. Martin's Press, New York), 1984.

Michie, Allan A., *The Air Offensive Against Germany* (Henry Holt and Company, New York), 1943.

Middlebrook, Martin, *The Battle of Hamburg—Allied Bomber Forces Against a German City in 1943* (Charles Scribner's Sons, New York), 1981.

_____. *The Berlin Raids—RAF Bomber Command Winter 1943–1944* (Cassell & Co., London), 1988.

Miller, Edward S., *War Plan Orange* (Naval Institute Press, Annapolis, Maryland), 1991.

Millis, Walter, *Road to War—America 1914–1917* (Houghton Mifflin Company, New York), 1935.

Mitchell, William, *Memoirs of World War I: From Start to Finish of Our Greatest War* (New York, Random House), 1960.

_____. *Our Air Force* (E. P. Dutton & Company, New York), 1921.

_____. *Winged Defense* (Kennikat Press, Port Washington, New York), 1971 (first published in 1925).

Morella, Joe, Edward Z. Epstein, and Griggs, *The Films of World War II* (Citadel Press, Secaucus, New Jersey), 1973.

Morison, Samuel Eliot, *Aleutians, Gilberts and Marshalls, June 1942–April 1944* (Little, Brown and Company, Boston), 1951.

_____. *Breaking the Bismarck Barrier* (Little, Brown and Company, Boston) 1950.

Morrison, Wilbur H., *Fortress Without a Roof* (St. Martins Press, New York), 1982.

_____. *Point of No Return: The Story of the 20th Air Force* (Times Books, New York), 1979.

Morrow, John H., Jr., *The Great War in the Air: Military Aviation from 1909 to 1921* (Smithsonian Instition Press, Washington), 1993.

Muirhead, John, *Those Who Fall* (Random House, New York), 1986.

Murray, Williamson, *The Luftwaffe 1933–45: Strategy for Defeat* (Brassey's, Washington), 1996.

National Fire Protection Association, *Fire and the Air War*, Boston, 1946. (See Bond, Horatio, ed., above.)

Newby, Leroy, *Target Ploesti* (Kensington, New York) 1986.

Niellands, Robin, *The Bomber War: The Allied Air Offensive Against Nazi Germany* (Overlook Press, Woodstock, New York), 2001.

Olsen, Jack, *Aphrodite: Desperate Mission* (G. P. Putnam's Sons, New York), 1970.

Overy, R. J., *The Air War 1939–1945* (Stein and Day, Publishers, New York), 1981.
Peden, Murray, *A Thousand Shall Fall* (Stoddard Publishing Co., Ltd., Toronto, Canada), 1988.
Perera, Guido R., *Leaves from My Book of Life*, vol. II (privately Printed, Boston), 1975.
Perret, Geoffrey, *Winged Victory: The Army Air Forces in World War II* (Random House, New York), 1993.
Price, Alfred, *The Bomber in World War II* (Macdonald and Jane's, London), 1976.
Quester, George H., *Deterrence Before Hiroshima* (Transaction Books, New Brunswick, New Jersey), 1966.
Revie, Alastair, *The Bomber Command* (Ballantine Books, New York), 1971.
_____. *The Lost Command* (David Bruce & Watson, London), 1971.
Rhodes, Richard, *The Making of the Atomic Bomb* (Simon and Schuster, New York), 1986.
Robinson, Douglas H., *Giants in the Sky* (University of Washington Press, Seattle), 1973.
_____. *The Zeppelin in Combat* (Schiffer Publishing Ltd., Atglen, Pennsylvania), 1994.
Ross, Stewart Halsey, *Propaganda for War: How the United States Was Conditioned to Fight the Great War of 1914–1918* (McFarland & Company, Inc., Jefferson, North Carolina), 1996.
Rumpf, Hans, *The Bombing of Germany* (Holt, Rinehart and Winston, New York), 1963.
Saundby, Sir Robert, *Air Bombardment: The Story of its Development* (Harper Brothers, New York), 1961.
Schaffer, Ronald, *Wings of Judgment: American Bombing in World War II* (Oxford University Press, New York), 1985.
Sherrod, Robert, *Tarawa* (Duell, Sloan and Pearce, New York), 1944.
Sherry, Michael S., *The Rise of American Air Power—The Creation of Armageddon* (Yale University Press, New Haven), 1987.
Sigaud, Louis A., *Douhet and Aerial Warfare* (G.P. Putnam's Sons, New York), 1941.
SIPRI (Stockholm International Peace Resarch Institute) monograph, *Incendiary Weapons* (MIT Press, Cambridge, Massachusetts), 1971.
Sledge, E. B., *With the Old Breed at Peleliu and Okinawa* (Oxford University Press, New York), 1981.
Smith, Perry McCoy, *The Air Force Plans for Peace, 1943–1945* (Johns Hopkins Press, Baltimore), 1970.
Smith, Peter C., *Dive Bomber* (Naval Institute Press, Annapolis), 1982.
South, Oron P., *Medical Support in a Combat Air Force* (Air University, Maxwell Air Force Base, Alabama), 1956.
Spaight, J. M., *Bombing Vindicated* (Geoffrey Bles, London), 1944.
Spector, Ronald H., *Eagle Against the Sun* (Free Press, New York), 1985.
Speer, Albert, *Inside the Third Reich* (Macmillan Company, New York), 1970
Spick, Mike, and Alfred Price, *Great Aircraft of World War II* (Chartwell Books, Inc., Edison, New Jersey), 1997.
Steinbeck, John, *Bombs Away* (Viking Press, New York), 1942.
Stimson, Henry L., *Diary* (Sterling Memorial Library, Yale University, New Haven).
The Strategic Air War Against Germany 1939–1945: Report of the British Bombing Survey Unit (Frank Cass, London), 1998.
Tanner, Stephen, *Refuge from the Reich: American Airman and Switzerland During World War II* (Sarpedon, Rockville Centre, New York), 2000.
United States Strategic Bombing Survey, 316 vols., Washington, Government Printing Office, 1945–1947.
Van der Vat, Dan, *The Pacific Campaign* (Simon & Schuster, New York), 1991.
Veale, Frederick J.P., *Advance to Barbarism* (Institute of Historical Research, Newport Beach, California), 1979.
Verrier, Anthony, *The Bomber Offensive* (Macmillan Company, London), 1969.
Vincent, C. Paul, *The Politics of Hunger: The Allied Blockade of Germany, 1915–1919* (Ohio University Press, Athens), 1985.

Vonnegut, Kurt, *Slaughterhouse-Five* (Dell Publishing, New York), 1966.

Webster, Charles, and Noble Frankland, *The Strategic Bombing Offensive Against Germany 1939–1945*, Vols I–IV (Her Majesty's Stationery Office, London), 1961.

Weighly, Russell F., *The American Way of War* (Macmillan Publishing Co. Inc., New York), 1973.

Weinberg, Gerhard L., *A World at Arms* (Cambridge University Press, New York), 1994.

Weir, Adrian, *The Last Flight of the Luftwaffe—The Suicide Attack on the Eighth Air Force, 7 April 1945* (Cassell & Co., London), 1997.

Wells, Herbert George, *The War in the Air* (G. Bell and Sons, Ltd., London), 1908.

Wells, Mark K., *Courage and Air Warfare—The Allies' Aircrew Experience in the Second World War* (Frank Cass, London), 1995.

Werrell, Kenneth P., *Blankets of Fire: U.S. Bombers Over Japan During World War II* (Smithsonian Institution Press, Washington), 1996.

_____. *The Evolution of the Cruise Missile* (Air University Press, Maxwell AFB, Alabama), 1985.

White, Donald W., *The American Century* (Yale University Press, New Haven), 1996.

Wilson, Theodore A., editor, *WW2: Readings on Critical Issues* (Charles Scribner's Sons, New York), 1972.

Wittner, Lawrence S., *Rebels Against War: The American Peace Movement, 1941–1960* (Columbia University Press, New York), 1969.

Wyden, Peter, *Day One, Before Hiroshima and After* (Simon and Schuster, New York), 1984.

Ziff, William B., *The Coming Battle of Germany* (Duell, Sloan and Pearce, New York), 1942.

Zuckerman, Solly, *From Apples to Warlords* (Hamish Hamilton, London), 1978.

Articles

Bernstein, Barton J., "Compelling Japan's Surrender Without the A-Bomb, Soviet Entry, or Invasion: Reconsidering the US Bombing Survey's Early-Surrender Conclusions," *Journal of Strategic Studies*, June 1995.

Biddle, Tami Davis, "British and American Approaches to Strategic Bombing: Their Origins and Implementation in the World War II Combined Bomber Offensive," *Journal of Strategic Studies*, Vol. 18, March 1995.

Brodie, Bernard, "The Heritage of Douhet," *Air University Quarterly Review*, Vol. VI, 1953.

Compton, Karl T., "If the Atomic Bomb Had Not Been Used," *The Atlantic Monthly*, December 1946.

Crane, Conrad C., "Evolution of U.S. Strategic Bombing of Urban Areas," *Historian*, Vol. 50, November 1987.

Crossman, R.H.S., "Apocalypse at Dresden," *Esquire*, November 1963.

Galbraith, John Kenneth, "After the Air Raids," *American Heritage*, April/May 1981.

Gentile, Gian Peri, "A-Bombs, Budgets and Morality—Using the Strategic Bombing Survey," *Air Power History*, Spring 1997.

_____. "Advocacy or Assessment? The United States Strategic Bombing Survey of Germany and Japan," *Pacific Historical Review*, Vol. 66, Winter 1997.

Lay, Beirne, Jr., "Regensburg Mission," *Air Force Magazine*, December 1943.

MacIsaac, David, "What the Bombing Survey Really Says," *Air Force Magazine*, June 1973.

Nickerson, Hoffman, "The Folly of Strategic Bombing," *American Preparedness Association*, Washington, Jan.–Feb. 1949.

Oliver, Todd, "The Americans Are Not Invincible," *New Left Review*, Vol. 47, Jan.–Feb. 1968.

Sherman, Don, "The Secret Weapon," *Air & Space,* February 1995.

Smith, Melden E., Jr. "The Strategic Bombing Debate: The Second World War and Vietnam," *Journal of Contemporary History,* Vol. 12, 1977.

Stimson, Henry L, "The Decision to Use the Atomic Bomb," *Harper's Magazine,* February 1947.

Wright, Maj. David G., ed., "Observations on Combat Flying Personnel," for the Air Surgeon, Army Air Forces, *Josiah Macy, Jr. Foundation,* New York, October 1945.

Index

Kennedy, Joseph P., Jr. 114, 115, 116
Kennedy, Joseph P., Sr. 114, 116
Kennedy, Robert F. 116
Kettering, Charles F. 117
Kettering Bug 117
Kharagpur 77
Knox, Frank 46
Kokura 192
Konoye, Fumimaro 10
Kurata, Yasuo 209
Kuter, Laurence S. 46, 47, 51, 132
Kyoto 82, 191

Lawrence, Ernest O. 122
Lay, Beirne, Jr. 143
LeMay, Curtis E. 5, 79, 80, 85, 95
Lenin, Nikolai 128
Levin, Meyer 56
Lindbergh, Charles A.
Little Boy 7, 9, 97, 99, 120
Lockheed P-38 Lightning 101, 102, 115
London 20, 21, 23, 110
Louis XIV 11
Lovett, Robert A. 196

MacArthur, Douglas 55
MacIssac, David 197, 202
Manhattan Project 120, 121, 122
Mao Zedung 76
Marconi, Guglielmo 14
Mariana Islands 60, 76, 83, 95, 108, 124, 160, 161
Marie Antoinette 11
Market Garden 106
Marshall, George C. 67, 127, 140
McGovern, William M. 187, 188
Memphis Belle 154, 156
Messerschmitt Bf 109 164, 165
Messerschmitt Me 163 Komet 169
Messerschmitt Me 262 Swallow 167, 168, 169
Middleton, Drew 126, 139
Missouri 10
Mistel 117
Mitchell, William "Billy" 2, 3, 15, 25, 34, 38, 39, 40, 41, 42, 44, 52, 77, 187
Montgolfier Brothers 11
Morgenthau, Henry, Jr. (Morgenthau Plan) 46
Moss, Malcolm 47
Muirhead, John 109, 110
Mussolini, Benito 35

Nagasaki 6, 9, 31, 37, 119, 176, 192
Napalm 107
Navigation 125, 136
New York City 11, 13, 14
New York Times 18, 29, 55, 68
Nicholas II, Czar 15
Norden, Carl Lukas 128
North American P-51 Mustang 102, 103, 104

Oftsie, Ralph A. 205, 206
Okinawa 77, 97
Oppenheimer, J. Robert 122, 190

Pathfinders 125
Pearl Harbor 3, 36, 40, 51, 53, 55
Peirse, R. E. C. 63
Perera, Guide R. 198
Picasso, Pablo 31
Pohl, Hugo von 19
Precision bombing 29, 44, 46, 84, 125
Propaganda 1, 2, 14, 24, 41, 44, 59, 105, 142, 154, 156
Proximity fuze 171

Radar Navigation 126, 136, 137
Ravens 174
Regensburg 67, 143, 144, 202
Republic P-47 Thunderbolt 99, 100
Rex 85, 86
Ribot, Alexander 24
Richthofen, Manfred von 16
Rickenbacker, Eddie 16
Robida, Albert 12
Robins, Donald 55
Roosevelt, Franklin D. 3, 32, 33, 45, 46, 51, 53, 59, 65, 66, 68, 76
Ross, Stewart Halsey 3
Russo-Japanese War 36, 52

Saratoga 77
Saundby, Robert 87, 88
schrage Musik 166
Schweinfurt 54, 67, 68, 202
Shanghai 30
Shenandoah 22, 41
Silverplate 97
Snow, Edgar 30
Sonderkommandos 172
Spaatz, Carl E. 6, 8, 41, 60, 72, 74, 185
Spanish-American War 11
Speer, Albert 67, 72, 171, 179, 201, 202